700 · 8664

HIDDEN HISTORIE

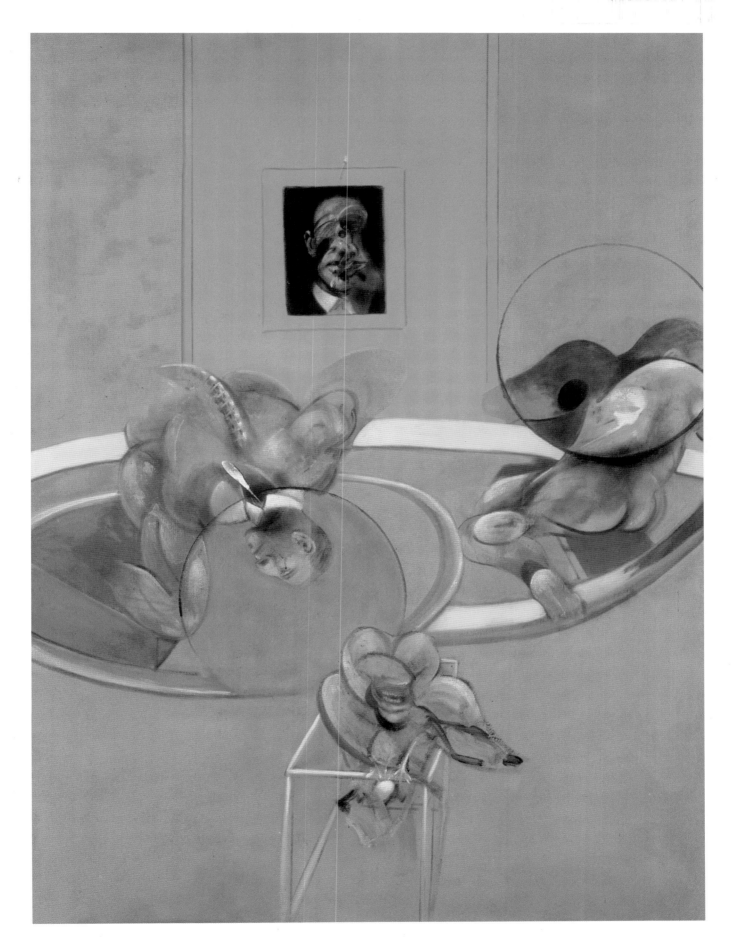

HIDDEN HISTORIES

20TH CENTURY MALE SAME SEX LOVERS IN THE VISUAL ARTS

Michael Petry

ARTMEDIAPRESS

This book is dedicated to Travis Barker

With support from
Arts Council England
International Support Office for Contemporary Art Norway, Oslo
Leslie-Lohman Gay Art Foundation, New York
Millivres Prowler Group, London
Royal Academy Schools
Swedish Institute, Stockholm
Tom of Finland Foundation, Los Angeles
University of Wolverhampton, School of Art & Design

Lenders to the exhibition:
Albert Dawson Collection, Falmouth; Alison Jacques Gallery, London; Per Barclay; Barrett-Forster; Berthold Bell; Birmingham Museums and Art Gallery; Nayland Blake; Ross Bleckner; Keith Boadwee; Richmond Burton; ClampArt; Devin Borden Hiram Butler Gallery, Houston; Engen Fine Art, London; Simon English; Robert Flynt; Thomas Frangenberg; Galleri Wang, Oslo; Xavier Huffkens; General Idea (AA Bronson); Hamiltons, London/Cheim & Read, New York; Sunil Gupta; Karin Hellandsjo; Jack Shainman Gallery, New York; Bill Jacobson; John Hansard Gallery;The University of Southampton; Jonas Gardell and Mark Levengood; Derek Jarman Estate/Richard Salmon Gallery, London; Jay Jopling/White Cube (London); The Provost and Scholars of King's College, Cambridge; Ivan Katzen; Micah Lexier; John Lindell; Martin Maloney; Ivan Massow; David Medalla & Adam Nankervis; MOCA London; Donald Moffett; Michael Morris; Paul Morris; Bryan Mulvihill; National Museum of Contemporary Art, Oslo; Peres Projects, Los Angeles; Rebecca and Alexander Stewart, Seattle; Eric Rhein; Rhodes + Mann, London; RM Fine Art, London; The Russell-Cotes Art Gallery and Museum, Bournemouth; Mike Sale; Fin Serck-Hanssen; Michael Shaowanasai; The Tom of Finland Archive, Los Angeles; Stephen Friedman Gallery, London' Sundaram Tagore Gallery, New York; Tate, London; The New Art Gallery, Walsall; Jerry Williams, Houston; Cerith Wyn Evans.

Michael Petry would like to thank Amelia Black (Administrative Assistant), Travis Barker (for additional editing), Deborah Robinson, Emily Marsden, Louise Oakley, Sue Parkin and all the staff at the New Art Gallery Walsall

Michael Petry would also like to thank Joshua Abelow, Alison Abrams, Mark Aldbrook and Robert Drake, Kathrin Almerfors, Ciléne Andréhn, Robert Atkins, Professor John Ball, Luis Barajas, Koan-Jeff Baysa, Mark Ball, Devin Borden, Guy Brett, Andrew Brewerton, Alicia Brockwell, AA Bronson, Sue Buck, Hiram Butler, Mara Castilho, Julie Chiofolo, Brian Clarke, Catherine Clement, Matthew Cornford, Gillian Cuthill, Susan Davidson, Durk Dehner, Angela de La Cruz, Paul Delaney, Kate Dobson, Daniel Dror, Stephen Foster, Photios Giovanis, Alex Graham, Chris Hall, Wendy Hanson, William Hartman III, Gerard Hastings, Karin Hellandsjo, Jan Hietela, Alison Jacques, Tim Jefferies, Peter Jenkinson, Juliane Jung, Marius Kwint, Sotiris Kyriacou, Bill Lowe, Honey Luard, Fred Mann, John McCord, Pippa McNee, David McNulty, Laura Messing, Dr Kate Meynell, Dr Jim Mooney, Professor Francis Mulhern, Bryan Mulvihill, Sandy Nairne, Terry New, Sandra Paci, Antonia Payne, Javier Peres, John Peters, Adrian Rifkin, Larry Rinder, Benjamin Rhodes, David Robinson, Peter Rose, Dallas Seitz, Wayne Snellen, Ronald Sosinski, Erik Steen, Anna Maria Svensson, Rosalind Tamez, Simon Topham, Georges Tourtellotte, Andrew Tullis, Robin Vousden, Alan Wardle, Tony Wilburn, and all the lenders and contributing artists and their representatives.

Front Cover: Michael Petry, **Nothing Changes**, 1997, video installation still, dimensions variable, Courtesy the artist
Page 1: Francis Bacon, **Three Figures and Portrait**, 1975, oil and pastel on canvas, 198.1 x 147.3 cm. © Tate, London, 2004/Estate of Francis Bacon, 2004. All rights reserved, DACS.
Page 2: Andy Warhol, **From Marilyn**, 1967, screenprint on paper, 91 x 91 cm. © The Andy Warhol Foundation for the Visual Arts, Inc./ARS, NY/DACS, London 2004/Tate, London, 2004.
Page 3: Ross Bleckner, **Flow + Return**, 2001, oil on linen, 2.13 x 3.66 m. Courtesy of the artist

Published in Great Britain in 2004 by **ARTMEDIA PRESS**
Culvert House, Culvert Road, London SW11 5AP

ISBN: 1 902889 10 X

Printed and bound in Italy

Contents

Introduction

Do artists who are same sex lovers have anything in common besides their sexual desire? How does gender preference impact the way work is made? Is art by same sex lovers as diverse as that of the heterosexual majority? What is the importance of documenting same sex history?

This book hopes to address these questions, and in doing so two main observations emerge. First, a horizontal reading of history is necessitated by the predominantly verbal record of same sex history. Second, a heterosexual filter may be lifted from prevailing interpretations of the work of artists included in this text.

Horizontal history

Hidden Histories collates published information to produce a history of male same sex lovers in the visual arts. Where no written record exists, each generation must learn first-hand anew. This volume attempts to gather information from oral tradition (horizontal history) and compile it into a vertical history for future readers (of any sexuality) to access.

Heterosexual filter

Ordinarily, a heterosexual filter is placed before the work of same sex lovers (this heterosexual filter functions similarly to the male gaze on work made by women). This text attempts to remove such filter. It is not an attempt to queer the pitch; on the contrary, the text attempts to remove interpretative distortions. The book highlights the heterosexual filter, arguing that it is disruptive to the accumulation of knowledge.

Same sex love

The sexuality of an artist matters for a variety of reasons, primarily because no one is unaffected by those whose affections they seek. Many artists have made works for and about their same sex lovers. This information is as important as knowing that Dora Marr was Picasso's lover and muse, not his maid or cook. She was no mere model, nor were many of the men who sat for their same sex lovers. This information opens up different and important meanings and understandings of their work.

Some artists discussed in this text have been married, had children, and were in social situations where conformity to marriage was vital. This did not alter their affections for their own sex. To avoid any notion of hierarchy of hetero-, bi- or homosexuality, the term 'same sex lover' will be used unless artists refer to themselves otherwise. Artists included in this book were involved in sexual and amorous affairs with other men, irrespective of whether they had heterosexual contacts. The fact that they had consensual same sex erotics separates them from the heterosexual majority. Homosexuality is still considered a liability, a sin or a criminal offence by a significant number in the heterosexual majority. For a man willingly to have sex with another marks him out. Same sex lovers (female or male) are still exposed to prejudice, and in many countries are imprisoned for their love. Homophobia is still globally acceptable (gays and lesbians were denied observer status at the 2001 UN conference on racism). Same sex lovers will not have chosen their gender, but do choose to act on their affections, and these choices make a lived life.

It is not this text's contention that there is a gay aesthetic; a glance at the diversity of work included in this text should dissuade readers from such a conclusion. However, each artist, whatever his style or the content of his work, has been influenced by his same sex desires. This is important to say; it is as simple as that. Taking note, remarking, then passing on, may be the way forward for heterosexuals and same sex lovers. While it is not possible to remove all filters, those that can be removed should be. This book is not attempting to be an encyclopaedia, but hopes to provide a broad overview of the twentieth century. That said, the author is interested in further information on artists not included. Readers may be surprised at the inclusion of so many prominent and pivotal artists from that century. When it is no longer a surprise, this text will have done its job.

Glyn Philpot. **The Man in Black.** 1913. oil on canvas. 76.8 x 69.2 cm. © Tate, London, 2004

1 Definitions and terms of reference

1.1 'GAY ARTISTS' *VS* 'ARTISTS WHO ARE GAY'

'Although Mapplethorpe set out to incorporate explicit gay imagery into high art, he was reluctant to be identified "simply" as a gay artist. In the 1970s and 80s (and in many gay circles today), the term "gay artist" was considered a restriction, not just commercially but also aesthetically ... [W]hether Mapplethorpe wanted to be considered gay or not, retrospectively he has been thrust into this role' (White, 1995: p129).

Nomenclature remains important and many require the distinction between being seen as 'artists who are gay' and 'gay artists'. A reluctance to embrace and defeat language allows others to define the self. This is reinforced by institutions, the art press and collectors, irrespective of whether an artist's prefix is 'gay', 'black' or any other.

Such distinctions aside, it is possible to work within a seemingly narrow aesthetic field and still be treated as a serious artist. Only when a vision is pejoratively described does the art world balk at its inclusion in serious discourse. Much work by women has historically suffered this fate, as has work by artists of colour. It could have been said that in the 1970s Sol Le Witt was obsessed with geometry, and that would not have been seen as problematic; yet the perception that Judy Chicago was obsessed with vaginas was. Were Mapplethorpe to have survived longer, sooner or later he would have had to address issues relating to his (white) gaze upon black men. Turning the camera towards himself, he created a tragic aesthetic escape route, as it is difficult to describe the image of his eyes just prior to death (*Self-Portrait*, 1988) as 'gay art' in any pejorative sense.

Mapplethorpe was a same sex lover, and his last self-portraits (of a gay man dying from a disease perceived as 'gay') speaks universally of death, fear of death and possibly even of redemption (he remained a Roman Catholic to the end). Any work that wishes to be seen as art (as opposed to pornography or reportage) must transcend object choice and enter into the discourse of art; art with no prefix. How future same sex lovers will handle nomenclature remains to be seen. What is important is that scholars, viewers and readers realise that object choice is not the issue.

Yet to say that same sex love still matters remains a taboo even in an art world that likes to see itself as *über* liberal. A traditional history of the art world (as opposed to any history of Art) is one where men who loved other men often married women, forming a *mariage blanc*. Bisexuality was not something unduly worried about, and while many marriages were a pose, others included heterosexual intercourse. Rauschenberg had a child, but soon found the charms of other men (particularly other male artists) irresistible, and did not return to women after his early divorce (Hopps and Davidson, 1997: p552). Equally, many young men of his time thought that marriage might 'straighten' them out.

Prior to the 1980s few depictions of same sex love were presented in mass media other than negative images of effeminate homosexuality, criminality and cravenness. Jamie Russell's *Queer Burroughs* deconstructs Burroughs' texts and the climate in which they developed, stating: 'The passivity of the fag leads only to regulation by the dominant, a regulation that codes his body as non-autonomous. This, then, is the zenith not simply of Burroughs' effeminophobia but, more importantly of his vision of effeminate identity as a schizoid fragmentation of the gay male self in which masculine autonomy is replaced by the state-sponsored and sanctioned identity of the fag' (Russell, 2001: p46).

Over the twentieth century, the idea of what/who was a same sex lover was a complex medical construct, which portrayed same sex lovers as mentally and physically ill, an effeminate social construct based in the cult of the aesthete, and a criminal construct of legal violations deserving punishment and imprisonment. These constructs led to homophobia in the dominant and the individual. For a same sex lover to overcome this social training and see him/herself in a positive light was a significant challenge. It is no wonder that many did not overcome this conditioning, and found themselves in marriage. This phenomenon still occurs, though to a lesser extent. Among married artists there are many who have produced heirs, and having done so, produced affairs with other men. In such circumstances an artist's sexual orientation invariably alters his perception of the world, and the world's view of him.

Now is the time to reassess work made by same sex lovers from a same

Per Barclay, **Révérence (Arnaud)**, 2001, inkjet on paper, 250 x 250 cm (dimensions variable).
Collection of The National Museum of Contemporary Art, Norway. Courtesy of Galleri Wang, Oslo

sex perspective. In the new millennium it is important to speak of their work/lives, lest they be absorbed into a heterosexual canon of makers. Sex still matters, even in the arts. This text sets out to reclaim a history that exists, is often told by word of mouth, but has historically not been included in the dominant.

Who is/isn't a same sex lover remains a battle zone between those who want to speak and those who prefer silence. It can be uneconomic if an artist is not economical with the truth. It has been argued that an artist's sexuality is irrelevant to his or her work. Yet if an artist is heterosexual with strings of lovers (Picasso), the public is encouraged to be aware of his conquests. Heterosexual relationships are an easy means of depicting an artist (often a suspect character for lay heterosexuals) as a real person: a father, a brother, perhaps a cad, but someone the public might want in their homes or at least on their walls. Contrariwise, same sex love tends to be hushed up by dealers (for whom sales may be the overriding aim) and institutions. Some closeted artists perpetuate myths about their sexuality and may not allow curators to borrow works or have access to their circles of friends if their true sexuality is publicly mentioned. Institutions often remain tight-lipped, even when their participation in the retention of a heterosexual filter is exposed (see Chapter 2.1).

Equally, academics are usually conservative in their outlook, demanding absolute proof of an artist's same sex gender identity before mentioning it, and requiring others to put it into context. Academics prefer a smoking gun, stained bed sheets, police photos *in flagrante*, or 'confessions', often rejecting the word of ex-lovers, love letters and lifestyle (as they would between a man and a woman) in documenting same sex loves. Trevor J. Fairbrother (a Sargent expert) added to the debate, stating, 'Sargent's art is the best "evidence" of his personality, and the homoeroticism of some portraits and many informal studies has been prudishly avoided by most scholars' (Fairbrother, 1994: p8).

Academics often provide ludicrous explanations for the lives of same sex lovers. Men's letters to other men declaring passion, love and lust are often dismissed as platonic in mode (*Independent*, 27 June 1999) and are presented as pure, non-physical love. Walt Whitman's work was long projected thus, though now it is only the most reactionary scholars who read him heterosexually. Academics often doubt the word of the same sex lovers of artists, suspecting they may have an axe to grind, are showing off, or aiming at second-hand glory, while relying on similar heterosexual sources. Why would a same sex lover lie and set himself up for ridicule any more than a heterosexual? Why should academics doubt the word of Jasper Johns stating that he and Robert Rauschenberg were lovers, but believe Rauschenberg's ex-wife when she claims that he is the father of her child?

The lives of male same sex lovers have often been depicted as those of lifelong bachelors with a secretary, valet or chauffeur who lived with them. These transparent euphemisms remain opaque to many heterosexual scholars. Actor and prolific autobiographer Dirk Bogarde, long described Tony Forwood (*Radio Times*, 8–14 December, 2001: p38) as his chauffeur, and treated him as such in public, yet among their circle of thespians it was known that they were lovers. Similarly, Sargent's male secretary remained discreet about their relationship. 'The lithe, young Italian model Nicola d'Inverno was associated with the artist John Singer Sargent for the greater part of twenty-six years' (Esten, 1999: p19). Now is the time clearly to state that they were lovers. It is time to give up on complicated ruses, to strip away cosy fictions.

Why is it necessary to write such a history? Firstly, the documentary evidence exists, is available and is pertinent to the art made by same sex lovers; secondly, in writing such a history it is possible to address outstanding legal and social prejudices. There is little room for debate as to the sexual practices of the men included in this book. Men exist who have spoken, who can be believed and who often have 'incriminating photos'. One comes out, is exposed as gay or admits to loving one's own sex. Language itself is of hierarchy, and same sex lovers rank low. In Western law and society there is still little equality between heterosexuals and those of another gender. It is still possible to fire an individual from his or her job in America simply because he or she is homosexual. Although Western oppression has diminished, equality before the law still remains

John Singer Sargent, **Tommies Bathing**, 1918, watercolour and graphite on white wove paper, 39 x 52.8 cm. Courtesy of The Metropolitan Museum of Art. Gift of Mrs. Francis Ormond, 1950. (50.130.48). Photograph © 1999 The Metropolitan Museum of Art, New York

elusive. If academics, curators and those in the arts cannot lose their prejudices, what hope do same sex lovers have from the general public? Western Europe has seen huge strides towards equality, but on issues as diverse as partnership rights, children and pensions much remains to be done. Europe is a beacon of reasonableness compared to America or most of the rest of the world. Only the new South African constitution recognises the equal rights of homosexuals, yet law and reality diverge. The spread of AIDS has led many African leaders to condemn homosexuality as a Western disease imported to decimate their culture (*The Advocate*, 5 March 2002, web source).

Social prejudice cannot be legislated out of existence. African-Americans had the legal right to vote but 'Jim Crow' laws, the Ku Klux Klan and other pressures meant they did not have full enfranchisement until the 1960s. In the American presidential election (2000) many African-Americans reported being prevented from voting by police, or were removed from voting rolls by white officials in Florida (Moore, 2001: p4). Legal protection is vital, but enforcement is also an issue. The foremost concern should be honesty, the honesty of minorities claiming equal rights and for the majority honestly to honour those rights. For artists, being open about their sexuality may be seen as a measure of their personal integrity, but not a necessary precursor to being a good artist.

1.2 WHO IS IN AND WHO IS OUT

Artists presented in this book fall into three categories: those who were primarily same sex lovers; those who were active bisexuals; and those who were largely heterosexual yet experimented with homosexuality. It is not this text's project to 'out' anyone. All information presented (as to artists' sexuality) exists in the public domain. This text solely aims at trying to order that data and compile it into a history. Michelangelo Signorile, who has been credited with the concept of outing, writes in his seminal *Queer in America* that 'Every day the media discuss aspects of public figures' heterosexuality when these facts are relevant to a news story whether or not the subjects want the facts reported and no matter how private they may

be. But most of the "responsible" media refuse to reveal public figures' homosexuality, even when relevant – except, of course, when such revelations play into their homophobic agenda' (Signorile, 1994: pxv).

Terms such as 'out' or 'in' are still applicable (though inappropriate in the twenty-first century), because they prejudicially imply that the knowledge of sexual preference is acceptable or not. The terms also imply a hierarchy between same sex lovers (are out men better than those who are in?), and between homo- and heterosexuals. This text includes only artists who have been outed already, who came out or who were never in. Whatever readers' views on outing (by individuals or news organisations), outing is not an issue in this text. Artists are public figures, and most living artists of recent generations do not hide their sexuality.

Same sex lover is the term that will be used for artists who mainly or exclusively had sex with other men, and who form the main body of this book. The term will be used to document their actions, not as a definition of the men or their work. *Bisexual* will be used for men who were married, different sex cohabiting and/or were sexually active with women while having active same sex love lives. *Heterosexual* will be used for men with no or minimal same sex activity.

Same sex lover is a precise way for speaking about the erotic activities of the men under consideration. The text is based on Kinsey's paradigm of a sliding scale of consensual sex between men. Men who could be classed as 'virgins' (or having had only sex with other men) are at the opposite end from those never known to have had a single homosexual encounter. Kinsey found that 10 per cent of adult men were exclusively or mainly homosexual, and while these data have been contested, recent statistical analysis has shown the underlying truth of the data (Gathorne-Hardy, 1998: p285). Jonathan Gathorne-Hardy states that, 'whether the figure for exclusively or partly homosexual behaviour is 2 percent or 12.7 per cent or anything in between makes not the slightest difference to Kinsey's argument. Two percent of US or UK males is such a vast number it is quite absurd to suggest they should be prosecuted' (Gathorne-Hardy, 1998: p285). Many still are. The use of 'gay' will be minimal, applied only

where artists use it for self-definition. This text discusses men who have had sexual and romantic interaction with other men, and how it affected their work. A microcosm of the dominant twentieth-century artistic concerns emerges, as same sex lovers were often at the forefront of major shifts in the visual arts.

This text makes no statements about any overriding aesthetic or sensibility. There may be an underlying link between these men's work, but if it arises, it will be between the margins of the work. Their artefacts are as diverse as the men who made them. There is no 'ism' that they all fit into, nor a general concern for the sexual or the conceptual. The body makes an appearance in many works, as it does in the work of heterosexuals. For every rule there will be many exceptions but this text seeks out neither and can be read as one story, one version of an historic period.

If from that reading comes a better understanding of the work then the text will have been successful. If seen only as salacious information, it will have failed. This book examines how the historical sexual fact of same sex love altered or affected artistic production. It is not interested in who slept with whom unless relevant to the work. If a man depicts his female lover it is important to know that she was not a paid model, and such information is usually included in heterosexual biographical material. How an artist depicts an intimate is not only of interest, but it also provides additional understanding of the work, whether made by a same sex lover or heterosexual.

How might the knowledge that an artist was a same sex lover alter the understanding of his work? Male same sex lovers occupy an odd niche within the art world establishment, long having been inside those structures, yet having been outside the system at the same time. Historically, upon revealing (publicly or privately) their same sex status, they lost a certain power and were legally at risk. Women cannot hide their biology and were/are treated prejudicially by the dominant. People of colour cannot hide that fact, and continue to encounter prejudice. But male same sex lovers are not necessarily obvious to those who might discriminate against them. Effeminacy may be seen as a marker, but even then, many

effeminate men are heterosexual. It is up to same sex lovers to reveal or confirm their sexuality, and in doing so lose establishment power (located in heterosexual males in the patriarchy).

For many in the dominant, same sex lovers are unequal to 'real' heterosexual men. While it might seem quaint to speak of this today, the lives of same sex lovers around the world starkly confirms that this is the case. Even in the art world, cases of institutionalised homophobia abound. When a man voluntarily partakes in same sex activities and makes this information public, he excludes himself from certain establishment domains. In the arts there are many out gay men in positions of authority, yet they face homophobia and glass ceilings. What makes the position of male same sex lovers unique is that unless they are 'out', they are 'in'; they 'pass'. Few people of colour can 'pass', and therefore are still denied areas of access and power. Male same sex lovers have the ability to choose exclusion, giving up institutional power in exchange for personal freedom.

James Baldwin's heterosexual tale *Go Tell it on the Mountain* (1953) brought him success and he was sought out as a spokesman. Yet the topic of *Giovanni's Room* (which made his homosexuality clear) complicated its American publication. 'His editors at Knopf, already irritated at not receiving a second novel set in Harlem, feared legal action over the homosexual content of the novel and decided they wouldn't publish it' (Campbell, 2001: p96). Upon publication (in France), he was no longer seen as a spokesman for his race by fellow African–Americans. Yet his activism commanded a private meeting with Attorney General Robert Kennedy during the racial segregation battles (1963), only for him to be placed on secret FBI files (Campbell, 1991: p163). FBI files on Martin Luther King Jr reveal that King felt Baldwin was 'better qualified to lead a homosexual movement than a civil rights movement' (Campbell, 1991: p175). King purposely kept Baldwin (who featured on the coveted cover of *Time* magazine) at arms length because of his openness. Had Baldwin 'passed' for straight, he would have been treated differently in both black and white communities.

Men who engaged in sexual acts with men and women form a smaller but significant addition to this book. In the twentieth century some found themselves in a marriage before realising the extent of their male sexual longings (Cage), others married to enjoy its status and safety (Eakins), and some sired children, using those experiences in their work (Rivers). Today they would be considered bisexuals. This text will remark on their same and different sex erotics. Traditional art history does the viewer a disservice by hiding their same sex loves. Some artists lived and spoke openly about their bisexual lives, while others were terrified that their secret would come out. The terror is of interest as it suggests insecurity in the financial world of the art market, the curatorial world of the museums, and their legal status.

What is of interest is how dual sexual activity fed into their production, where there was conflict, and how it was resolved. This may be of interest to young artists who are no longer content with 'queer' or 'gay' nomenclature. Many do not feel that their professional (and private) lives need be at one extreme end of the Kinsey scale, as many did in the 1980s (for political and health reasons). The same sex community has also shifted, becoming more inclusive of those whose sexuality is not as clear as gay/straight might indicate.

Some heterosexual artists had significant same sex encounters that are only now being recognised. It is important to look at how these artists were historically viewed and how this new information colours a reading of their works. That a man who does not consider himself homosexual (at core) has sex with another man is an act of consequence. Same sex lovers may have had heterosexual encounters as a result of being socialised to expect heterosexual marriage. Societal pressure may have coerced many to try heterosexuality, to determine if homosexuality was 'a phase'. Yet the opposite is not considered proper experimentation; no concerned father suggests that heterosexuality might be a phase and that his son experiment with another male.

Male same sex lovers who had sexual encounters with women have been co-opted into the heterosexual canon. Such artists have been claimed as heterosexual irrespective of evidence to the contrary. Actions that are congruent with the social norm are 'good' or 'natural'. Men who

William S. Burroughs, **Target**, shot target, 13.97 x 13.97 cm (framed 21.59 x 21.59 cm). Private collection, London

try even one same sex act are not seen in this golden light, and may at best be described as Bohemian, worldly. Equally, they must have been seen as 'active' in same sex encounters. Latent male fear of passivity may be the basis of misogyny, and is as prevalent in the homosexual world as the heterosexual. Russell comments on one of Burroughs' most famous characters: 'In this respect, the Talking Asshole routine follows the traditional patriarchal practice of reading the phallus as a symbol of (masculine) identity and the anus as radical negation of identity, for as [Paul] Hocquenghem notes "only the phallus dispenses identity; any social use of the anus, apart from its sublimated use, creates the risk of a loss of identity. Seen from behind we are all women"' (Russell, 2001: p52).This text does not include artists who have had same sex encounters thrust upon them, and is concerned only with consent.

This text excludes artists who are female same sex lovers. After discussion with a diverse group of women artists and curators (hetero-, homo- and bi-sexual), the general conclusion was that their history is legally and personally different. Any such historical space spoken of would be filtered through the author's male gaze, no matter how sympathetic. It is not that a writer cannot or should not try to speak of areas outside his physicality, only that it may not always be appropriate to do so. If this is a failing, it is honestly presented. Perhaps a female member of the same sex community should speak for women, creating their own space, opening up opportunities for women to write a parallel female same sex history. Each time a marginalised people (ethnically, religiously or sexually) creates space for themselves within the dominant, they enable other histories to emerge. This increase in space in no way detracts from or diminishes heterosexual history; to the contrary, it enriches the global body of knowledge. This text acknowledges women and ethnic minorities in the arts, the male gaze and academic falsification of the historical record, and assumes readers will be aware of such discourses.

Examples will be cited in which a heterosexual man (Robert Hughes) has written about homosexuality, and examines his biased filtering. Until the contribution of others (including same sex lovers) is openly acknowledged

by the dominant, heterosexual writers speak from a position of superiority about those without voice. A voice is found and then used by a group, and is never 'given' them. Groups are never 'allowed' to speak. They just do. Whether the dominant hears (let alone listens) is another matter. Voice must make itself heard, perhaps shouting, perhaps arguing a case or even whispering, but it is from within a community that it arises.

This text does not presume to be 'The History', but merely a starting point in a dialogue between hetero- and homosexual histories. Nor is it 'The History' of all male same sex lovers in the arts, as such a text would form an encyclopaedia were it to include writers, actors, filmmakers or those in other fields of artistic endeavour. Performing artists who had relationships with visual artists (Cage and Cunningham) are documented where those relationships are important to the work of the visual artist concerned. The text does not impose or presume a hierarchy between the arts, but looks only at works made by painters, photographers, sculptors and artists using multimedia. It does not attempt to document artists working in film unless their work is seen within a fine art context. This includes Derek Jarman whose work in mainstream film derived from experimental films and painting. It rules out filmmakers like James Whale (director of Frankenstein movies), whose primary activity was Hollywood production.

The text also excludes same sex lovers from the world of letters. To explore the lives of Whitman, Gide, Auden, Wilde or Vidal would complicate the text beyond reason, yet it is as if each writer handed on a secret homotext to his successor. Writers read each other's works and pass on same sex information over generations. Speaking of this tradition, Mitchell and Leavitt state that, 'readers displayed an astonishing tenacity in locating those poems, stories, novels, essays, and even individual sentences in which references to homosexual experience might be found' (Mitchell, and Leavitt, 1998: pxiv).

Many same sex visual artists are ignorant of each other's production. This may change with the Internet, yet visual works of art are generally unique and can be seen only in one place at a time. Knowledge that they exist is not the same as the experience of artworks. A book can be read

John Cage, **GLOBAL VILLAGE 1-36**, 1989, aquatint on two sheets of brown smoked paper, 97.79 x 134.62 cm. Edition 15, published by Crown Point Press. Courtesy of Devin Borden Hiram Butler Gallery, Houston

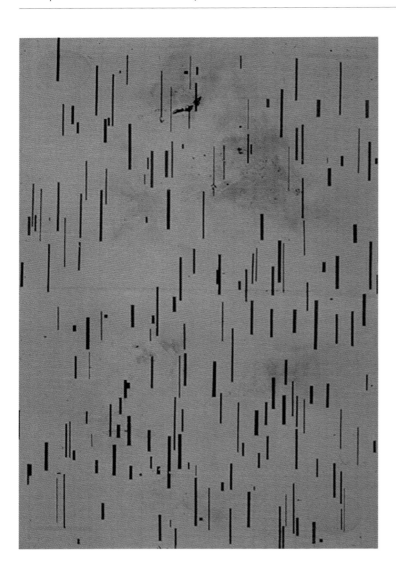

throughout the world (subject to problems of translation), but most art-works are unique information. Men of letters have had a different distributional history from those engaged in the visual arts. This text does not document same sex lovers in the theatrical arts for similar reasons.

1.3 PRIVACY

'The Private is the Public' is as true a saying today as ever. Two types of privacy exist in relation to same sex love: privacy from the state and privacy from fellow citizens.

For contemporary Western readers the notion of state persecution of homosexuals may seem far-fetched, but for the majority of same sex lovers, state persecution remains a concern. Although illegality did not stop same sex lovers from enjoying a sex life, continually breaking the law overshadowed their lives and impacted their work.

In 1954, British journalist Peter Wildeblood was imprisoned for homosexual offences in a case connected with Lord Montagu of Beaulieu. Both men went to prison, but once released Wildeblood wrote of his experiences. He saw himself and others like him within an oppressive medical and criminal paradigm: 'I am a homosexual [page 1] ... I am no more proud of my condition than I would be of having a glass eye or a hare-lip. On the other hand, I am no more ashamed of it than I would be of being colour-blind or of writing with my left hand. [page 2] ... For many years I [have] kept it a secret from my family and friends, not so much from choice as from expediency ... I shall not try, at this stage, either to explain or to excuse it, but simply describe my condition [page 3] ... Nothing would be easier for me than to assume a superficial normality, get married and perhaps have a family. This would, however, be at best dishonest, because I should be running away from my own problem, and at worst it would be cruel, because I should run the risk of making two people unhappy ... [The homosexual] will always be lonely; he must accept that ... he will at least have the austere consolations of self-knowledge and integrity. More than that he cannot have, because the law, in England, forbids it. A man who feels an attraction towards another man

... becomes a criminal' (Wildeblood, 1955: pp1-3).

Wildeblood described an all-too-common scene in which 'The younger and better-looking of the two policemen had been sent into a lavatory for the purpose of acting as an *agent-provocateur*. It was his duty to behave in such a way that some homosexual would make advances to him' (Wildeblood, 1955: p43). Anyone who took the bait would be arrested. This method of crime prevention still exists in many countries. The targeting of known public conveniences (where same sex lovers meet) has a long tradition, one captured in Johns' *Target* works. Cottages (tea-rooms) have often been a meeting place for married same sex lovers and those seeking quick sexual gratification.

Citizens in a democracy have the right to expect privacy from the state. However, most prohibit the 'private' practice of certain types of sexual activity. Such laws are routinely enforced. In a third of US states it was illegal for men to commit 'sodomy' in 'private' until 2003. Sodomy was so broadly defined that it included kissing as well as genital activity. In 1998, the Houston police force broke into a private home and arrested two men making love. They were successfully prosecuted for sodomy under Texas law (*Pink Paper*, 12 February 1999: p10). Only when the US Supreme Court declared the law unconstitutional was it (and similar legislation) overturned. Privacy does not exist if you cannot enjoy it for fear of harm or arrest. Homosexual American teenagers are still under threat owing to a 1979 Supreme Court ruling that parents could institutionalise their children if they displayed 'deviant behaviour' (Smith, 2000: p63). Even today American children may be forced to undergo aversion therapy (long since discredited throughout Europe) for their same sex desires.

In *The End of Privacy*, *The Economist* argues that, 'Today, most people in rich societies assume that, provided they obey the law, they have a right to enjoy privacy whenever it suits them. They are wrong. Despite a raft of laws, treaties and constitutional provisions, privacy has been eroded for decades' (*The Economist*, 1 May 1999: pp105–7). The home is no longer the inviolable castle. Technology allows heat-sensing cameras to reveal bodies in sexual congress through bedroom walls. Satellites can follow individuals getting into their car and track them from A to B, and few urban spaces are not videoed by CCTV cameras. Official misuse is always a danger. Rights are further eroded as television programmes show such footage as entertainment. Governments have long monitored citizens believed to place the state at risk.

Since 11 September 2001, many countries have hurried through laws that further undermine notions of privacy (USA, UK, etc). It is now possible to be detained without trial and held for an indefinite period for suspected (unproven) terrorist activities. While states have a legitimate right to defend themselves, citizens have an equally legitimate right to defend themselves from the state. Civil libertarians' worst fears have yet to be realised, but the individual is now unduly exposed to state interference and surveillance. Although the Internet remains relatively free from governmental interference, politicians continually demand keys to encrypted mail. Defeated UK legislation would have required ISPs to send a copy of every email to MI5 (UK internal intelligence). President Clinton could not get a similar bill passed in the US. That politicians try to control the web is evidence of its power.

South America and Africa have a history of violent reaction to homosexuality. Robert Mugabe, the Zimbabwean dictator, continues to incite his supporters to attack homosexuals who he believes are 'lower than dogs'. When Peter Tatchell attempted to make a citizen's arrest of Mugabe (during a UK visit, 1999), the President's fury was directed at Prime Minister Blair who he claimed 'was controlled by a cabinet of queers'. Tatchell was beaten unconscious by Mugabe's bodyguards when he attempted an arrest in Brussels (*Gay Times*, October 2001: p54). Daniel Arap Moi (President of Kenya) referred to homosexuals as a 'scourge', and Yoweri Museveni (President of Uganda) has had homosexuals arrested for being 'against the Bible' (*Pink Paper*, 19 November 1999: p9). While few readers live in 'Big Brother' states, many of the included artists had grounds to fear scrutiny of their private lives. For nearly three quarters of the twentieth century most same sex lovers in the West lived in fear of arrest, and those in Egypt, China, Africa and Asia continue to do so.

What private zone can be claimed by those who live in the public eye? Paparazzi besiege the homes of the rich and famous (who use their services as much as flee them). Princess Diana exemplified this modern media paradigm. What public figures do is of interest to the general public, if not their business. Warhol predicted that everyone would have fifteen minutes of fame. Now everyone has the potential to come within the media's gaze, winning the lottery, surviving a plane crash or sending a home video to a television programme. Modern media need copy (no matter how sordid), just as long as it is telegenic. The web cam is the exhibitionist's and voyeur's dream – exposed in the privacy of the home.

Many contemporary artists embrace the phenomenon of the public persona. But if you place your life for inspection as art, where does art stop and life begin? If Tracey Emin glows in the scandal of her stained underpants, what privacy can she claim? She posits her life stories as art, though it is difficult to know if they are true or fictional. Is it important to know if she is lying to assess her work? She asserts she is heterosexual, and it gives a reading to her work. If she turned out to be a lesbian how would the works be seen? In a world where come-stained sheets are art, is any private space left? Have artists the right to say where privacy begins? Jeff Koons would have his baby, his ex-wife and their life as part of his art mythology (Signorile, 1994: p158). As a heterosexual man it gives him power, and he uses it. Koons' work is seen through a subliminal heterosexual filter. Commenting on the outing of Pete Williams, Pentagon Gulf War Press Officer (and homosexual spokesman for an organisation where homosexuality is illegal), Anthony Marro (editor of *New York Newsday*) said, 'I don't feel any need to say that an official at the State Department is heterosexual, so why should I say that someone is gay?' However, as Michelangelo Signorile notes, 'Somehow, it never occurred to Marro that every time his paper printed photos of Norman Schwarzkopf with his wife and family, he was revealing that Stormin' Norman was a heterosexual' (Signorile, 1994: p158).

Artists also surrender privacy when they bring wives and children into the public domain. Anyone who puts himself into the public domain has

a right to complain about the level of privacy accorded, but gets little sympathy from the general public. Artists are not forced to work, and choose to send art into the public domain, engaging in a dialogue between themselves, art histories and the viewer – in public.

What is the public domain the artist enters? The principal public domain is the commercial gallery. However, it is ironic that many galleries subtly exclude the public. Museums suffered from similarly bad attitude until education officers were appointed. Unsurprisingly, the public is wary of artists and art. Viewers have the right to expect a dialogue with the work and the institutions that present it. Yet only the most sensational art remains in the public gaze as the media leverage sensation to sell newspapers or obtain viewing figures. Art need only be as interesting as a calf with two heads, and it runs the risk of becoming a sideshow where serious discussion cannot take place. If the public are left in the dark, is it surprising they are hungry for salacious detail?

Artists are aware that 'the public' who will see their work comprises mainly other artists and art professionals. The general public is not a major part of the discourse. This may be unfair to socially motivated artists, but the gallery system ensures a certain class closure. These issues aside, when artists exhibit their work they are in effect 'publishing' it. The phrase is 'to publish' a website. Information published becomes part of the global discourse. An important distinction exists between publishing work on the web and in a gallery. Few works are made explicitly for the web, most images are simulacra (illustrations in virtual books), not actual works of art (unless digitally originated). Anyone can create an identity in the virtual world; it has been estimated that at any time, 40 per cent of those online use fictive genders. While people do not yet live in this utopia (or dystopia), the Internet presents the possibility for them to make work and lives of their choosing. It comes as no surprise that many same sex lovers are involved. 'According to Overlooked Opinions, a Chicago-based market-research firm, ten times more queers work in the computer industry than in the fashion industry ...' and '... are much less likely to be locked in the closet' (Signorile, 1994:

p345). Notwithstanding, until humans leave their physical bodies and become virtual beings, their sexual desires will continue to matter.

1.4 HOMOPHOBIA

Why does sexual identity still matter? An answer may be found on the barbed wire fence in Wyoming where Matthew Shepard was tortured and murdered in 1998. A few months later, another gay man, Billy Jack Gaither, was murdered for his sexuality in Alabama. Many murders have since followed. The disinterest of fellow Americans permits an atmosphere of open hatred towards same sex lovers. The Religious Right openly gloated about the murders (a Kansas minister even set up a website: www.godhatesfags.com). What can be done when murder is condoned, when protesters voicing legitimate concerns are arrested (at Shepard's peaceful vigil in New York)? Societies need enemies. The West demonised Communism for most of the twentieth century. The collapse of Soviet Russia left a vacuum, which was abhorrently filled with Muslims and homosexuals. It is still possible to make homosexual slurs although few would make openly racist remarks in print. 'Highjack this fags' was scrawled across a bomb (by American Navy personnel) destined for the Taliban in Afghanistan, neatly conflating the two new enemies (*Metro*, 12 October 2001: p7).

Latent homophobia is part of the social and media backdrop. In media coverage of Versace's murder, 'Gays were demonised once again ... "Homicidal homosexual" is the way Tom Brokaw described Cunanan (the alleged killer) on the NBC Nightly News' (*The Advocate*, 2 September 1997: p25). No news programme pretending objectivity would use equivalent phrases like 'black butcher', 'mexican mutilator', or 'chinese chopper'. American culture currently flows against inclusion and diversity. A *Time*/CNN poll (26 October 1998) found that 64 per cent of Americans are against homosexual marriage, and only 51 per cent think open gays or lesbians should be allowed to teach in schools (*Time*, 26 October 1998: pp36, 44). Artists do not stand apart from society, and cannot escape the actions of society at large.

Same sex marriage is legal in Holland and Belgium, and other EU states are considering following suit. Similar legislation should be passed by Canada in 2004. Eastern European countries applying for membership to the EU are now required to repeal homophobic laws as a condition of entry. The UK is requiring its Overseas Territories to repeal similar legislation, and Section 28 (Prime Minister Margaret Thatcher's 1988 statute prohibiting the promotion of homosexuality) has been repealed (2003). Although many same sex lovers don't want to marry, most want the legal right to decide. Denial of rights and criminalisation have been the twentieth century's consistent response to same sex love, resulting in posthumous novels (E.M. Forster), highly constructed male to female replacements (Proust) and professional constructs (Benjamin Britten's love for Peter Pears was wrapped in the composer/singer/muse model).

Why attempt to configure history into a new 'open' paradigm? Because that which is hidden under the drapery of shame awaits the sunlight, awaits being viewed. Viewing is the culmination of the secret, of being exposed. Exposure brings acknowledgement, if not acceptance, and acknowledgement need not be assimilation. The works of the artists included in this text are too diverse for that, and assimilation is not something most would want as an outcome. The American army's 'don't ask don't tell' policy allows lesbians and gay men to serve in the American military but requires them to stay in the closet. This problem is found throughout the Army, not just at Fort Campell where Private Barry Winchell was murdered (1999), and where 'The US Army's Inspector General has ruled that institutional homophobia played no part' (*Gay Times*, September 2000: p65). Winchell's parents disagree. 'Don't ask don't tell' 'legislates the closet, codifies into policy the very means of homophobic oppression' (Crimp, 2002: p234). Such oppression within the visual arts at last shows signs of collapsing.

Richmond Burton, **I am (Holographic #3)**, 2001, oil on linen, 106.68 x 127 cm. Courtesy of Hamiltons Gallery, London

George Platt Lynes. **Male Nude.** 1932. gelatin silver, vintage print. 16.51 x 11.43 cm. Courtesy of John Stevenson Gallery, New York

2 The door can always open, case studies

The following case studies deconstruct exhibitions and texts, identifying homophobia and highlighting particular aspects of heterosexual filtering. They are merely examples of homophobia; many other case studies could have been selected.

The first study (Rauschenberg retrospective, Guggenheim Museum) examines how an artist might work with an institution to obscure his same sex erotics. The second (*The American Century*, Whitney Museum) identifies institutional homophobia within a progressive institution, and the third (*American Visions*, Robert Hughes) considers outright homophobia.

2.1 ROBERT RAUSCHENBERG: HOMOPHOBIA AND THE INDIVIDUAL

If the sexual history of an artist is not important, why does the chronology provided by the Robert Rauschenberg retrospective (1997) catalogue document his marriage (Hopps, 1997: p551) but not his sexual relationships with men? In the chronology of *Robert Rauschenberg: The Early 1950s* (Hopps, 1991: p226) the same marital information is provided, with no mention of his same sex relationships. From these chronologies, it would seem that he never had further sexual encounters after his divorce, as no other woman is sexually linked to him: he is firmly situated within a heterosexual domain, a filter affixed to his work. Rauschenberg has given issue, and is presented in a guise as heterosexual as Picasso who also painted his wife and lovers. Picasso is the Minotaur, the bull, a stud. These texts would project Rauschenberg if not as a stud, at least not as a heifer. Rauschenberg's sexual relationship to Jasper Johns and its depiction in his paintings to/for Johns have been sanitised. Similarly, the sexual element between Rauschenberg and Cy Twombly is omitted. Rauschenberg is misrepresented as heterosexual. If sexuality is not important in the understanding of an artist and his work, why pass on otherwise useless information about marriage and children? If sexuality didn't matter, this information would not be included, or same sex information would also have been cited.

But it does matter that any hint of Rauschenberg as a same sex lover has been excised. Why lead the reader to believe that Rauschenberg continues to be a heterosexual? Is it frightening that his oeuvre may be homoerotic and include elements of his relationships with Johns and others? Misdirection of the reader is not often condoned, and parties to the exhibition were taken to task by the media. 'If the current retrospective were your only guide, you'd think that Rauschenberg was a happily married straight guy …The great benefit of the open secret is precisely its deniability. Forty-odd years later, everyone knows but no one's talking. But when will the art world cease to be complicit in the erasure of queer culture? Museums, as publicly funded institutions, have a greater responsibility to the public than to the artists they show. Rauschenberg's biography – not excluding his sexuality – is entirely germane as a subject because he made it part of his art' (*Out*, April 1998: p90).

With knowledge of Rauschenberg's same sex activities, his numerous erotic images of men come into a new homoerotic focus. Rauschenberg depicts a love of sportsmen, astronauts, Robert Kennedy, missiles and creamy white paint. Warhol often made fun of the 1950s mythology that only 'real men' like the Abstract Expressionists (Jackson Pollock, Franz Kline and Willem de Kooning). Andy Warhol inverted the slur and instructed assistants to work on his behalf. An essay in *Time* magazine (1967) 'described pop art as part of a "vengeful, derisive counterattack" by "homosexual ethics and esthetics" on "the straight world"' (Kaiser, 1998: p168). Rauschenberg's retrospective forced the issue. He now acknowledges (on a discreet basis) his same sex activities, and his works can now be read more openly.

2.1.1 Rereading important works

Many of Rauschenberg's important works from the early combines to later graphics are coded with homosexual information and desire. Often works referred directly to current male lovers. The following examines important works and their same sex contents.

Rauschenberg's same sex activities have informed his work from the earliest combines such as *Untitled* (1954) (Hopps, 1997: p109). The viewer sees a black and white photograph of a handsome man in an ice-cream

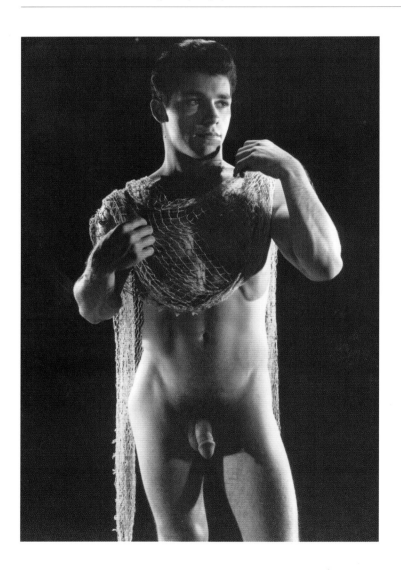

white suit mounted above a small mirror so that he and the viewer can see his reflection. He is next to a real stuffed chicken, a Plymouth Rock hen. Chicken is gay parlance for a young man. Immediately above the chicken is another photograph of a man in a masturbatory pose akin to Bruce of LA photographs. Other photos of men abound on the object, including drawings by Cy Twombly (Rauschenberg's lover). The most striking feature of *Untitled* is the visual focus of the work, a white painted phallic piece of wood. It stands erect holding up the entire edifice. The penis holding up the patriarchy is an overused metaphor, but in 1950s America *Untitled* functioned as an apt symbol of that concept. The white wood links the chicken with the cocksure dandy whose hand is in his creamy trousers. It is surely one of the most erotic works Rauschenberg devised.

Rauschenberg often employs *beards*, gay parlance for women who accompany homosexual men in public, to act as heterosexual cover. Beards (facial) give men a hyper-masculine identity signified by an abundance of hair. Women as beards fictively act as secondary sexual attributes. Rauschenberg often adds the odd naked woman (draping the work in a heterosexual cloak) when using pictures of men. *Untitled* might be about the unspoken love that dare not speak its name, but it shouts to those who know or knew the signs of same sex love. If you could not read the signs or were fooled by the pictorial beards, Rauschenberg could be seen as one of the lads, not one looking at them.

Bed (1955) (Hopps, 1997: p115) speaks for itself; displayed vertically, erect even, all dishabille, like a night of hot sex. White paint drips from a pillow at head height, which can be read as a painterly mark, as paint, or as semen. Spilt red and white paint on the bed sheets can be seen as the detritus of a sexual encounter. The red paint drips can allude to inexperienced or forced sexual behaviour, permitting either a hetero- or homosexual reading. The pattern on the quilt cover comprises miniature targets, row upon row being present for Rauschenberg's sexual aim. His wife was no longer the target of his affections, but his male lover Jasper Johns was (Johns' own work featured targets at this time). Johns' *Targets* (made in the same year as *Bed*) are also highly sexualised and homosexually

coded. *Bed* is 'a messy "combine" of found objects that transmuted into art the very sheets and folk-style quilt on which he and Johns had been sleeping' (Saslow, 1999: p247).

The Guggenheim catalogue states that Rauschenberg acquired the quilt 'from artist Dorothea Rockburne' and that he 'also applies red nail polish and striped toothpaste to the work' (Hopps, 1997: p554). Because no mention is made of Rauschenberg and Johns' sexual relationship, a heterosexual filter descends upon the work. Where the nail polish came from is not stated. Readers are led to infer it was Rockburne's, and that they had some sort of sexual relationship. How else would he have her bed linen? The catalogue states, 'at the time, he does not have enough money to buy canvas'. Was the quilt a lover's gift? That is the implication, as lovers often do give their sexual partners intimate items. Even today, women generally don't give away their bedclothes willy-nilly. Perhaps Rockburne, being aware of the men's relationship and Johns' imagery, offered the quilt for use, personal or public. None of this is made clear in the text, quite the opposite; it consciously leads the viewer away from Johns (male) to Rockburne (female). The bed is heterosexualised, along with Rauschenberg.

In any book, space limitations require material to be edited (and the curators and writers should be given the benefit of the doubt), but nowhere in the Guggenheim text is Rauschenberg's same sex activity acknowledged, while his heterosexuality is continually brought up. It is never noted that Rauschenberg and Johns shared a sexual life from 1954 to 1961. Curators and academics generally follow the artist's lead, and Rauschenberg was closely involved in his retrospective. *Bed* is an important art-historical object, and is also a milestone in same sex erotic depictions.

In *Odalisk* (1955/58) (Hopps, 1997: p113) a similar *mise en scène* to *Untitled* emerges. A stuffed Plymouth Rock rooster, a cock, is perched on top of a wooden box plastered with 'girlie pics' and a few men. A white painted stave supports a box while penetrating a white pillow. A small winged Eros hovers above a naked woman (a 1950s cheesecake photo), while contemporary women face the viewer, all mingled with images

Neil Emmerson, **Untitled (I Want Your Sex)**, 1998, lithograph, 40 x 30 cm. Courtesy of the artist

from Titian's *Pastoral Concert* (1510–11). At the heart of the piece is a large rectangular semi-transparent screen, which also filters the work. The wire screen shifts the viewer's focus from the cock, as the women screen the viewer from Rauschenberg's sexuality Teasingly, the viewer's gaze penetrates the screen. *Odalisk* is one of Rauschenberg's most significant combines, and it is important to see how it functions as a same sex artefact. *Odalisk*'s perversity lies in its own transparency.

With hindsight it seems improbable that *Odalisk* could only have been read heterosexually. Like a good conjuror, Rauschenberg shifts the viewer's gaze from the fast-moving hand, hiding what lies beneath the surface. The viewer sees what Rauschenberg wants seen, the image of the cocksure artist, who is not interested in the flesh but in ideas of the flesh. *Untitled*, *Bed* and *Odalisk*, if they speak of ideas of the flesh, speak of a homosexual flesh, a desire for same sex love, not of female images pasted on as false beards.

The retrospective catalogue (Hopps, 1997: p554) gives a brief description of these and other works, accompanied by four contemporaneous black and white photographs. One shows Johns and Rauschenberg in his New York studio. Although no mention is made of their sexual relationship, the photograph is a tender portrait of two lovers. Their open body language communicates their easy knowledge of each other. On the facing page, Rauschenberg has taken a photo of his lover, Johns, who stares into the camera with a knowing smile on his lips. Johns is completely unguarded and at ease. This is a family snap, not formal documentation. Yet nowhere in the vast catalogue (632 pages) is space found to acknowledge their relationship. Ironically, at the top left corner of the spread, a photo of Rauschenberg's son sits like a ghoul over their sexuality. The child screens off any idea that his father and Johns are anything other than painting buddies.

Rauschenberg and Johns' relationship is one of the most famous male same sex loves in the visual arts since Charles Ricketts and Charles Shannon, and possibly the most important sexual relationship in the twentieth-century visual arts regardless of sexuality. No other artist

couple comes close to their joint and individual achievements.

2.1.2 Male themes

There is no doubting Rauschenberg's productivity or handsomeness. This can be seen in the many staged photos of him in rehearsal and performance works. Like a catwalk model, he turns his best side to the camera, always aware of its presence. He is never caught unawares. Nothing seems to be left to chance – odd for someone close to John Cage. The virile young men in his works also display this handsomeness. Rauschenberg is caught by male beauty, if only of an American variety, regularly using images of attractive Kennedy clones. The traditional reading of his Kennedy fixation is that, like other contemporary Americans, he saw Kennedy as a fallen hero and made works in his homage. Perhaps an unconscious erotic hero worship is a more realistic reading; sex and death, extremes of passion and privilege coming together pictorially.

Rauschenberg's use of found imagery is sophisticated and he can hardly claim sexual innocence. *Studies for Currents #1* (1970) (Hopps, 1997: p332) features a young male basketball player juxtaposed with armed soldiers and historic male figures. Most striking of all (top right corner) is a clenched fist. Michel Foucault spoke of the 1970s as a time in which S&M and fisting were an important part of the gay scene for himself and others and that '"Physical practices like fist fucking" [explained to Jean Le Bitoux in 1978] "are practices that one can call devirilising, or desexualising. They are in fact *extraordinary falsifications of pleasure* ..." which might make it possible "to invent oneself"' (Miller, 1994: p269). The fist Rauschenberg employs is internationally recognised (in the gay world) as a fisting metaphor. This image was commonly seen in international leather bars, and is now used on the Internet by the fisting ring, www.gayfist.com.

Studies for Currents #26 (1970) (Hopps, 1997: p332) presents a torn newspaper page of Noël Coward in top hat and tails bearded by two women. The photo was taken when Coward was knighted, accompanied by Gladys Calthrop and Joyce Carey, 'his most intimate female friends'

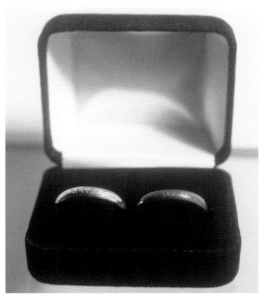

Micah Lexier, **Gentleman Rings (silver and copper version)**, 1989, silver and copper engraved rings, 22.86 x 10.16 x 12.7 cm. Courtesy of the artist

(Morella, 1996: plate 9). Coward wrote the song 'Mad About the Boy', and his own recording is the definitive queer in straight clothing. Coward sang from a remarkably out closet, yet never publicly commented on his same sex loves. Many performers inhabit the demi-monde of the discreet homosexual, the non-threatening limp-wristed effete, who shares his sophisticated secret with the general public. Fans of closeted stars (Liberace, Anthony Perkins) continue to deny that the objects of their affection died from AIDS-related illnesses. Yet when Rock Hudson acknowledged his illness, he met with wide support. Rauschenberg wryly juxtaposed Coward's image with a news cutting, reading 'Ready for a Visitor', Her Majesty the Queen meeting Mr Coward; when crowns collide, indeed.

Hands and feet abound in Rauschenberg's work, along with sexual metaphors and fetishes. *Lawn Combed* (1954) (Hopps, 1997: p108) sees an outline of Rauschenberg's feet on found canvas. Rauschenberg's right foot stands upon a label, which identifies the fabric as 'Standard Sample of Swan white' and has a small image of a swan at its base. Inside the left foot tracing are two drawings of swans. Swans mate for life, and this work dates from the earliest period of his relationship with Johns. Later, Rauschenberg coyly hinted at his own status as a same sex lover when, again using his anatomy, he 'edged closest to confession in a 1960 series illustrating Dante's *Inferno*: on the drawing for *Canto 14*, where sodomites run barefoot over burning sand, he traced his own foot' (Saslow, 1999: p247).

Would it matter if Rauschenberg were publicly open about his same sex relationships? Unlikely, as his place as a defining artist of the twentieth century is solid. Such revelations could possibly impact the value of his work, but vested interests would endeavour to preserve it, and prices are unlikely to plummet. George Michael's popularity did collapse after his debut in a toilet, but Rauschenberg is held in far higher cultural regard. Rauschenberg's same sex status is well documented and it is every historian's duty to embrace it. Openness is its own reward.

2.2 THE AMERICAN CENTURY: HOMOPHOBIA AND THE INSTITUTION

2.2.1 Naming

Naming objects gives them existence. Radioactivity did not exist until Madame Curie found it and gave it a name (Carey, 1995: p191). Nineteenth-century 'homosexuals' helped define the terms used for same sex lovers, such as uranian and invert, imbuing them with meaning. Prior to medicalisation these words had few prejudicial connotations, as physical acts (sodomy) were seen as actions to be policed, but not defining traits. Sex between men took place, but was seen as moral corruption that any member of society could partake in. The sinner was not the sin. Walt Whitman searched for words to define same sex lovers, settling on comrades. Homosexuality (as a self-defining term) was first used in an anonymous German text (1869) and the word 'first appeared in English in the 1890s when it was used by Charles Gilbert Chaddock' (Spencer, 1995: p10). As the term gathered meaning, Magnus Hirschfeld founded the Scientific-humanitarian Committee in Berlin (1897) to advance homosexuality. Oscar Wilde was an aesthete, yet aesthetes were not defined as homosexuals, neither were all aesthetes same sex lovers (James Abbott McNeil Whistler). But by the twentieth century aestheticism had become a definition of effeminacy, if not homosexuality. 'Aestheticism became a component in the image of the queer as it emerged, but it is a mistake simply to read this attitude back before the Wilde trials' (Sinfield, 1994: p84). Naming is all.

By not naming, things can be made invisible. It is not enough *not* to be prejudicial in outlook; things must be clearly named. In this case study, the whole is greater than the sum of its parts. The reader will be presented with numerous small denials, which may not appear significant. However, ultimately they add up to a negation of same sex history. No overt homophobia is displayed, but the persistent not naming of known same sex lovers grows to encompass the whole project. Like the proverbial rolling snowball, which grows to the size of a boulder, many small excisions amount to evisceration.

The Whitney Museum (New York, 1999, 2000) undertook a massive

Jasper Johns, **Three Flags**, 1958, encaustic on canvas 78.4 x 115.6 x 12.7 cm. 50th Anniversary Gift of the Gilman Foundation, Inc., The Lauder Foundation, A. Alfred Taubman, an anonymous donor, and purchase 80.32. Photo by Geoffrey Clements. Jasper Johns/VAGA, New York/DACS, London, 2004. Courtesy of the Whitney Museum, New York

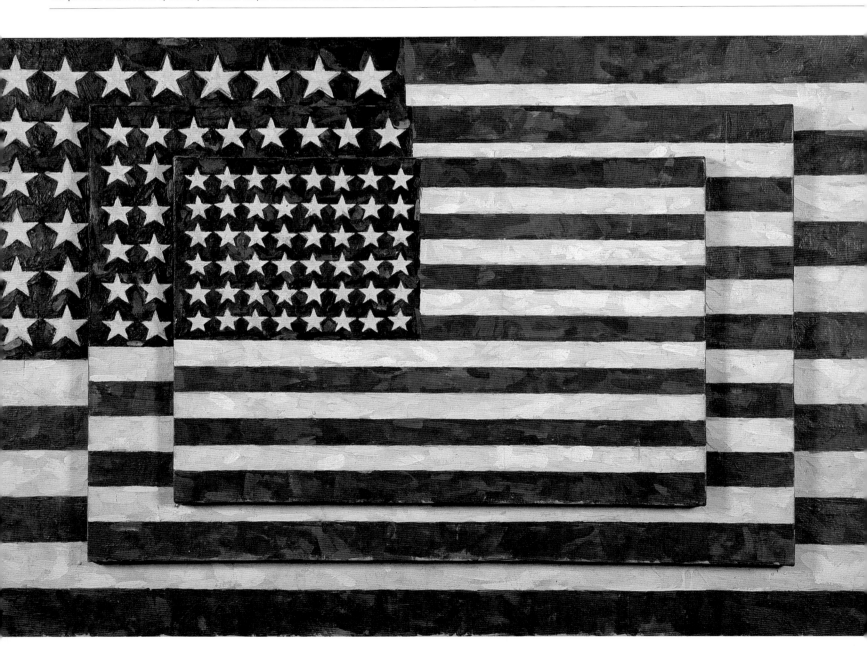

project in book (two volumes, 800 pages) and exhibition form called *The American Century*. In Part 1(1900–1950), Barbara Haskell states: 'As an expression of American life, the cult of virility was highly esteemed in Stieglitz's milieu. Dove, Marin, and Hartley – notwithstanding the latter's homosexuality – were praised for what Rosenfield called the "male virility" of their work' (Haskell, 1999: p203). However, she does not mention Demuth's (or many others') homosexuality in her essay. Part 1 deals mainly with deceased artists about whom she should be able to speak frankly, though she does not.

In Part 2 (1950–2000), Lisa Phillips (with others) clearly identifies only a few artists as same sex lovers (Mapplethorpe, Wojnarowicz). In most cases the text alludes only to sexuality, even when artists have defined themselves as gay/queer. The allusions often take the form of euphemistic references to AIDS (Gonzalez-Torres), conflating homosexuality with illness. It is important to note this distinction from the start, because the heterosexuality of artists is continually brought up, confirmed and spoken of throughout both parts.

Discussing the background to 1950s American culture, Part 2 states: 'The widespread homophobia of the day often served as a convenient tool for discrediting cultural enemies. Many errant artists were attacked for the gay content of their work' (Phillips, 1999: p37). The discussion focuses on the gay content of work, and not the sexuality of the makers. The text even asserts that some heterosexual artists were discredited for having allegedly homosexual content in their work. Speaking of content does not (and should not) confirm the sexuality of the maker.

The following examination of the language used in *The American Century* reveals the subtlety of institutional homophobia, even in the most open organisations committed to change (like the Whitney). Homophobia is often overlooked, and only in the details can it be seen. Institutional homophobia presents a Potemkin history in which illusion is presented as reality. The curators involved are of the highest integrity, and their attempts at inclusivity are not in doubt. Rather, the purpose of this text is to examine the phenomenon of institutional homophobia, while endeavouring to give the writers the benefit of the doubt. In particular, *The American Century* can be seen within the context of the right-wing backlash against (then) Hawaiian legislation legalising same sex marriage (which was overturned). This major political issue resulted in Defence of Marriage counter-legislation across America, and is still a point of contention.

The covers of both volumes of *The American Century* feature Jasper Johns' painting *Three Flags* (1958), purchased by the Whitney in 1980 (Phillips, 1999: p320). There may be no more famous American art icon than these stars and stripes, and the American flag by a same sex lover, an *American fag,* would not do. Perhaps widespread homosexuality in the visual arts was not acknowledged for two reasons. First, the project was jingoistic. A claim is made that the century belongs to America, irrespective of whether the case is made. The Whitney wants their document to be a cultural cornerstone supporting what it means to be American in an American Century. It follows that they might not wish it to be seen as a 'queer' century. It would imply something wholly different from being American. Second, the authors/curators had to deal with issues other than historical accuracy. American art institutions receive little public funding (unlike their European counterparts), and when they accept money from the National Endowment for the Arts (NEA), they are obliged to accept political restrictions. Senator Helms (having passed anti-gay legislation) has seen to it that arts bodies cannot *promote* homosexuality (Phillips, 1999: p332). American arts bodies must deal with this reality, which makes it difficult for institutions to speak openly (even if they are sympathetic). *The American Century* had 'major support' (Phillips, 1999: p9) from the NEA. American arts bodies also depend on corporate donors and ticket sales. The 'Statement of Collaboration' from Andrew Grove, Chairman of Intel, states that, 'Intel and The Whitney Museum will be working together over the course of *The American Century* to design a range of new interactive and educational tools that will enrich the museum experience and extend the exhibition into homes and classrooms around the world' (Phillips, 1999: p5). Irrespective of Intel's views on same sex love, it would have been a problem if *The American Century* had been used

in the classroom and seen as 'promoting' homosexuality in any way. Even the naming of same sex lovers can be construed as promotion.

In 'Closing the Gap Between Art and Life' (Phillips, 1999: p83), Phillips makes the case for Rauschenberg's importance stating, 'The artist who most clearly redefined the boundaries of art in the 1950's by bringing real life into it was Robert Rauschenberg'. She quotes him saying, 'Painting relates to both art and life' (Phillips, 1999: p9). Ironically, Rauschenberg has tried to keep his private life out of public awareness. Phillips was not free (or felt unfree) to state the sexual basis of known relationships. She says, 'Jasper Johns first came to New York from South Carolina in 1948. Six years later, he met Robert Rauschenberg, a meeting that would irrevocably alter the course of American art history. From 1956 to 1961, the two shared loft space in lower Manhattan. During this period, they nourished and encouraged each other in many ways, producing exceptional bodies of work' (Phillips, 1999: p89).

Johns is now open about the fact they were lovers, and there is no longer any art-historical reason to hide this. Phillips likely knew they were lovers, depicting their relationship in such intimate terms ('nourished'). Referring to Johns' *Painting with Two Balls* (1960) she states it 'introduces sexual imagery, another element that persists throughout Johns' work. Personal symbolic references abound, despite the visual air of cool detachment, and we are offered clues and codes that beg deciphering' (Phillips, 1999: p92). The painting has a huge slit in the top third of the canvas, into which two plaster balls are inserted; one of Johns' more graphic images, it remains in his own collection. Phillips cautiously observes that clues and codes need to be worked out and named. Johns' relationship was an open secret, yet Phillips does not confirm information already in the public domain.

This section of *The American Century* is subtitled *Rauschenberg, Cage, Johns, Cunningham*. What is the basis for this peculiar ordering of their names? It is not an alphabetical or an age order, nor is it the conventional ordering of Rauschenberg, Johns, Cage, Cunningham. Rauschenberg and Johns' names are kept apart. Cage and Cunningham are likewise divided.

This ordering is as disruptive as Bonnie, Antony, Clyde, Cleopatra. The nature of the relationships is obscured. Heterosexual relationships are freely spoken of in the preceding chapter 'Truth Tellers and Rebel Angels'. In a side box by Chrissie Isles ('The New American Cinema') she introduces Stan Brakhage and 'His highly subjective, personal form of film making, which took his domestic life, his wife and children, and his own inner struggles as central subjects' (Phillips, 1999: p69). The Whitney brings up Rauschenberg's erotic life stating that he had a wife (Phillips, 1999: p92), thus shading him as heterosexual, while any homosexual side is edited out. In one of the longest descriptions (twelve pages) of any artist (in either book), the same sex relationships between Rauschenberg/Johns and Cage/Cunningham are not mentioned. Art professionals perpetuate a conspiracy of institutional silence because it still matters if the general public perceives artists to be homosexuals.

Larry Rivers (twice married) openly acknowledged a long-term same sex relationship with Frank O'Hara. Yet the text doesn't mention this when discussing Rivers' full frontal nude of O'Hara 'wearing nothing but a pair of socks' (Phillips, 1999: p46). No comment is made on why O'Hara, a curator at the Museum of Modern Art, posed naked for another man. The text is more straightforward discussing literary figures. In an essay on 'The Beat Generation', Kerouac, Ginsberg and Burroughs (Burroughs is spoken of only as an author) are said to have 'served one another as sexual partners, literary agents, mentors, and, above all, developing writers who read and encouraged each other's work' (Phillips, 1999: p65). This clarity is reserved for writers, dancers (page 346), actors (page 224) or references to general culture (page 223), but not used when discussing visual artists.

Phillips states Warhol '... was a unique character – cool, pallid, passive, asexual ... With his entourage of handsome boys, artists, drag queens and rock stars, he never failed to infuse a charge into any social gathering' (Phillips, 1999: p130). Warhol was many things, but he was not asexual. Warhol was one of the most open of all twentieth-century artists involved in same sex erotics. His frequenting of gay bars, his foot/shoe fetish, and

Larry Rivers and Frank O'Hara, **Stones**, 1957, lithograph on paper, 35 x 45 cm. © Larry Rivers/VAGA, New York/DACS, London/Tate, London, 2004

the fact that he was a same sex lover are well known and also well documented. This is not a man who ever was in the closet; there can be no outing Warhol. This is a deliberate attempt to *in* him. The text would deny him his sexuality. Poet John Giorno often speaks of their sexual relationship (Rodley, 2002). Richard Meyer states that, 'The New York design world of the 1950s furnished one of the few professional areas in which gay men could work without closeting their sexual identities. Warhol not only took full advantage of this openness in his day-to-day life, he translated it into his visual art' (Meyer, 2002: p99).

It might be said that Warhol projected an asexual air that was part of his public persona, but that is not the same thing as denying his documented same sex loves. What is not denied is his artistic importance: 'Of all the Pop artists, Andy Warhol was the one who most brilliantly exploited and transformed the culture industry by perfecting the art of publicity' (Phillips, 1999: p130). This might explain the attempt to deny his sexuality, for Warhol changed the course of American art history as significantly as Rauschenberg or Johns. Again, a same sex lover is acknowledged as pivotal but his sexuality is negated, denied or misnamed.

In 'American Underground Cinema 1960–1968', Isles brings together Jack Smith, Kenneth Anger and Warhol, all same sex lovers, though this is only alluded to rather than stated. Isles notes that their work was within a 'homoerotic mode' (Phillips, 1999: p132), but heterosexuals can include homoerotic imagery in their films (Julian Schnabel, *Before Night Falls*, 2000). Even homophobic films like *Cruising* (1980) can be directed by and star heterosexuals (William Friedkin, Al Pacino) who are not presumed to be homosexual. Friedkin went so far as to place images of gay sex within the movie's murders 'these four frame and six frame intercuts of pornography in the murder scenes' were 'Friedkins equation of gay sex and murder' (*Out*, February 1996: p86)

Discussing Anger's film *Scorpio Rising*, Isles says, 'Fantasy images of the hero Scorpio and of homosexual motorbike subculture are intercut with found footage of James Dean and a religious gathering' (Phillips, 1999: p133). Isles only directly says that Anger uses the subculture in cross editing

to allude to his homosexuality, reference to subcultures substituting for direct acknowledgement of sexuality. Dean's same sex activities are widely documented, yet he is more often depicted as heterosexual. Referencing Warhol's use of sexuality, Isles states that, 'The low-budget, deadpan format of the porn movie that Warhol adopted in *Couch* (1964), *Blow Job*, *Kiss*, and later, more explicitly, *Blue Movie* (1968) similarly subverted the structure and expectations of mainstream cinema' (Phillips, 1999: p133). As with Warhol, the homosexual content of Jack Smith's film *Flaming Creatures* is described, but no reference is made to the artist's sexuality. Smith filmed himself and his friends dragging up. Anger used film to document the gay leather scene, while Mapplethorpe used photography. In the text, same sex lovers are reduced to actions and milieus.

British artist Rebecca Scott uses images of gay male erotica from sex magazines as the basis for many of her paintings, but this does not make her a gay man. Monica Majoli paints scenes of gay sex in California bathhouses. She has not personally viewed these encounters, but has heard male friends describe the action. She imagines what this milieu must look like in her painting, but this does not make her a male same sex lover. To infer is not to name.

The text proves overly cautious even when referring to Mapplethorpe; it states that he 'started producing highly graphic depictions of the gay S&M underworld in which he participated' (Phillips, 1999: p249). This description is as far as the Whitney goes in stating that Mapplethorpe was homosexual. Mapplethorpe is referred to as someone who partakes in homosexual acts, but not as homosexual. They allow others (an American Family Association press release) hostile to Mapplethorpe to confirm it, quoting from it. Same sex love is implied or suggested by others and the Whitney drew the line at clearly naming him themselves.

Perhaps it helps that he is dead. In 'The Culture Wars ' Mapplethorpe's saga is described as it played out in the American courts (Phillips, 1999: p325). Mapplethorpe did not hide his sexual practices, he documented them, but at the same time he was not open to his family. His parents' refusal to believe that he was homosexual (because he had not told them

himself) exemplifies the indignity of not naming. For them, no smoking gun was enough, no photo of Mapplethorpe with a bullwhip inserted in his anus counted. He didn't tell them he was gay, he did not use the word, so he wasn't its meaning. Mapplethorpe's sister Nancy visited him upon learning that he had AIDS and asked 'the question everybody in the family had always been afraid to ask. "Robert," she said, "are you a homosexual?" He slowly exhaled the smoke from his cigarette before murmuring a barely audible "Yes"' (Morrisroe, 1995: p340).

It was left to her to inform their parents and their mother refused to believe it. '"Listen, Ma," Nancy said, exasperated. "I already told you ... Robert is gay!" But Joan (his mother) still had her doubts. "No," she replied. "I don't think so"' (Morrisroe, 1995: p341). Unless the sexuality of artists is openly discussed and documented, it can be denied, reinforcing the stigma attached to same sex love. The art world exists within a greater culture where same sex lovers continue to experience prejudice. In the twenty-first century it is still a slur on an artist's name to be called a gay artist. Mapplethorpe's long-standing love affair with collector Sam Wagstaff was well known and documented. Wagstaff educated Mapplethorpe in the arts and gave him his first professional camera. As with almost every same sex lover in the Whitney's text, positive aspects of their lives are withheld.

2.2.2 Homosexuality = Death

The American Century's descriptions of openly gay artists like Felix Gonzalez-Torres, Robert Gober and Jack Pierson are completely devoid of any such reference, even though many works are based on or feature same sex love. What is presented is an AIDS connection and an implication of homosexuality through disease. In the subsection 'Art about Aids', Robert Atkins states: 'Many talented artists were cut off in their prime – or before they had reached it – among them Scott Burton, Arnold Fern, the General Idea members Felix Partz and Jorge Zontal, Felix Gonzalez-Torres, Tony Greene, Keith Haring, Peter Hujar, Adrian Kellard, Robert Mapplethorpe, Nicolas Moufarrege, Rod Rhodes, Hugh Steers, Paul Thek

and David Wojnarowicz' (Phillips, 1999: p327). There is no other confirmation that these men were same sex lovers, only the implication that they were, because they died of AIDS. Atkins' text places the AIDS discussion within a greater assault on the arts in the 1980s. That Atkins was able to raise the issue at all is creditable, but it is within a medical paradigm. Surely artists would have been happier classified as same sex lovers than as victims of a disease.

The text implies that those who make work that seems to be about AIDS or who are included in the list of AIDS deaths must be same sex lovers, colouring their work, which often has nothing to do with illness. That said, the text does describe a Gran Fury bus poster project featuring homosexual male and female couples and a heterosexual couple kissing with the slogan 'Kissing doesn't Kill: Greed and Indifference do', which prompted one Chicago alderman to call the print ad 'an incitement to homosexuality'. Readers are likely to presume that artists who are same sex lovers are obsessed with their predicament, which will inevitably lead to death. The Whitney clearly links homosexuality with American visual artists within an AIDS context. This is a dysfunctional view of same sex lovers, who are presented as problems (to funding, to health), and may leave readers questioning the validity of their inclusion.

This may be why artists who are same sex lovers but not dying from AIDS-related illnesses are not referred to as same sex lovers (Johns, Kelly). The problem for an institution like the Whitney is that a paradigm conflating same sex love with illness forces them to hide unpalatable sexual information about artists of such standing as Johns and even Warhol. Does the institution really want to utter the words Rauschenberg and AIDS in the same breath, or historically link Kelly with Mapplethorpe? It becomes almost impossible for the uninformed reader to make any judgment about the work in this diseased atmosphere. Institutional homophobia transforms ACT UP's slogan 'Silence = Death' into 'Homosexuality = Death', making a greater problem for the institution, as the text does not contain positive statements about same sex love (possibly for fear of being seen to promote homosexuality).

Felix Gonzalez-Torres, foreground: **Untitled (Public Opinion)**, 1991, black rod licorice candies, individually wrapped in cellophane, endless supply, dimensions vary with installation, ideal weight 700 lbs (ARG# GF1991-63); middle: **Untitled (Party Platform 1980-1992)**, 1991, black paper, endless copies, 17.78 at ideal hight x 101.6 x 66.04 cm (ARG# GF1991-62); back: **Untitled**, 1987 framed photostat, edition of 3, 1 A.P., 25.4 x 33.02 cm (ARG# GF1987-19). Installation view from Camden Arts Centre, London, England "Symptoms of Interference, Conditions of Possibility; Ad Reinhardt, Joseph Kosuth, Felix Gonzalez-Torres" January 7 - March 6, 1994. © The Felix Gonzalez-Torres Foundation. Courtesy of Andrea Rosen Gallery, New York.

The text states that Gonzalez-Torres 'died of AIDS in 1996' and 'produced art in a variety of media that confronted real and projected loss. Following his partner's death, he made a photographic billboard project depicting their empty bed' (Phillips, 1999: p355).

It is important to deconstruct this passage as it suggests that Gonzalez-Torres was a same sex lover but does not state it. Only someone aware of the contemporary art scene or viewing same sex lovers as AIDS victims would know that Gonzalez-Torres was homosexual. Blockbuster exhibitions like *The American Century* are aimed at as large an audience as possible, and organisers are aware that many of the public attending will be intolerant of same sex lovers, and neuter language accordingly. Gonzalez-Torres' partner is referred to, yet nothing can be presumed about the sex of that partner as no pronouns are used. The partner may have been a woman who died from breast cancer. Gonzalez-Torres may have been a heterosexual haemophiliac who contracted HIV from blood transfusions (as thousands did). These are reasonable readings of the text as it is deliberately evasive. Stating that Gonzalez-Torres died from AIDS is a tasteless euphemism for homosexuality, and one that reinforces the harmful prejudice that AIDS is a gay disease. Someone who has died of an AIDS-related illness should not be presumed to have been of any particular sexuality. Yet, throughout the text, references to artists who have 'died of AIDS' are the only indication of their sexuality.

Readers are left to infer that Gonzalez-Torres and his lover were men, either because they already have that information or, more distressingly, because the presumption of the text is that for general readers, only gay men die of AIDS. If sexuality is only implied through disease, the reader is left with an underlying bias that filters the information. Only with a medical paradigm in mind can the text be read to presume that Gonzalez-Torres was homosexual and the dead partner a man. This type of text denies the openness needed to erase such modern myths. As long ago as 1988 the Museum of Modern Art faced protests from ACT UP for an exhibition featuring photographs of AIDS sufferers. ACT UP issued leaflets that declared:

We believe that the representation of people with AIDS (PWAs) affects not only how viewers will perceive PWAs outside the museum but, ultimately, crucial issues of AIDS funding, legislation and education ... In portraying PWAs as people to be pitied or feared, as people alone and lonely, we believe that this show perpetrates general misconceptions about AIDS ... (Gott, 1994: p220).

Institutionally, not much seems to have changed.

Same sex lovers can make, have made and continue to make work that speaks across gender/sexual divides. While an artist of colour can make work about love that speaks to/for the dominant, this is not true of same sex lovers. Any work he might make addressing the issue of love is still seen as other, exotic and possibly sensational. The depiction of two men kissing has a different resonance from a black heterosexual couple kissing. A heterosexual couple of colour can represent any couple, a homosexual couple does not. The issue of race need not be explicit in a work of art that features or has been made by a person of colour, while the homosexual corollary does not hold true. Same sex love appears only to represent *the other* for the dominant. Similar otherness occurs when interracial heterosexual couples are involved, as racism is still an active force. While Gonzalez-Torres' work may be a dignified representation of loss and the potential for renewal, the Whitney's lack of clarity denies it such dignity and closes off additional readings of the work. His empty bed should speak to all viewers regardless of sexuality, his loss one any person of any gender or colour might feel, and the strength of the work transcends object choice.

2.2.3 Market power

Ross Bleckner's painting (along with Julian Schnabel and Eric Fischl) is discussed in the context of 'Market Power'. His 'romantic pictures that were memorials to friends lost to AIDS' is related to Gerhard Richter and the fact that they had 'two contradictory painting styles' (Phillips, 1999: p311). Bleckner's 'lost' friends should only signify that he knew people who had AIDS. Heterosexual artists could make and have made memorials to

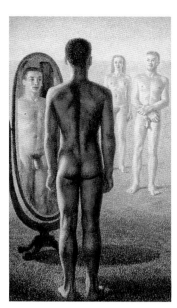

Jared French, **Face to Face**, 1949, casein on canvas mounted to panel, 53.34 x 28.58 cm. Private collection, New York. Courtesy of DC Moore Gallery, NYC

Ross Bleckner, **Memory of Larry**, 1984, oil on canvas, 121.92 x 101.6 cm. Courtesy of the artist

friends *lost* to AIDS, but Bleckner is openly gay. Why not say so, why imply he is gay through friendship with the dead? The reader is again asked to presume that the dead are all gay men who died from AIDS, not hetero-sexuals. Disease is linked with being homosexual, whether the institution means to or not. Bleckner is interested in people who died from a disease attributed to gay men, *ergo* he too must be gay. Bleckner's work is dis-cussed in terms of market forces, AIDS and a greater artistic discourse, but his art is radically queer at core. Again, the Whitney links disease, death and homosexuality, and no glimpse of work by same sex lovers is not thus tainted. Bleckner's work could provide a meaningful reading of the same sex experience to a heterosexual audience, but if readers are only presented with same sex lovers' work within a negative context, the work is lost to it. Bleckner continues to make highly sophisticated abstract paintings, and, at least in popular culture magazines like *Vanity Fair*, he is openly described as a gay man.

Jack Pierson's *Desire Despair* (1996) (Phillips, 1999: p353) uses found, three-dimensional alphabetic letters, to spell out the words. Such works are sparse and derive their visual power from the battered and worn let-ters that form the groupings. The Whitney owns *Desire Despair*. Pierson came to prominence through photographic work of his own gay and drug-abusing milieu. For a time, Pierson and Mark Morrisroe (White, 2001: p107) were lovers, photographing each other. Pierson's own desire is often the focus of his images. There is no mention of their working/loving relationship and each is spoken of separately, Morrisroe on page 297, Pierson on page 352. Surprisingly, Pierson's drug addition is well docu-mented and proves easier for institutions to speak of than his sexuality.

Lari Pittman fares better. His 'work of the nineties draws on a range of ethnic traditions, high and low culture and gay politics' (Phillips, 1999: p358). The text acknowledges that the work has a gay polemic, but again it assumes that the reader will draw the implication that the artist is gay. Yet men can be feminists or use feminist critique without being women. Heterosexual artists (including Nan Goldin who went to school with Pierson and Morrisroe) might or might not engage gay politics, or use 'gay' imagery. Golden's eye falls on gay men kissing but that does not make her a gay man. Pittman's work is often overtly homoerotic, ele-gantly depicting ejaculating penises and winking anuses in candy colours.

Institutional homophobia is insidious because it hides in the open. It should come as no surprise that *The American Century* is not overtly homophobic; the act of omission (the writing out of a history) is what is objectionable. Institutional homophobia, like institutional racism, is hard to identify and root out. No matter how sympathetic everyone involved in *The American Century* project may have been, they all had to act within an institution, which had external pressures to consider. The result is that artists who are same sex lovers all but disappear (except as victims), or are co-opted into the heterosexual body. They are presented through hetero-sexual filters. Artists become straight, they are ined, and their loves negated. The text unintentionally presents the happy heterosexual and the crushed queer (struggling with AIDS). This is obviously not their project but it is one outcome nonetheless. *The American Century Part 1* leaves out per-tinent and documented same sex information on Sargent, Demuth, Cadmus and French, who are heterosexually filtered in. Each small exclusion, each drip of misinformation, adds up to a neutered whole. Perhaps it is too important to Americans' view of themselves to acknowledge that so many of their artists were same sex lovers. Within the institutional framework there is little to be gained in claiming that Mapplethorpe was American, but quite a lot in doing so for Sargent, more to be gained trying to include Demuth than Hujar. Demuth is seen as an important artist, a serious painter of the Americas, Hujar took photos of gays and junkies. Demuth is more important as an American to the art establishment, and Demuth can be hung in the homes of the bourgeois, but only the most adventurous col-lectors would show their friends Hujar's frank images.

The market comes into play more than institutions let on, as they pas-sively collude with it. Institutions focus their spotlight on artists through exhibitions. Artists' commercial galleries then use the institutional space as an extended sales room. Many works in institutional exhibitions are for sale, and indeed are sold while on their walls. This is neither good nor bad,

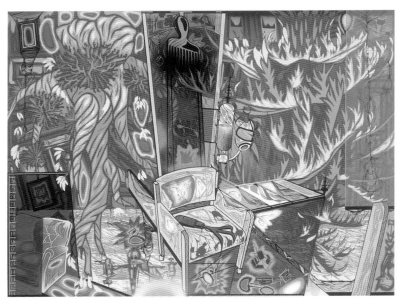

Lari Pittman, **Untitled #11**, 2003, matte oil, aerosol lacquer and cel-vinyl on gessoed canvas, 193.04 x 259.08 cm. Courtesy of Regen Projects, Los Angeles

just what happens. For many of the commercial reasons stated, the Royal Academy was criticised (internally and externally) for allowing Charles Saatchi to use its galleries for the exhibition *Sensation* (1999–2000). What is untenable is for institutions to fool themselves into believing they are a neutral space.

Rauschenberg's credibility may have fallen because of the closeted nature of his retrospective, but the price of his works did not. The market appears to need men of his status to be, if not straight, then neutered. Artists' reticence to being out is not surprising given the current and historical climate. Institutional homophobia makes it easier for them to be in. Internalised homophobia also plays a part. People of colour have faced internalised racism and while they have not made all the inroads into the dominant culture they deserve, pride in themselves and their colour is no longer an issue. Many same sex lovers still internalise homophobia, and their shame is food for bigots.

Phillips, Isles and Atkins are to be commended for the amount of light they have let into the institution, but *The American Century* shows that dark corners exist in the brightest of places. Clear recognition of same sex lovers in an 'historic' survey of Americana (with all the kudos and gravitas of the Whitney) proved too difficult. This is a troubling state of affairs, as other institutions (internationally) have similar policies. The Whitney text is emblematic of far too many others. As Douglas Crimp has said, 'What must be done now – if only as a way to begin rectifying our oversight – is to *name* homophobia' (Crimp, 2002: p162).

2.3 AMERICAN VISIONS: HOMOPHOBIA AND ITS EXPRESSION

2.3.1 The heterosexual filter of Robert Hughes
This case study looks at an openly homophobic text, which differs significantly from *The American Century* in tone and attack. While both attempt to co-opt artists into a heterosexual canon, Hughes is happy to call a same sex lover a 'flaming queen'. His open contempt is easy to spot, and is representative of many texts.

Hughes (critic and author of *The Shock of the New*) planned to document American art in *American Visions* (1997). Hughes informs the reader that the book came from his BBC television series of the same name, noting that neither was 'encyclopaedic' or 'definitive', and footnotes weren't needed as the book was aimed at 'the general intelligent reader' (Hughes, 1997: pviii). Stating that, 'Our object was not to do an "art series" as such, but rather to sketch some answers to an overriding question: "What can we say about Americans from the things and images they have made?"' (Hughes, 1997: pvii), Hughes states that the project was 'also doomed' to 'all efforts at inclusiveness at the outset'.

The reader is informed that he will look at work made by non-indigenous people, excluding those who might truly be called Americans, Native Americans, despite their vast cultural history. They are not deemed of sufficient interest. Hughes claims, 'American Indians were immigrants too, having made their way across the Bering Strait from eastern Asia some 10,000 to 14,000 years ago' (Hughes, 1997: p3). This shows either a clear misunderstanding of the contemporaneous usage of immigrant or a politically revisionist motive. Migration of peoples over continental land masses (over aeons) is not the same as immigration. Hughes is aware of this; he is after all an Australian. *Indians* are seen through Spanish or English eyes, like captive birds: they are seen in feathers (Hughes, 1997: p6) or hanging from ships' masts (Hughes, 1997: p7), presented as exotic and hardly human. Hughes is a proudly unreconstructed man, and his magazine criticism is deliberately provocative. His dismissal of non-Europeans can be seen as symptomatic of his attitude to the non-dominant, and his homophobia quickly rears its head.

Recounting the life of John Singleton Copley (1738-1815), Hughes mentions that in marrying a rich young woman, he was 'at the same social and financial level as his sitters, and was deluged with commissions' (Hughes, 1997: p84). This is important information. Knowing that Copley was married (to whom, and that her connections affected his ability to prosper) is pertinent. That Copley was not a same sex lover is an important aspect of his life that enriches the reader's understanding of his work. Hughes does

not use this openness when speaking of same sex lovers. In describing erotic work of John Singer Sargent, Hughes chooses only images of women (of which there are only a few) and not of men (which abound). Readers are left to mistakenly conflate women as Sargent's erotic object choice. In discussing *El Jaleo* (1880), Hughes states it 'is about ecstasy. It celebrates the Dionysiac urge' and that 'if you added up all the nudes painted by American artists before this, they wouldn't amount to a tenth of *El Jaleo*'s erotic charge, even though all you see of the women is their arms and faces' (Hughes, 1997: p251).

Decoding the image, Hughes notes that it was highly posed and that the central dancer was a 'French professional' (Hughes, 1997: p252). Sargent's painting of flamenco dancers is erotic, but it is not necessary to find a subject erotic in order to depict it as such. Sargent sees the woman, and makes her erotic because he understands the erotic impulse, not because he necessarily finds her erotic. Only in Sargent's male nudes and watercolours of naked English soldiers is his object choice rendered with true verve. Hughes' positing of *El Jaleo* as the most erotic of American paintings positions it within a heterosexual context by including *all the nudes painted by American artists*. Most nudes of the period were of women painted by heterosexual men. There is no doubt that *El Jaleo* is a remarkable painting, but Hughes masks Sargent's homosexuality by claiming his depiction of her is *echt* erotic, and implying that she is Sargent's object choice. Hughes is no ingénu and probably knows that Sargent was a same sex lover, as he proves to have such information about other artists. Hughes states, 'For Sargent, pictorial truth arose from editing reality, perfecting fictions' and points out that Sargent believed in [*l'art pour l'art*] art for art's sake', a quality 'that Sargent had in common with his closest literary friend and most intelligent supporter, Henry James' (Hughes, 1997: p250). Hughes must be aware that James and Sargent were part of a well-connected group of same sex lovers. But Hughes is not the only one who speaks in fictions.

The exhibition *American Drawings and Watercolors in the Metropolitan Museum of Art: John Singer Sargent* (2000) had heterosexually skewed captions for extremely homoerotic drawings. The exhibition (and book) featured nude male images (with their genitalia thrust at the viewer) described as 'Sargent's long-standing interest in *académie* exercises' (Herdrich, 2000: p236). Private erotic works are described as studies for other commissions. *Man Standing, Head Thrown Back* is described thus: the 'expressive pose recalls in spirit the figures in Sargent's later library murals such as *Judgement*' (Herdrich, 2000: p239). Most viewers would recognise the nude pose as erotic (if not orgasmic) as opposed to religious. The extremely provocative and un-academic *Man with Red Drapery* is described in terms of its composition and brushstroke: 'A brilliant example of Sargent's mastery and efficiency is his rendering of the figure's navel. A small oval of paper is left in reserve; above it, a pool of darker pigment gathers, as if by accident, to describe the shadow of the navel' (Herdrich, 2000: p265).

Tate Britain's catalogue for *Exposed, The Victorian Nude* (2001) features a similar work, *Reclining Nude Male Model*, described as 'set in close imitation of the famous antique Barberini Faun'. Edwin Austin Abbey (a contemporary) is quoted saying, '"stacks of sketches of nude people ... saints, I dare say, most of them, although from my cursory observations of them they seemed a bit earthy"'. The text ends with a statement that, 'After his death the artist Jacques-Emile Blanche spoke of Sargent's active sexual relations with men' (Smith, 2001: p164), demonstrating that institutions need no longer provide beards.

2.3.2 The Whitman followers

Hughes makes reference to Walt Whitman throughout 'The Gritty Cities', wherein he speaks of the nineteenth-century American 'appetite for the real, the scientifically verifiable, and the pragmatic' (Hughes, 1997: p273). Whitman is presented as the most willing to look four-square at the post-Civil War American landscape. Hughes benchmarks Whitman in relation to others. In referring to Louis Sullivan (1856-1924) Hughes says, 'Sullivan passionately admired Walt Whitman – he was, one might almost say, the Whitman of architecture' (Hughes, 1997: p282). In relation to Thomas

Eakins, he notes that, 'The two met in 1887 and were close "comrades" until the poet died five years later' (Hughes, 1997: p300). Eakins photographed and painted Whitman. Hughes states Whitman found 'Eakins was a democratic artist, capable of reaching the heart of the common, nonspecialist audience with his plain visual truths' (Hughes, 1997: p300). Hughes approves of democratic truthfulness, yet is troubled by the fact that both were same sex lovers. Hughes can be under no misapprehension about Whitman. *Leaves of Grass*, Whitman's best-known work, carries lines such as:

('Song of the Open Road' – stanza 15)
Camerado, I give you my hand!
I give you my love more precise than money,
I give you myself before preaching or law;
Will you give me yourself? Will you come travel with me?
Shall we stick by each other as long as we live? (Whitman, 1940: p14)

and

('Starting from Paumanok' – stanza 19)
O camerado close! O you and me at last, and us two only.
...
O hand in hand – O wholesome pleasure – O one more desirer and lover!
O to haste firm holding – to haste, haste on with me. (Whitman, 1940: p33)

'Song of Myself' is so full of male to male imagery that the reader is recommended to swallow it whole, but let stanza 24 suffice:

Through me forbidden voices,
Voices of sexes and lusts, voices veil'd and I remove the veil,
Voices indecent by me clarified and transfigur'd. (Whitman, 1940: p60)

It is one of the most erotic male to male love poems ever written. It is important to recognise that in 1855 no man took a woman as a *camerado* (the 'o' is a masculine ending), nor did he go travelling with a woman friend. It is tempting for reactionaries to ask for photographic evidence of male to male love, making it all but impossible to find proof of homoerotic actions. In a nineteenth-century context, when a man writes of his forbidden sex (the love that dare not speak its name), it is clear he is addressing same sex love. Jonathan Katz goes into great detail about Whitman's creating a new way to speak of same sex love. Whitman's poems bring about homosexual voice in a period before the term was coined. 'The first poem of the new Calamus section constructed "comrades" as Whitman's major, approving name for men who loved men' (Katz, 2001: p115).

The Confederate soldier Pete Doyle was Whitman's longest-standing love. Whitman wrote of him that, 'He used to say there was something in me had the same effect on him. We were familiar at once – I put my hand on his knee – we understood' (Rouse, 1977: p293). After Whitman's death Doyle said 'I never knew a case of Walt's being bothered up by a woman' (Rouse, 1977: p294). Whitman, Sargent and Eakins used their art to depict their male erotic object choices. Poem after poem declares Whitman's love for men, in a physical and emotional sense. Whitman influenced the vast secret world of same sex lovers, providing a lighthouse in the stormy Victorian sea. One of Wilde's first stops on his initial tour of America was to visit Whitman (Ellman, 1988: p168).

In a book on American visions, Hughes places great emphasis on Eakins. 'He realized, quite early, that his field of experience had to be American life, American character, and American ideas' (Hughes, 1997: p287). Hughes' thesis is that Eakins' observational mode of painting was far removed from Academies, as 'No American painter ever worked harder to make the human clay palpable and open to scrutiny' (Hughes, 1997: p287). Eakins' *The Gross Clinic* is a painting of a medical operation. It is bloody and realistic, and when shown in New York was denounced as revolting. Hughes writes, 'Eakins' public often resented having

Thomas Eakins, **Swimming**, 1885, oil on canvas, 69.53 x 92.39 cm. ACC No.: 1990.19.1. Courtesy of the Amon Carter Museum, Fort Worth, Texas.
Purchased by the Friends of Art, Fort Worth Art Association, 1925; acquired by the Amon Carter Museum, 1990, from the Modern Art Museum of Fort Worth through grants and donations from the Amon G. Carter Foundation, the Sid W. Richardson Foundation, the Anne Burnett and Charles Tandy Foundation, Capital Cities/ABC Foundation, Fort Worth Star-Telegram, The R.D. and Joan Dale Hubbard Foundation and the people of Fort Worth

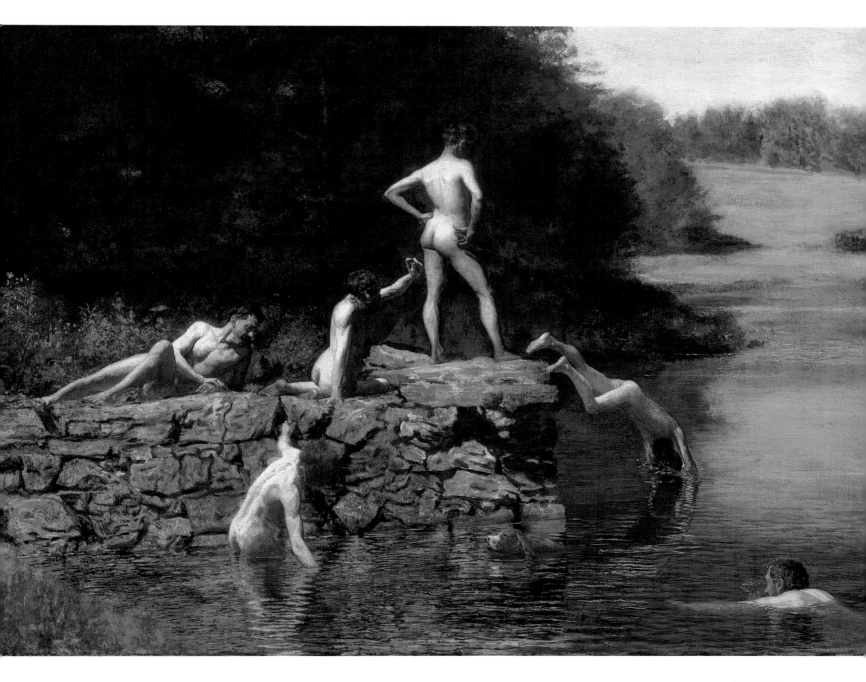

unvarnished truth shoved at it' (Hughes, 1997: p295). The same might be said of Hughes when it comes to Eakins' sexuality.

When describing *Swimming (The Swimming Hole)* 1885, Hughes is in two minds. He admits its sensuality, whilst explicitly denying Eakins' homosexuality: '*Swimming* (page 298) is a discreetly homoerotic image. Eakins took one of the chief themes of classical art – loving companionship between men and boys – and brought it up to date. He wanted to thaw the sexual content of such classical motifs out of the cold, dusty plaster of the Academy. The beautiful figure of the standing youth, buttock thrust out, is erotically coded as Donatello's *David*, and the whole image is permeated by the feelings Walt Whitman released in his description of young Americans bathing, surrendering themselves to sensation ...' (Hughes, 1997: p298):

... An unseen hand also pass'd over their bodies,
It descended tremblingly from their temples to their ribs,

The young men float on their backs, their white bellies bulge to the sun, they do not ask who seizes fast to them, ...

After quoting Whitman Hughes adds, 'No public allegations of homosexuality were made against Eakins in Philadelphia, and there is no evidence that he had an active gay life' (Hughes, 1997: p287). There are a number of points to make regarding Hughes' statements. There is nothing discreet about *Swimming*; it is about as explicitly homoerotic as an image could be in 1885. Hughes also employs the old chestnut of Platonic, non-erotic love, itself as dusty as the French Academics he criticises. Bizarrely, he employs Whitman as a *faux* heterosexual poet to imply non-sexual male activities. Hughes must be aware that Whitman's poem can be (and almost always is) read as homoerotic, and because it is so homoerotic (as is *Swimming*) he attempts to undermine any potential homosexual allegations. Hughes does not admit to the reader that such overtly sexual, overtly homoerotic images evidence Eakins' same sex desires. He goes so far as

to say that even if Eakins were a same sex lover, there is *no evidence that he had an active gay life*. Why does Hughes need to defend Eakins' heterosexuality or, at very least, his abstinence?

Since there are no known compromising photographs, Hughes attests that Eakins must be straight. Ironically, neither does there exist incriminating heterosexual evidence. No reports of syphilis of the anus, or of criminal conviction for gross indecency exist, therefore Eakins must be straight. Hughes dismisses the subject matter of the paintings as evidence. Such heterosexual filtering enables Hughes to place Eakins (a painter he admires) at the centre of nineteenth-century heterosexual American painting. Later, it will be shown that Hughes clings to an outmoded model of effeminate homosexuality that wilfully blinds him to any same sex love between men who are not 'flaming queens'.

Hughes notes that Eakins photographed his male students, himself and his wife nude, that photos 'such as a shot of his wife, Susan, naked, seen from behind, leaning on the neck of a horse, carry a distinct sexual charge today, which must have been more vivid a century ago' (Hughes, 1997: p297). Why does Hughes ascribe an erotic charge only to images of nude women and not Eakins' nude men? True, the nude image of a woman was probably erotic, but why not those of naked men? Nude photographs always carry some element of eroticism. Eakins' photographs of naked male youths are extremely erotic, and whether readers find his object choice to their taste, there is no denying their sexual pull. Eakins in fact did not marry Susan MacDowell (one of his students) until he was forty, comparatively late for that period. Hughes does not provide this information. He implies theirs was a young passionate love, not a mature relationship. Equally, being a same sex lover does not preclude Eakins from having sexual relations with his wife. Yet Eakins stated that, '... I can conceive of few circumstances wherein I would have to paint a woman naked, but if I did I would not mutilate her for double the money. She is the most beautiful thing there is – except a naked man ...' (Baker, 1960: p657).

Wilde, the prototype homosexual, was married and had children. This was the *modus vivendi* for the majority of Victorian same sex lovers (see

3.4.1). Whether a man married or single does not alter his same sex loves. Hughes resents having the unvarnished truth 'shoved at' him and goes to extremes to claim that certain artists were not proven homosexuals. By the same token, Hughes cannot establish 100 per cent proof of their heterosexuality. Taken to its logical extreme, even the existence of children is no proof of heterosexuality, unless there is DNA evidence that a husband was also a father. It would be ludicrous for academics to expect DNA evidence or images of coitus for proof of heterosexuality, but why then is such proof demanded for homosexuality?

Same sex love in the guise of the cult of male friendship was at its height at this period. David Deitcher's *Dear Friend: American Photographs of Men Together, 1840–1918* documents intimate male friendships. He states that 'the naturalised identification of marriage and parenting with heterosexuality has often been used to deny the queer past. Countless gay men and lesbians have been coerced into acquiescing in this conspiracy of self-denial. Given how commonplace it has been for same-sexers to lead double lives, and the force of the terror that has fuelled this masquerade, universal heterosexuality seems a more convenient than fitting conclusion to draw from this matrimonial glut' (Deitcher, 2001: p41).

Deitcher notes that heterosexual historians have 'been content to find in the absence of the category *homosexual* reason to presume the heterosexuality of nineteenth-century American men who fervently loved other men' (Deitcher, 2001: p59). His text is full of illustrations of young men in each other's arms posed in front of the camera. They are relaxed, often a couple depicted in group portraits, where others are not posed in such an intimate fashion. Deitcher concludes by saying that 'the anonymous portraits of comrades and romantic friends that fill the pages of this book cannot ultimately be enlisted as incontrovertible evidence of a gay past; but neither, by the same token, can they be taken as proof that such a past did not exist' (Deitcher, 2001: p150).

In the same way that Wilde came to define the nineteenth-century homosexual paradigm, Eakins' homoerotic paintings formed a body of work that would define a modern benchmark for same sex loving artists.

Eakins' frankness and honesty, his lustful desire are there for anyone to see, erotically depicting sportsmen (boxers, rowers) with the eye of a connoisseur of the flesh. Eakins did not translate them into polite drawing room paintings. While it is still acceptable to gaze upon a naked female as a passive visual object, men are a different story. Eakins looked at these men and they looked back. They are the bit of rough that Wilde hired by the hour. They are not passive. These non-effeminate same sex lovers unnerve Hughes, who is more used to viewing than being viewed.

2.3.3 Flaming queens

Hughes states that, 'Demuth was not a flaming queen, in fact he was rather a discreet gay, but if he could not place his deepest sexual predilections in the open, he could still make art from them' (Hughes, 1997: p380).

This statement reveals as much about Hughes as it does about Demuth. His homophobia and misogyny are made explicit in his dismissal of the 'flaming queen', decrying feminine traits. Hughes implies that to be a discreet gay is to be a good gay. He is as uncomfortable with same sex openness as he is with sexual acts they might participate in. He dislikes the queen, as do many same sex lovers with internalised homophobia. Hughes implies that a queen is somehow less of a man than he, yet the Stonewall Riot (which led to the gay rights movement) was led by transvestites, by 'flaming queens'.

It would be impossible for Hughes to refer to 'darkies' or 'good blacks', or to use 'abo' when referring to Aboriginal peoples. Yet he feels free to abuse homosexuals. 'Flaming queens' have a long and distinguished history of standing up for themselves, whereas many discreet gays have helped to oppress their fellow same sex lovers. Michael Portillo, ex-Minister of Defence in the Margaret Thatcher government, recently publicly confirmed that he had same sex relationships for eight years before marrying a woman. While he was a minister, he opposed the inclusion of same sex lovers in the British Army, even though technically, he was in charge of it.

If it is possible to call Eakins a discreet same sex lover, it becomes clear why Hughes wants to label him heterosexual. Numerous discreet

homosexuals have long hoped to pass as heterosexual, and Hughes is willing to lend a hand. Demuth was thus described in the Museum of Modern Arts' retrospective catalogue (1950): 'He had the typical esthete's love of good clothes, good food and drink and gay company' (Ritchie, 1950: p365). Precisely.

Hughes describes Hartley as 'a diffident, gangling Down Easter from Lewiston, Maine, and the greatest of early American modernists' and 'An early orphan; a homosexual in a fiercely prejudiced society, where even fellow artists (who were apt to stress their orthodox masculinity to rebut Philistine jeers) deprecated the "pansy" and the "nancy-boy"' (Hughes, 1997: p365).

Knowing that prejudice existed, Hughes is aware that it must have had some impact. He sees that prejudice is a bad thing, and yet in the same text abuses Hartley for his effeminacy. Hughes condemns homophobia in others, yet is homophobic. The best that can be said is that Hughes is aware that heterosexual artists diminished those in their group who were seen as effeminate, regardless of their sexuality. Hughes states on page 365 that abusive behaviour commonly took place in the first years of the twentieth century, then on page 380 abuses homosexuals in exactly the same manner at the end of the century. It is perhaps an unconscious slur, that is bad enough. It might be possible to read his attacks ironically, but this is not supported by the overwhelmingly negative attitude Hughes takes to same sex lovers throughout his text.

Hughes mentions Hartley's development as an artist under the tutelage of Alfred Stieglitz in New York, and charts the influence of Kandinsky on his painting. Hughes writes, 'The second thing that happened to Hartley in Paris was equally important. He was in a cosmopolitan wonderland, with a strong gay subculture in which his sexuality, driven underground in Maine, could now disport itself' (Hughes, 1997: p367).

Hughes poses his openness to homosexuality only to sneer at it. He compares tolerant Paris with puritanical America, proving that he, Hughes, sees American backwardness in its treatment of same sex lovers. He then exposes his prejudices by saying that homosexuality could be *disported*, implying that it was apart from Hartley, an otherness. Hughes treats it as something that he and the reader must deal with in order to justify Hartley's importance *as the greatest of early American Modernists*. This crude word *disport* reveals Hughes' attitude to same sex lovers, implying that Hartley's sexual life was not based in love, but sport, a game. Readers can apply the word *disport* to a heterosexual and the meaning is clear: it is a pejorative term. A heterosexual man who disports himself sexually is at best a stud and at worst a cad. A heterosexual woman who disports herself might be labelled a slag.

In discussing Hartley's love affair with Karl von Freyburg (a Prussian officer), Hughes states, '... Hartley began to fall deeply and sentimentally in love. It was the need for Von Freyburg, quite apart from artistic considerations, that took him to Berlin' (Hughes, 1997: p367). How Hughes knows Hartley's love was sentimental is not explained, but even had Hartley sent Von Freyburg roses every day, what is seen as sentimental alters over time. All Victoriana might be broadly brushed as sentimental. How would Hughes see their love if they were heterosexuals? Hughes thinks it is absurd that Hartley should follow his heart and go to Berlin, implying that it artistically hurt his career. If a man leaves town for the love of a woman, this is not generally seen as sport.

Hughes even claims great knowledge of same sex lovers. 'The Berlin to which Hartley came in 1913 offered him a spectacle he had never imagined before: a city with the strongest homosexual subculture in Europe, linked to flamboyant rituals of military display. The "sweets", the "warm brothers", were everywhere, and Berlin's gay nightlife was less available than inescapable. Homosexual acts were still proscribed as crimes under Article 175 of German law' (Hughes, 1997: p367). Hughes makes readers aware of his knowledge of the euphemisms of the day, as if he was chummy with *warm brothers* (but didn't burn his fingers). Hughes speaks of homosexuality as inescapable, as if it would force itself on Hartley or heterosexuals walking down the street. This type of jokey paranoia continues to this day. Modern homophobes often say they don't mind homosexuals as long as they keep it to themselves, and get angry when

Charles Demuth. **The Figure 5 in Gold.** 1928, oil on composition board. 91.4 x 75.6 cm. Courtesy of The Metropolitan Museum of Art, Alfred Stieglitz Collection, 1949. (49.59.1). Photograph © 1986 The Metropolitan Museum of Art, New York

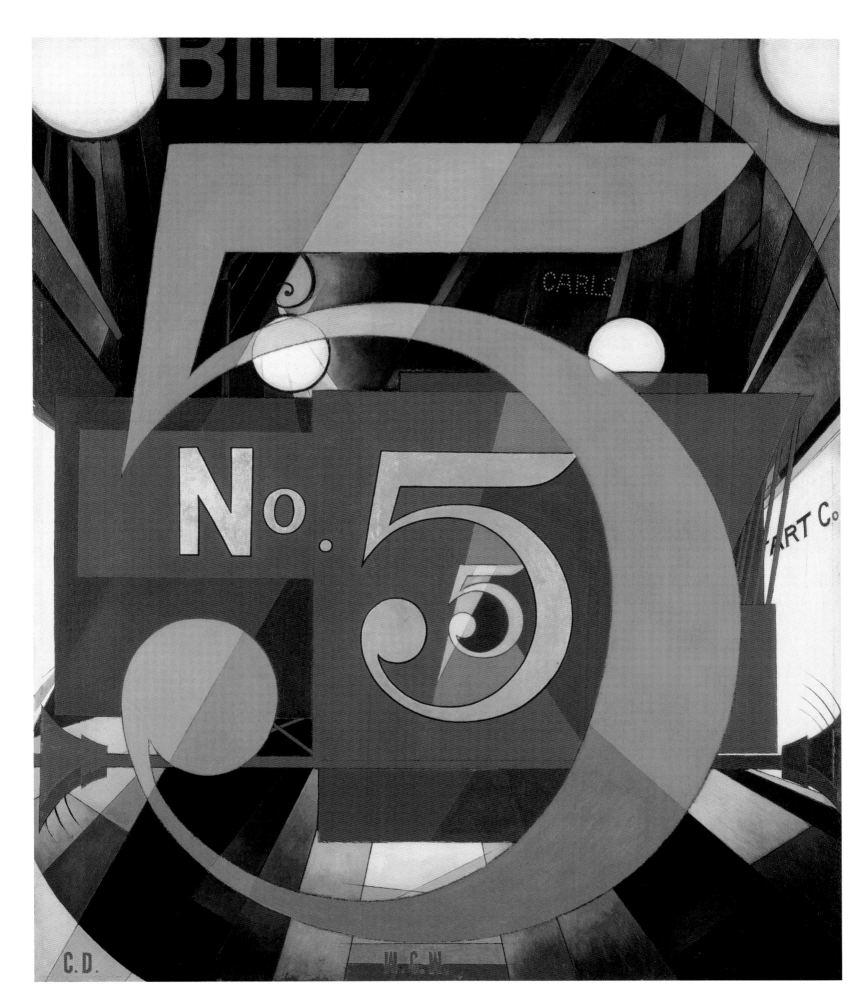

Marsden Hartley, **Portrait**, c. 1914-1915, oil on canvas, 81.92 x 80.96 cm. Courtesy of the Federick R Weizman Art Museum, Minneapolis

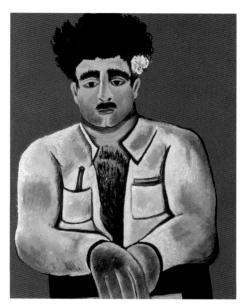

Marsden Hartley, **Adelard the Drowned, Master of the 'Phantom'.** (Alty Mason), c. 1938-39 oil on board, 70.8 x 55.88 cm. Courtesy of the Frederick R Weizman Art Museum, Minneapolis

gays 'flaunt' themselves in public. This flaunting, this flaming is itself a right of self-expression. Yet even in the San Franciscan heyday of the 1970s, a visitor still had to go to the Castro or the Tenderloin to see men holding hands or kissing. The flaunting was not widespread, nor was it inescapable. One had to seek it out, and still does. The underlying fear is that same sex love will become acceptable to the masses, but such an eventuality (dream or nightmare).

There is a mention of Article 175, a law used by Hitler to kill homosexuals in the Second World War. Though numbers are disputed, current figures suggest up to 300,000 homosexuals were interned. Homosexuals imprisoned in concentration camps did not receive compensation from the German government (who strenuously fought such reparations) until 2001. For Hartley and his American compatriots, same sex love was illegal. This illegality took its toll on same sex lovers, the furtiveness, the double lives, the possible imprisonment. It was physically dangerous to be thought of as nancy boys, and it is no wonder that many lived as quiet, discreet gays.

Hughes notes that, 'Von Freyburg was the first great love of Hartley's life. Nothing much is known of him except that Hartley was ecstatically happy with him and idealized him without restraint. Nothing is known, either, of the sexual side of their relationship, and no photo of von Freyburg has survived. Hartley remembered him as a "Man in perfect bloom/of six foot splendour/lusty manhood time – all made of youthful fire/and simple desire"' (Hughes, 1997: p367). Hughes incredulously implies that theirs was a chaste male friendship in a sexual kingdom that was throwing itself at every passer-by. Photos do exist of Von Feyburg, and while not every same sex lover's object choice, he is recognisably handsome in his Prussian uniform (McDonnell, 1997: p37). Hartley's quote is proof enough of the sexual side of their relationship. Does Hughes really need photographs of them caught in flagrante? Hughes speaks of the inescapable nature of this homosexuality, but then says it cannot be proven. Hartley the great painter is left untainted by actual same sex erotics; he is unsexed, he is left in the ideal of platonic love. It

is contradictory, if not naive, to take it that they were not engaged in same sex erotics. Hughes quotes Hartley's letters, which don't give the impression it was an unrequited love. When von Freyburg dies in war, 'Hartley was inconsolable. He wrote of his "eternal grief" and "unendurable agony"' (Hughes, 1997: p368). Hughes argues that this grief freed up his painting and made him a better artist. Hughes wants the reader to accept this effeminate same sex lover into a canon of greats, but needs to neuter him for this to occur, as with Eakins or Demuth.

Introducing an old slur against homosexuals, Hughes states that, 'In 1927 he left for Berlin, where boys were marching again – this time in brown shirts. Though an aging queen like himself would not have lasted a week in the New Germany that was coming, he got a crush on Adolf Hitler' (Hughes, 1997: p389). Hughes implies Hartley loved his oppressors, and that all homosexuals are tainted by the Holocaust (some German military men were homosexuals, such as Ernst Roehm,). Hughes states that 'Of Hitler's genetic programs, Hartley remarked that "it is really an all right idea abstractly. There is no use in having defectives to support"' (Hughes, 1997: p390). Hughes posits that an *aging queen* would have been butchered, alongside an unsupported claim about a *crush* on Hitler. That Hartley, along with Neville Chamberlain and a host of others, was taken in by Hitler is no stain on same sex love, though it might colour a modern view of such naive individuals. Hughes perniciously links homosexuality with weakness and the immorality of Nazism.

In any serious text it is not possible to imagine an author quoting the Reverend Farrakhan spouting anti-Semitic ideas, nor would a reasonable writer call a black painter, in a similar situation, a *nigger*. Anti-Semitism, homophobia and racism abound, and at the time of the Holocaust, Joseph Kennedy (then American Ambassador to Great Britain), was an appeaser who met with Herbert von Dirksen (the German Ambassador). Von Dirksen conveyed Kennedy's anti-Semitic sentiments, reporting' 'It was not that we [Germany] wanted to get rid of the Jews that was so harmful to us, but rather the loud clamor with which we accompanied this purpose' (*New York Review of Books*, 18 October 2001: p32). The Roman

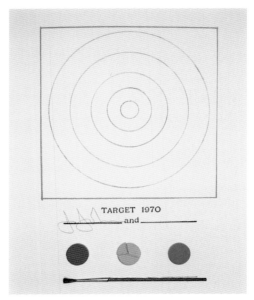

Jasper Johns, **Target multiple**, 1970, plastic, print, watercolour, 22.86 x 26.67 x 2.54 cm. © Jasper Johns/VAGA, New York/DACS, London, 2004. Private Collection, London

Catholic Church proved to be one of the worst collaborators in the deaths of the Jews (Baxter, *The Sunday Times*, 13 January 2002). Many in the British aristocracy (including recent evidence about the British Queen Mother [*Vanity Fair*, August 2001: p72]) are known to have been appeasers and supporters of Hitler. It is important to note that in the 1930s, while politicians and popes would have had access to damning information on Hitler, artists were not at the head of the queue for sensitive reports. Though Hartley may have had little excuse for his foolishness, his and other historic remarks do not justify Hughes' homophobia.

2.3.4 Targets

'Americans had always revered the Stars and Stripes as their prime symbol of national identity, but now they [1950s] began to worship it rather as Catholics do the consecrated Host' (Hughes, 1997: p511), placing the flag into a cultural context. Johns' flags are objects and depictions, abstract and realist, ever shifting, paralleling the stance that Johns took as a same sex lover in a time when 'American hatred of homosexuals ran particularly hot' (Hughes, 1997: p514). Hughes places Johns' *Target* paintings amidst the anti-communist hysteria of the 1950s when (as now) Americans saw themselves as targets from unseen, ever-present others. Reagan invoked this hysteria in the 1980s calling Russia an 'evil empire', and G.W. Bush fears an 'axis of evil'.

Johns had a more prosaic reason for feeling that he was a target as a same sex lover. Hughes states that, 'Jasper Johns was a reserved, closeted gay. *Target with Four Faces* is all about threat and concealment; its impassive, identical plaster casts of faces are contained in boxes with hinged doors, small "closets" in a row above the ominous target' (Hughes, 1997: p515). This is not an unfair statement. Johns is reserved and following Hughes' logic, must be a good gay. Johns is too important a living artist for Hughes to trash in any way. His permission would have been needed for any reproductions in Hughes' book. So Johns is a 'closeted gay', a man hunted by 'primitives' (Hughes quotes Dean Acheson). Hughes ignores a major element in the *Target* paintings (illustrated page 514), where only

mouths and noses are seen. There are no eyes or distinguishing characteristics of the people who sat for the casts. In *Target with Plaster Casts* (1955) (Phillips, 1999: p93), male body parts (nose, mouth, hand, foot, penis) are positioned above the painted target. These paintings are not just about the abstract idea of being a homosexual target in a heterosexual world, they depict a sexual act that many closeted gay men engaged in then, and now, known in gay parlance as *cottaging*. Anonymous men place their genitalia through holes cut into toilet walls at crotch level and have oral/anal sex, not with a whole person but with whatever is on the other side:is on the other side; a mouth, a hand, an anus. Sex in such situations is about body parts in other body parts. The anus or mouth is the target for the penis. This is a metaphor no same sex lover could have missed in 1955 or 2004.

George Chauncey writes that, 'Of all the spaces to which men had recourse for sexual encounters, none were more specific to gay men – or more highly contested, both within the gay world and without – than the city's public comfort stations and subway washrooms' (Chauncey in Sanders, 1996: p249). Hughes is either genuinely unaware or is not willing to talk about this detached, sexual aspect of the work. These works are about *fucking*, not making love. Toilet sex is lust confined to urinals. Anonymous sex existed because of fear of the legal implications of open same sex love. Johns' relationship with Rauschenberg was on one level illicit and, on a practical level, illegal. The target paintings can also refer to the act of targeting an individual whom one might cruise on a bus, in the subway, or at a theatre. Cruising exists through looks and nods and hesitations. The target of the look might lead the looker to a toilet and another target. The situation might lead to a cul-de-sac where the looker becomes the target of a well-planned queer bashing. Looker and target change places continually: a man may be *active* in one encounter and *passive* in another. Even these quaint expressions for same sex actions found their voice in gay parlance of the time. Johns' *Target* works are as much symbols for same sex lovers as his *Flags* are for heterosexual America.

Hughes is at his worst when coy. 'Because of their early friendship, and

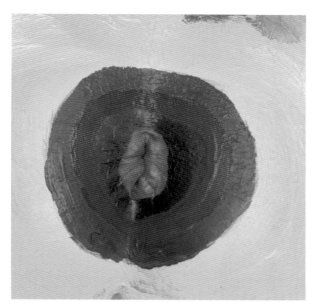

Keith Boadwee, **Butthole Target Yellow**, 1992, c-print, 101.6 x 101.6 cm. Courtesy of the artist

Ross Bleckner, **Bellybutton**, 2001, unique b/w photograph, 27.94 x 38.1 cm. Courtesy of the artist

because both men emerged as stars at the same time, Robert Rauschenberg (b.1925) is habitually bracketed with Johns' (Hughes, 1997: p515). Hughes states that Rauschenberg was in the Navy (a masculine trope undermined by the historical prevalence of homosexuality in the profession) and it is commendable that he leaves the wife and child out. Hughes reports that Rauschenberg went to Black Mountain College where he met 'Cage and his friend the dancer–choreographer Merce Cunningham' (with no mention that they were lovers) and that *Monogram*, Rauschenberg's famous combine of a goat in a tyre, 'is an image of anal sex, the satyr in the sphincter' (Hughes, 1997: pp516, 518). At no point is it made clear that Rauschenberg is a same sex lover or that he was Johns' lover, their sexual relationship, widely known at the time, might be why they have so often been linked together. It is rather telling that Hughes, who calls a queen a queen, was not so brave as to call Rauschenberg a same sex lover of any type, closeted, flaming or discreet. Hughes, like any schoolyard bully, runs at the prospect of a real fight. In the end all Hughes can say is that Rauschenberg 'had a bigness of soul and a richness of temperment that recalled Walt Whitman' (Hughes, 1997: p515).

2.3.5 Amnesia

In his description of Warhol, Hughes is even more coy. At no point in his text does he mention that Warhol was sexually active; Warhol's work exists only in a contest between high and low art. Hughes' omission undermines an essential element of Warhol's work, the sexual. It is a form of amnesia that seems to overcome many heterosexuals when speaking about the work and lives of same sex lovers. This information, which would be of use to any reader is seemingly forgotten or deemed unimportant; a heterosexual filter veils the senses and a trance-like sleep descends on reason.

Although Hughes' book may contain useful information and insights on America, yet the cumulative effect of his off-hand style is like water torture. Drip by drip, homophobic remarks are made, in a jokey, good old boy way, which undermines any attempt at a non-prejudicial reading.

At the same time, he knows that casual racist remarks would not have been tolerated. No 'general intelligent reader' would tolerate blatant, nay, flaming bigots. Institutional racism or homophobia is the most effective form of oppression, preventing non-dominant groups from gaining true equality. When the bigot can turn around and say, 'Where? Point out this prejudice,' it is the hardest for them to see. Surely Hughes does not see himself as a homophobe, yet it must be noted where he is homophobic. These comments are not mindless political correctness, but important illustrations of a heterosexual filter being employed to harmful effect on the work of same sex lovers.

Hughes attacks 'The two PCs – patriotic correctness on the right, political correctness on the left' (Hughes, 1997: p619). While same sex lovers have come out of the art-historical closet, too many scholars want to place them back in, as if in forgetting this information themselves, everyone else will. The distortion that occurs is not good for anyone. What is needed is a new honesty and openness and a belief that the viewer is able to accept and process information. Anything else is elitist and patronising.

3 Speaking over time

This chapter describes social and legal attitudes towards homosexuality in Europe and the United States of America during the twentieth century. It does not constitute an exhaustive history, but is intended to provide an overview of the context in which artists found themselves.

A horizontal history. The dominant historical view is learned in a vertical fashion, as successive generations add to the written historical narrative of their predecessors in a continuous, incremental fashion. By contrast, same sex lovers learn their shared history from one another in an oral tradition that is rediscovered by each generation, characterised as a 'horizontal history'. The purpose of this text is to provide a written narrative that might help transition homosexual history from the horizontal to the vertical, from the oral to the written. In doing so, previously hidden codes and meanings in social and artistic practice can be made decipherable to the general viewer.

The arch of openness. Homosexuality has gone through successive peaks of openness and troughs of oppression throughout the twentieth century, describing a figurative sine wave or 'arch of openness'. The principal peaks and troughs on this arch describe five distinct periods in twentieth-century homosexual history: post-Wildean (1900–18); the inter-war years (1918–39); homosexual and communist conflation (1939–60); Stonewall and a new legality (1960–85); and AIDS and its responses (1985 to the present).

Notions of the self. A significant literature exists, which discusses the legitimacy of ascribing contemporary notions of 'homosexuality' to individuals who lived at times when no equivalent notions existed. Such literature borrows from philosophers such as Vico who, conversely, identified the impossibility of occupying classical mind sets and therefore truly understanding the meaning of notions such as virtue in classical literature. Two arguments are made to challenge the accusation that notions of the self are misapplied in a history of homosexuality in the twentieth century. The first argument is that, although the notion of homosexuality has changed, those changes have been moderate and have always included same sex erotics; continuing the diagrammatic metaphor of an 'arch'

of openness, one might argue for a 'linear' notion of the homosexual self in which incremental change builds upon an unchanging and recognisable core. The second argument is that there is an equal risk of misapplying notions of the self if historians err on the side of caution by de-sexualising personal histories. Describing relationships as 'platonic', is as contemporary as calling them 'gay'.

3.1 A HORIZONTAL HISTORY

Same sex love was visible throughout the twentieth century, but rarely acknowledged or regarded positively by the dominant. Although the artistic contribution of same sex lovers has not been dismissed, their sexual histories have often been presented negatively or neutered. Children's education ignores open reference to gays and lesbians, and Mrs. Thatcher made it illegal to 'promote' homosexuality in British schools. Americans balk at the thought that any of their heroes (from James Dean to Rock Hudson) were same sex lovers. Their hidden history largely remains unacknowledged except by those in the know or of liberal bent. Consequently, same sex history is learned horizontally, each generation seeking out a shared history on its own, finding fellows, present and historical.

By contrast, dominant history is typically taught in a vertical, linear fashion. Time began and then events occurred. Actions were brought about (mainly by white heterosexual men), whereas women and others (until recently) were seen as objects of those actions. Men wrote things down. Feminist critique has debunked the idea of 'A History'. Alternative readings of history are now linear, as is the history of histories. Written histories can be and are taught in a vertical fashion. Most start at a ground zero, nominally, the creation of the visible universe. Counting systems employed do not matter (Creationists use this point as well), only the names and dates are argued. These histories move to the point at which humans alter nature and their environment. Wars, births, deaths and public events are stacked on top of one another (with whatever meaning or importance they hold for the recorder). Facts are seen to exist and are taught in this linear fashion. Women and people of colour have successfully forced

Howard Hodgkin, **Late Afternoon**, 2002–03, oil on wood, 63.5 x 73 cm. Courtesy of Gagosian Gallery, New York

most Western educational systems to take into account additional historical views, bolting them on to a pre-existing vertical framework.

Nayland Blake has said that, 'Queer people are the only minority whose culture is not transmitted within the family ... The extremely provisional nature of queer culture is the thing that makes its transmission so fragile' (Blake, 1995: p12). When the dominant is fearful of a history it often disappears. Same sex history has mainly been passed on by word of mouth. It is thus horizontal because it has to be continually learned anew. There are forces slowly moving this history from the horizontal to the vertical (Gay and Lesbian studies), but others move it in the opposite direction (the religious right). The dominant remains broadly unaware of university studies, which, in any event, are an academic discipline, remote even from many same sex lovers who may not attend and who are not a homogeneous group. Furthermore, the dominant discourages same sex lovers from writing their vertical histories with the threat of the loss of power. The dominant is a world of power, the power to write a history. Therefore, those without power are left without a voice and without a history. In the process of reordering information, filters can be removed (though others may be put in place as there is never the possibility of true objectivity). What others demand of the dominant is that their ordering also be accommodated into mainstream teaching and understanding of history.

3.2 THE ARCH OF OPENNESS

This historical overview describes social and legal attitudes towards homosexuality in terms of an 'arch of openness'. The periods of maximum openness were in the 1920s, 1960s and 1990s and the lows in the early twentieth century, the 1950s and 1980s.

These periods are rough approximations. All histories elide into one another, exceptions exist for all distinctions. Movement through periods was gradual. Cultural change was (and remains) an incremental process. Legal change typically involves repealing or amending specific existing statutes while leaving others unchanged. Thirty-three years after the legalisation of homosexuality in the UK, homosexuals continue to be

Simeon Solomon, **Self-Portrait**, 1859, pencil on paper, 16.5 x 14.6 cm. © Tate, London, 2004

treated differently from heterosexuals in terms of sexual offences, family law and fiscal partnerships. The twentieth century has been characterised by the gradual increase of tolerance towards same sex lovers. Even events that appeared singular (Stonewall) came in the context of slow changes in the mainstream. Pivotal moments are just that: points at which openness to homosexuality changes direction within a gradual movement, rather than binary switches that suddenly turn toleration on and oppression off.

Levels of acceptance to openness in the dominant affected the private and professional lives of all same sex lovers. Whether artists incorporated same sex imagery in their work or not, there were periods when it would have been dangerous to do so. It is important to keep in mind that most individuals remained fearful as they manoeuvred around the slow-moving iceberg of homophobia. It is unlikely that a Victorian could ever have wholly freed himself from social sanctions and embraced an open 1960s lifestyle. Equally it is difficult for modern readers to comprehend the mountain a Victorian would have had to climb to obtain openness. 'For most of the nineteenth century, sexuality was not perceived as permeating the intimacies of men. This is important; not until the last decade of the nineteenth century, and the last years of Whitman's life, did his portrayals of male–male eros begin to be perceived as such and publicly condemned' (Katz, 2001: p105), as were Wilde's and those of other prominent same sex lovers.

3.3 NOTIONS OF THE SELF

The twentieth century provides an opportunity to document artists' sexuality in a way that is no longer possible in respect of those who came before. Michelangelo Buonarroti cannot be proved a same sex lover, though court records attest to his being charged with male sodomy. His love sonnets to Tommaso de'Cavalieri (a young man) imply active same sex love and his imagery is *echt* homoerotic.

... If to be blest I must accept defeat
It is no wonder if, alone and nude,

I am by one in arms chained and subdued (Buonarroti, 1961: p59).

Officers of the Night were established in Florence (1432) to charge men with sodomy (Saslow, 1999: p83), punishable by death in Michelangelo's day, so written accounts of same sex adventures are unlikely to surface in his hand. In today's terms, Caravaggio was gay, but there is little proof that academics might feel is incontrovertible (his court records aside). The term gay, the concept itself, was not the coinage of the day, and it isn't fruitful to apply it to those who would have had no conception of it. But Francis Bacon called himself gay, and can be said to have been gay, and there is no reason to shy away from such clarity. Though homosexual, gay and queer have referred to different things throughout the twentieth century, a notion of identity around same sex erotics remained. Awareness of an otherness occurred at the end of the nineteenth century, and as the term homosexual became common, it was used in the legal and medical paradigms to punish or suppress a positive same sex identity (Katz, 2001: p73).

In ancient Greece, marriage was for procreation and transfer of property, arranged marriages being similar to today's. It is not the intention of this text to argue that Greek men slept with women for procreation only. But most ancient texts show that marriage was primarily a social contract and that men took lovers (women were discouraged from openly doing so) for what would now be called romantic love. Whether lovers were men or women depended on personal taste; no overriding social disapproval was incurred if men chose men. Wives were a public display of ownership. Romantic love (as understood now) was for same sex lovers. Heterosexual 'spouses who were actually "in love" with each other were thought extraordinary and odd before the later empire' (Boswell, 1996: p39).

John Boswell notes that modern translations of the Greek for the distinctions between 'love' and 'in love' are spurious. 'Plato himself referred to the archetypal attic lovers Harmodius and Aristogiton (both males), claimed to have founded the Athenian democracy, by using within a single sentence both ερως and φιλια for the same relationship' (Boswell,

Henry Scott Tuke, **Noonday Heat (Bathing Group)**, 1901, watercolour, 39.5 x 60 cm. Courtesy of the Albert Dawson Collection, Falmouth

1996: p7). Boswell makes clear that they were sexual lovers, but that should not lead to referring to them as homosexual, as it was not part of their concept of self. Boswell details problems in textual translation, noting the context of the words, as well as their social usage. This is pertinent, as he argues there existed a Christian ceremony for the marriage of two men called the making of *Brothers*. 'But if, as seems inescapably clear (see Ch.7), the meanings of the nouns to contemporaries were "lover", and "form an erotic union", respectively, then "brother" and "make brothers" are seriously misleading and inaccurate translations for English readers, who will relate such concepts more to feelings of goodwill and fraternal concern than to intimacy and romantic attachment' (Boswell, 1996: pp19–20).

Boswell documents the deliberate obscuring of the meaning of male sexual bonding. Victorian translations took a prudish view of what was clear in Greek and Roman texts: men had sex and made love to each other. Victorians found these acts impossible to state (Boswell, 1996: p25), and hid them in phrases like 'spiritual brotherhood'. In pre-Christian texts men could 'marry' each other. Modern notions that older men took boys only for sex are profoundly wrong. Adult men were often in loving relationships. This was seen as the norm not only in (fourth-century BC) Greece, but in Roman culture. This commitment between men is illustrated in Lucian's text (*Toxaris*, 61) in which 'a man who saved his best friend from a fire, leaving his own wife and infant to fend for themselves. When rebuked for this he replied that he could easily get another wife and more children – as if they were fungibles and of little particular emotional significance – but he could not easily find another friend' (Boswell, 1996: p77).

Men married 'under the same law by which a woman takes a husband' (Boswell, 1996: p80). Only the deliberate mistranslation of terms caused the ceremony to be considered a form of non-sexual bonding. The history of male artists who were same sex lovers has also been deliberately obscured. Imposing modern notions of homosexuality on the past may be anachronistic, but shying away from sexualising people's relationships may be equally in appropriate. In the context of this project, the dilemma is mitigated by the fact that, although aspects of the notion of the homosexual self have changed, a core pertains throughout the period. To some extent the closet door has opened in the arts. Most artists no longer fear the law in their bedrooms, and are open about their sexuality even if it does not appear to be an element of their work. Mapplethorpe presented same sex imagery head on, and few in the art world would deny that he was gay, yet his parents continued to see him as 'straight'. What are the reasons for a heterosexual denial of the homosexual? In Mapplethorpe's case religious beliefs override evidence. Histories are often rewritten so that omissions become accepted untruths.

The presentation of 'facts' is always a worrying thing, and readers should be aware that facts were chosen for this text that illustrate its points. Proust was perceived in a heterosexual light, as it suited the reputation of French letters. The economic agenda was a strong one and drove him and others to write in a coded fashion. For Proust, the law was not a problem, for unlike Mapplethorpe, for sodomy and the S&M sex that he engaged in were illegal in America. Both were Roman Catholics and in some ways constrained by religious guilt. The lack of same sex history in the mainstream reinforces oppression from without and within. That information is hidden is nothing new. 'A 1952 retrospective of the work of Charles Demuth at the Museum of Modern Art in New York City did not include any of the artist's extraordinarily erotic watercolours depicting sailors in flagrante ... Lincoln Kirstein's 1992 catalogue essay for a retrospective exhibition of Paul Cadmus at the Midtown-Payson Gallery makes only veiled reference to homoeroticism' (Blake, 1995: p2).

3.4 PERIODS UNDER REVIEW

3.4.1 Post-Wildean artists
From 1885 to 1914, it was not possible to be seen openly as a same sex lover. It spelt social exclusion and almost certain imprisonment, and marriages of convenience were common. Images of male sexuality were couched in classical themes (Eakins) or the naked martyrdom of Christian saints (Philpot). From this nadir of openness (centred on Wilde's public

Pavel Feodorovitch Tchelitchev, **Study of Massine**, c. 1928, watercolour, 27.94 x 17.78 cm. Courtesty of the Albert Dawson Collection, Falmouth

immolation), the arch of openness could only have ascended. The conviction in 1895 of Wilde (under the recently passed, Labouchère Amendment, 1885) threw the genteel world of British and American same sex lovers into disarray. Many fled to France – '600 gentlemen had crossed from Dover to Calais on a night when normally only sixty would have' (Spencer, 1995: p286) – or Italy, where attitudes were more relaxed as long as same sex love was not spoken of, but only practised. Men were happy to be paid men and bed servants. It was seen as a means for the poor to secure a future, often for generations of the same family. German industrialist Alfred Krupp took up residence in Capri, committing suicide in 1902 as a result of his outing (White, 1999: p123).

It was social death to be known as an invert, a uranian, a hermaphrodite, an androgyne, a bisexual (used then to describe same sex lovers only), of the intermediate sex, or a practitioner of similar-sexualism. To 'be *labelled* a homosexual in print was social anathema, even in Paris, until the very recent past' (White, 1999: p76). While André Gide was not particularly open about his homosexuality, he was censorious of Proust's negative writing about same sex lovers when he was one. Gide rejected Proust's *Swann's Way* (the first volume of *À la recherche du temps perdu*) when it was brought before him as a member of the Gammillard publications committee (White, 1999: p3), observing that, while a master work of fiction, it was rather self-hating. His 'general closetedness – a secretiveness that was all the more absurd since everyone near him knew he was gay' (White, 1999: p3) was considered eccentric. Open acknowledgement of same sex love was not a possibility for those in the public gaze. Unspoken sexual relationships were common, as can be seen by society's treatment of Proust and his lover, composer Reynaldo Hahn. 'The two men travelled together and were put up in chateaus together by tolerant hostesses' (White, 1999: p62). Hahn (five years younger) was referred to as Proust's little brother.

Lytton Strachey chided E. M. Forster that his book *Maurice* was rather diseased, as the protagonists only masturbated. In his lifetime, the novel was widely read by an extended group of male same sex lovers. But

Marsden Hartley, **One Portrait of One Woman**, 1916, oil on composition board, 76.2 x 63.5 cm. Courtesy of the Federick R Weizman Art Museum, Minneapolis

Forster never allowed the book's publication out of respect for his married policeman lover, Bob Buckingham (who named his son Morgan after Forster [Spencer, 1995: p328]). A European north/south divide towards same sex love cemented after the Wilde and Von Eulenburg trials (Rouse, 1977: p209). Prince Philip von Eulenburg-Hertefeld had been the favourite of Kaiser Wilhelm II, and suffered a similar fate to Wilde but for political reasons.

In the nineteenth century, Eakins created American images harking back to a naked simplicity presumed to have existed in Greece. *Young Spartans* (Edgar Degas, 1860–62 [Boggs, 1988: p99]) represents this lost classical innocence from a heterosexual viewpoint. The corporeal ideal can be seen in the young men's bodies in Eakins' *Swimming*, or his boxers featuring lightly clad modern gladiators. Eakins ran foul of the Pennsylvania Academy authorities only after allowing young women (expected to become Victorian wives) to draw nude male life models (Saslow, 1999: p198).

In himself the remains of the classical world (Greece, Turkey, Northern Africa), a tacit acceptance of same sex activity remained as long as it involved foreigners or sex with youths. Access to women was (and still is) highly regulated. In Islamic states men generally associate only with each other, and practise same sex erotics only to return to heterosexuality as soon as possible. The difference between heterosexually identified men (who only have same sex erotics *in extremis*) and Eakins, Grant, etc. is that these artists used heterosexuality *in extremis*. Wives were social grease, conferred respectability, and were not primarily for pleasure. 'A man's marrying and reproducing was thought of then as a duty, not as demonstrating any exclusive, other-sex erotic interest' (Katz, 2001: p142).

In Italy, two cousins photographed young men in faux classical repose. Wilhelm von Gloeden and Wilhelm von Plüschow used the then ultra-modern method of image making to capture a continuing homosexual mythology. Their efforts were financially rewarding as rich same sex lovers bought early erotic souvenirs of local lads (and a few girls) near Taormina. For Von Gloeden (1931), 'the major part of his negative and printed materials was confiscated and destroyed' (Weiermair, 1988: p16) by Italian

Fascists. In Naples, Von Plüschow took similar images, and both used Vincenzo Galdi to print and sell their work. They were as open to the dominant as was possible.

Today, it can be hard to look at their photographs without cynicism. Their attempts to create photographic equivalents of French Academic painting seem corny. Manet may have destroyed the myth of an Arcadian summer only to see it photographically replicated in sepia. Later, Bruce of LA created similarly silly (but no less erotic) depictions of the male nude. With the passage of time, these works can be seen as stylistic explorations of the male nude. Kitsch, but no less powerful for that? In America, Frederick Holland Day's photographed re-creations of the Crucifixion (using comely youths) caused a great outcry. While the arch of openness may have been at a nadir, artists using classical disguise made it possible for same sex lovers to eke out a brotherhood of signs. St Sebastian, Apollo and swimming holes all pointed to a hidden homosexual experience and history.

3.4.2 Artists of the war and inter-war years 1914–45

Same sex visibility increased as the First World War brought large mobilisations of the male populace into cities. With that came social mixing and a shift in the arch of openness. Men of different sexual inclinations encountered many more willing partners than in rural communities. Much homophobia was based on a feminine paradigm and while military officials often claimed that open homosexuals would be disruptive and cowardly, this proved patently false. T. E. Lawrence and many same sex lovers (both enlisted men and conscripts) distinguished themselves. Western armies were happy to have same sex lovers as manpower in conflict, only to court-martial them in peacetime. Siegfried Sassoon noted the comradeship and love between soldiers, to the chagrin of the British military.

As the First World War ended (with its immense social and physical devastation), the public looked towards a new era. The 1920s saw the rise of openness in the Weimar Republic, Paris and London. Berlin became a magnet for dissident sexuality. Bars and cabarets flourished and Isherwood, Hartley and others documented it in their work. In London

Duncan Grant. **Maynard Keynes.** 1908. oil on canvas. 81.3 x 59.7 cm. Collection of the Provost and Scholars of Kings College, Cambridge. Courtesy of Fitzwilliam Museum, Cambridge

Beaton and Bacon wore full daytime make-up; costume balls and drag parties abounded. Bars and coffee shops where same sex lovers could meet sprouted, and, while open to police prosecution, were generally left alone. New York and Los Angeles opened their arms to an army of lovers. 'Cruising parks and streets provided many young men and newcomers to the city with a point of entry into the rest of the gay world, which was sometimes hidden from men looking for it by the same codes and subterfuges that protected it from hostile straight intrusions' (Chauncey, in Sanders, 1996: p226).

The Bloomsbury Group (funded by Maynard Keynes, Grant's ex-lover) was formed of Bohemians who married and swapped partners in every combination. The collectors Shannon and Ricketts gave support to Glyn Philpot. Beaton photographed W. H. Auden, Gertrude Stein, Noël Coward, Jean Cocteau and later Truman Capote, Rudolf Nureyev and David Hockney. In Paris, Gertrude Stein's salon gave comfort to Hartley, Pavel Tchelitchev, George Platt Lynes and heterosexual artists (Picasso). Her approachability was a model for others. Lynes, Glenway Wescott, Monroe Wheeler and Kirstein opened New York to European same sex lovers who portrayed their affections on canvas and exhibited the results. Homosexuality had an air of sophistication about it. In Hollywood, same sex lovers added to the allure. Alcohol and cocaine were commonly in use and fuelled the 24-hour cities. So common was raucous behaviour that Cole Porter had a popular hit featuring the line 'I get no kick from cocaine'. Working class men returned from the First World War with broader horizons and expectations, and shared the openness felt in artistic circles. Same sex imagery started to appear in popular cinema, and, although 'homosexuals' were portrayed in negative stereotypes, visibility offered some solace.

With the onset of the Second World War, openness took a nose dive. Large numbers of young men were marching again and recent gains made by same sex lovers were overturned. A search for order, moral certainties and uniformity saw the end to make-up and mischief. The Nazis used pre-existing Penal Code 175 to incarcerate and murder homosexuals. Under Hitler's persecution, homosexuals were made to wear a pink triangle on their concentration camp uniforms to distinguish them from Jews. In 1934, Stalin brought into Soviet law Paragraph 121, to persecute homosexuals, declaring that homosexuality was a product of bourgeois culture (Schwules Museum, 1997: p297). On average, 800 men a year were tattooed with the number 121 and they were incarcerated until the 1970s. Same sex lovers served their countries (many with distinction) on both sides of the conflict, but the majority just got on with the job of survival.

Openness within the corps was often greater than would have been expected. John Beardmore, a gay man who joined the UK Navy (1939), recalled that a friend, Freddy '... was immensely popular on the ship – everyone loved him ... and that ... when the captain issued orders to open fire, Freddy simply repeated, "Open fire, dear" which would crack up the troops' (Jivani, 1997: p64). Many married officers chose to have sexual relationships with Beardmore (Jivani, 1997: p66). Sexual contact was rife, illicit, but tolerated during war.

3.4.3 Homosexual and communist conflation: 1945–60

Demuth's erotic watercolours of sailors hardly caused the wrath that Cadmus' The Fleet's In! did; the American Navy demanded it be withdrawn from exhibition. With the end of the Second World War and the start of the Cold War, anti-homosexual feeling reached a new height. Having knowingly drafted homosexuals in war, the US and UK military now wanted to pretend they did not exist. Anti-communist hysteria swept the West, and same sex lovers were seen as legitimate targets; most went under cover for physical and professional protection. Even work by relatively open men (Bacon) wasn't discussed in terms of sexuality. Bacon's Two Figures (1953), which features nude men on a bed, was often described as depicting 'wrestlers'. Johns and Rauschenberg became one of the most romanticised same sex couples, whose artistic production was deeply affected by their relationship. Their open secret, being deniable among art professionals, paralleled the Hollywood situation where same sex lovers posed as heterosexual icons (Hudson, Dean).

This duality forced many artists into heterosexual disguise. 'The metropolitan campery of people like Noël Coward, which had reigned supreme before the war, was out of fashion, and instead plays, books and films portrayed the robust wholesomeness of suburban life' (Jivani, 1997: p91). Jose Pickering said, 'I got married because in those days it was the done thing – you left school, you went to work, you got married and you had children' (Jivani, 1997: p93).

Only camp media depictions of homosexuals existed, and an effeminate paradigm was used to hunt communists and homosexuals, lumped together as the new red/pink threat. Two events helped form this underlying feeling. Alfred Kinsey's *Sexual Behaviour in the Human Male* (1948) informed the heterosexual majority that up to 10 per cent of adult males had regular same sex erotics, 37 per cent had had at least one incidence of same sex activity in adulthood, and 4 per cent were exclusively homosexual (Gathorne-Hardy, 1998: p259). The dominant found they were swimming in a very mixed sexual sea. Kinsey's report was a bombshell for many heterosexuals who believed there existed only a few isolated homosexuals. Some today profess that they do not know, nor have ever met any homosexuals. This is most unlikely. There must be same sex lovers in their circle who are not open to them. Campaigns for openness in the 1970s were based on this confusion, and the belief that if heterosexuals became aware of homosexuals in their community/family, they might become more accepting.

Homosexuality was linked in the dominant's imagination with betrayal and communism by the exposure of spies Guy Burgess and Donald Maclean. ' ... what really rattled the Establishment was that any of its men had slept with other men. Burgess had never been particularly discreet, but nobody had taken any action because the very idea that a Foreign Office man could be homosexual had seemed absurd' (Jivani, 1997: p97). Anthony Blunt was the third man whose 'consciousness of the illegality of homosexuality, which meant that his very identity broke the law, may have helped to make acceptance of Burgess's approach seem less of a big step' (Carter, 2001: p177). While some same sex lovers may have revelled in outlaw status (Auden, Genet), most were terrified of being revealed.

The 1950s American witch hunt was undertaken largely by homosexuals. On live television Gore Vidal said, 'The only thing I really found attractive about [Senator Joseph] McCarthy was of course the fact that he was homosexual – and was extremely tolerant of having them around him' (Kaiser, 1998: p77). McCarthy's legal council, Roy Cohen (Kaiser, 1998: p76), and J. Edgar Hoover (head of the FBI, who lived with his partner Clyde Tolson ([Kaiser, 1998: p224)] for 50 years) were also same sex lovers. They turned back the tide of tolerance (more than any religious fanatics), mercilessly hunting down anyone with links to socialist parties. They blackmailed and blackballed writers, actors and directors. No one was safe from their call to the Senate, and no recourse to constitutional rights was honoured. This was the climate of fear in which artists like Johns and Rauschenberg found themselves. Legal, moral and medical strictures against same sex lovers increased, and individuals had to find survival strategies. Homosexuality was viewed as a disease and many took their own lives (John Minton, for example). Mathematician Alan Turning (whose work broke the Second World War Enigma codes and who is credited with 'inventing' the computer) committed suicide after being forced to undergo homosexual aversion therapy (Jivani, 1997: p123).

Life in the major empires (American, British and Soviet) was harsh for same sex lovers, and similar legal strictures held sway over most of the globe. In New York it was common to see 'uniformed officers harass women dressed like men because women were legally required to wear at least one article of women's clothing whenever they appeared in public. Knowingly serving a drink to a gay person automatically made a bar disorderly under state law, and it was illegal for two men to be on a dance floor together without a woman present' (Kaiser, 1998: pp83–84). Pretty policemen were used in the West and East to entrap same sex lovers.

Resistance emerged in Los Angeles with the birth of the Mattachine Society (1951). Harry Hay, a member of the Communist Party, based his organisation on the idea that gays must find pride within themselves. Yet, at all times they were apologists for homosexuality, as Burroughs

Paul Cadmus, **The Fleet's In!**, 1934, oil on canvas, 76.2 x 152.4 cm. Courtesy of The Navy Museum, Washington, DC

John Minton. **Painter and Model**. 1953. oil on canvas. 205.7 x 144.8 x 10 cm. Courtesy of the Russell-Cotes Art Gallery and Museum, Bournemouth

complained. The Mattachine Society produced documents for its members on what to do if arrested, held discussion groups, and claimed in its mission statement that it wished 'To Unify ... To educate' and believed homosexuals could 'lead well-adjusted, wholesome, and socially productive lives once ignorance and prejudice against them' was 'successfully combated ... ' (Hay, 1996: p131).

They worked with Dr Evelyn Hooker to produce T*he Adjustment of the Male Overt Homosexual* (1956) (Kaiser, 1998: p124). The study provided the basis for the eventual overturning of the American Psychiatric Association's view that homosexuals were mentally ill (1973). *The Homosexual in America* (1951) by Edward Sagarin (published under the pseudonym Donald Webster Cory [Kaiser, 1998: p125]) called for homosexuals to free themselves from the dominant. These works are considered cornerstones of homosexual liberation. After an exhaustive study, the Wolfenden Report (UK, 1957) concluded that same sex erotics between consenting adults should no longer be illegal, but law was not enacted until 1967. As the Cold War's fear of homosexuals melted, a new view of same sex lovers emerged also in the West. Many were unable to make the mental transition (so ingrained were social strictures, religious guilt and medical prejudice) to make use of new-found freedoms.

3.4.4 Stonewall and a new legality: 1960–85

The conservative world that same sex lovers knew fell away with the 1960s sexual revolution and women's and black empowerment. Many were involved in those struggles as a prelude to Gay Liberation, including James Baldwin, Vidal and Susan Sontag. Having learnt civil disobedience, organisational and media skills, younger individuals involved themselves in pre-existing organisations (Mattachine Society), to turn their apologist ideas upside-down. The younger generation had taken over the role of community leaders by 1965. Jack Nichols and Franklin Kameny (a Second World War veteran) 'organised the first in a series of annual pickets outside Independence Hall in Philadelphia' (Kaiser, 1998: p1) on 4 July 1965, bringing gay visibility to the dominant.

Kennedy's assassination, the Vietnam war and a burgeoning drug culture brought into question old certainties. Parisian students revolted (1968) and revolutionary groups formed (Bader-Meinhof, Red Brigades). On a hot summer night in 1969, drag queens revolted against police harassment in Greenwich Village. The Stonewall Inn, which owed its existence to 'two groups that younger gay people despised: the Mob, which owned it, and the local police, who took weekly payoffs from it' (Kaiser, 1998: p142), as was common at the time (Chauncey, 1996: p226), became part of horizontal history. Drag queen Storme de Larverie was hit by a policeman, and hit him back, causing a riot. Within minutes police were hiding in the Stonewall as growing crowds threw coins and bottles. Police drew their guns and were prevented from shooting only by special (more professional) police forces. The dominant had never seen same sex lovers stand up for themselves and the nation was stunned. William Wynkoop recalled, 'I think it's wonderful that the ones who started it were drag queens. Young, young, tender drag queens. Flaming faggot types' (Kaiser, 1998: p200). The liberation of Stonewall proved pivotal. Wilde's trial saw same sex lovers jump into the closet; after Stonewall they exploded on to the streets demanding equal rights.

For the first time since the 1920s openness swept the Western world, bringing with it a new art. Warhol became de facto king of the art world. No opening, party or club was hip if he was not there. Warhol understood the power of the media (having started his career in advertising [Crone, 1987: p278]) and created the climate for media artists who dominated the end of the century. Warhol and his Factory formed a sexual and artistic cauldron that shook the stuffy art establishment. Warhol understood that Pop was in the surface, and relegated his paintings to assistants. He organised rock performances and created a radically queer environment. Men and women of all sexes flocked to the Factory to work, have sex and become stars. Joe Dalessandro, who had modelled for Bruce of LA, became a Warhol find.

Art world attacks on Warhol, Rauschenberg and Johns were often based on their sexuality. Warhol's sophisticated project depended on his

cool stance, as Gilbert & George's depends on non-confirmation of their sexuality. Gilbert & George may be a gay construct, but the men behind it need not be (establishing this 'fact' might demolish the myth). Warhol projected a myth of indifference, but was an open practising same sex lover. Others like Ellsworth Kelly emptied the self out of their work, hiding in the open. Including Kelly in a list of artists across genres who were notable gay nonconformists, Kaiser states that, 'One reason that lesbians and gay men often make great artists may be that being gay and creating art both require similar strengths: the ability to create an original world of one's own' (Kaiser, 1998: p89).

In the 1970s Hockney defined Los Angeles in paint, allowing the city to see itself, and his influence cannot be understated, as Hollywood exported his vision to the rest of the world. This was a hedonistic period for hetero- and homosexuals. Germany's Paragraph 175 was liberalised (1969), creating an age of consent of twenty-one (Schwules Museum, 1997: p297). Rainer Werner Fassbinder and Michael Buthe explored their sexuality within their work and many artists worked in a way directly opposed to the previous generation. The Gay Liberation Front was formed in London (1970) (Spencer, 1995: p368), its aims being sexual equality and its practice being zaps: mass same sex kissing and publicity stunts. Derek Jarman in London, Peter Hujar in New York were among many artists at the forefront of Gay Liberation. Hujar staged the photo used for the '1970 poster created in tandem with the first anniversary of Stonewall' (Meyer, 2002: p162); it included his lover Jim Fouratt. Overtly homoerotic imagery entered the mainstream. Jarman showed male same sex love to the general public in an honest (if camp) style in *Sebastiane* (1976). Mapplethorpe shocked where Hockney charmed. All placed their same sex desires at the heart of their art and in public view. Films like *Sunday Bloody Sunday*, *Cabaret* and *My Beautiful Laundrette* featured same sex desire as part of the sexual whole and, for once, not as mental disorder.

Not all was openness. Architect Philip Johnson asked that his sexuality not be revealed in a *New Yorker* profile as he was competing for the AT&T project (which he won). Johnson's lover David Whitney was described as 'his friend' (Kaiser, 1998: p213). This useful phrase does not easily die out, and it was only in the late 1990s that Johnson openly discussed his homosexuality.

Hedonism in the 1970s took the form of dancing, drugs and casual sex. Gay bathhouses opened in most American and continental cities (but not in the UK until the 1990s) where men could have sex twenty-four hours a day. Leather bars (The Mine Shaft, Der Spike) opened from San Francisco to Berlin, featuring dark rooms with slings for hard core-sex (fisting, S&M). Cocaine and poppers kept many people partying, travelling from dance club to bathhouse, as documented in the writings of John Rechy, Edmund White and Alan Hollinghurst. Philosopher and leather aficionado Michel Foucault stated that S&M is '... the real creation of new possibilities of pleasure' (Miller, 1994: p263). He and other same sex lovers took their bodies to new extremes. Foucault stated, 'The private life of an individual, his sexual preference, and his work are interrelated, not because his work translates his sexual life, but because the work includes the whole life as well as the text' (Miller, 1994: p19). Foucault's influential works *The Order of Things* (1966), *Discipline and Punish* (1975) and *The History of Sexuality* (1976) placed him at the intellectual forefront. Openness and freedom embodied in 1960/70s radicalism sought to overturn 1950s values of closure, secretiveness and punishment.

By the mid-1970s the arch of openness was at a new peak. At no time in heterosexual history had same sex lovers forced such tolerance from the dominant. Acceptance of difference was mirrored in the everspinning disco balls. Awareness of a gay male subculture (and its ease of sexual release) bred resentment, which flowed into anti-feminist and anti-equal opportunities movements. What little power non-dominant groups had taken was sorely begrudged. The far right increased its attacks on the rights of people of colour, same sex lovers and women, but little did they know that soon they'd be handed a great political tool.

3.4.5 AIDS and its responses

Foucault, who died of an AIDS-related illness (1984), was open about his sexuality only towards the end of his life, fearing being seen as a 'gay

Gilbert & George, **Nine**, 2001, nine panel piece, 213 x 253 cm. © the artists. Courtesy of Jay Jopling/ White Cube, London

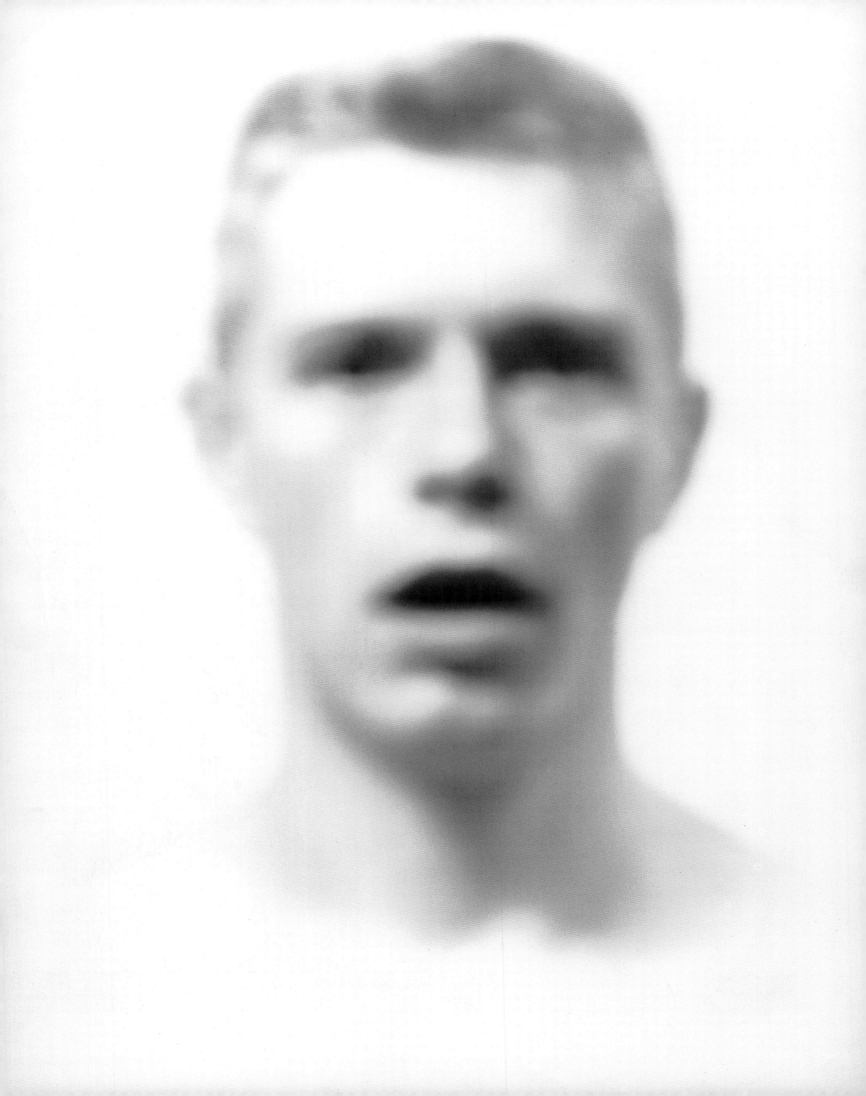

General Idea, **Aids Wallpaper (Nauman)**, 1991, ink on wallpaper, installation size variable. Courtesy of AA Bronson

Bill Jacobson, **Interim Portrait 373,** 1992, photograph, edition of 9, 60 x 50 cm, Courtesy of Rhodes+Mann Gallery, London

intellectual' (Miller, 1994: p25). In 1980 the first cases of gay cancer appeared in medical literature, and the terms ARC and then AIDS (caused by the HIV virus) came into use (1982). A hostile global environment developed, featuring vengeful religious commentators who called AIDS a God-sent plague on homosexuals (before the disease was identified as affecting far more heterosexuals). Reagan uttered the word AIDS only in 1987, years after tens of thousands had died (*The Advocate*, 19 March 2002: website). With no hope of a treatment or cure in sight, few public figures admitted they had AIDS. Many felt the philosophy of openness had betrayed them. Daniel Defert, Foucault's lover of twenty-five years, defended his reputation, which remains tainted. It should be remembered that in the West, calls were made for AIDS concentration camps, quarantines (Meyer, 2002: p219) tattooing of sufferers, and in Cuba sufferers were indeed sent to such camps.

Discrimination and medical ignorance were global. Only when Rock Hudson spoke about his illness (1984) did the Western dominant understand the threat, but linked it with homosexuality. AIDS was already out of control in heterosexual communities in Africa. AIDS threatened sexual and social freedoms in an unprecedented way. Artists (from all genres) died in their thousands including Rotimi Fani-Kayodé, Felix Gonzalez-Torres, Hujar, Jarman, Mapplethorpe and Wojnarowicz. Many grew angry with the medical and political establishments, religious bigotry and pharmaceutical companies, and took direct action to demand health care, cheaper drugs and dignity.

Aids Coalition to Unleash Power (ACT UP) emerged (1987) as a grass roots, direct-action collective with no leader (though Larry Kramer is said to be its founder), and other groups emerged globally. They performed die-ins, under the sophisticated media management of Michelangelo Signorile (New York) and Peter Tatchell (London). Wojnarowicz, Gran Fury, General Idea and a host of others provided the visual imagery. Posters, T-shirts and art works flooded a market where greed was good. Artists made work outside the gallery context, trying to save lives, and for a brief period brought real change. Many took up the term 'queer' (as opposed

to 'gay') for self-identification. 'Silence=Death' (underneath the Nazi's Pink Triangle) became a global emblem of defiance. This image/slogan devised by the Silence=Death Project (Crimp, 1990: p15) became the ACT UP logo and was translated into a plethora of languages.

Direct action forced recalcitrant governments to fund HIV/AIDS research. Artists used sophisticated conceptual art practices to comment on their lives and loves and were at the heart of contemporary visual culture. 'The AIDS backlash had led to a hardening of public attitudes towards gay men and lesbians, as evidenced by the British Social Attitudes Survey. In 1983, sixty-two per cent of respondents had said that they did not approve of homosexual relationships. The proportion of people who espoused this attitude increased steadily through the Eighties, rising to sixty-nine per cent in 1985 and to seventy-four per cent in 1987' (Jivani, 1997: p195). The backlash took many forms, personal (physical/verbal attacks), public (discriminatory laws enacted) and social (the hostile reaction to deaths of community leaders). Same sex lovers were demonised. Tabloid media elements described a 'gay' disease, disregarding information concerning heterosexual HIV infection. Innocent victims were portrayed as those who contacted HIV via blood transfusions. Gays were not innocent, nor victims; their illness a manifestation of their 'lifestyle'. Conservative leaders (Thatcher, Reagan) and their governments allowed the disease to spread throughout the West, and hundreds of thousands were infected before serious governmental interventions were made.

The situation for same sex lovers reached a nadir with the Bowers *v.* Hardwick case (1986). Essentially, the US Supreme Court stated that homosexuals had no right to privacy, creating a second class of citizens based on gender. The case was similar to its Dred Scott ruling (1857) that found negroes were property and could be slaves (Kaiser, 1988: p320). 'The NAMES Project Quilt, conceived by San Franciscan Cleve Jones, has ballooned into the largest gay art project in history' (Saslow, 1999: p279). Individuals and families made 'patches' that commemorated the lives of loved ones who had died from an AIDS-related illness. Sewn together in large sections stored separately, they formed a remembrance quilt. 'First

Piotr Nathan, **The Outline of the Place, that was Bombed During the Last Days of the War, Follows the Enlarged Contour of a Urine Stain that Was Left Behind on the Mattress of a Person Dying of AIDS**, 1992, ceramic, burnt dirt, oil colours, c. 2,500 elements, II x 770 x 590 cm. Installation at Schloss Wilhelmsthal, Kassel. Courtesy of the Sabine Schmidt Gallery, Köln

displayed in its entirety on the national Mall in Washington, DC, in 1987 ... it has now reached forty thousand panels covering the area of twenty-four football fields' (Saslow, 1999: p279). President George Bush refused to cross the street to see it (Crimp, 2002: p201).

The Perfect Moment, Mapplethorpe's last travelling exhibition before his death (Whitney, 1989) was a defining one. Political pressure forced the Corcoran Gallery (Washington) to cancel the show, and when it was mounted at the Contemporary Art Center (Cincinnati, 1990), Dennis Barrie, the director, was charged with obscenity. Prosecutors attempted to smear Mapplethorpe's and the Center's names, but a jury found them innocent (Morrisroe, 1995: pp371–75). Homosexuality was again placed in a medical paradigm, perceived to be attached to gay sex (though lesbians have the lowest HIV rate). As people of all sexes and genders contracted HIV, the medicalisation of sexuality as a whole became apparent. Artists in the gay/queer communities grew weary from the mounting death toll, and anger evolved into care and management. Despite all evidence to the contrary, President Mbeki of South Africa (the country worst hit by AIDS) insists AIDS is not caused by HIV.

In 1992 a Colorado State initiative, passed by a large majority, set out to deprive same sex lovers of any rights under the law. Four years of legal action brought the case to the US Supreme Court where it was deemed unconstitutional. Justice Kennedy said that, 'A state cannot so deem a class of persons a stranger to its laws' (*New York Times*, 21 May 1996: p1). That it and similar laws were passed is worrying enough. In 1993 'Boris Yeltsin revoked Paragraph 121, and the other member states of the Community of Independent States followed his example' (Schwules Museum, 1997: p297).

3.5 The current climate

Homophobia continues to diminish within the art world, as openness expands. Nayland Blake and Larry Rinder's survey *In a Different Light* proposed a queer aesthetic that included homosexual and heterosexual artists. Gilbert & George had a world tour of their *Naked Shit Pictures*.

Goodbye to Berlin, *100 years of Gay Liberation* at the Schwules Museum, Berlin (1997), covered aspects of homosexual German life in the twentieth century. Work by open same sex lovers is part of the mainstream. Dealers such as Charles Saatchi and Larry Gagosian have bought and sold works by Gober, Bleckner and many others. Yet society continues to struggle with same sex love and its depictions, and outside major metropolises fear of physical violence and discrimination continues. At least sevent-four nations categorise homosexuality as illegal, and in places as diverse as Egypt and China same sex lovers are still being arrested for consensual adult acts in private.

Openness is not an option for many, and those in the West need to remember this. Overcoming internalised homophobia is difficult, but with a history to look upon with pride, people can learn and grow. The twentieth century will not be seen to have engendered a queer aesthetic or a gay style. Everything from figurative to performance art exists within the work of same sex lovers. No school ties them together, no body of naked men is common to their work. It must be hoped that same sex lovers will be seen as individuals with their own story to tell, men who happened to love other men. Just as there is no overriding theme to/of heterosexuality, so there is no homosexual one. What has been missing is their hidden history.

Michael Elmgreen & Ingar Dragset, **Short Cut**, 2003, Fonasione Nicola Tussardi, mixed media, installation view at Galleria Vittorio Emanuele, Milano, 250 x 850 x 300 cm.
Courtesy of the artist and Galleria Massimo de Carlo, Milan

Artists' Biographies

Ajamu, **Poetics of Provocation**, 2002, video still. Courtesy of the artist

Ajamu

1963, Huddersfield, UK

• Ajamu is co-director of Rukus, a London black queer arts organisation, and his work is based on S&M play and notions of transgression within gender, race and body polemics. He is known for his stark black and white photography (often self-portraits), though recent work has seen him experiment with video.

Kenneth Anger

1927, California, USA

• Anger was born in Santa Monica. Primarily a filmmaker, he is discussed in Chapter 2. He is best known for his openly homoerotic art films, *Fireworks* (1947), where Anger plays a gay bashed youth; *Scorpio Rising* (1963), a critique of American culture, featuring leather-clad bikers; and his book exposé *Hollywood Babylon* (1958).

Patrick Angus

1953–1992, California, USA

• Angus was born in Hollywod. He frankly documented the world of gay erotic cinemas and male strip clubs in his loosely painted canvases that were all but ignored in his lifetime. As bars, bathhouses and toilets closed under successive administrations in an attempt to stem the HIV tide, Angus caught the mood of guilty pleasures taken by men in the dark, where inhibitions were tossed aside as casually as clothing. Angus, extremely poor and unable to afford a doctor, collapsed and died from an AIDS-related illness. His work and reputation have since been revisited.

Ron Athey

1963, Connecticut, USA

• Athey was born in Groton, Connecticut and raised in Los Angeles by a fundamentalist Pentecostal family (who thought he was a messiah). Athey's performance art works have long contrasted his ultra-religious roots, with his same sex erotics. A practitioner of body manipulation (tattoos, piercings) and pain endurance (as catharsis), his performances are often seen as shocking. Based on the idea that pain inflicted by others (emotional/physical), can only be released by means ritual self-infliction to regain control of one's body. His 1990s *Torture Trilogy of Martyrs & Saints* (featuring nurses administering pain), *Four Scenes from a Harsh Life* (where a real-life Sebastian was pierced with arrows) and *Deliverance* (where psychic surgery was performed) saw Athey and his performers draw blood, both real and metaphorical.

Ron Athey, **Nun**, 1995–7, image of performance. Photograph courtesy of Julie Fowells. Courtesy of Rhodes+Mann Gallery, London

Patrick Angus, **Hanky Panky**, 1990, acrylic on canvas, 102.87 x 137.80 cm. Courtesy of the Collection of the Leslie-Lohman Gay Art Foundation, New York

Don Bachardy, **Christoper Isherwood**, 1985, ink on paper. Courtesy of the artist

Don Bachardy

1934, California, USA

• At eighteen, Bachardy met Christopher Isherwood (then forty-eight) on an LA beach and they became lovers (*Village Voice*, 2 July 1985). Their thirty-two year relationship was documented in text (Isherwood) and imagery (Hockney). In his late twenties, Bachardy attended the Slade (London), and held his first one-man show at the Redfern Gallery (1961). Bachardy is known for his erotic male nudes and drawings of Isherwood expiring on his death-bed (Bachardy, 1990). Widely exhibited, his work is included in the Metropolitan Museum of Art (New York), the Smithsonian (Washington, DC) and the National Portrait Gallery (London). His work, long overshadowed by his relationship with one of the giants of homosexual culture, is now widely respected.

Francis Bacon

1909–1992, Dublin, Ireland

• Born to English parents (Leiris, 1987: p20), Bacon grew up in Ireland, where his father, Eddy, who came from a distinguished family, settled to train racehorses. Eddy's harsh military regime did not suit the sensitive young Francis, whose asthma made him allergic to animals. Eddy had 'his small son regularly horsewhipped by the grooms'

(Peppiatt, 1997: p16) to toughen him up. After the beatings, the grooms regularly had sex with him, forming his adult tastes for sadomasochism.

Peppiatt notes: 'Its importance [his homosexuality] to Bacon's development, to his later life and to his vision as a painter cannot be overstated: one might reasonably say that, along with his dedicated ambition as an artist, his sexuality was the most important element in his life. Bacon would refer to himself as "completely homosexual"' (Peppiatt, 1997: p17). Reflecting his Edwardian upbringing, Bacon said that 'Being a homosexual is a defect ... It's like having a limp' (Peppiatt, 1997: p17). This view of same sex love, based in self-oppression, took (in Bacon) an extreme sexual form. Social mores of the day reinforced his negative self-attitudes as effectively as the horsewhip. In later life, Bacon still felt this way, exemplifying the difficulty many pre-Stonewall men had in overcoming internalised homophobia.

Eddy caught 'the effeminate, wayward sixteen-year-old trying on his mother's underwear' (Peppiatt, 1997: p21) and sent him to Berlin (1927) with his uncle Harcourt-Smith in a last-ditch attempt to set him straight. Bacon said of his uncle, 'My father thought he would change me. But of course it changed absolutely nothing, because a

bit later we were in bed together ... I really don't think it made the least bit of difference to him whether he went with a man or a woman' (Peppiatt, 1997: p27). Bacon found in Berlin a wilder homosexual nightlife than in London, and took to using make-up, shoplifting and prostitution (Peppiatt, 1997: p24). He went to Paris where he saw Eisenstein's (a same sex lover) *Battleship Potemkin* with its memorable image of a bloodied nurse's face in full scream. This image was to resound throughout Bacon's career. Bacon saw first-hand the Parisian avant-garde before returning to England (1928) as a furniture designer and decorator, having made important friendships in the artistic and gay worlds.

Bacon was a successful designer but often stated that his first work appeared in 1944. He met and formed a beneficial relationship with Australian painter Leroy (Roy) de Maistre (Peppiatt, 1997: p 48) who remained a lifelong friend. He gave Bacon many technical skills and social introductions, even though Bacon was advertising himself in *The Times* as 'a gentleman's companion' (Peppiatt, 1997: p55). After Bacon's initial success, he was described by a catty acquaintance thus: 'As for her [Bacon], when I knew her, she was more famous for the paint she put on her face than the paint she

put on canvas' (Peppiatt, 1997: p56). Bacon used facial cosmetics throughout his life and was 'to express himself freely: women's underwear, and notably, fishnet stockings were an essential part of the artist's wardrobe for most of his life' (Peppiatt, 1997: p102).

Peppiatt notes, 'It would be true to say that, on one level or another, much of what he painted is a projection of sado-masochistic practices, though as if by some odd consensus of propriety, his pictures were almost never viewed in this light during his lifetime' (Peppiatt, 1997: p58). This consensus was the heterosexual filter editing out what the dominant would rather not see in such an important artist's work.

John Russel speaks of such of works as *Two Figures* (1953) as relating to wrestlers, referencing Muybridge and Greek bronzes (Russel, 1979: p94). In his 1971 edition on Bacon, Russel discusses paintings featuring George Dyer, Bacon's lover, yet no mention is made of the fact. Dyer is just a model, and in the 1979 revised edition, after Dyer's suicide, all Russel says is, 'In the lives of all of us there is a human being whom we least wish to lose. Bacon sustained that particular loss at the time of his retrospective in Paris in 1971–72' (Russel, 1979: p151). There was no mention of who that person might

Per Barclay, **Interieur**, 1992, installation photograph. Galerie
Renos Xippas. Photo by Fin Serck Hanssen. Courtesy of the artist

Barrett-Forster, **WRECK!**, (installation detail), 2003–04, mixed media
installation. Courtesy of the artists

have been. While Bacon's images often scream their homosexual desire, it is often mistaken only for pain.

The *Potemkin* scream echoes in Bacon's *Three Studies for Figures at the Base of a Crucifixion* (1944), which catapulted him to fame. *Screaming Popes* followed (1949) and throughout his output, images appear nihilistically howling. Bacon's work pattern was simple in the extreme: painting in the morning, a boozy lunch, a hard-drinking dinner, and on through the night visiting private drinking clubs. Only as a last resort did he sleep a few hours before starting all over, with sex and violence often thrown in. His fear of death was well known, and, while burning the candle at both ends, he lived to an old age.

Bacon's take on religious subject matter was that works like *Crucifixion* (1933) were 'almost nearer to a self-portrait' (Peppiatt, 1997: p99). Bacon's complex feelings towards his parents, religion and his sexuality struggle for focus in the empty rooms he painted. Portraits from life (of lovers and friends) show deep suffering, and in many works death is in the background or the focus, culminating in *Tryptych May – June 1973*, depicting Dyer's suicide on the same day as Bacon's retrospective at the Grand Palais (Paris) (Peppiatt, 1997: p235).

Ten years earlier (1962–03), 'News of Peter Lacey's death was among the telegrams that arrived to congratulate the artist on the opening of his retrospective' at the Tate (Peppiatt, 1997: p192). Lacey was Bacon's then lover and his death also brought about a series of retrospective portraits.

Bacon's tortured personal affairs often unleashed his best works, perhaps subconsciously choosing partners who would provide him with the angst he needed for painting. Non-sexual readings of Bacon's work are out of sync with the paintings, and while his life is lived out on canvas, the works go beyond autobiography to touch on the core of human experience. Yet, for the general public, Dyer became a friend, Lacey a pianist and drinking buddy, never the cruel sexual partners who beat Bacon black and blue. His paintings became technically and conceptually more adept over the years, but it is in their raw emotional power that they made an impact. The works speak beyond their frame of sexual preference, but it was his intense personal, sexual life that provided the imagery and content for the work.

Bacon's friendships with artists almost all ended with a bitchy remark he made about their work. He said of Hockney, 'I can certainly see why he's popular ... People like his work because

they don't have to struggle with it' (Peppiatt, 1997: p283). Bacon fell out with his first commercial dealer, Erica Brausen (a lesbian), and switched to Marlborough Fine Art dealers (1958), who agreed to pay off his debts. Bacon, a lifelong gambler, even had his own gambling club for a time. Marlborough proved an effective selling machine and Bacon became an extremely wealthy man. He lived in a small flat in Reece Mews (London), where he kept a studio. After his death, the studio was given to the Irish Museum of Modern Art, dismantled and re-sited there (after the Tate refused the offer). At the time of writing, Marlborough is still involved in legal actions with Bacon's estate over payments to the artist. Marlborough was involved with similar clouded dealings with Mark Rothko.

The Metropolitan Museum of Art held a retrospective of his work in 1975, where he met Andy Warhol and Robert Rauschenberg. He continued to have commercial exhibitions until his death. His second retrospective at the Tate (1985) cemented his place as one of the greatest twentieth- century painters. His exhibition at the New Tretyakov Gallery (Moscow, 1988) brought him greater international respect. Ill with cancer, he died in Madrid in a hospital run by nuns,

apparently 'Bacon's worst nightmare' (Peppiatt, 1997: p316).

John Banting

1902–1972, London, UK

• Banting was a member of the British Surrealist group that included Roland Penrose and Eileen Agar. He and his lover John (Jim) Davenport (Chappell, 1985: p162) were good friends with Edward Burra, and Banting was painted by their mutual friend Cedric Morris (Morphet, 1984: p24). Banting's best known surrealist joke was to help 'find' an unknown artist, Bruno Hat. Bryan Guinness (in on the joke) held an exhibition of Hat's work at his London house (1929) to great critical acclaim. Lytton Strachey (also a prankster) unknowingly bought one of Banting's faux paintings. Banting, highly regarded in his own right, played down the joke in old age.

Per Barclay

1955, Oslo, Norway

• Best known for his series of water (*Oksefjord*, 1990), oil (*The Jaguar's Cage*, 1991) and blood (*The Slaughterhouse*, 1996) installations that reflect the rooms or locales they are sited in. He has also made a series of glass works that are based on house structures' where violence is always imminent. In *Pas de deux* (2001) two

Cecil Beaton, **Self Portrait**, 1939, pencil on paper, 63.5 x 50.8 cm. Courtesy of a private loan, United Kingdom

Berthold Bell, **Peter Colly**, Paris 1972, polaroid photograph, 14.61 x 14.61 cm. Courtesy of the artist

chainsaws were suspended on a metal ring in the gallery space and let rip, cutting pristine walls to pieces. Barclay also encodes many of his seemingly conceptual abstract works with a queer sensibility, as in *Untitled* (2001), where he placed hundreds of blue disinfectant discs (used in male urinals) in a gallery space that was next to a men's toilet where cottaging was possible. His works with human subjects often contain tension or violence, wherein beautiful semi-nude ballerinas are partially painted with a black oily substance or depicted in extreme vulnerability as in *Révérence (Arnaud)*, 2001.

Barrett–Forster

James Barrett, 1962, Orsett, UK
Robin Forster, 1960, Newcastle, UK
• Formerly known as Art2go, Barrett and Forster have long worked together as well as being same sex partners. Their work looks at same sex desire from odd perspectives. Their most famous photo series features men having sex with each other while being X-rayed. The resultant images of bodies colliding can be deciphered by noting the position of the metal genital jewellery of the participants. In this way a 'blow-job' becomes two impossibly connected sets of bones, and the medical paradigm that has long governed same sex erotics is inverted. In recent

photo installations, a crazy cast of urban men and women party as if there is no tomorrow, as in *WRECK!* (2003/04), where hedonism is examined with a knowing and ironic gaze.

James Richmond Barthé

1901–1989, Mississippi, USA
• Barthé moved to Chicago (1924) and attended the School of the Art Institute, before settling in New York, where he became a sculptor and part of the Harlem Renaissance. He used his art as a means of working out his internal conflicts related to race and sexuality. Like James Baldwin, he was labelled a 'Negro artist', and struggled to accommodate his race and homosexuality in his work. Barthé (like many same sex lovers of the period) was not open about his sexuality, but belonged to the New York network that included his friends Paul Cadmus, Jared French and Lincoln Kirstein.

Walter Battiss

1906–1982, Somerset, South Africa
• The Battiss family moved to Koffiefontein after the First World War (1917), where he became interested in archaeology, becoming art master at the Pretoria Boys' High School (1936). He began studying rock drawings by native Bushmen and his scientific copying of their works highly influenced his

own. Battiss gained the nickname of The Bushman painter. He exhibited the bush works widely and won a Bronze Medal at the International Olympiad (London, 1948), and was made a member of UNESCO in 1954. He continued his explorations throughout his career, working prehistoric images into contemporary paintings and woodcuts.

Cecil Beaton

1904–1980, London, UK
• From the age of eleven Beaton made photographs of his sisters in highly composed scenarios (Danziger, 1980: p9). He attended Harrow and Cambridge, consolidating his artistic position in the glittering inter-war years when the 'bright young things' took the social and artistic lead. 'Walking arm in arm through the colleges, the students flaunted a naively exhibitionist brand of homosexuality' (Danziger, 1980: p15). His first *Vogue* photograph, *The Duchess of Malfi*, featured George Rylands in full female drag outside a men's toilet. Many of Beaton's photographs are technically inept but wonderful images. He was never a photographer's photographer. Beaton became one of the many aesthetes aping the Wildean era but with considerably more make-up and pearls. Sergei Diaghilev reviewed his work in Venice (1926) and encouraging him. Beaton

returned to London and portrait work for friends, socialites, the rich and the famous. His photographs were unlike formal portraiture: highly styled, almost histrionic in fashion. Beaton was much sought after. Edith Sitwell commissioned him and a long photographic collaboration developed. His first one-man show (1928) was a financial and public success.

American *Vogue* brought him to New York (1929). Beaton continued to use substandard equipment and have his film developed in drugstores, even when photographing film stars (Fred Astaire) and millionaires (Mrs Harrison Williams). His unconventional work was well received, and he was placed under contract by *Vogue*. On a return trip to England he met Noel Coward (Danziger, 1980: p27) on board ship and they became friends. Coward advised Beaton to tone down his look if he wanted to be truly successful. Beaton went to Hollywood in 1931, where he created some of his most memorable images. The exiled Duke of Windsor asked him to photograph Wallis Simpson and, later, their marriage.

Beaton's potency as an image-maker was recognised by the Queen, starting a symbiotic relationship that culminated in the creation of a visual style for the modern notion of monarchy. Beaton continued to fashion the Royals

Barton Lidicé Benes, **Cremains of James and Noel**, 1998, cremains, wood, glass, 61.60 x 34.29 cm. Collection of the artist. Courtesy of Lennon, Weinberg, Inc., New York

James Bidgood, **Pan**, 1971, digital c-print on Fuji Crystal Archive Matte, 40.64 x 50.8 cm. Courtesy of Paul Morris, New York

in his image (at the coronation and wedding of Queen Elizabeth II), as he documented their lives. He worked for the Ministry of Information during the Second World War, capturing stark images of bombed London, the effect it had on the urban poor and the wounded. When stationed in Cairo, India, China and Burma, he recorded the wars progress. The impact of this dandified gent on the troops can only be imagined. But he wrote of them, 'It was even a little alarming to see masculinity oozing at every pore with sweat and the desire for these unappetising yet available pieces of Balkan femininity. These hideous hags, with inept clumsiness, had the impertinence to sing Tyrolean songs in strong Hungarian accents' (Beaton, 1943: p26). Beaton's misogyny (well documented in his diaries) was somewhat countered by his love of the feminine as seen in his fashion shoots.

Beaton had commercial success after the war, but he was soon seen as old-fashioned, and lost his *Vogue* (1955) contract (Danziger, 1980: p46). His portraiture, to which he returned in the late 1950s work was more direct, focused on finding the personality of the sitter, no longer placing them in a contrived story, as in his poignant image of Marilyn Monroe. His need for theatricality was satiated by work in

theatre and film, culminating in his acclaimed sets and costumes for *My Fair Lady*. In the 1960s he continued to photograph the celebrities of the day, Mick Jagger, Rudolf Nureyev and David Hockney. Beaton continued magazine work until his death, and in 2004 received a major retrospective of his work took place at the National Portrait Gallery (London).

Berthold Bell

1948, Bell, Germany

• Bell studied art and design in Vienna and Cologne, settling there to make illustrations, photographs and *The Last Adventurer*, an award-winning cartoon book. Bell's photographs of the 1970s depict his then lover Peter Colly, an American dancer and opera singer, of whom Bell has observed that he 'was the only man I ever met who could wear long glittery nails without looking ridiculous' (Petry, 2001: p2). For the double portrait, *Peter Colly/Berthold Bell* (1972) the lovers took a Polaroid of each other while in Paris.

Barton Lidicé Benes

1942, New Jersey, USA

• Benes is a conceptual artist who used his own HIV-infected blood to make disturbing sculptural collages (*Lethal Weapons*), or ashes of the dead to fashion sculptures (*Cremains of James and*

Noel, (1998) in an attempt to draw attention to the AIDS crisis. At seventeen he had his first exhibition at a gay bar (New Colony) owned by the Mafia, this led to work as a window dresser and an introduction to Howard Meyer, Benes' lover for over thirty years. For most of his career, work revolved around performance events. With Meyer's death (1989) his work was radicalised, and elements of Meyer's life (and body) turn up in Benes' reliquaries. Benes had made water pistols, Molotov cocktails and poison darts filled with his own blood for *Lethal Weapons*. When shown around the world, the work was largely misunderstood by the mainstream, and Benes was depicted as an AIDS terrorist, even landing up in court.

Christian Bérard

1902–1949, Paris, France

• Bérard studied at the Académie Ranson (1920) with Edouard Vuillard, and exhibited at Galerie Druet (1924) with Tchelitchev and the Neo-Romantics (Artnet.com, website). Virgil Thomson (American composer and same sex lover, 1896–1989) was a friend who was highly influenced by these painters (McDonagh, website). A successful theatre designer, Bérard, worked on many of Cocteau's projects, most notably *La Belle et La Bête* (1946),

creating Jean Marais' special effects beast make-up (Kael, website). He worked on Jouvet's *La Folle de Chaillot* (1945) and *Dom Juan* (1947). Like Cocteau, his abuse of opium affected his work and health; during the Second World War and they pooled their drug supplies. Unlike Cocteau, Bérard did not live to enjoy post-war success, and 'dropped dead during a rehearsal of Moliére's *Les Fourberies de Scapin*' (Brown, 1968: p381).

James Bidgood

1933, Wisconsin, USA

• Born in Madison, Wisconsin, Bidgood created a fantasy world of fairies, glitter and naked young men and is the forerunner of *Pierre et Gilles*. He learnt his high camp and kitsch as a drag performer in New York's famous Club 28. Like many other artists, his work as a window dresser and costume designer, allowed him to garner a myriad of props to use in his garish technocolour images. Like Bruce of LA he also worked for *Physique* magazine, and used his home as a studio, even for most of the elaborate sets in his movie *Pink Narcissus* (1971). This classic features Bobby Kendall as a hustler in love with his own beauty, who escapes from the harsh reality of prostitution through erotic fantasies as a matador, Roman slave and forest nymph. Bidgood with-

Nayland Blake, **Mopes Line II**, 1997, steel, rope, and stuffed animals, 50.8 x 22.86 x 25.4 cm. Courtesy of Rhodes+Mann Gallery, London

drew his name from the film after falling out with the production company that had helped finance it. Following the death of his long-term lover (1985), Bidgood destroyed much of the working material related to the film.

Nayland Blake

1960, New York, USA

• Born in New York, Blake moved to San Francisco to write, curate and make art, and conceptual work based on a queer premise. *Workstations* were 'sculptures of metal and leather that suggest props or sets for sadomasochistic activity' (Herbert, 1996: p3). Blake is not the stereotypical drag queen, yet in the 1980s he regularly staged performances as *Princess Coco*. When 'he happened by a costume store and saw a rabbit costume' it became a signature motif (Herbert, 1996: p3). Rabbits, long linked with fertility images (and in the vernacular 'to fuck like a rabbit'), are associated with promiscuity, a concept also applied to same sex lovers. Unlike Jerome Caja, Blake was always considered a serious artist. 'Blake's *Negative Bunny* (1994) is a video in which a worn stuffed bunny looks directly into the camera and harangues an unseen character to have sex with him, continuing for 30 minutes assuring his friend that he has just been tested for HIV and he is

"really, really, really negative".'

Blake, who was born to a mixed race couple (Caucasian mother, African–American father), uses rabbits to explore 'the African–American folk hero of the Uncle Remus tales' (Kemp, website). *The Little One* (1994) features faceless black porcelain dolls dressed in white bunny suits, referring to some African–Americans' ability to pass (for white), as many gays pass (for straight). Blake has said of his 122-kilo body that, 'My race is not visible. My fat is' (Carr, website), and has incorporated this issue into a video *Gorge*, where he is continually forced to eat. Blake also performed with his lover of ten years, Philip Horvitz, suited in a 66-kilo (Horvitz's weight) bunny costume, dancing to instructions shouted by Horvitz from offstage, until he literally dropped.

Ross Bleckner

1949, New York, USA

• Bleckner was born in New York and studied at the New York University (1971) and the California Institute for the Arts (1973) before exhibiting with the Mary Boone Gallery (1979). He became internationally acclaimed for his early, almost abstract paintings that incorporated his (gay) personal identity while commenting on their Abstract Expressionist (largely heterosexual)

roots. Many works feature funereal imagery dealing with loss as a metaphor for the AIDS crisis. Towards the end of the 1980s his works featured chandeliers in a dark background. These points of light evolved into abstract patterned works, which led into a series of paintings resembling cell formations that speak of the AIDS epidemic in a more poetic fashion. He has had a major one-man shows at the Guggenheim (New York, 1995) and the Astrup Fearnley Museet for Moderne Kunst (Oslo, 1995), and has also been included in *Pictura Magistra Vitae* (Fondazione Cassa di Risparmio, 2003), *Jasper Johns to Jeff Koons: Four Decades of Art from the Broad Collection* (Corcoran Museum, 2002 and LACMA, 2001), *Nuevas Abstracciones* (Reina Sofia, Madrid, 1996, Kunsthalle Bielefeld, Museo de Arte Contemporaneo, Barcelona) and *In a Different Light* (Berkeley, 1995).

Keith Boadwee

1961, Mississippi, USA

• Boadwee became famous in the 1990s for a series of pieces that looked like Abstract Expressionist works but were made by the artist taking paint enemas and then releasing the fluids on to the canvas. The use of his anus as a means of mark making undermined their heroic stance and macho ethos

(see Warhol). He also made a series that reread Jasper Johns' *Target* series from an openly gay perspective, with his anus as the bull's-eye.

Oliver Boberg

1965, Herten, Germany

• Boberg's highly sophisticated photographs present far more than simple exteriors of nondescript German houses, factories or roadsides. Boberg in fact creates lifelike miniature models of these contemplative environs from numerous photo studies he has taken of similar 'real' sites. Once the models are complete (after meticulous painting to make them look weathered), he has them professionally photographed Boberg posits the fictive as the real in his investigations into meaning, and while the images hide in the open, the viewer is left to imagine the lives of those who might inhabit his buildings.

Gregg Bordowitz

1964, New York, USA

• Born in Brooklyn, Bordowitz is an author, video- and filmmaker whose radical queer stance, activism and anger, have urged him to produce a searing analysis of the AIDS crisis. As an out gay man and out HIV positive activist, in *Fast Trip Long Drop* (1993), he addressed his own mortality. In the 1980s he was a member of ACT UP,

Gregg Bordowitz, **some aspect of a shared lifestyle**, 1986, video still. Courtesy of the Video Data Bank, Chicago

Per Christian Brown, **Sexualized Landscape 1**, 2000, c-print on aluminum, 165 x 130 cm. Courtesy of the artist

Leigh Bowery, **Session VII, Look 34** (detail), June 1994, 60.96 x 60.96 cm. Photograph by Fergus Greer, Manchester Art Gallery, Manchester

and a founder of DIVA TV (Damned Interfering Video Activists), which documented its interventions. His *A Cloud in Trousers* (1995), based on a poem (1916) by Vladimir Mayakovsky, concerns the conflict between political and personal life. He has written for *Village Voice*, *Frieze* and *Artforum*, and teaches at the School of the Art Institute of Chicago and on the Whitney's Independent Study Program.

Leigh Bowery

1961–1994, Sunshine, Australia
• Born into a working-class family, Bowery was a large child, interested in clothes and sewing from an early age. Bowery moved to London (1980), becoming part of the club scene that produced Boy George. Bowery designed clothes for himself and Trojan (his best friend and muse), making a breakthrough with his *Pakis from Space* collection. This was the first of many outfits altering Bowery beyond costume, creating a new form of performance art: a 1980s self-obsessed 'being-ness'. Bowery's club Taboo (1985) quickly became the place to be seen. A hangout for artists (including Wyn Evans and his lover Angus Cook), Taboo was more than a gay bar, it was a new type of club harking back to 1920s Dadaism. Bowery appeared each week in an even more outrageous outfit. He

shaved his head, and in the daytime wore badly fitting wigs and polyester outfits like those found in the suburbs he had left. He performed with dancer Michael Clark, and at the d'Offay Gallery (1988), suitably costumed, he lay on a chaise behind mirrored glass.

Bowerys nose for finding toilets meant that hardly a day went by without sex. He was arrested and charged with sexual assault (1991) (Tilley, 1997: p70) and fined, but immediately went back on the streets seeking more. His costumes present a neutered sexual prototype of a hermaphrodite nightmare, half woman (Bowery's large breasts were natural) and half castrated male, with genitals seemingly removed. His performances became more involved and disturbing, giving 'birth' onstage to his wife, Nicola (married in 1994) (Tilley, 1997: p92). Theirs was not an ideal sexual union but one based on her enthralment to his overriding personality. The sexual side to their relationship focused on Bowery's fascination with sexually humiliating her (Tilley, 1997: p88). He proffered many reasons for his marriage, none of them for love, yet their relationship endured his illness and daily toilet sex. Bowery became a life model for Lucian Freud (introduced by Wyn Evans, 1990) and his relationship to the art world fundamentally changed. His large

Marc Brandenburg, **Hirnsturm MB03-Z035**, 2003, pencil on paper, 21 x 36 cm. Courtesy of Crone Gallery, Berlin

fleshy body became an icon under Freud's unsparing gaze. The works formed a suite of paintings considered to be amongst the finest figurative work of the twentieth century. While not a traditional collaboration, the two men influenced each other greatly. Bowery died in 1994 from an AIDS-related illness.

Joe Brainard

1942–1994, Arkansas, USA
• Born in Salem to an artistic family (two siblings are artists, and his father painted), Brainard grew up in Tulsa a working class area (Lewallen, 2001: p5). He had a stutter. He met local poets Ted Berrigan and Patricia Mitchell (1958), and set up the *White Dove Review*. Brainard moved to Manhattan (1963), becoming part of the art/poetry scene and befriending Frank O'Hara and Larry Rivers. He evaded the draft by admitting that he was homosexual, and became lovers with Kenward Elmslie (Lewallen, 2001: p26).

Brainard met and was influenced by Warhol, Johns and poets from the St Mark's Poetry Project. Rivers selected his work for exhibition at the Finch College Museum (1964), where it gained a wider audience. He had his first one-man show at the Alan Gallery. Frank O'Hara also asked Brainard to design sets for *The General Returns*

from One Place to Another. Brainard's work featured semi-religious kitsch Madonna collages, and many works feature the cartoon character Nancy. ('Nancy boy' is a term of abuse for effeminate men.) Brainard's work was widely disseminated through cover designs for books, poetry magazines and record album sleeves for Elsmlie (Caples, website).

Brainard showed at MOMA and the Whitney, and continued to have one-man exhibitions in New York, culminating in a major show at the Long Beach Museum of Art (1980). His assemblages, paintings and collages have a sense of determined beauty and playfulness. Brainard ceased artistic practice in the 1980s. While remaining friends with Elmslie (for 29 years), Brainard and actor Keith McDermott became lovers (White, 2001: p256). Brainard died of AIDS-related pneumonia, and the Joe Brainard Archive was set up at the University of California, San Diego. Since his death the Berkeley Museum of Art (2001) has held a retrospective of his work.

Marc Brandenburg

1965, Berlin, Germany
• Brandenburg was born in Berlin, but grew up in Texas before returning in 1977 with his German mother. A mixed-race child with an

African–American father, he has spoken about always feeling as if he belonged to an 'other', an outsider group, which Berlin also was. He had no formal art training, yet once back in Berlin he became a part of the punk/art scene at a time of great stress and eventual change in Germany. His images reflect that chaos, and are derived from photographs he had taken, as well as clippings from newspapers and magazines. His drawings are often presented one next to the other, blurring their boundaries, and the certainty of photo-realism and of life itself.

Per Christian Brown

1976, Stavanger, Norway
• Brown's photography captures the fictional reality of the sexual moment. He photographs locations where men have public sex, making sure that no human presence is seen. Tracks in snow, discarded condoms or toilet paper hanging from trees are all the evidence of pleasure. Brown attempts to capture beauty in its fleeting moments.

Bruce of LA

1909–1974, Nebraska, USA
• Bruce Harry Bellas was born in Alliance, Nebraska. He became famous for his photographic work of male

nudes in 1950s beefcake magazines. He grew up in Nebraska, getting a degree in chemistry, which stood him in good stead for printing erotic images that could not be commercially processed. Arrested for 'taking nude photographs of a male model' (Bentley, 2001: p5) and forced to resign as a teacher, he moved to Los Angeles. Bruce claimed 'that any man would drop his pants merely for the promise of a free photo' (Bentley, 2001: p5). Early photographs depict rural America, full of hearty prosperity and worldly innocence. While technically less accomplished, they are among his finest. The men are often erect or engaged in sex, but aware of the camera. They have sex along with the photographer (as participating voyeur); their consensual male gaze is homoerotic, and focused inward.

Bellas obtained a business licence to photograph bodybuilders at Venice's Muscle Beach (1948) (Bentley, 2001: p5), and his style dramatically changed. Befriending the models, he photographed them in competitions, in the nude, or with tiny posing pouches. As staff photographer for Weider (gym equipment producers) publications, he had greater access to models. Bellas made his name with the Athletic Model Guild, influencing Bruce Webber, Robert Mapplethorpe and a host of

Bruce of LA, **Untitled**, c. 1950, b/w photograph, 12.7 x 17.78 cm. Collection of MOCA, London

contemporaries. John Lindell has recreated some of the props used in the photographs as abstract art works. Bellas' clean-cut all-Americans often posed ridiculously as gladiators cowboys or caught in nets (referencing Tuke).

American postal laws forbade Bellas from sending images by post, so he travelled extensively to deliver his prints, photographing new models on the way (Dolinsky, 1990: p9). His studio in Alamitos, California, was a suburban garage equipped with Hollywood props and lights. Fifties Hollywood lusted for muscle men, making B-movies starring many of Bruce's models, including Steve Reeves (Mr Universe). Bellas' photos have a Hollywood glamour that transcends their original purpose as gay pornography. Bellas died of heart complications while photographing cowboys at a rodeo (Bentley, 2001: p5).

Edward Burra

1905–1976, London, UK

• Burra's wealthy Rye family encouraged his artistic talents as an antidote to his fragile health: childhood arthritis, anaemia and an enlarged spleen (Chappell, 1985: p9). He lived in his family home all his life. He attended Chelsea Polytechnic (1921), befriending William Chappell, and the Royal College of Art (1923) (Rothenstein, 1973: p13). In letters to friends Burra

created an illustrated life story, based in reality and fiction, often writing as women, posing himself and friends as 'hardened hustlers, prostitutes and alcoholics' (Chappell, 1985: p27). Burra was of a generation of same sex lovers who often used camp names, and he photographed himself as Lady Bureaux, even signing correspondence as such (Chappell, 1985: p27).

Burra's fine drawings of the Roaring Twenties were a camper (if no less insightful) version of Grosz. Paul Nash introduced him to the Parisian avant-garde and, like Bacon, he quickly fitted into the art and gay scenes. He befriended Cedric Morris and choreographer Frederick Ashton for whom he designed sets (*Don Juan* and *Rio Grande*), calling Ashton 'Hotsy Trackles' (Chappell, 1985: p7). In the 1920s Burra visited Paris, Marseilles and Toulon, and though he had extremely bad health, made long journeys to work new imagery into his pictures. Burra's *The Snack Bar* (1930) remains one of the Tate's most popular images. He toured New York (1933), making paintings of Harlem and Spain (1935), where he frequented infamous drag bars (as in London [Chappell, 1985: p138]). In Mexico (1937) he became ill and nearly died, returning to England 'a dehydrated, emaciated, almost corpse-like figure' (Chappell, 1985: p97).

Richmond Burton, **View Behind the Curtain**, 1996, oil on canvas, 238.76 x 147.32 cm.
Courtesy of the artist

Chappell (a dancer for Ballet Rambert) continued to receive outrageous letters even after joining the army as a gunner (1940). Burra addressed him 'Well dearie', signing off 'love Ed'. Burra was too ill to fight, but his large gardens provided much-needed fruit and vegetables for city friends. Burra made ink and watercolours, as oils were too physically demanding, producing some of his finest work including *Fleet's In* and *Soldiers at Rye*. A major exhibition of his works (Lefevre Gallery, 1952) reflected religious themes and thems drawn from the Second World War and the Spanish Civil War: *The Mocking of Christ* (1952) is darkly sinister. His work, like that of fellow invalid Marsden Hartley, has an undercurrent of death flowing through it. Living in Rye, Burra regularly visited London's gay bars and the Colony (Bacon's haunt). Burra received a retrospective of his work at the Tate (1973), and died aged seventy-one, having been told in his youth that he would not 'make old bones' (Chappell, 1985: p9).

Richmond Burton

1960, Alabama, USA
• Born in Talladega, Alabama, Burton trained as an architect working with I.M. Pei on the glass pyramids for the Louvre (Paris) before realising that his heart lay in painting. In New York, he became Susan Sontag's assistant, and his first exhibition of paintings at Postmasters Gallery (1987) was a critical success. Burton, who has long been interested in notions of beauty and the possibilities of extending the visual representation of it, placed his deft brush handling within a strict geometric grid. This allowed him a formal base to explore the margins of beauty. Over his career, he has let that grid go and his *I AM* (2000) series has seen his work flourish and become ever more organic and sensual. Like Ken Kelly, he does not bring his biography into his production, yet in recent works sperm-like ejaculations flow across the picture plane, and his declaration of being (I am) has encouraged viewers to read the work in a same sex light. He has stated that he is interested in 'breaking down boundaries; tribally, sexually, materially, dimensionally, and between abstraction and figuration. Those are the places that I find really juicy' (Stalford, 2002).

Scott Burton

1939–1989, Alabama, USA
• Burton moved from his birthplace, Greenboro, Alabama to Washington DC (1952) when his parents divorced. He 'studied painting with Leon Berkowitz and Hans Hofmann' (Francis, 1985: p9). He moved to New York (1959) studying literature at Columbia

Michael Buthe, **Sonne-Federsonne**, 1981, wax and grains collage on wood, 140cm (diameter).
Photo by Barbara Deller-Leppert. Courtesy of the Goetz Collection, Munich. © DACS, 2004

(1962) and NYU (1963), before working for *Art in America* and *Art News*. Burton's 1960s works were drag performances that developed into *tableaux vivants*. He directed groups of people in various movements (*Group Behaviour Tableaux*, 1972), which became sculptural installations using furniture for participants, giving way to a cast Queen Anne *Bronze Chair* shown at the Whitney Biennale (1975) (Francis, 1985: p12). *Steel Furniture* (1979), *Rock Chair* (1980-2) and works in granite *Settee* (1982) function as in/outdoor sculpture and furniture. These works function as objects to contemplate, and on which to base the contemplation of other works. Burton wanted his works to function as public art and private collectible objects. Museums 'privately' own them, but they are used 'publicly'.

Burton was a Southern gentleman, polite, preppy and 'the younger lover of the Firehouse painter John Button' (Saslow, 1999: p281), a leather jacketed, bearded bear of a man. They were seen as an extremely odd couple. The besuited Burton was openly gay: 'Scott, as the saying goes, could make a truck driver blush' (White, 2001: p242). Burton was included in *Documenta VI and VII* (1977/82) and in the New Museum's seminal *Extended Sensibilities: Homosexual Presence in*

Contemporary Art (1982). *Scott Burton Chairs* toured the Fort Worth Museum, Walker Art Center and CAM (Houston, 1983). He exhibited at MOMA (New York, 1984) and the Tate Gallery (1985), and was commissioned by public and private bodies. Shortly before his death, 'a retrospective exhibition was organised jointly by museums in Düsseldorf and Stuttgart' (Smith, *New York Times*, 1 January 1990). Burton died of an AIDS–related illness.

Michael Buthe

1944–1994, Germany
• Born in the Rhine area of West Germany, Buthe studied in Kassel (1964–68) before moving to Cologne. He exhibited constructions, made action performances in the Cologne/Düsseldorf area and was included in *Prospekt* with Sigmar Polke, at the Stedelijk (1969) and ICA London (1969). His first trip to Morocco (1970) greatly influenced his work, inspiring him to make videos and installations with mystical and Arabic themes throughout his career. Many performances (and related objects) incorporated Buthe's male Moroccan lovers. Buthe travelled in Afghanistan, Uzbekistan, Kuwait, Tunisia and Spain and visited Marrakesh, Cairo and Istanbul. Buthe's Cologne base saw him as a, catalyst for art actions, scene

Paul Cadmus, **Study for David and Goliath**, 1971, acrylic on canvas, 127 x 137.16 cm. Courtesy of DC Moore Gallery, New York

events and his art film *Phantomas Phantastico* (1979). Buthe's collages and fragile works on paper, decorated with symbols of his personal mythology, were widely exhibited (Documenta V and VI, Kunsthaus Zurich, 1979). Larger mixed-media works from the 1980s recall Rauschenberg combines, but have a playfulness and fleeting quality of their own, often appearing as fetish objects or performance event left-overs. Buthe was included in Documenta VII (1982), the Venice Biennale (1984), *Chambre d'amis* (Ghent, 1986), the Sydney Biennale (1988), and was shown at the Guggenheim (New York, 1989) (Kunstmuseum Düsseldorf, 1999: p219). Like Gysin, Buthe's imagination lay in the desert sands, and in the arms of its native men. These relationships were strained by the difference in status, wealth and locale, and Buthe paid a heavy price. Buthe died from liver failure, caused by heavy drinking.

Samuel Butler

1835–1902, Langar, UK
• After studying at Cambridge he travelled to New Zealand (1859), setting up a sheep farm. In Christchurch he met Charles Paine Pauli. 'Pauli was two and a half years younger than Butler, Oxford educated, tall and considered handsome (Butler wrote that a San

Francisco barman had called him "the handsomest man God ever sent into San Francisco")' (Young, website). Returning to England in 1864, Butler gave Pauli a stipend for thirty-four years, as did the poet Swinburne, unbeknown to each other, until Pauli's death in1899. Pauli never revealed where he lived, though he saw Butler weekly. Butler had other male relationships including Alfred Cathie, who provisionally served as a manservant (Young, website) who provisionally acted as a manservant. Butler wrote that their relationship was similar to Sargent's with his valet, Nicola d'Inverno. Butler exhibited at the Royal Academy (1869–76), and is held in the Tate's collection, but is best known for his book *Erewhon* (1872).

Hamad Butt

1962–1994, Lahore, Pakistan
• Born in Pakistan, he moved with his family to the UK in1964, where he studied at Goldsmiths (1990). With Loren Masden, Butt was involved with the early years of the Milch Gallery (London). While his career was extremely brief (he died of an AIDS related-illness), he made several important installations and was posthumously included in *Rites of Passage: Art for the End of the Century* (Morgan, 1995: p144) at the Tate (1995).

John Button

1929–1982, California, USA
• Although, a native of San Francisco, Button lived and worked in New York, and was part of Frank O'Hara's highly influential poetry circle . Button's work was based in realism and was out of favour with post-war and pop sensibilities, but he was highly regarded for his commitment to his vision. In later years, Button was part of the *Firehouse* (the Gay Artists Alliance Building, New York City) group of painters and he and Mario Dubsky painted *Agit Prop* (1971), a huge 12-metre mural honouring the gay community. Button and Scott Burton were lovers.

Paul Cadmus

1904–1999, New York, USA
• Cadmus' parents met at the New York Academy of Design, which he later attended before studying at the Art Student's League. He worked for the Blackman Company as a layout artist (1928) before meeting Jared French. The two became lovers (Leddick, 1997: p33) and they went to Paris (1931), then Majorca, where Cadmus painted *YMCA Locker Room* (1933) and *Shore Leave* (1933), homoerotic works that set the tone of his realist style. Returning to America they became Public Works of Art Project artists. *The Fleet's In!* (1935), which was

to be included in an exhibition at the Corcoran Museum, was withdrawn prior to the opening at the demand of the Assistant Secretary to the Navy. 'This censorship was enthusiastically seized upon by the national press which reproduced the picture across the country. Cadmus, at twenty-nine, was labelled an '*enfant terrible*' (Kirstein, 1992: p25).

The two artists lived together in New York, befriending Lincoln Kirstein, who introduced them to George Platt Lynes. Lynes photographed all three, and the painters made nude erotic portraits of the others. Friends included Pavel Tchelitchev, his lover Henri Carter Ford, and Lynes' *ménage à trois* partners Glenway Wescott and Monroe Wheeler. Lincoln Kirstein, a same sex lover, who 'was never formally "out"' (Leddick, 1997: p27), married Cadmus' sister Fidelma. Kirstein, a board member of the Museum of Modern Art, gave artistic support to Cadmus, Lynes, and Tchelitchev. Cadmus designed the set and costumes for Ballet Caravan (a touring company of the American Ballet, founded by Kirstein and Balanchine [Leddick, 1997: p46]) *Filling Station* (1938). In the 1930s French with his wife Margaret and Cadmus, formed the PAJAMA group (Leddick, 1997: p12). Their photography, intended as studies for paintings (taken on

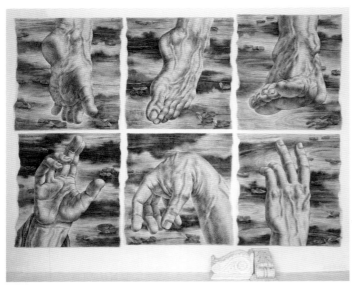

Ricardo Cinalli, **I miss you (Homage to Eric)**, summer 2003, pastel on layers of tissue paper, approx. 3.45 x 3.15 m. Courtesy of the artist and Galleria Planetario, Trieste, Italy

Installation view of Rick Castro's Furotica Exhibition, image **Snow Wolf**, 2001, digital photo manipulation 50.8 x 76.2 cm, by Tony Labadie. Courtesy of Rick Castro and Bryan Mulvihill

Fire Island, a gay resort), is now seen as independent work.

Life magazine commissioned Cadmus to paint the *Herrin Massacre* (1940), when union workers murdered 26 strike breakers in 1925, but found the graphic image too shocking to publish. Over time, Cadmus and French switched from oils to egg tempera, changing their styles and content. Cadmus embarked on a series of ballet and PAJAMA-based works, which became increasingly homoerotic with *FinisEtre* (1952). It featured two near-nude male bicyclists, dockside, in which a bicycle seat enters the bared buttocks of a lad holding an immense French loaf. In *The Bath* (1951), a ginger-haired, milky-skinned youth kneels in a bath, soaping his buttocks in front of a dark-haired male companion (also nude save for black socks), who combs his hair in front of a mirror. Kirstein describes the scene as 'a homely still life of laundry – damp and drying towels and socks draping the day's salute to a continuum of the week's study and chores. Their shared existence – chums in common feasts and famine, books, bath and bed – free from military discipline, held in its cozy routine the blessings of a world freshly at peace' (Kirstein, 1992: p83). They are obviously not brothers, so they must be brothers in arms, if not in each

other's arms. Kirstein knew Cadmus was a same sex lover, but publicly sidestepped any indication he had knowledge of his sexuality. In Kirstein's 1992 text he mentions his own marriage as a further heterosexual veil.

In the 1960s, Cadmus' work became allegorical culminating in *Study for David and Goliath* (1971), placing a drawing of Caravaggio's painting of the same subject in the background. The main figure, a curly-haired American David, lies nude on a bed, his manhood hidden by Cadmus' seemingly severed head. Jon Anderson, Cadmus' lover, modelled for David and reappears in *Artist and Model* (1973), and *The Haircut* (1986) (*Metrosource*, February/ March 2003: p38). Cadmus disliked abstract art and painted *The House that Jack Built* (1987), as 'a covert attack on the current local fame of color field abstract-minimalism, among whose prophet is Ellsworth Kelly' (Kirstein, 1992: p112). His works are held in many public institutions, but his stature as a painter rests on works made early in his career. Like the other Magic Realists, his work is undergoing critical reassessment.

John Cage
1912–1992, California, USA
• Born in Los Angeles, Cage studied with Schoenberg, creating his first

work for prepared piano in Los Angeles (Seymour, 1990: p9). Schoenberg 'insisted that he devote his life to music' (Gill, 1995: p28) and it was not until 1969 that he started making visual works. At Black Mountain College, Cage made music, performance art and happenings with Rauschenberg and dancer Merce Cunningham. Cage's infamous score *4'33"* (consisting of the stated length of silence) was first performed in 1952, creating a paradigmatic shift in the conception of what music could be. He was the most influential composer of his generation, and made visual scores (based on Chinese I Ching), his installations culminating in a retrospective, *Rolywholyover a Circus* (Los Angeles Museum of Contemporary Art, 1993)(Cage: 1993)

'Cage told Thomas Hines that by the age of twenty, when he was living in Los Angeles with Don Sample (his lover) and having affairs with other men' (Johnston, 1996: p1996), he wanted his homosexual desires to end. Cage married Xenia Kashevaroff (1935), having informed her of his past, but when he met Cunningham (1938), the marriage collapsed (Gill, 1995: p29). Cage's lifelong relationship with Cunningham was artistic (writing music for his dances) and homoerotic. David Revill, Cage's official biographer, never confirmed the relationship. Cage

lived a relatively open (but deniable) gay lifestyle, and was evasive about his sexuality until the year of his death. For a period Cage and Cunningham were best friends and collaborators with Rauschenberg and Johns.

John Gill points out in his comments on the news coverage of Cage's death and lack of detail about Cunningham that, 'As Peter Pears found out, obituaries are places where queers are buried in unmarked graves and where their lovers can expect to be Disappeared' (Gill, 1995: p26).

Jerome Caja
1958–1995, Ohio, USA
• Caja was born in Cleveland and later in his life attended Cleveland State University (1984) before studying at the San Francisco Art Institute (1986) where he started a simultaneous career as a drag queen. Caja used high art and camp references in his paintings made from his make-up box. No material was considered too low to be incorporated. *The Immaculate Conception* (1983) features nail polish and white-out fluid on paper. Other works were made with lipstick or mascara on discarded metal, paper or plastic. *The Foot of Christ* is enamel spread with a tiny brush on to the lumpy surface of Jerome's own toenail clippings. *Bozo Fucks Death* (1988) focuses on his

Brian Clarke, **Studies for Caryatids**, 2002, each panel in stained glass, 208 x 91 cm. Courtesy of Faggionato Fine Arts, London

fight with AIDS. Considered frivolous and too fugitive for much of his career, it was not until the *Bad Girls* show that Caja's work gained critical attention. Prior to his death, his studio collection was accepted into the Smithsonian Institution Archives of American Art, and works were purchased by MOMA San Francisco (Avena, 1996).

Rick Castro

1958, California, USA

• Castro was born in Los Angeles. He is a filmmaker and photographer whose work explores the edgier aspects of the fetish underground. He has worked for as disparate publications as *Vanity Fair* and *Bound & Gagged*. He worked with Bruce La Bruce on *Hustler White* (1996), but is best known for his documentary on Furries, people who like to dress up in animal costumes to have social and physical intercourse. His film *Plushies & Furries,* shown on MTV (2002), propelled him into the mainstream limelight, and he presented an exhibition of work *Furotica: It Ain't Exactly Bambi* (Track 16, Santa Monica, 2003) made by himself and said fetishists.

Ricardo Cinalli

1948, Argentina

• Cinalli works in a variety of traditional media: frescoes, paintings and his meticulous drawings on layers of tissue paper. His fluid line and superb draftsmanship could have led him to sterile neo-Classicism were it not for the content of the work. Cinalli revisits classical beauty and finds in its fleeting moment a reminder of death, no more so than in *I Miss You (Homage to Eric Elstob)*, a memorial to a past love and lifelong friend. No sentimentality is present, only deep sentiment and the ability to address important contemporary issues in a medium long thought worn out.

Brian Clarke

1953, Oldham, UK

• Clarke is well known for his architectural glassworks, creating major installations with many of the world leading architects (Foster, Alsop, Hadid) for the United Nations Headquarters (New York, 1995), the Maria Königin Catholic Church (Obersalbach, Germany, 1998) and the new Hong Kong Chep Lap Kok airport (1997). The works are mainly abstract but very beautiful, incorporating stained glass and mosaics, and are worked into the site's architectonics. He has simultaneously made a large body of abstract paintings that incorporate architectural elements. His new body of work, *Studies for Caryatids* (screen printed on large panels of glass), features bikini-clad surfers, and openly expresses his same sex desires.

Jean Cocteau

1889–1963, Paris, France

• Cocteau's prosperous family collected paintings and cultivated society. Money came from his mother who dominated his early life (his father gave up the law after marriage). Cocteau wrote, 'my family was too artistic for me to be able to rebel against them, and not artistic enough to give me useful advice. Now advice is an excellent thing – not to follow, but to disregard' (Steegmuller, 1970: p8). Cocteau was widely acclaimed on publication of *Le Prince Frivole* (1910). His acceptance as a handsome, rich young poet inflamed André Gide and his lover Henri Ghéon. Gide declared literary war, but remained a correspondent throughout his life. Cocteau was declared unfit for service in the First World War, but had a uniform made by Paul Poiret (a Parisian designer), and drove through the battlefields picking up wounded soldiers in Misia Sert's Mercedes. Their convoys were some of the first of the war, and Cocteau proved gallant, saving many lives. Gide wrote that Cocteau '[d]ressed almost like a soldier' (Steegmuller, 1970: p123).

Sergei Diaghilev commissioned Cocteau's libretto for *Le Dieu Bleu* (Paris, 1912), which had poor reviews (Brown, 1968: p89), but in the company of artistic masters (Vaslav Nijinsky, Igor Stravinsky), he learnt stage craft. Diaghilev famously ordered him to 'Astound me!' (Steegmuller, 1970: p179) and Cocteau replied with *Parade* (1917). *Parade* launched Cocteau into the heart of the avant-garde. Cocteau (not Picasso) created *Parade*, commissioning Picasso to make the backdrop and costumes, Erik Satie to write the music and Léonide Massine to choreograph. Cocteau's vision impressed fellow artists; *Parade* was a *ballet réaliste*, a performance about performance itself. A Chinese magician, two acrobats and an American girl perform at a fair. Three managers drum up business, but the enterprise fails, as there is no audience. From this simple story Cocteau made one of the first Dadaist performances. Satie's score used typewriters and revolver shots, and Guillaume Apollinaire wrote the programme note in which he coined the term *surréaliste* (Steegmuller, 1970: p182). Apollinaire ignored Cocteau's part as creator of the project, and mentioned him only as the inventor of the term *ballet réaliste*. This slight dogged Cocteau for the rest of his life: having created something completely new, he saw the credit go to others. *Parade* was a *succès de scandale*, and everyone involved benefited from one of the first modern performance art works. Marcel Proust wrote to Cocteau,

Jean Cocteau. **The Erection (Richard)**, c. 1920, pencil on paper, 26.5 x 21 cm. © ADAGP, Paris and DACS London, 2004. Courtesy of Engen Fine Art, London

'I cannot tell you how delighted I am by the considerable stir made by your ballet' (Steegmuller, 1970: p188).

André Breton was virulently jealous of Cocteau and wrote to Tristan Tzara that, 'You don't know what he is really like. My opinion – completely disinterested, I swear – is that he is the most hateful being of our time' (Steegmuller, 1970: p226). Breton fell out with Francis Picabia after he invited Cocteau to perform at an opening of his paintings (1920). 'Duchamp has said that to Breton, Cocteau's wit was the rag to the bull' (Steegmuller, 1970: p226). Breton had Cocteau and other (Gysin) same sex lovers expelled from the movement. Gide attacked Cocteau and *Parade* in print, and in his private journals. In later life Breton was known to frequent male prostitutes; perhaps Cocteau's crime was his overtness.

Cocteau met a young poet, Jean LeRoy, a soldier in the trenches, and the two became lovers. After LeRoy was killed (1918), Raymond Radiguet, another young poet, bloomed and died in Cocteau's hothouse. Before meeting Cocteau, Radiguet (aged fifteen [Steegmuller, 1970: p248]) had poems published by Tzara. Like Paul Verlaine and Arthur Rimbaud, Cocteau and Radiguet were passionate about their work and each other. Radiguet's *Le Diable au Corps* (1923) made him a

household name in France (then only twenty), but he died later that year of typhoid. Gabrielle (Coco) Chanel paid for and oversaw the funeral. Cocteau was too upset to attend, and started smoking opium. His paean to Radiguet, *L'Ange Heurtebise* (1925) was strongly influenced by his addiction. The poem evolved into Cocteau's play *Orphée*, reworking the Orpheus myth. Cocteau became the sexual magnet for aspiring young French artists. *Orphée* had a sartorial effect, as Chanel's 'simple country clothes' (Steegmuller, 1970: p371) and pink ball gown (worn by Death), became fashionable, as did the black leather motorcycle jackets used in the film version. Cocteau wrote 'With *Orphée*, I decided to take the risk of making a film as if cinematography could permit itself the luxury of waiting - as if it was the art which it ought to be. Beauty hates ideas. It is sufficient to itself. A work is beautiful as a person is beautiful. The beauty I mean (the beauty of Piero della Francesca, Uccello and Vermeer), causes an erection of the soul. An erection is unarguable' (Bernard, 1992: p157). Cocteau then became involved with writer Jean Desbordes, introducing him to opium.

Cocteau wrote *Livre Blanc* (1926), a homosexual novel, but was forced to claim that he had only found the manuscript, fearing social opprobrium. It

was one thing to be known as a homosexual, quite another to confirm it in print. Cocteau illustrated it with some of his finest erotic drawings. The preface states, 'I have ... accompanied this text with drawings which are patent evidence of the fact that if I do not specialise in a taste for my own sex, I do nevertheless recognise therein one of the sly helping hands fond nature is wont to extend to humans' (Cocteau, 1958: p8). In 1928 Cocteau took a cure for his addiction (Steegmuller, 1970: p395) and the resultant book, *Les Enfants Terribles* (1930), caused a sensation. Cocteau created some of the first literary teenagers whose disaffection with the adult world still reverberates. Charles de Noailles asked Cocteau to make a film (Brown, 1968: p293), and *Le Sang d'un Poéte* (*The Blood of a Poet*, 1932) sprang into life. It was considered as important as *Un chien andalou*, less surrealistic, more imagistic, a visual poem. Cocteau said, 'The style is more important than the plot and the style of the images allows everyone to suit himself and read the symbols as he wants' (Bernard, 1992: p134). Desbordes took a small role, a signature element in Cocteau's films.

Cocteau returned to opium, and 'was a veritable Pied Piper whose flute brought into the magic circle any number of nubile youths spoiling for libera-

tion ... A few years sufficed to tarnish their physical charm' (Brown, 1968: p247). Desbordes married (1937) and Cocteau took an Algerian lover, Marcel Khill, whom he cast in a play. In the same year Cocteau meet Jean Marais, took him as a lover and cast him in *Les Chevaliers de la Table Ronde* and *Les Parents Terribles*. Marais helped Cocteau stay off opium for most of the Second World War, and together they withstood attacks by the Vichy government. Cocteau even paid for Jean Genet's defence when charged with stealing a book of Verlaine's poetry (1943) (Steegmuller, 1970: p445). Genet, Gide, Cocteau and Marais were known homosexuals, decadents and enemies of the state. To Cocteau's credit he fought Vichy, but was accused of being a collaborator for positively reviewing an exhibition by Arno Becker (a fascist). Khill was killed in action, and as a Resistance fighter Desbordes was tortured to death by the Gestapo (Steegmuller, 1970: p448). After the war Cocteau resumed smoking opium and continued to do so for the rest of his life.

Cocteau made Marais into a star with his films *La belle et la bête* (*Beauty and the Beast*, 1947) and *Orphée* (1949-50). Marais claimed he owed everything to Cocteau, though his skill (and good looks) would have taken him to

Michael Craig-Martin, **Eye of the Storm** (installation details), 2003, gallery installation. Courtesy of Gagosian Gallery, New York

the top of French cinema. The last of Cocteau's loves to be filmed was Edouard Dermit in *The Eagle Has Two Heads* (Steegmuller, 1970: p464), and he was made Cocteau's legal heir. Throughout his career Cocteau drew, painted and, in his final decade, made a series of murals, but by then his powers were past their prime. Cocteau remained in Picasso's shadow, who often made fun of him. 'What need of Picasso's Cocteau filled is somewhat more mysterious, but Picasso adopted him during Apollinaire's absence, just as he would readopt him in the fifties after Paul Eluard's death' (Brown, 1968: p138). A retrospective of Cocteau's work at the Pompidou (Paris, 2003) has seen his reputation restored.

Colquhoun & MacBryde

Robert Colquhoun
1914–1962, Kilmarnock, Scotland
Robert MacBryde
1913–1966, Maybole, Scotland
• Colquhoun attended Kilmarnock Academy (1927) (Goldberry, 1963: p52) before winning a scholarship to the Glasgow School of Art (1933), where he met fellow painter MacBryde. Colquhoun won a scholarship and they travelled to Italy, becoming lifelong partners, known as *The Two Roberts* (The Gazetteer for Scotland, website). During the Second World War,

Colquhoun served in the RAMC and was injured on ambulance duty. He returned to London (1941), where he and MacBryde settled. Their circle included Wyndham Lewis, Michael Ayrton and John Minton (who shared a studio with Colquhoun). Colquhoun and MacBryde designed costumes and set for Scottish Ballet's *Donald of the Burthens* (1951) with choreography by Léonide Massine, and *King Lear* at Stratford (1953). The Roberts jointly exhibited at the Lefevre Gallery (1942). Colquhoun had a one-man show the following year, and continued to show there until the 1950s.

Despite their cosmopolitan surroundings, many of Colquhoun's works featured the landscape and farm labourers, and were influenced by the war. MacBryde's still lives were his strength and both were part of the neo-Romantic movement (Moffat, website). The Roberts moved to Lewes (1947), working for Miller's Press, before returning to London (1954). Colquhoun had a retrospective at the Whitechapel Gallery (1958) and in 1960 the Roberts held their last joint exhibition at the Kaplan Gallery.

Michael Craig-Martin

1941, Dublin, Ireland
• Craig-Martin studied at Yale School of Art (1966), then moved to London,

where he had his first one-man show (Rowan Gallery, 1969). He was included in *The New Art* (Hayward Gallery, 1972), which saw conceptualism gain a position of intellectual dominance in the visual arts. Craig-Martin's pivotal work *An Oak Tree* (1973), is one of the definitive examples of the period. 'An Oak Tree soon became notorious, deliberately exemplifying some of the most contentious and provocative aspects of conceptual art' (Craig-Martin et al., 2002: p9). The following year he started teaching at Goldsmiths College, where he became the most influential teacher of the twentieth century. In the late 1980s artists later known as YBAs (Young British Artists – including and Damien Hirst Sarah Lucas) launched their careers from Goldsmiths' degree shows under his tutelage. He was the Millard Professor of Fine Art (1994–2000) before becoming Professor Emeritus, and was a Trustee of the Tate (1989–99).

Craig-Martin had a retrospective at the Whitechapel (1989) and has made major installations for MOMA (New York, 1999), the Pompidou (Paris, 1994), Kunstverein Hannover (1998) and represented the UK in the XXIV São Paulo Bienal (1998). Craig-Martin opened the refurbished Manchester Art Gallery with a vast, site-specific wall installation, *Inhale/Exhale* (2002). 'In

most of his work, Craig-Martin avoids any direct reference to the human figure' (Craig-Martin et al., 2002: p11). His work (like Kelly's) strives to be impersonal, emptied of his own history and sexuality. Yet Craig-Martin has said on his use of bright colours and simple shapes, 'Frankly, I'm doing everything I can to seduce a person! Having done so, I don't want to disappoint them, but what I'm trying to do is provide leads, or rather possibilities' (Craig-Martin et al., 2002: p22).

René Crevel

1900–1935, Paris, France
• Crevel's family were involved in music publishing and his father committed suicide when René was fourteen. Crevel worked with the Dadaists in early performance art works and wrote *Detours* (1924). Crevel was openly homosexual and denounced by André Breton. So homophobic was the atmosphere that Paul Eluard slapped Crevel at a performance of an anti-surrealist work at the Théâtre Michel (Steegmuller, 1970: p292). Crevel was a friend of Dalí and wrote a text for him, *Dalí ou l'antiobscurantisme* (1930) (Raeburn, 1994: p48). Crevel was erotically involved with Tchelitchev and Lynes. Crevel's lasting observation of the period was that, 'Painting is not photography, the painters say. But

Mario Dubsky, **El Paso**, acrylic on canvas, 1967, 188 x 188 cm. Collection of Professor John Ball

photography is not photography either' (Raeburn, 1994: p142). He gassed himself, believing suicide to be the greatest act of man.

Frederick Holland Day

1864–1933, Massachusetts, USA

• Day was born to a wealthy family who allowed him to follow his artistic desires. An aesthete and known as a dandy, Day co-founded Copeland and Day (1884) as a private publisher for works by friends, including Oscar Wilde. Day took up photography (1886), defending the practice as high art long before it was considered such. He asked, 'And if it chance that [a] picture is beautiful, by what name shall we call it? Shall we say that it is not a work of art, because our vocabulary calls it a photograph?' (*Getty: Explore Art*, website). Day was part of the Pictorialist group, and was considered a Symbolist. His use of attractive male nudes in religious photographs was contentious from the start. Like von Gloeden's, Day's nudes were often placed in classical settings. Day was considered a serious artist on a par with Alfred Stieglitz, with whom he worked. A fire in Day's studio (1904) forced him to use a new camera, bringing forth a new spontaneity, but his use of platinum prints was disrupted with the onset of the First World War,

making their production impossible. Day became seriously ill in 1916 and did not return to photography, eventually donating his archive to the Library of Congress (Washington, DC).

Charles Demuth

1883–1935, Pennsylvania, USA

• Demuth was born in Lancaster, Pennsylvania, to a cultured family whose money came from tobacco (Ritchie, 1950: p7), Demuth was lamed in an accident at the age of four). Several female family members were accomplished amateur painters, and he attended the Pennsylvania Academy of the Fine Arts (Philadelphia, 1905), prior to his first visit (1905) to Paris, Berlin and London. His delicate watercolours of flowers, landscapes and acrobats were immediately successful. Further study in Paris (1912–14) followed, but he was forced to return to America with the onset of the First World War. His first one-man show (Daniel Gallery, New York, 1915) received praise and support from Alfred Stieglitz. Demuth made a series of watercolours illustrating Zola's *Nana*, Wedekind's *Lulu* and Poe's *Dance of the Red Death* for his own enjoyment. Never intended for public view, they were similar to his watercolours of men engaged in a full gamut of homosexual erotics. A 1950s commentator said, 'If Demuth's great-

est flower pieces have often a disturbingly sinister quality, many of the figure pieces have even more explicit suggestions of decadence, not to say evil, about them' (Ritchie, 1950: p10).

Demuth started working in oils in 1920. His most important work, *I Saw the Figure 5 in Gold* (1928), was based on William Carlos Williams' (a same sex lover) poem about a red fire truck bearing a golden number 5. It was one of several *Poster Portraits* of friends, which included Marsden Hartley (with whom Demuth spent winters in Bermuda) and Georgia O'Keeffe. *I Saw the Figure 5 in Gold* has its roots in Demuth's study of Cubism in Paris, where he returned (1921) following his diabetes diagnosis. Demuth was one of the first patients to receive insulin, which allowed him to survive for another decade. His American brand of Cubism, inspired by factories and machines, has come to be known as Precisionism. Demuth's gallerist referred to his work as part of the Immaculate School. After his death (1935) exhibitions of his work were mounted at the Whitney (1937 and 1987), Cincinnati Art Museum (1941) and the Metropolitan (1950).

Mario Dubsky

1939–1985, USA

• Dubsky trained at the Slade under Keith Vaughan and was an outspoken

member of the Gay Liberation movement (he introduced Vaughan to gay politics). Dubsky was deeply affected by the Stonewall riots and felt he had to bring the politics of the day into his work. To that end, he and John Button painted a huge mural honouring the leaders of the Gay Liberation movement at New York's Firehouse (Gay Alliance Building) called Agit Prop (1971). Dubsky also made large abstract paintings that recalled his travels, and delicate drawings on religious themes.

John Dugdale

1960, Connecticut, USA

• Dugdale was born and raised in Stanford, Connecticut. He was a successful commercial photographer working for fashion companies (Ralph Lauren) when he was rendered almost completely blind (with only 10 per cent vision in his left eye) by CMV retinitis, an AIDS-related illness (1993). Dugdale then turned to art photography, using a core of studio assistants who helped him make his images. He describes the image he intends to achieve, and his assistants take the photograph. He then painstakingly reviews the images with a magnifying glass to check their truth to his intention. He uses a large plate camera and nineteenth-century technology to make his haunting

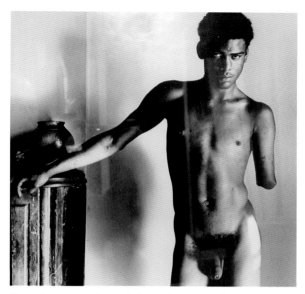

George Dureau, ... **on the mantle (man with missing arm)**, c. 1980, b/w photograph, 50.8 x 50.8 cm. Courtesy of the Collection of Leslie-Lohman Gay Art Foundation, New York

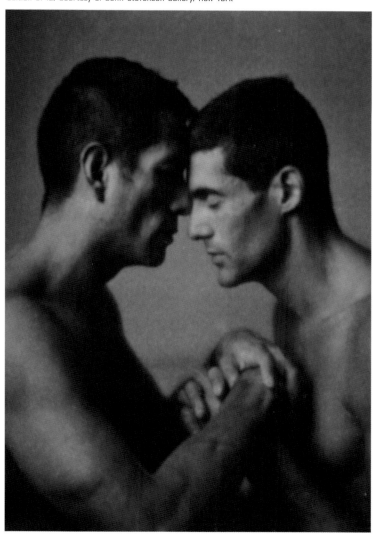

John Dugdale, **The In Dwelling Devine Spirit, Morton St., NYC**, 2002, Cyanotype, 25.4 x 20.32 cm, edition of 12, Courtesy of John Stevenson Gallery, New York

images, which recall Whitman, Eakins and Day. Unlike McDermott & McGough (who use old techniques to satirise the present), Dugdale's project is a sincere attempt to capture beauty and its passing from his memory of what things look like as a metaphor for life and death.

George Dureau

1930, Louisiana, USA

• Born in New Orleans, Dureau attended Louisiana State University (1946–52) and the School of Architecture at Tulane (1952). He started photographing to aid his painting, but quickly became known for his distinctive images of fellow African–American men. 'One of the amputees George photographed had been his lover ... and Dureau's photographs suggest nobility through the directness of the images' (Verga, 1998: website). Dureau's sitters are not presented as fantasy props as in Peter Joel Witkin's work. 'His photographs are immediately recognisable, not for their trickiness or technical virtuosity, but for their apparent straightforwardness. Technically, they seem to hark back to the 19th century, to have some of the stillness and formality of daguerreotypes' (Lucie-Smith, 1983 p.81).

Mapplethorpe visited Dureau, purchased a number of prints and arranged Dureau's first New York show (1980). After their meeting, Mapplethorpe started photographing black men (1977), but where he was interested in the ideal, Dureau contemplated the real. Dureau's men return the camera's gaze as much as they are observed, and are not objectified as in Mapplethorpe's images. Dureau's photograph of Mapplethorpe was used on the cover of Jack Fritscher's *Assault with a Deadly Camera*.

Dureau has exhibited internationally, including the Photographers' Gallery in London (1983), and in Paris (1986), sponsored by the Ministère de la Culture Reims. A retrospective was held at the Contemporary Arts Center (New Orleans, 1999). Known for his work with disabled black men, Dureau's most reproduced image is of an extravagantly fit nude white man, David Kopay, the first openly homosexual professional American football player (Lucie-Smith, May/June 1983: p81).

Thomas Eakins

1844–1916, Pennsylvania, USA

• Eakins was born in Philadelphia and later educated at the Pennsylvania Academy of the Fine Arts before going to Paris to study at the École des Beaux-Arts (1866), where he first encountered nude academic studies. He returned to teach at the

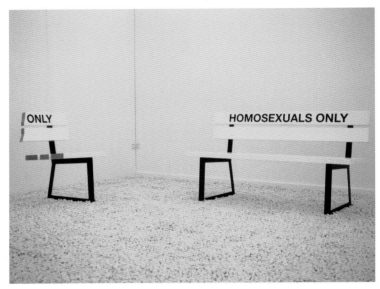

Michael Elmgreen & Ingar Dragset, **Powerless Structures**, Fig. 117, 2001, iron, MDF, paint, silkscreened letters, installation view at Witte de With, Centre for Contemporary Art, Rotterdam, 80 x 50 x 40 cm; 80 x 120 x 40 cm. Courtesy of the artists

Simon English, **El Greco's Knee**, 2003–4, oil and ink on paper, 210 x 185cm. Photo by Gaswin Schwendinger. Private Collection

Pennsylvania Academy (1873), where he introduced the French methods, and included nude photography, which was intended as an aide to painting. Eakins' open attitude included being naked with his male students, wrapped in the guise of recreating ancient Greece, and classical ideals, culminating in *Swimming Hole* (1883). Based on Walt Whitman's poem 'Song of Myself', like many of his works it was highly homoerotic, and would have appeared even more so in its day, given that Eakins depicted himself swimming. He became the director of the school (1876) and nude studies became the basis of all teaching, until he was controversially removed (1886) when he allowed women to draw men nude. Aged forty, Eakins married a student, Susan Macdowell, but soon met Whitman (1887) whose work had long influenced him. While making society portraits Eakins continued painting virile young men (wrestlers, rowers). See chapter 2.3 for further discussion.

Elmgreen & Dragset

Michael Elmgreen, 1961, Copenhagen, Denmark
Ingar Dragset, 1969, Trondheim, Norway
• In the Ottagono of the Galleria Vittorio Emanuele, *Short Cut* (2003) questioned the city's daily life and its

history. The Ottagono (1861) is the traditional entrance to the historic centre of Milan, featuring cafes, shop and restaurants for tourists and locals. Elmgreen and Dragset posit an imaginary trip through the centre of the earth (by lost tourists pulling a caravan), destroying the marble floor. *Short Cut* short-circuits viewers' expectations of who is allowed to travel across borders, as rich tourists would certainly not travel like 'gypsies', who are still seen as potential threats in Milan and the newly expanded European Union. Elmgreen and Dragset's work has long questioned all aspects of authority (whether that of the museum or state) over their work and lives as open gay men.

Neil Emmerson

1956, Australia
• Emmerson studied in Sydney before travelling to Europe and China, where he learnt the Asian mythology of *nan feng*, loosely translated as 'those of the southern custom', a euphemism for homosexuals. His work *The Rape of the Lock-Dream* (1997) contrasted the Victorian dandy Aubrey Beardsley and the Chinese Revolutionary hero Lei Feng. A curtain wall of black laser-cut silhouettes exposed each to the other and the viewer. Emmerson has been involved in queer polemics throughout

Mark Flood, **Quetzacoatl**, 2003, acrylic on canvas, 152.4 x 243.84 cm. Courtesy of the artist

Neil Emmerson, **The Rape of the Lock — Dream**, 1997, installation detail, 330 x 1000 cm. Courtesy of the artist

his career, including work in *Queer Crossing* (University of NSW, 1997). *Untitled (I want your sex)* 1998, is a series of lithographs based on the idyllic California landscape of palms, balmy weather and terracotta structures, and features a newspaper image depicting the public restroom where George Michael was arrested for allegedly masturbating in front of a cop.

Simon English

1959, West Berlin, Germany

• Born to British parents, English (who lives in London) is well known for his beautiful and fanciful paintings and drawings that recall Lewis Carroll. A superb draftsman, he addresses a certain lost Englishness from a very queer (in the older sense of the word) perspective. His cast of odd characters dress up in bunny costumes to have sex with teddy bears over prostrate art critics and bewigged judges. Some large canvases see only one such character in isolation, but the majority of his works feature a miasma of wonderfully observed, quirkily sexualised beings in seemingly safe everyday surroundings where a discernible dark undercurrent is ever-present.

Pepe Espaliú

1955–1993, Cordoba, Spain

• Espaliú attended the School of Fine

Art in Seville, settled there and worked with *Figura*, an important arts periodical. He made an important body of work based in performance and installation art, dealing with his HIV positive status. For *Carrying* he was literally carried about and was at the same time carrying (illness and art). His installation at the Madrid Hospital de le Venerable Orden III, *Untitled* (1992) (Morgan, 1995: p93) consisted of three huge steel birdcages, which opened out into the space, freeing the occupants, artist and viewer. In one work he summed up illness as a prison, yet one where release is always imminent. After his death his work was shown at the Reina Sofia Museum (Madrid) and the Tate.

Rotimi Fani-Kayodé

1955–1989, Lagos, Nigeria

• Fani-Kayodé's father was a Yoruba priest and politician, who had to flee with his family to the UK when the military took over (1966). Fani-Kayodé attended Pratt (1983), where he started photographing black men (often in tribal gear). His work attempted to reconcile his open sexuality with a deeply homophobic African background. He never allowed his homoerotic work to be shown there for fear of harm to his family, and never returned to Nigeria. Fani-Kayodé was a co-founder of

Autograph (an association of black photographers, see *Gupta, Ajamu*). With his lover artist Alex Hirst, he brought out a book *Black Male/White Male* (1988). Fani-Kayodé's best-known series is *Ecstatic Antibodies* which looked squarely at his own ill health prior to death from an AIDS-related illness. After Fani-Kayodé's death, Hirst published *The Last Supper: a creative farewell to Rotimi Fani-Kayodé* (1992), and co-signed many images that were previously attributed only to Fani-Kayodé.

Robert Farber

1948–1995, USA

• Farber is best known for his painting series *Western Blot*, which compares the AIDS epidemic with the Black Death, first shown at Artists Space (New York, 1992), and for *Every Ten Minutes*, a sound work made for A Day Without Art (1991). It featured a bell ringing at the then interval between AIDS deaths in America (White, 2001: p250). The work was exhibited at galleries and museums around the world; its clarity and tolling of the epidemic was emphatic. A member of ACT UP (anger at his own HIV positive status came out in his works), he tirelessly campaigned for better drug and health access. He bequeathed his wealth to a foundation that is one of

the mainstays of the Estate Project for Artists with Aids.

Mark Flood

1957, Texas, USA

• Born in Houston, Flood's work in the 1980s was based on an ironic look at the decade, with shows like *My Relationship with my Co-Workers* (Instituto Stato de Cultura, 1987) and *Celebrity Idolatry* (Commerce Street, 1989). These works gave way to more queer imagery in *Trophy Paintings* (Zero One, 1993) and *Temple Signage* (Commerce Street, 1998), where his fascination with young male teen idols was explored. Attempting to make the backgrounds compete with the collaged images, he started a series of lace paintings where tablecloths were applied to sections of the canvas, painted and removed. This technique has evolved to form the basis of his current work.

Robert Flynt

1956, Massachusetts, USA

• Flynt was born in Williamstown. At the age of seven he was given a camera and ever since then he has continued making imagery. His muti-layered images fuse new images of the male nude, which he has created with found photographs, medical drawings, first aid textbooks, maps, menswear

GAN — Gösta Adrian Nilsson, **Untitled (Sailor)**, c. 1920. Courtesy of Jonas Gardell and Mark Levengood

Robert Flynt, **Untitled** (BG; hypothesis rising), 2002, c-print, 60.96 x 50.8 cm.
Courtesy of the artist

catalogues and classical sculpture. These highly charged images float in pools (*Compound Fracture* series), are superimposed on nineteenth-century male portrait cards (*[Your] Numbered Days* series), or show the fragility of the body in an AIDS environ (*Partial Disclosure* series). Recent works feature hypnosis and examinations to create disturbing, yet highly sexually charged images that speak of loss, identity and power. Flynt has collaborated with dancers, choreographers and perform-ance artists (like his partner, Jeff McMahon) to make the work.

Jared French

1905–1988, New York, USA
• French was born In Ossing, New York to an artistic mother who encouraged his painting, French grew up in Rutherford, New Jersey (1919), where he attended Amherst College (1921). French worked as a Wall Street clerk, studying painting at the Art Students' League, where he met Paul Cadmus (1926), and the two became lovers. With the Wall Street Crash (1929), French decided to devote his life to painting, visiting Europe with Cadmus before setting up studios and a home in New York (1933). The following year, French met artist Margaret Hoening, and married her in 1937. French was known as '[s]omething of a

heartbreaker' (Leddick, 1997: p36), continuing a complex relationship with both Cadmus and Hoening.

French and Cadmus worked for the government's PWPA project, painting murals including one for a Pennsylvanian post office. French showed widely, exhibiting at the 2nd Whitney Biennial (1936). French's work featured beefy young men in various states of undress, as farmers, sailors or friends. From 1937 to 1945, 'the Frenches and Cadmus summered together on Fire Island, where they formed a photographic collective they called PAJAMA, an acronym taken from the first two letters of their names' (Grimes, 1993: p X). Throughout the Second World War French exhibited, participating in the Metropolitan's *Artists for Victory* (1942). George Tooker joined the PAJAMA party, along with Bernard Perlin (Leddick, 1997: p39). French was commissioned to paint dancer Martha Graham (1946), and met E. M. Forster (1947), with whom he became friends. French played host to Forster on his New York visit (1949), and the same year he moved his wife into St Lukes Place (which he continued to share with Cadmus). The group travelled through-out Europe along with Tooker.

French set up a studio in Florence (1951) and a permanent residence in

Julio Galán, **Nino elephante tomando Ele-rat 7**, 1985, oil and acrylic on canvas, 117 x 188 cm. Courtesy of Galeria Ramis Barquet, New York

Rome (1961), spending part of the year on his Vermont farm. Since 1940, French had been enthralled with Magical Realism and Renaissance techniques, using egg tempera instead of oils (Grimes, 1997: pX). This enabled him to create highly polished images of pale young men, including *The Double* (1950), based on the Resurrection yet heavily influenced by Jung's *Archetypes and the Collective Unconscious*. While Realism (and the Magical Realists) fell out of favour with the onslaught of Abstract Expressionism, French continued to be selected for the Whitney's shows of American painting. He changed styles: 'In the late works, an anthropomorphized landscape heaves with primordial energy. If the earlier works captured states of being, these final drawings and paintings image the process of becoming' (Grimes, 1993: pxviii). His last one-man show featuring these works (1969) was critically mauled. French returned to Rome where he died after continued eye problems.

Donald Friend

1915–1989, Sydney, Australia
• Friend was a rebellious youth, leaving school at sixteen to ride the rails around the country, then studying in London and Nigeria (1938). He became an official war artist in Borneo and Morotai, gaining a fine reputation in Australia as one of its most prized artists. After the war he travelled throughout Asia, settling in Bali (1966–80) before returning to Sydney owing to an AIDS-related illness. Throughout his life his graphic realist drawings were in demand, while his private erotic works (depicting same sex male orgies) were not as popular but have since become so. Like Keith Vaughan, Friend was a prodigious diarist (over 2 million words), detailing his life, loves and thoughts; they are currently being published in four volumes by the National Library of Australia (2002).

Julio Galán

1959, Músquiz, Mexico
• Galán (like Zenil) started making work in the style of *ex-votos* and *retablos*. *Niño Dios* (Christ Child) (1986) may look like a devotional icon, but it is devoted to his identity and vulnerability. Galán's early work dually posits art as a form of suffering and healing. Galán also makes large-scale paintings that extend the possibilities of investigating his position as a gay man in a homophobic Latin culture. Yet his surreal images (which tend to have an atmosphere of dread about them) function as imaginary narratives that any viewer can enter.

GAN (Gösta Adrian Nilsson)

1884–1965, Lund, Sweden
• Using the acronym GAN, GAN's early work was influenced by Beardsley, he studied in Berlin (1914) and later became one of Sweden's first modernist painters incorporating Cubism and the French avant-garde. On his return to Lund he found that his lover Karl Edvard Holmstöm had died of pneumonia, in his grief he threw himself into his work. These canvases recall Gris and Braque, and later works took on more obvious figurative elements, including sailors (Untitled: Sailor), young men at sport (Olympiad, 1924) or working (Maskinarbetaren, 1918). One sailor, Edvin Andresson, became a friend and lover who long promoted GAN's work and helped him overcome the loss of Holmstöm. Enthralled by technology, GAN's figures became more robotic and machine-like. By the end of the 1920s he was making purely abstract work which he returned to in the 1940s after a detour via Surrealism. His later works were more romantic and he is seen as Sweden's most influential modernist painter.

General Idea

A. A. Bronson, Felix Partz, Jorge Zontal, 1968,
• General Idea was founded as a framework for three Canadian artists to chide the mainstream art world. Their first show as a group, *Garb Age*, Toronto (1969), the 1971 *Miss General Idea Pageant* and *File Megazine* (a counter-cultural magazine placed in supermarkets, to look like *Life* magazine) (Malsch, 1992: p15) set the tone of their disruptive interventions. Performances, videos, even electioneering (Mr Peanut ran for mayor as a General Idea candidate) led to the *Ruins of the 1984 Miss General Idea Pavilion* (1977). This fictional future place was scored out with concrete, lime and smoke bombs. It dealt an end to their conceptual phase and ushered in their production of multiples. The ruins of 1970s idealism led to their engagement with 1980s greed, and they produced a highly successful series of multiples that included *Liquid Assets* (1980, a test tube and a US dollar sign cut from Plexiglass), *Ghent Flag* (1984, edition of fifty) and a series (unlimited) of chenille crest badges.

In the first in the series *Test Tube* (a video tape), the 'emphasis on the power of the media and advertising intercut with reflections on the role, tasks and potential responses of the artist makes this video tape historically significant. On the threshold of the 1980s General Idea [had] 'anticipated the essential thematic fields' (Malsch, 1992: p35) of the next decade. These

Gilbert & George, **Postcard Sculpture**, 1974, paper on board, 127 x 94.3 cm.
© The artists/Tate, London, 2004

works included a series of paintings featuring poodles engaged in sex acts (*Mondo Cane Kama Sutra*, 1983), works that questioned authenticity (*Leather and Denim Copyright #3*, 1987) and the market as a whole (the 1987 *Untitled* series depicts well-known brands, Mastercard, Visa, Marlboro as paintings made from dried pasta).

As for many same sex lovers, the shadow of HIV saw a turning point in their production. In their painting *AIDS (Cadmium Red Light)* in 1987 their work become overtly political. The painting featured the word spelled out in the same typeface and colouring as Robert Indiana's *LOVE* painting (Malsch, 1992: p15). Just as *LOVE* had become ubiquitous with the sexual freedom of the 1960s, their AIDS painting became a metaphor for the cultural wars surrounding that freedom. They issued the painting as wallpaper, and used it in many installations. *AIDS (Nauman)* at Fundació Joan Miró saw them recreate a seminal work by Bruce Nauman, where viewers had to pass through a tight, darkly lit corridor. In General Idea's version the entire internal surface was covered with the AIDS wallpaper, forcing viewers to press up against the wording. They created poster versions that were fly-posted throughout New York, Amsterdam, Berlin and San Francisco on subways, trams and walls.

The *Imagevirus* series saw a three-dimensional version of the *AIDS* lettering cast in metal, similar to Indiana's cast version of *LOVE*.

Their work culminated in a series examining the drug AZT. *One Year of AZT* and *One Day of AZT* (Württembergischer Kunstverein, Stuttgart, 1991) featured 1,825 (30-centimetres long) AZT pills mounted to the gallery walls and five huge (2-metres long) floor replicas. The distinctive pills (white with a blue band) used to suppress the HIV virus are still at the centre of accusations of AIDS profiteering. With *Red (Cadmium) PLA@EBO* (1991), a similar work in scale and intensity, General Idea questioned the scientific principle of giving AIDS sufferers placebos in drug trials. General Idea has been included in the Venice Biennale (1980) and Documenta VII/VIII (1982, 1987), and has had major solo exhibitions at the Kunsthalle Basel (1984), Contemporary Arts Museum (Houston, 1986), Wacoal Art Center (Tokyo, 1988), and the San Francisco Museum of Modern Art (1993). Felix Partz and Jorge Zontal (1995) have both died from AIDS-related illnesses.

Gilbert & George

1967, London, UK
Gilbert, 1943, Dolomites, Italy
George, 1942, Devon, England

Robert Gober, **Drain**, 1989, cast pewter, 10.8 cm in diameter and 7.62 cm deep. Photograph by Geoffrey Clements. Courtesy of the artist

Robert Gober, **Untitled**, 1985, plaster, wood, steel, wire lath, semi-gloss enamel paint. (2 pieces) left: 76.2 x 86.36 x 68.58 cm, right: 68.58 x 86.36 x 68.58 cm. Courtesy of the artist

• 'They say that Gilbert and George is one artist. Two people, but not a collaboration' (Marshall, 2001: p8). Gilbert & George was born when the two men met at St Martin's School of Art, and their career is one of continuous success from their first living sculpture (1969). Offered exhibitions as the one persona, *Living Sculptures* was performed throughout Europe (London, Amsterdam [Passmore, 1986: pp260–261]) and America in the late 1960s. If a fictional character (based in the lives of real men) can be homosexual, Gilbert & George may be the ultimate same sex lover. That the individual artists who form Gilbert & George refuse to confirm or deny whether they are lovers is immaterial. Were they to foreclose the argument, the artist (Gilbert & George) might cease to exist, as uncertainty is integral to the programme of the two mens.

Gilbert & George embarked on a series of *Magazine Sculptures* and *Postal Sculptures* (limited mail art editions). In 1969, photography entered the work as a tool for drawing large charcoal images of the pair in natural settings, built up of individual sheets of paper, similar in format to their later, better-known photo works. In 1972, Gilbert & George made video shorts and postcard sculptures like *It Takes a Boy's Point of View* (from found postcards

formatted into larger images). They produced their first photo-sculptures; collections of images individually framed and hung en masse, initially loosely collected, they evolved into a grid format. The contents of the photo and postcard works were of domestic scenes, drinking and, in *Dirty Words* (1977), photographs of rude graffiti.

Gilbert & George's work started to depict young men (as object choices) in homoerotic situations pictured with the artists. The 1980s saw the work gain greater art world acceptance with *Modern Fear* (102 individual pieces), and the film *The World of Gilbert and George* (1981). Their series *Death Hope Life Fear* (1984) and *New Moral Works* (1985) addressed life and death against the background of the growing AIDS epidemic as friends became ill (Robilliard, Heard). They made twenty-five works for CRUSAID (a charity helping AIDS sufferers), shown at the d'Offay Gallery (London, 1988), and donated their total profits (Farson, 1991: p106). Gilbert & George co-funded deluxe book editions of their works, making them widely accessible. Yet, 'Fellow artists criticise them. They made a book which should sell for £20 but help it to sell for £12. At the AIDS show people said "fools – idiots – no person should give away so much money"' (Farson, 1991: p102).

Gilbert & George commented that the *Guardian* (a left-wing newspaper) is 'only anti-gay in our case; while the *Sun* (a right-wing paper) has never gay-bashed us' (Farson, 1991: p19). An overriding spirit of community, the one they document, exist in and aim to transform, can be felt throughout these works. Gilbert & George engaged the culture wars by dropping their pants and bending over. The two men, long featured besuited, now appeared naked, to much consternation: middle-aged gentlemen with floppy penises and wide open anuses.

Their work has been exhibited worldwide, with shows in nearly every major museum, and participation in the Venice (1978), Sydney (1984) and São Paulo (1981) Biennales and Documenta (1972, 1978, 1982). When they exhibited in (then Soviet) Moscow, they met UK resistance. 'A top official in the British Council revealed the extent of their hostility by asking Russian organisers why they were promoting the work of "two homosexual fascists"' (Farson, 1991: p29). The exhibition was a major triumph for Gilbert & George. People flocked to see the work in Gorbachev's new Russia, and it received great reviews. Gilbert & George funded the event, as no money was forthcoming from the British Council.

Gilbert & George use nude male bodies to question the patriarchy and disrupt the gallery space. In a phallo-centric culture, it is important that the penis stay out of sight, keeping its power in reserve; exposing the secret of its fragility brings rupture. The female nude may still be seen as a vessel, or even a parody of one, but any naked man can be reduced to his genitalia. That they expose the male anus is even more disturbing (see Burroughs). Gilbert & George's work is full of laughter along with the darker side of the human experience, looking life, as well as death, in the eye.

Robert Gober

1954, Connecticut, USA
• Gober was born in Wallingford, Connecticut. His work questions the *normal*, the *natural*, and how patriarchial views disrupt the individual. Lynne Cooke, comparing women's oppression in the 1950s with Gober's childhood, wrote that for 'children, like Gober, who from an early age knew themselves to be gay, this regressive ideology was equally damaging' (Nesbitt, 1993). Gober takes everyday objects and in remaking them questions their status as normative. 'In terms of gay/or Catholic artists, the great precedent for Gober is Andy Warhol, who was also driven to repeat

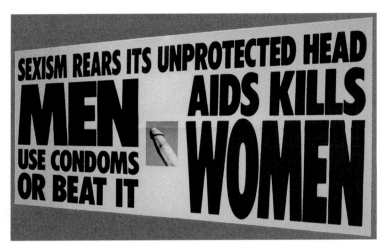

Felix Gonzalez-Torres, **Untitled (Loverboy)**, 1989, blue fabric and metal rods, overall dimensions vary with installation (ARG# GF1989-1); **Untitled (Portrait of Jennifer Flay)**, 1992, paint on wall, overall dimensions vary with installation (ARG# GF1992-20). Photo by Marc Domage/Tutti. © The Felix Gonzalez-Torres Foundation. Courtesy of Andrea Rosen Gallery, New York. Installed at Galerie Jennifer Flay, Paris, France. "Not Quiet" March 21 — April 18, 1992

Gran Fury, **Untitled**, 1990 (Venice Biennale), printed billboard, dimensions vary. Courtesy of MOCA, London

traumatic images, at least in his early work. But both these artists queer a prior figure, and that is Duchamp' (Foster, 1997: p21). David Hickey speaks of Gober's wallpaper series and total environments (Jeu de Paume, Paris, 1991, Dia Center, New York, 1992) as 'interior decorating with a vengeance – a cold blooded turning of that classically camp celebration back on itself' (Hickey, 1993: p21). Gober's project reclaims negative stereotypes and in embracing them defeats them, as gay activists have reclaimed *queer* (Queer Nation), turning it from an abusive slight to a badge of honour.

Drain (1989) came from a desire to have a cast from his kitchen sink, which proved impossible. Gober took three separate drains and combined them into the final object. 'I thought of the drains as metaphors functioning in the same way as traditional paintings, as a window into another world. However, the world that you enter into through the metaphor of the drain would be something darker and unknown' (Nesbitt, 1993: p9). The intimacy of Gober's kitchen is shared with Donald Moffett. The drains open up fictional (non-autobiographical) windows, based in autobiography. Nature, what is natural, what is considered against nature or unnatural is explored through this work. From Gober's earliest exhibi-

tions, he has often been grouped with artists exploring consumerism (Koons, Steinbach). His project was out of kilter with male heterosexual accounts of American culture, and positioned his work into the dominant. His work has a strong conceptual basis, which underpins its *lux* appeal.

Gober exhibits worldwide and has had major one-man shows at Kunsthalle Berne (1990), Reina Sofia, Madrid (1991), Dia Center, New York (1992), Tate Liverpool and Serpentine, London (1993), and has been included in the Whitney Biennial (1991), Documenta IX, Tate's *Rites of Passage* (1995) and Pompidou's *Féminin/masculine* (1995).

Felix Gonzalez-Torres

1957–1996, Güaimaro, Cuba
• Born in Cuba, Gonzalez-Torres was sent to Spain (1971) and then to live with an uncle in Puerto Rico. He moved to New York (1979) and took part in the Whitney's Independent Study Program (1981) before attending Pratt (1983) and the International Center of Photography (1987) (Deitcher, 1992: p29). Gonzalez-Torres' work often involves audience participation. Stacks of printed posters are free for each visitor to take away, some refilled, others not. His candy pieces offer the opportunity to take away or eat the artwork,

consuming it totally. 'To eliminate these works is to complete them, and yet they are endlessly reproducible. What is original is not unique; a sculpture is an edition of prints; an installation is ingestible. Gonzalez-Torres relates this formal deception to his homosexual orientation and the idea of "straight-acting"' (Cruz, 1994: p16).

The amounts of candy relate to his body weight, or that of his lovers, friends or family. Eating the candy is not unlike the Roman Catholic consumption of the host. Art becomes a regenerative act, the act of remembering in the process of loss. These works speak of loss, the passing of life (friends, lovers), and at the same time employ conceptual art strategies. His light sculptures can be hung in any way the owner/institution cares to mount them. Built-in flexibility undermines minimalist presentation, where the artist's decision is generally deemed to be paramount (Martin Creed). Gonzalez-Torres leaves it up to the viewer, providing the props and framework for meaning only.

Many works are 'Untitled' with parenthetical additions providing clues to meaning, as in *Untitled (Perfect Lovers)* 1987–90. Two seemingly identical office clocks hang next to each other ticking away the same time, yet slowly get out of sync as the mechanisms are

not perfect. Reflecting on same sex imagery Gonzalez-Torres stated, ' ... one thing that bugs me about artists who are doing so-called gay art [is] their limitation of what they consider as an object of desire for gay men. When I had a show at the Hirshhorn, Senator Stevens, who is one of the most homophobic anti-art senators, said he was going to come to the opening and I thought he's going to have a really hard time explaining to his constituency how pornographic and how homoerotic two clocks side by side are. He came there looking for dicks and asses. There was nothing like that. Now you try to see homoeroticism in that piece' (Storr, 1995: pp24–32).

A series of works was made in memory of Canadian artist Ross Laycock (Cruz, 1994: p40) who died in 1991. Gonzalez-Torres met Laycock at Boybar (1983), and they were lovers for eight years. Only shortly before Laycock's death did they live together on Rossmore Avenue (Los Angeles). *Untitled (Rossmore)* (1991), a 4-metre line of candy, *Untitled (Rossmore)* (1992), a single strand of lights (Cruz, 1994: p41) and *Untitled (1991)*, a photograph featuring their empty bed for discussion) offer a window into the personal space of their relationship. Gonzalez-Torres and Laycock were

Lothar Götz, **Forever Young**, 2002, acrylic on wall, dimensions are site-specific. Courtesy of Chisendale Gallery, London

highly political artists who fought for government action in the AIDS crisis. *Untitled (Placebo)* was made in memory and 'First and foremost it's about Ross' (Starr, 1995: pp24-32).

Gonzalez-Torres joined Group Material (1987), to create work in a democratic forum. His work, couched within a minimalist discourse, enabled him to address the political in a much more sophisticated way. He said, ' ... we know aesthetics are politics. They're not even about politics, they are politics. Because when you ask who is defining aesthetics, at what particular point – what social class, what kind of background these people have – you realize quickly again that the most effective ideological constructions are the ones that don't look like it. If you say, I'm political, I'm ideological, that is not going to work, because people know where you are coming from. But if you say, "Hi! My name is Bob and this is it," then they say, that's not political. It's invisible and it really works' (Starr, 1995: pp24-32).

Gonzalez-Torres exhibited commercially with the Andrea Rosen Gallery, and participated in the Whitney Biennial (1991), the 45th Venice Biennale (1993) and the 10th Biennale of Sydney (1996). His one-man shows include the New Museum of Contemporary Art (New York, 1988),

Museum of Modern Art (New York, 1992), Museum of Contemporary Art (Los Angeles, 1994) and the Guggenheim (New York, 1995). Following his death, retrospectives were held at the Sprengel Museum (Hannover), St. Gallen Kunstmuseum (Switzerland) and Museum Moderner Kunst Stiftung Ludwig (Vienna).

Lothar Götz

1963, Günzburg, Germany
• Götz's installations are minimal in nature but have a maximal optical effect. Almost all his works are site-specific installations. Using geometric patterns as a basis, Götz chooses colours that will vibrate when applied directly to the walls (often with up to seven coats of paint). The clinical white space of the contemporary gallery is flooded with colour.

Gran Fury/ACT UP

1987, New York, USA
• Larry Kramer is seen as the founder of ACT UP (Aids Coalition to Unleash Power), started in response to the inactivity of the Reagan administration and Mayor Koch (New York) in respect of the AIDS crisis. Frustrated members of the public started chapters throughout the US and Europe (London, Berlin, Paris), seeking to change medical structures to better suit the needs of AIDS

patients and political structures to provide funding. SILENCE=DEATH was the logo of a previous group, who joined with ACT UP to bring the issue of the AIDS epidemic into a broader cultural context. Gran Fury was created to make the myriad images that were needed for its campaigns. The name derived from the make of undercover police cars used in New York at the time: Plymouth Gran Fury (Crimp and Rolston, 1990: p 16).

ACT UP's peaceful civil disobedience was paralleled by Gran Fury posters, badges and media materials. Humour and satire formed a large part of their collective stance with *Wall Street Money*, 1988 (photocopied US notes with text on the reverse – *White Heterosexual Men Can't Get AIDS ... Don't Bank on it*), or poster works like *He Kills Me* (Donald Moffett, 1987), showing a target, juxtaposed with a smirking Reagan. Images and texts were placed on T-shirts, buttons and peel-off stickers, including now famous phrases like 'Men use condoms' or 'Beat it', 'All people with AIDS are innocent', 'AIDS profiteer' (targeting Wellcome for their excessive drug prices), 'Read my lips' (for mass same sex kiss-in demonstrations). Many works referenced other visual artists like Adam Rolston's *I am out therefore I am*, based on a Barbara Kruger image,

or *Riot*, based on Indiana's *LOVE* (see General Idea). Other artists involved with Gran Fury include Gregg Bordowitz, Ken Woodard, Tim Miller, Richard Deagle, Vincent Gagliostro, John Consigli, John Lindell and writer Douglas Crimp.

Duncan Grant

1885–1978, Rothiemurchus, Scotland
• Grant was born in the town of Doune to a distinguished Scottish family and his life encapsulated a century of changing attitudes towards same sex lovers. His wan style of English Modernism continues to come in and out of fashion. The underlying strength of his personal vision (from a privileged middle-class world) documented a time when Britain was at the apex of its power, and Grant painted it through its decline. Grant's series of dancers owes much to Cézanne, but in the documentation of his world, the work gathered strength. Paintings of his lovers show an intimacy seldom equalled. In formal portraits the openness of the sitter comes across, small foibles allowing entry into their world. Grant's portrait of his lover Maynard Keynes (1908) shows a tenderness not generally associated with the famous economist (Spalding, 1997: colour plate1). Keynes bought works from Grant, and made sure that he was

Sunil Gupta, **Queens, New York/ Lambeth, London**, 2000—2, lamda print, edition of 5, 76.2 x 149.86 cm. Courtesy of John Hansard Gallery, University of Southampton

financially looked after long after their affair ended and Keynes married. Grant was a handsome man and lovers included his cousin Lytton Strachey, whose younger brother (James) also fell in love with Grant (Spalding, 1997: p43). Through Lytton's intervention Grant became involved in an erotically complex relationship with mountaineer George Mallory (Gillman, 2000: p47), who posed nude for a series of remarkably candid photo studies.

Strachey introduced Grant to the Stephens family, Adrian, Vanessa (later Bell) and Virginia (later Woolf), whose father Leslie wrote the British *Dictionary of National Biography* (1907). Grant took Adrian as a lover (Spalding, 1997: p92), then Vanessa. Married to Clive Bell, she had taken Roger Fry, then Grant as lovers, never divorcing. Grant and Bell's relatively non-sexual relationship was his longest partnership. Bell, a fine painter in her own right, was the mother of Grant's only child, Angelica. Bell did not compete sexually with Grant's male lovers, remaining a needed companion, and if not overly happy sharing him, she did so knowingly. Their bohemian relationship was common in Grant's circle.

The oddest marriage in their set was between Grant's ex-lover David 'Bunny' Garnett and Grant's daughter Angelica (who thought Clive Bell was

her father until she was eighteen [Spalding, 1997: p360]). Their relationship produced many children, though Angelica separated from Garnett and took up with another ex-lover of her father's, George Bergen. The sexual comings and goings of Grant's lovers are documented in his work, a nude portrait of Angus Davidson (1924) being one of the most erotic. Grant's society portraits and images of London during the Second World War are also of historical interest.

The naked young men grappling in Grant's *The Bathers* (1926) recall Eakins and Tuke, and his love for male flesh is obvious. Yet his relationship with Bell hid his homosexuality. For most of Grant's life same sex activity was illegal. His sexual relations with men were first documented in Michael Holroyd's biography of Lytton Strachey in 1967 (Holroyd, 1994: p181). Grant's main concern on publication was whether he might be arrested, as this was a real possibility. Grant became more open, even attending a meeting of the Gay Liberation Front (1974).

Grant and Bell's relationship evolved into shared parental love, as he continued to have same sex relationships. Grant's last partner was Paul Roche (Turnbaugh, 1989: p 10), whom he picked up in Piccadilly Circus (1946), presuming him to be a rent boy. Roche

encouraged the belief before confessing he was in fact a Roman Catholic priest. Roche left the priesthood, and for the next 32 years looked after Grant. Roche, while exploring his heterosexual side, allowed Grant to fellate him on a regular basis (Spalding, 1997: p402). Their relationship upset Bell, with whom Grant continued to live. Grant held exhibitions of new work even in his ninetieth year. On a trip to Paris (accompanied by Roche), Grant caught pneumonia and died. Retrospectives of his work were held at the Scottish National Gallery of Modern Art (1975) and MOMA, Oxford.

Andris Grinberg
1946, Latvia
• Grinberg, an open bisexual, studied at Riga's Applied Arts School making clothing and staging performance art events in the 1960s. His *The Wedding of Jesus Christ* (1972) saw him marry Inta Jaunzeme (a woman) within a polysexual event. *Self-Portrait* depicted Grinberg kissing one man in a public toilet and bedding another (both in the nude), and was intercut with a sex scene with Jaunzeme.

He was persecuted by the KGB and his film was hidden for a quarter of a century reappearing only in 1996. He continued to make unofficial (and increasingly open homoerotic) art,

and is even more active since the collapse of the Soviet Union.

Hervé Guibert
1955–1991, Saint-Cloud, France
• Guibert studied film in Paris and La Rochelle and by 1973 was writing film criticism (Guibert, 1993: biography). He was highly regarded as a photographer and novelist. In 1977, his theoretical photographic book *La mort propagande* was published. He started working for *Le Monde* (until 1985), and met Michel Foucault (Miller, 1994: p355), becoming close friends. Their relationship was on a philosophical (non-physical) level. In 1979, Guibert exhibited two photo series, *Suzanne et Louise* (published in 1980 and presented at the Agathe Gaillard Gallery) and *Coulisses du Musée* Grévin (at Remise du Parc, Paris). From 1981 he published with Editions de Minuit (*L'image-fantôme*, *Les aventures singulières*, *Les chiens*) and in 1982 his film *L'homme blessé* won a César in Cannes. *Les aveugles*, published by Gallimard (1985), won the Prix Fénéon. He won a stipend to the Villa Medici (Rome, 1987) but had to deal with the onset of AIDS (1988). His seminal text on the rights of AIDS sufferers, *A l'ami qui ne m'a pas sauvé la vie* (*To the friend who did not save my life*, 1990) remains one of the most fraught descriptions from

Mats Gustafson, **Eric (#2)**, 1991, watercolour on paper, 28 x 28 cm. Courtesy of Galleri Charlotte Lund, Stockholm

Martin Gustavsson, **Phil I:1-4**, 2002 oil on glassine, 140 x 190 cm. Courtesy of the artist

the period on the right to privacy. His text also documents the downward spiral of Foucault and their intense final conversations.

Sunil Gupta

1953, New Delhi, India

• After becoming a Canadian citizen (1972) Gupta attended the Royal College of Art (1981) and has since lived and worked in London. He was a founder of Autograph and has long placed politics, race and gay polemics in front of his camera. His photo series have included portraits of gay lovers, the experience of black individuals in the UK, outdoor gay Indian meeting sites, and his own HIV+ status. For *From Here to Eternity*, Gupta juxtaposed images of himself (receiving treatment, ill) with the facades of South London gay sex clubs and saunas. In his most recent project, *Homelands,* Gupta attempted to link his various physical homes (London, Canada, New York and India) with the notion of the HIV virus as a traveller, one that travelled within his own body to the locales that he photographed. Gupta, aware that he could not fully document such a project, decided to narrow it to a *conversation* between himself 'as someone living in the West and me as if I had never left India' (Gupta, 2003: p105).

Mats Gustafson

1951, Sweden

• Gustafson is best known for his highly original watercolour fashion illustrations of *haute couture*, which have appeared in most major magazines. In the 1990s he had also exhibited sensual watercolours of his then lover Eric Rhein, and has recently started a series of stark contemplative round stones floating in reflective pools of water. Gustafson's mastery of the watercolour technique allows him to make images that convey an almost zen-like stillness.

Martin Gustavsson

1964, Göteborg, Sweden

• Gustavsson's wry oil paintings knowingly play off gay sensibilities, as in the *Daisy Chain* series (2000) that depict extreme close-ups of chrysanthemum heads, or men's heads thrown back in what could be sexual ecstasy (with their mouths wide open) in the *Somebody Else's Head* series (2000). In recent work, he has switched to oil on glassine paper to make fragile self-portraits and images of lovers, grouped together in sets of four or six. In fragmenting the total image, the groupings speak of the fracture of relationships and identity, and the viewer is left with several versions of what may be the truthful (or not) depiction of desire.

Brion Gysin

1916–1986, Taplow, UK

• Gysin was educated in Canada, returning to England to attend Downside College (1932). He studied at the Sorbonne (1934) (Wilson, 2001: p231), and quickly became a part of the Surrealist movement, but was expelled by André Breton for his open homosexuality. 'I had my first show with them in December 1935, which was a group show of drawings that included, uh, everybody famous in the group ... when I went to the gallery the afternoon that the show was to open I found Paul Eluard, the poet, taking my pictures down off the wall ... ' (Wilson, 2001: p37).

Gysin travelled to the Algerian Sahara (1938), returning to Paris for his first one- man show (Galerie Quatre Chemins, 1939) before going to New York (1940). He joined the Army (1943) and was taught Japanese, developing an interest in calligraphy. After the war Gysin went to Tangier (1950) with Paul Bowles, establishing a restaurant (*1001 Nights*). There he met William Burroughs with whom he became a friend and collaborator. Gysin, enamoured with Arabic calligraphy, made it the focus in his work. Moroccan independence (1956) forced Gysin to return to Paris where he and Burroughs founded the Beat Hotel. They developed the cut-up technique, and Gysin invented the *Dreammachine*. Gysin's paintings were exhibited internationally (ICA, London, Palazzo Guggenheim, Venice), and he made some of the first happenings (1960). Robert Filliou and Gysin formed the Domaine Poétique (1962) influencing a generation of poets and musicians with performance events, drug taking and open homosexuality.

Gysin continued to paint and held his *Calligraffiti of Fire* (Samy Kinge Gallery, Paris, 1986) just before his death. Gysin 'felt that his artistic innovations had been conspiratorially ignored by an imagined coterie of matriarchs and heterosexists (a paranoia not necessarily ungrounded)' (Caveney, 1998: p173) and it is only now that the full impact of his work is being recognised. Burroughs said of Gysin that 'He is a confirmed misogynist. The whole concept [for him] of Woman is a biological mistake' (Wilson, 2001: p15) but that he 'was the only man I've ever respected'.

Brion Gysin, **dead head in bed**, 1989, ink brush on paper, 17.78 x 22.86 cm. Courtesy of Bryan Mulvihill

Lyle Ashton Harris, **Memoirs of Hadrian No. 17**, 2002, 50.8 x 60.96 cm unique polaroid, 86.36 x 55.88 cm. Courtesy of CRG Gallery, New York

Keith Haring

1958–1990, Pennsylvania, USA

• Born in Reading, Pennysylvania, Haring was the oldest child of a US marine, and had a typical suburban American upbringing. His parents encouraged his creativity, but in his teens he was born again, his parents describing him as a 'Jesus Freak'. Haring stated that, 'after the Jesus thing I got into drugs' (Gruen, 1991: p16). His rebellion was a 'way of breaking out of the conformity of Kutztown' (Gruen, 1991: p20). Working for the Pittsburgh Arts and Crafts Center (1977) with mainly inner-city black employees, brought new influences into his life and work.

The Alechinsky retrospective at the Carnegie (1977) influenced Haring and he started working on large sheets of paper, incorporating his now signature drips. He also started having sexual relations with men. He went to the School of Visual Arts (New York, 1978), befriending Kenny Scharf, dancer Molissa Fenley, singer John Sex and photographer Tseng Kwong Chi. They become part of the punk/gay scene centred at CBGB's and the Mudd Club. Haring, interested in the graffiti, liked the work tagged SAMO (who turned out to be Jean-Michel Basquiat), and started his own efforts (1980), culminating in his famous image of a crawl-

ing baby. He worked with Scharf, Basquiat and other graffiti artists to move street language into fine art. Kwong Chi became Haring's official photographer documenting his projects, and died a week after Haring (from an AIDS-related illness) (Gruen, 1991: p219).

Haring met Juan Dubose (1981), a young black DJ, and the two became lovers. Throughout their relationship (and later with Juan Rivera), Haring had sex with other men and went to bathhouses. Having worked for Tony Shafrazi, Haring had his first one-man show at Tony Shafrazi's Gallery (1982). Haring's graffiti, music and art world connections collided with the *Zeitgeist*, and he was instantly famous. Six months later he exhibited at the Fun Gallery and became friends with Warhol and Madonna. Haring made two large tarpaulin paintings for Documenta V11, and started to exhibit internationally. He made body paintings on singer Grace Jones (photographed by Mapplethorpe) and dancer Bill T. Jones, also in a gay interracial relationship (with Arnie Zane, who died of an AIDS-related illness, 1988). Jones said, 'I'm not calling Keith a racist. I'm saying he doesn't understand that he is a product of a racist environment' and 'that Keith loves people from a class lower than his own' (Gruen, 1991: p98). Haring, like

Mapplethorpe, took a series of uneducated Hispanic or black lovers and when he tired of them, moved on. Dubose died from an AIDS related illness (1988).

Between 1984 and 1988, Haring exhibited widely to popular, if not critical acclaim, something that annoyed him in his lifetime. He opened a *Pop Shop* (1986) to sell his work, which started to incorporate safer sex, anti-drug and *queer politics* messages, and he made a collaborative print with Burroughs (1988). His fame was fuelled by an ambition for fame, and while he continued to have affairs with hustlers and men from disadvantaged backgrounds, Haring never made a real connection with them, nor do they feature in his work. Haring's whimsical ciphers of men came to represent his life, brandable, consumable and, in the end, consumed. Haring died of an AIDS-related illness in 1990.

Lyle Ashton Harris

1965, USA

• Harris (based in Los Angeles) explores what it means to be a black man in America. His self-portraits (in wigs or ballet tulle) deconstructing Mapplethorpe's take on African–American male stereotypes garnered considerable attention in the exhibition *Black Male: Representations of Masculinity in Contemporary Art*

(Whitney, 1994). He continues to look at gender, race and its construction, depicting himself as a boxer in his *Hadrian* series.

Marsden Hartley

1877–1943, Maine, USA

• Born Edmund Hartley, in Lewiston, Maine, he studied at the New York School of Art (1899) and the National Academy (McDonnell, 1997: p77), changing his name to Marsden (1906), his stepmother's maiden name, before his first show (New York, 1909) at Alfred Stieglitz's 291 Gallery. His landscapes were inspired by transcendentalism, the philosophical movement around Emerson and Whitman. Hartley's encounter (1911) with works of the European avant-garde (Picasso, Cézanne) changed his work radically. Patricia McDonnell notes that throughout his career Hartley's style changed. 'This incessant shifting in his art, I believe, relates in part to his homosexuality ... The insecurity of leading a closeted existence helped fuel his need to recreate himself' (Mc Donnell, 1997: p21). Adding that, 'as a gay man in an era when public admission of that side of oneself meant social and artistic ruin – to say nothing of criminal prosecution – he routinely masqueraded as something he was not'.

Mabel Dodge said, 'Hartley was

Marsden Hartley, **Seated Male Nude**, c. 1923, sanguine on paper, 45.72 x 58.42 cm. Courtesy of the Collection of Leslie-Lohman Gay Art Foundation, New York

Oliver Herring, **P+G Heroic Reflection** (Vert), 2002, c-type print, edition of 5, 57 x 38.5 cm. Courtesy of Rhodes+Mann Gallery, London

moody, gifted, homosexual but unable to form lasting intimacies with anyone' (Ryan, 1997: p3), yet in Paris (1912), he became fast and permanent friends with the notoriously fickle Gertrude Stein. She bought paintings, wrote about him and sat for *One Portrait of One Woman*. He met the great love of his life in Paris, Prussian officer Karl von Freyburg, following him to Berlin (1913) where he painted abstracted, imagistic portraits of the city and Von Freyburg. When Von Freyburg was killed (1914), Hartley's grief was total, and forced him to return to America (1915). When shown in New York, the Von Freyburg paintings received critical acclaim. In 1916 he and his great friend Charles Demuth travelled. Both were trying to reinvent the pictorial plane within an American idiom. Hartley chose the landscape, Demuth the city. Hartley returned to rural roots and for the next few years travelled throughout America and Europe. Hartley's friendship with George Platt Lynes produced a portrait of Hartley by Lynes and Hartley used Lynes' studio for a while.

In 1933 Hitler became German Chancellor and Hartley visited Germany for the last time, but soon returned to America (1934). Hartley was physically a meek-looking man, and his love of all things military was at odds with the spiritual goals in his

work. His love for supra-virile men kept him in their close proximity, be it in the city (soldiers) or rural (labourers) environs. He sought them out for sexual partners and painting subjects. Hartley exhibited a portrait series of rural Americans with Hudson D. Walker (New York), painting the people of Nova Scotia and Maine until his death. His *Dogtown* series redefined the view of the American landscape. In sinking himself in the land, Hartley had no need to confront the internal, yet his landscapes are often a swirl of emotions, and in reference to his final works, McDonnell states they 'convey the heroic simplicity Hartley so loved about Northeasterners. He celebrated these craggy fisher folk, drawing from his intimate knowledge of their labours' (McDonnell, 1997: p67).

Andrew Heard

1958–1993, Hertford, UK
• Heard went to Chelsea School of Art (1979) before moving to West Berlin (1983) where (like Lukacs) he became part of the gay skinhead scene. Back in London, he shared a studio with David Robilliard and was taken up by Gilbert & George, who said, 'Andrew was a public-school boy with lower-class aspirations, dressing like a skinhead, behaving like a gentleman' (Forde, 1993: p11). His paintings look at Englishness

Andrew Heard, **Here we go, here we go, here we go**, 1988, silkprinting ink on board (multiple), 101.6 x 76.2 cm. Courtesy of the Estate of Andrew Heard

Jan Hietala, **LIQUID**, 2001, moving digital image installation, mini dv, 105 x 180 cm. Private collection in Paris, Stockholm and Zurich. Courtesy of the artist

David Hockney, **Untitled**, 1974–75, b/w engraving, 15 x 21 cm. Courtesy of the Ivan Katzen Collection, London

and how it changed over the Thatcher period; *Paradise Lost* (1990) depicts a seaside coastal scene with a tug of knowing nostalgia. Local British iconography of the postwar period was juxtaposed with skinheads (*The Council*, 1981) or the meeting of the Kray twins and Emma Peel, *Screaming Abdabs* (1987). Heard also painted his lover Chris Hall in several portraits including *Here We Go, Here We Go, Here We Go* (1988). Heard died of an AIDS-related illness in 1993.

Oliver Herring

1964, Heidelberg, Germany
• Herring lives and works in New York using a variety of media, but is best known for his (labour-intensive, process-orientated) delicate sculptures made from Scotch tape and knitted mylar. Herring also makes performance artworks with strangers whom he has recruited over the Internet, as in *Spit Reverse* (2002), where Herring had people dressed in white tops spew water on to each other. These unscripted events take on a life of their own, and in *Spit*, it is said one participant in the group rehearsal spewed water on his brother, which then became the focus of the performance. Herring makes the commonplace extraordinary, and reminds the viewer that living is all about the actions that go into making a life.

Jan Hietala

1962, Stockholm, Sweden
• Hietala is interested in how the scientific gaze positions humanity as objects for investigation on a physical level, yet is detached from any metaphysical understanding of what it means to be human. In *LIQUID*, Hietala shot images at Peter the Great's collection, *Kunstkammera* (Museum of Ethnography St Petersburg), of aborted foetuses from the seventeenth and eighteenth centuries and contrasted them with contemplative projections of waves, an eighteenth-century city mansion and a sculpture group (the *Atlantes*). The collection is one of the earliest known scientific cabinets of curiosities.

Alex Hirst

c. 1953–1994, UK
• Hirst, a co-founder of the gay *Square Peg* publication, is often seen only as a writer and filmmaker. His most important works are collaborations with his lover, the well known photographer Rotimi Fani-Kayodé. *Bodies of Experience* and *Ecstatic Antibodies* are generally seen as Fani-Kayodé's, but Hirst's input is undeniable. Hirst also exhibited in a solo capacity after Fani-Kayodé's death. Controversially, he co-signed many works in his possession that were believed to be by Fani-Kayodé alone. In

his book *The Last Supper* (1992), three years after Fani-Kayodé's death, he said, 'Rotimi was my friend, my lover but also my collaborator-unusual, especially for a black man and a white man' (Hirst, 1992: p6). Both their works addressed racism, homophobia and the AIDS crisis.

David Hockney

1937, Bradford, UK
• Born to a working-class family, Hockney went to Bradford Art School, before serving two years in a hospital (1957–59) as a conscientious objector (Geldzahler, 1988: p13). He attended the Royal College of Art (1959), where his dress sense and facility with drawing thrust him into the spotlight. *The Most Beautiful Boy in the World* (1961) and *We Two Boys Together Clinging* (1961) were unusual for their open homosexual content, and their reference to Walt Whitman poems. 'A major influence in David's early days in London were the homosexual and nudist magazines available there' (Geldzahler, 1988: p18) depicting American musclemen. Their vitality eventually drew Hockney to Los Angeles (1964) where many of the nude images originated. This source material can often be seen in his work: men in showers, asleep or in partial undress. Hockney was an immediate

success, and in the 1970s started designing sets and costumes for operas. *The Rake's Progress* (1975) and *The Magic Flute* (1978) for Glyndebourne, *Le sacre de printemps* (1981) for the Metropolitan, and *Tristan und Isolde* (1986) in Los Angeles are highlights of this area of his practice. Stage work and photography cross-fertilised his painting.

Hockney is forever linked to his depiction of a Hollywood version of Los Angeles. His use of the city's unique quality of light and iconic images of sprinklers and swimming pools have fixed the world's idea of party town LA. He captured the city's flatness in paint. The essence of the megalopolis of suburbs by the sea is found in the cut-up method of his photographic works. *Two Boys in a Pool, Hollywood* (1965), *A Bigger Splash* (1967) and *Portrait of an Artist (Pool with Two Figures)* (1971) have defined the way Angelinos think of their town. Perhaps not since Hogarth has an artist had such a major influence on a city's view of itself, nor has any artist captured a city so succinctly.

Hockney met Peter Schlesinger (one of his art students) and they were lovers for over ten years, Hockney endlessly drawing or photographing the young man. Schlesinger featured in Jack Hazan's film (on Hockney), *A Bigger Splash*, and their sex scene

Jim Hodges, **Going There**, 2003, white brass chain in 15 parts, 78.74 x 60.96 x 30.48 cm. Private collection, London. Courtesy Stephen Friedman Gallery, London

Howard Hodgkin, **Gardening**, 1963, oil on canvas, 101.6 x 127 cm. © The artist. Courtesy of Anthony d'Offay Gallery. From collections of Birmingham Museum and Art Gallery

proved highly provocative (Howes, 1995: p20). Their relationship broke up shortly after, but they remained friends. Hockney's celebration of the homosexual in a graphic and open manner was revolutionary at the time. His characters were attractive, virile, tanned and sexy, while mainstream depictions of homosexuals were uncommon and always unflattering.

Hockney created a new realism with portraits of family, friends and, above all, his male lovers. He painted Christopher Isherwood and Don Bachardy (1968) and then revisited the subject in photographic form (1983). Hockney made a series of works in the 1970s dealing with Picasso. In the 1980s, influenced by ancient Chinese scrolls, Hockney developed a changing pictorial perspective, as in *A Walk Around the Hotel Courtyard Acatlan* (1985). His partial loss of hearing in the 1990s led to a withdrawal from his former party life, and recent work has been more introspective, featuring flower paintings and portraits of his dog, Stanley.

Jim Hodges

1957, Washington, USA
• Hodges was born in the town of Spokane. He is interested in the fleeting moments that hold beauty and remind us not only of mortality but of renewal. He has made a body of works that focus on artificial flowers (*In Blue*, 1996). Large free-hanging screens of hand-sewn individual silk flowers form visual blankets of time caught as if in a spider's web. Hodges has also made installations from hundreds of white paper napkins (like those found in diners), on which he draws flowers, then groups them together according to colour or theme (*A Diary of Flowers/When We Met*). In his melancholy attempt to capture or manage time, Hodges makes spider's webs (*Going There*, 2003) from silver chain (varying in size or number) that hide in corners, catching the light, watching time go by, no longer ephemeral, but still fragile, mimicking life.

Howard Hodgkin

1932, London, UK
• Hodgkin attended Camberwell School of Art (1949), then the Bath Academy (1950-54). He did not start exhibiting until thirty, and was initially seen as a Pop artist. His project had more to do with how figuration could be rooted in a pictorial frame, where the painting was itself an object. He started to paint on board, as his continuous reworking of images could only be sustained on wood. Hodgkin's paint spills on to the frame, making the whole a painterly object. The figurative elements become ciphers for what they once were, painterly memories of events, feelings, places and people. He visited India (1964 and 1972), encountering the work of Bhupen Khakhar, eventually painting *From the House of Bhupen Khakhar* (1975–76) (Juncosa, 2002: p16). Hodgkin is known for his use of colour and the length of time his paintings take to complete (they are dated from start to finish, some encompassing ten years).

Hodgkin separated from his wife Julia (1976) and is now commonly included in lists of important British same sex lovers (*Independent on Sunday*, 6 August 2000: p13). Often in coded language, his interest in colour is dismissed as merely decorative (if not gay). He describes his works as distilled memories, making the original experience all the more important as an aspect. That they transcend autobiography is important, yet they are based within it. He has stated that his painterly project is about 'transforming moments of passion into monuments' (Collins, 2001: p6). These evocative works are more than colourful doodles, and with the knowledge of his sexuality, the works can be read as disrupting the status quo.

Hodgkin is a Trustee of the Tate (1970) and the National Gallery (1978). He was awarded the Lion d'Or at the XLI Venice Biennale and won the Turner Prize (1985). Solo exhibitions include the Arnolfini (Bristol, 1970), Museum of Modern Art (Oxford, 1976), Tate (1982), Whitechapel (London 1984/5), British School at Rome (1992), and a travelling retrospective at the Metropolitan Museum (New York, 1995), Fort Worth (1996), and London (1997).

Horst P. Horst

1906–1999, Saale, Germany
• Born near Weimar (home of the German avant-garde centred at the Bauhaus), Horst trained at the Kunstgewerbeschule (Hamburg, 1926). He first envisaged a career in architecture, moving to Paris as an apprentice to Le Corbusier (1930). Once there, he started to work as a photographer for *Vogue* (1931), where his photographic mentor and lover, George Hoyningen-Huene (chief photographer for *Vogue*) introduced him to the glittering celebrities of fashion (Chanel), arts (Cocteau, Beaton) and letters (Stein). Horst befriended and photographed them, taking over from Hoyningen-Huene in 1935. This freedom allowed his starkly elegant signature style to develop; photographing nudes, still lives and fashion in deep shadowy light. He started to work for American *Vogue*, emigrating to the US in 1935. He continued to work in New York and Paris.

Horst P Horst, **Marlene Dietrich #5B**, 1942, Platinum/Palladium print, signed in pencil recto and verso, edition of 25, 22.86 x 18.4 cm. Courtesy of Ivan Massow's private collection, Frome, Somerset

Peter Hujar

1934–1987, New Jersey, USA

• Hujar was born in the town of Trenton. His stark black and white photographs documented New York's gay, fashion and art scenes. Hujar took iconographic images of hetero- and homosexual artists, including David Wojnarowicz, Gary Indiana, Susan Sontag, Andy Warhol, William Burroughs, John Waters, Fran Lebowitz, Paul Thek, Robert Wilson, Merce Cunningham and Brion Gysin. As well as his fascination with everyday street life, Hujar made a series of works about rural America. Horses, birds, cows and dogs came across as pure portraiture. Hujar's skill allowed him to capture a person, without turning them into an object. The images are unstyled, yet Hujar's style of minimalist simplicity shines through. In contrast to Mapplethorpe, where many portraits of others become self-portraits, Hujar is present by his absence. *Divine* (after the famous drag performer and actor) reclines like an ancient geisha clad in white on a velvet blanket, his ample figure straining against fabric, with a calm detached look on his face (Kozloff, 1994: p63). Divine, as a person, not as infamous performer, looks out, a person, not a freak or even Hujar's notion of what Divine should or might be.

Robert Indiana, **LOVE**, 1996, silkscreen, 60.96 x 50.8 cm. © ARS, New York & DACS, London 2004. Courtesy of RM Fine Art, London

David Hutchinson, **Love (Genet Theme)**, 2002, chipboard and fabric, 20.32 x 30.48 x 15.24 cm. Courtesy of Devin Borden Hiram Butler Gallery, Houston

Hujar befriended Wojnarowicz (1980), becoming his lover and mentor. Hujar supported Wojnarowicz's ambition to be an artist and initially kept him from self-destructing. One of Hujar's most recognised images is of Wojnarowicz holding a snake; they made many works about each other. When Hujar was ill (from an AIDS-related illness) Wojnarowicz nursed him, and compassionately photographed him dying (Lippard, 1994: p72).

David Hutchinson

1957, Louisiana, USA

• Hutchinson was born in Houma. He presents seemingly abstract vertical stripes of colour that appear to be randomly placed one against the other, yet are translations of Jean Genet's texts. Genet, one of the twentieth century's true outsiders (thief, prisoner, writer and same sex lover) wrote of the brutal nature of the love between men at a time when its discovery meant almost certain prison and all the brutality therein. In Genet, Hutchinson finds an artistic soul mate to explore the nature of aesthetics and ethical boundaries. Hutchinson uses a different colour for each letter to write out the names of Genet's characters or lines of his prose (*Opening Line to Querelle*, 2002) in paint. The original French version is often placed under an English transla-

tion. In order to read the paintings the viewer needs to decode the language of Genet's erotics, or simply give in to Hutchinson's elegant translations.

Robert Indiana

1928, Indiana, USA

• 'His art became his way of life. Not art as life. But life absorbed by art' (Katz, 1971: p11).

Born Robert Clark, in New Castle, Indiana, he grew up in the Depression, joined the US Air Force at seventeen, then attended the Art Institute of Chicago (1949–53) and London University (1953–54). He moved to New York, where he met Ellsworth Kelly (1955). Indiana cites Kelly as an early painterly influence he needed to overcome (O'Leary, 1999: p30). Indiana showed at the Anderson Gallery (1961) and his *The American Dream* was bought for MOMA. Linked with Pop, Indiana's images depicted traffic signs, amusement machines and old trade names, as well as engaging politics: *Cuba* (1962), *French Atomic Bomb* (1959–60) and *The American Reaping Company* (1961) demonstrate his activism, and he donated works to many causes. Some works seen as political (*Yield Brother* series) can be and were read as a reference to same sex desire.

In the 1960s he made assemblages

and developed a style of vivid colour surfaces, involving letters, words and numbers. *Polygon: Square* (1962) features the number 4 at the centre of the image, below the word 'QUARE'. Four is associated with the cross (four arms), and 'quare was a homonym for queer' (O'Leary, 1999: p51). Indiana linked his work to Demuth's in *The Demuth American Dream No. 5* (1963) and *The Figure 5* (1971), a 'celebration of the artist's favourite picture by Charles Demuth, *I Saw The Figure Five In Gold*' (Katz, 1971: p11). His reference to another same sex lover's work is all the more interesting given that the quiet continuity of visual code is not always understood by the dominant. This work hung in the homophobic Nixon era White House until Indiana gave it to the Smithsonian. This small act of subversion is indicative of the duality of Indiana's work: on one level it is what it is, images of signs, codes demanding to be read, yet it resists any fixed reading. His work depicts America as it wants to be seen, yet debunks the myth as it speaks it. Jasper Johns contemporaneously made number works, again with a nod to Demuth.

Indiana was represented at Documenta IV (1968), and became known for silkscreen prints, posters and sculptures using the word *LOVE*. *LOVE* refers 'to erotic love and may even

mask specific sexual/homosexual allusions' (O'Leary, 1999: p30) as well as spiritual love. The *LOVE* series became the emblem of the love generation, with its tolerance of racial, sexual and gender difference while at war with their elders. *LOVE* became a global Pop icon. The same gallery represented Indiana and Warhol, but the 'two gay artists among the core Pop group' were not close, nor did they share 'particular ideas about the gay content implied' (O'Leary, 1999: p90) in their work. Indiana's *LOVE* (1967) posters were originally printed as unlimited multiples for mass circulation. With this seemingly simple image, he became a part of the American (if not global) culture. Reproduced in many formats (including US postage stamps), it has been ever present in the public subconscious. The *LOVE* series was later incorporated into the works of ACT UP (using the word *RIOT* in a similar typeface) and in General Idea's *AIDS* works (in the same font and colours).

The success of *LOVE* led many to believe that Indiana had sold out, and he became isolated within the New York art scene, moving to Vinalhaven, Maine (1978). He retreated from painting into printmaking until 1989. Over the next decade he made work based on Marsden Hartley's war motifs. These works and a major retrospective,

Bill Jacobson, **Songs of Sentient Beings 1648**, 1995, silver gelatin print, edition of 5, 91 x 71 cm.
Courtesy of Rhodes+Mann Gallery, London

Love and the American Dream: The Art of Robert Indiana (The Portland Museum of Art, 1999), have seen his reputation rehabilitated.

Bill Jacobson

1955, Connecticut, USA

• Born in Norwich, Connecticut, Jacobson was a successful photographer working for galleries and museums documenting the work of other artists before focusing on his own work in the 1990s. Jacobson is known for his out of focus images (a style he developed in the 1980s), which came to critical attention with his *Interim Photographs* (Grey Art Gallery). These blurry black and white images were intended to speak of loss, the loss of clarity (around AIDS and illness) and the inability of capturing time (in this they fight Barthes' definition of photography). His *Interim Landscapes* were shot outdoors and evoke the implausibility of memory. Both series were shot in black and white but printed in monochromatic colour. In Jacobson's current work, he has started to use colour to capture street life and landscapes, yet they too retain his assertion that the world and life itself are ever elusive.

Eugène Jansson

1862–1915, Stockholm, Sweden

• Jansson drew heavily on his photographic studies of young men working out in gymnasiums or swimming nude in the military baths. Like Eakins, Jansson was also photographed in the nude with his models, and his work features contemporary versions of classical ideals. His lover appears in many of the photos and paintings, Sittande Yngling (*The Resting Lad*) c. 1906 being one of the most tender.

Derek Jarman

1942–1994, Middlesex, UK

• Jarman's father was an RAF Officer, and the family moved between the UK, Pakistan and Italy. Jarman was interested in art and 'at his prep school he won prizes for gardening' (Wollen, 1996: p 18), later designing gardens for films and his Dungeness home (considered to be one of the finest contemporary gardens in Britain). Jarman went to the Slade, focusing on painting and stage design, and was part of the first exhibition at the Lisson Gallery (1967). John Gielgud (a same sex lover) asked Jarman to design the set for *Don Giovanni*, which received bad notices. Jarman moved to a Thameside loft studio (1969) where he made super 8 films, and designed the set for Ken Russell's *The Devils* (1970) (Wollen, 1996: p 35) and *Savage Messiah* (on the life of sculptor Henri Gaudier). Jarman hired a team of artists to help,

Derek Jarman, **Germs**, 1993, oil on canvas, 243.84 x 182.88 cm. Courtesy of Derek Jarman Estate and Richard Salmon Gallery, London

including Christopher Hobbs, who became a close friend. Hobbs worked on many of Jarman's films, and continues to paint and design films.

Jarman, as *Miss Crepe Suzette* (1975), won Andrew Logan's spoof *Alternative Miss World* contest. Jarman and Logan were openly gay stars of 1970s London, Hockney was in LA, and many older same sex lovers were still secretive. Jarman's openness was well received by the burgeoning gay community, and his status was secured with the release of *Sebastiane* (1976). St. Sebastian's martyrdom is recounted, and for the most part filmed in the nude, as soldiers at the edge of the Roman world found comfort in each other's arms. A dung beetle sequence pokes fun at Mary Whitehouse, a reactionary anti-gay campaigner. Whitehouse wrote Jarman a letter comparing him to Satan (Jarman showed this letter to the author).

Jarman was involved with the music scene, and when Punk was at its height he released his seminal film, *Jubilee* (1978). Based on the Silver Jubilee of Queen Elizabeth II, it starred Jordan, Adam Ant and Toyah Wilcox. Jarman's 1980s were a period of artistic achievement. He designed sets for Russell's operatic version of *The Rake's Progress* (1980), using the Angel underground station for inspiration. Jarman's films

received a wider audience, and he refound his painting voice. Jarman also made videos for Marc Almond, the Smiths and the Pet Shop Boys.

Although the Final Academy (Edward Totah Gallery, 1982) was indifferently received (Wollen, 1996: p 69), two years later, his retrospective at London's ICA was well reviewed, as was his book *Dancing Ledge*. The pivotal year of his life was 1986, with the release of his film *Caravaggio*, his nomination for the prestigious Turner prize and his diagnosis as HIV positive. *Caravaggio* was Jarman's most commercial film and starred Tilda Swinton (who became his filmic muse). Nigel Terry played Caravaggio, Sean Bean played Ranuccio (Caravaggio's lover) and Hobbs painted life-sized reproductions for the film.

Jarman bought Prospect Cottage (1987), home of his garden, and became politically active, taking every opportunity to harangue the Thatcher government for its lack of attention to the AIDS crisis. His work addressed these themes as the 1990s began. His health failing, Jarman exhibited a group of 'Queer' works at the Manchester City Art Gallery dealing with AIDS and the public's perception of it as filtered by the press. In quick succession Jarman released two autobiographical volumes, *Modern Nature* (10991) and *At*

your own Risk (1992), and two films, Edward II (1991) and Wittgenstein (1992), both on same sex lovers. Steve Waddington played Edward. Edward's lover (Piers Gaveston) was played by Andrew Tiernan, and Keith Collins (Jarman's actual lover) played the executioner of the King.

One of the overriding aspects of his films is the deluxe visual quality achieved on the smallest of budgets. Few of Jarman's films had budgets over £100,000 and he relied on friends to make costumes and sets and to act. His last major work, Blue (1993), first shown at the Venice Film Festival, featured a solid blue projection with a voice-over reading Jarman's text. Jarman died leaving Collins to tend their garden.

Jasper Johns

1930, Georgia, USA

• Johns' early life was unsettled; he was born in Augusta, Georgia and lived with his grandparents after his parents divorced. He moved to New York (1947) to attend a commercial art school, before being drafted and sent to Japan. On return (1952) he was introduced to Robert Rauschenberg (1954) and they became lovers. Their meeting (brought about by artist/critic Suzi Gablik) was momentous for the visual arts (Seymour, 1990: p159).

Their art (based on their sexual and artistic partnership) changed how art was made and understood. Rarely has there been a moment in any art form where two artists of such stature became lovers and changed the course of their field. Johns tried a brief affair with Rachel Rosenthal to 'avoid a relationship with Bob' (Johnston, 1996: p128). She knew Johns was in love with Rauschenberg, but still took a studio with him in Pearl Street (near Rauschenberg). 'When they moved in, Rachel made the mistake of telling Jasper she was in love with him, and that ended their relationship' (Johnston, 1996: p130). She moved to California (1955) and Rauschenberg moved into her loft above Johns'.

Rauschenberg introduced Johns to Cage and Cunningham (whom he knew from Black Mountain College) and Cage introduced Duchamp to them both. In 1955, Johns finished Flag and Target with Plaster Casts. Alan Kaprow (a pioneer of happenings) included Green Target in an exhibition at the Jewish Museum (1957) where Leo Castelli saw and remembered it (Johnston, 1996: p72). Soon after, visiting Rauschenberg, and unaware that Johns occupied the studio below (or the nature of their relationship), Castelli requested ice for his drink. Rauschenberg is said to have men-

tioned that Johns might have some. Castelli wondered if Johns was the painter of the Target series. Versions of this story abound, but Castelli saw Johns' work and immediately offered him a show. Three works were bought by the Museum of Modern Art (1958), catapulting Johns into the limelight, and disrupting the two artists' relationship. Rauschenberg had been the better known, was older and had allowed Johns to work with him as a shop window dresser to make a living (Johnston, 1996: p75). 'Their closeness led them, on occasion, to paint each other's pictures ' (Crichton, 1994: p33), yet by 1961, they were no longer together and were more or less rivals. After the success of Flag, Johns (Bacon after his instant success) destroyed all the work previous to it in his possession (Johnston, 1996: p129).

Flag is considered to be what a hand-made readymade would look like. It is a painting of a flag and it is a flag, it is the object it signifies, yet hides behind a formal rhetoric that it exposes. Johns stated, 'Using the design of the American flag took care of a great deal for me because I didn't have to design it. So I went on to similar things like the targets – things the mind already knows. That gave me room to work on other levels ... they're both things which are seen and not looked at, not

examined' (Crichton, 1994: p30). Things were seen, but not seen, and in an age where homosexuality was a career killer, Johns found a way to make art that visually did not speak of himself, but in the end did. Clues and puzzles were to form Johns' vocabulary, asking viewers to guess at what was hidden in plain sight.

Johns was disparaged by right-wing critics with a vested interest in keeping Abstract Expressionism in power. His retrospective at the Jewish Museum (1964) had 'almost singlehandedly deflected the course of Abstract Expressionism' (Johnston, 1996: p149), with not a little help from Warhol. They were attacked for their Duchampian connections, their dandyism and their work as shop dressers. 'Hilton Kramer's policing action was an effort to "return" Johns (and his friend Rauschenberg) to their homosexual origins, evidently with the hostile purpose of discrediting the two artists, whom he saw as upstarts, usurping the hard-won place of the Abstract Expressionists' (Johnston, 1996: p147). Kramer had also attacked Gore Vidal for 'proselytizing for the joys of buggery' (Vidal, 1999: p112). Calvin Tomkins said that 'artists of Pollock's and de Kooning's generation have been almost without exception aggressively male, hard-drinking, and

Ray Johnson/Michael Morris, **Marcel Duchamp Fan Club**, 1972, assemblage, approx. 33.02 x 40.64 cm. Courtesy of Michael Morris

heterosexual. Quite a few of the sixties artists were either bisexual or homo-sexual', adding that, 'The real irritant was publicity' (Johnston, 1996: pp 149, 150). In the art world homosexuals were considered acceptable, as long as they knew their place as second best. The publicity surrounding this new generation infuriated conservative crit-ics. Johnston adds that, 'Johns and Rauschenberg could "pass". Andy Warhol on the other hand ... was more obviously gay' (Johnston, 1996: p149).

Larry Rivers and his lover Frank O'Hara introduced Johns to the direc-tor of Universal Limited Art Editions (1960) and Johns' fascination (like Rauschenberg's) with the print medi-um began. Johns' painting *Figure 5* (which refers to Demuth's) was exhibit-ed in Paris (Sonnabend Gallery, 1962), and Johns was commissioned by archi-tect Philip Johnson (a same sex lover) to make a work for the New York State Theater. Johns' retrospective toured (London, Pasadena, 1964), and many of the works contained coded mes-sages about his lost relationship with Rauschenberg. *Periscope (Hart Crane)* (1963) memorialises the 1932 suicide (by diving overboard ship) of Crane (a same sex lover). Crane and O'Hara's lives were cut short, and stand in for Johns' loss. Johns' friendship with O'Hara led to a collaboration and a

memorial painting, *In Memory of My Feelings* (1967), after O'Hara's death.

Mark Rosenthal claims that, 'Johns' most cautiously approached inclusion was himself and his emotions. Early in his career, he preferred that art not be an "exposure" of his feelings; but a bet-ter statement of his intentions might have been the occasion on which he said that at that period he preferred to "hide my personality, my psychological state, my emotions"' (Francis, 1990: p127). Rosenthal asks readers to decode images from several stand-points, country of origin, style, even a mathematical point of view, but never from the sexual. Rosenthal never addresses the object choice of these emotions, and it is unlikely that Johns' same sex desires were unknown to him. That Johns felt the need to hide is significant. Johns' *Target* series can be and were read as metaphor for glory holes (public toilets where men have anonymous sex). Flaps that lift to open mouths are a direct reference to the action that takes place in such places even today. The anus is also a sexual target, as are homosexuals in the hos-tile American climate. In the 1950s homosexuality was considered a men-tal illness and Johns' psychological state would have been called into doubt had his desires been widely known. Rosenthal glosses over this and

ends with a coded reference to Johns' sexuality, stating that, 'While barely hinted at, these feelings are among the driving forces in his art' (Francis, 1990: p133). On the other hand, Jill Johnston feels that Johns is reticent about his sexuality because 'Johns conforms to post-modernist expectations of the artist. His responsibility is to keep look-ing aesthetically like himself, in order to maintain his market value' (Johnston, 1996: p298).

In 1967, Johns embarked on his *Map* paintings, and became artistic director of Cunningham's dance company. These multimedia collaborations included *Walkaround Time* (1968), which saw Johns' interpretation of Duchamp's *The Large Glass*. Johns also introduced Warhol, Stela and Nauman to the company. Johns worked with Gemini (graphics), making a body of prints, culminating in a show at the Philadelphia Museum of Art (1970) and MOMA (New York). In 1972, he painted *Untitled*, introducing cross-hatching, which was to become a signature for later work. Johns collaborated with Samuel Beckett on *Foirades/Fizzles* (1976), and had his first major retro-spective at the Whitney (1977), which toured globally (London, Paris, Cologne, Tokyo). Johns also became involved with a Cunningham dancer, Jim Self (Johnston, 1996: p267). Their

relationship, fraught with Johns' need for secrecy (Johns even insisted they shake hands in public) was over by 1981, and Self became Robert Wilson's lover (Johnston, 1996: p280). John's series of works *Dancers* and *Tantric* must be seen within this autobio-graphical light.

Johns' highly influential painting *The Seasons* was shown at Castelli's (1987), and he represented America at the 1988 Venice Biennale, winning the Grand Prize (the Golden Lion); 'the last American to be awarded the prize was Robert Rauschenberg in 1964' (Johnston, 1996: p103). Johns' sexuali-ty was often hinted at by right-wing critics who wanted to hurt his reputa-tion, or by left-leaning ones who want-ed openness, but 'when lesbian critic Jill Johnston's 1996 psychobiography of Johns flatly called him Rauschenberg's lover ... Johns refused to let his work appear in the book' (Saslow, 1999: p247). Johns has since discussed the matter, if only to close a chapter in his personal life.

Ray Johnson

1927–1995, Michigan, USA
•Johnson grew up in Detroit, Motor City, a town built on movement and change, perhaps giving an impetus to the transitory nature of his work (DeSalvo, 1999: p16). One of the

Isaac Julien, **Bird of Paradise (Before Paradise)**, 2002, pigment ink print, printed at Hare and Hound Press, San Antonio, Texas: 3 panels, each 100 x 100 cm. Courtesy of Victoria Miro Gallery, London

creators of *Mail Art*, he corresponded with General Idea, and sent thousands of collages and drawings by post, making temporary works from the 1950s onward. Johnson studied with Joseph Albers at Black Mountain College with Rauschenberg and Cage. 'If Rauschenberg introduced life into art, Johnson introduced art into life' (DeSalvo, 1999: p19). Johnson used collage to build separate images into a complex site. Using an anagram of osmosis, he called his standardised collages '*Moticos*' (DeSalvo, 1999: p21), which melded images of movie stars, brand names and objects of desire into comic or surreal compositions. Johnson also knew Warhol from their joint days in advertising, remaining friends throughout their lives.

Jonathan Weinberg states that both Johnson and Warhol 'grew up during the intense homophobia of the late 1940s and 1950s, when being gay usually meant being adept at discretion and an ability to pass. Warhol was never able to play the role of a straight man, and in his work he exaggerated his swishiness so as to undermine the codes of masculinity ... while neither Warhol nor Johnson was in the closet, they were not free of its effects. Johnson's art in particular is involved with strategies of hiding and revealing. At times it seems to be speaking in

code to a group of fellow travellers, yet just as often it is direct about sexuality both straight and gay' (DeSalvo, 1999: p101). This language of codes can also be found in the works of other same sex lovers of the period.

'George Buse remembered, "One of the worst stereotypes was the lie that all homosexuals are effeminate ... so a lot of us at the time who were gay had to prove our manhood"'(Kaiser, 1998: p32). Buse joined the Marines, yet as even in uniform, same sex lovers could see the coded signs of their fraternity, so too in Johnson's work. Early same sex references abound: the mailout for '*Camp records – I'd rather swish than fight*' (1964) shows a leather-clad youth leaning against a wall. Anyone likely to have received such a mailout would understand it. Johnson's portrait of *René Magritte* (1971) features a black and white photo of the same sex lover Montgomery Cliff.

Johnson also created his own fictional histories: having shows at non-existent galleries, creating fan clubs and enrolling people in them unasked, only to send them artwork later. It is impossible to have a complete archive of his work, as so many people were continually sent work. Marcel Duchamp (one of the originators of art actions) deeply influenced Johnson, who sent Duchamp one of his most touching

works, a hair net for a water wave, a 'Marcel' (DeSalvo, 1999: p83). In his lifetime academics, curators and dealers largely ignored Johnson, and he committed suicide by drowning in 1995 and has subsequently become an object of art world fascination.

Isaac Julien
1960, London, UK
• Julien's parents (from St Lucia) moved to London where he studied painting (St Martin's). While a student he started his formal investigation into race with his film *Who Killed Colin Roach?* (1983). Julien was a founder of Sankofa (a black film/video collective), which oversaw the production of his next few films. Only with *This Is Not an AIDS Advertisement* (1987) did his sexuality become prominent. His breakthrough television film *Looking for Langston* (1989) examined black gay sexuality through the lens of poet Langston Hughes. Julien's feature film debut, *Young Soul Rebels* (1991), a gay interracial love affair set in a British punk environ, was critically acclaimed but was not a box office success. Julien has also long made video installations and The *Road to Mazatlan*, his collaboration with Javier de Frutos (South London Gallery, 2000), won him a nomination for the prestigious Turner Prize.

Ellsworth Kelly
1923, New York, USA
• Born in Newburgh, Kelly studied at Pratt (1941) before being drafted (1943) and serving in camouflage units in Europe. He then studied at École des Beaux-Arts (Paris, 1949), and his abstracts brought introductions to Picabia, Miró, Brancusi and Arp. He returned to New York (1954), exhibiting with the Betty Parsons Gallery. By 1957 he was in the Whitney Collection and included in *Sixteen Americans* (MOMA, 1959). He won the painting prize at the Carnegie International (1964) and exhibited at the 33rd Venice Biennale. He started working with Leo Castelli (1973) and his reputation was such that he was given his first retrospective at MOMA. The Whitney held a sculpture retrospective of his three-dimensional work (1982), and Kelly was included in Documenta 1X (1992).

His influence as a minimalist master is unquestioned. The works have become ever more elegant and beautiful. Expanses of geometric colour (in two or three dimensions) hang or float in empty white museological space. Kelly's work is made for the museum. No clutter or children's toys should be anywhere near his works; they are austere, uncompromising and demanding. Yet for all their seemingly imper-

sonal nature, they can be said to present a mimetic picture of their maker. Kelly, while not in the closet, is intensely private.

In *Spencertown – Recent Paintings by Ellsworth Kelly* (with a Jack Shear photo essay), we read, 'Kelly has lived in Spencertown since 1970. Seeing his work in the context of this landscape, of his house and garden, his studio and the objects and images which surround him everyday, makes it easier to comprehend the nature and seriousness of his undertaking. Jack Shear's photographs reflect Kelly's unending search for the essential, the real and the true' (Bois, 1994: p7). Many filters are invoked as ways of seeing the work. Kelly has an 'esthetic of impersonality' (Bois, 1994: p38), implying his personality is of no influence. Yet if everyday objects influence his work, wouldn't his sexuality? Is a house or garden really of more influence than his lover? Kelly's abstractions coincided with sexual repression in 1950s America. His public persona is that of a real man, who even served in combat. The effeminate homosexual paradigm does not fit him well. Bois, referring to *Orange Relief with Green* (1991), states, 'two shapes share a space as two college roommates share a room: polite to each other but retaining their own privacy' (Bois, 1994: p48). Kelly and Shear share

space in the book and in their Spencertown home. Bois places a heterosexual filter over their relationship; 'college roommates' implies that they are of the same sex, but also filters out the likelihood that they are bedmates.

Charles Kaiser says, 'Notable gay nonconformists who struggled against the fifties tide included poets like Allen Ginsberg ... painters as diverse as Paul Cadmus, Jasper Johns, Robert Rauschenberg and Ellsworth Kelly' (Kaiser, 1998: p89). Their same sex world was almost invisible to those outside, and with few exceptions (Gore Vidal), most artists, while leaving traces of male to male desire in their work, were understandably afraid to speak its name. Kelly's decision to exclude the self was radical in terms of his art. Once seen as a gay nonconformist, Kelly is often viewed through a heterosexual lens and reduced to a roommate.

Ken Kelly
1955, Arkansas, USA
• Born in Magnolia, Arkansas Kelly, like Richmond Burton, is interested in abstraction and how it can contain or imply content or emotion in the formal space of the picture. To that end, Kelly uses repetition of patterning, doubling (like beautiful Rorschachs) and layering to achieve pictorial and emotional

Bhupen Khakhar, **Seva**, 1986, oil on canvas, 117 x 112 cm. Courtesy of
Bryan Mulvihill

Terence Koh, **MJ MJ**, 2003, Hershy chocolate, wood, plastic, cloth, 41.91 x
11.43 x 11.43 cm. Unique. Courtesy of Peres Projects, Los Angeles

depth. Works like *Lick* (1994) or *Tart*
(1994) feature whip-like tendrils
branding the canvas with visual tribal
tattoos. In *Spike* (1994) layers of white
vertebrae draw the viewer's eye deep
into the body of the painting, even
more so in *Punch* (1994), which
alludes to intestines and fisting, yet
they remain pattern, abstract, func-
tioning in the margin.

Bhupen Khakhar

1934–2003, Baroda, India
• Khakhar was educated as an account-
ant (Bombay University, 1956) before
studying art criticism (University of
Baroda, 1964). Part of the Baroda
School, he was seen as an outsider
owing to his Pop style and use of the
vernacular. 'Through his reference to
street art Khakhar produced a sign sys-
tem for denoting, thus signifying
kitsch' (Juncosa, 2002: p28). His *faux
naïf* works depicted ordinary Indians
(*Factory Strike*, 1972) along with homo-
erotic works (*Ranchodbhai Relaxing in
Bed*, 1977). He exhibited at the Second
Triennale of India (1972), where
Howard Hodgkin first encountered his
work and the two eventually became
good friends (Juncosa, 2002: p16).
 As India became an inspiration for
many Westerners, they too were of
interest to many in the post-colonial
world. Khakhar taught at Bath

Academy (UK, 1979), and showed with
Hockney before returning to India,
where the 'major feature of his work at
this time was the inclusion of gay sexu-
ality as a theme, which enabled him to
explore more fully the representation
of identity from self' (Juncosa, 2002:
p18). Khakhar's self-portraits (in erotic
situations) are set within a greater
Indian context. The individual experi-
ences their sexuality within the domi-
nant's gaze. Khakhar placed himself in
a vulnerable position (homosexuality is
still illegal in India) with works like *You
Can't Please All* (1981). His nude self-
depictions and frank representations of
his object choice (much older men)
exposed his inner self (*Picture Taken on
their 30th Wedding Anniversary* 1998).
 The BBC commissioned Khakhar to
paint Salman Rushdie (*The Moor*,
1995), giving him greater public aware-
ness. His late work features homo-
erotics, tension between Hindus and
Muslims, and the dominance of
Bollywood and its effects on contem-
porary society (*Beauty Is Skin Deep
Only*, 2001). Timothy Hyman's book on
Khakhar helped place his achievements
in international perspective. He contin-
ued to paint and exhibit up to his
death, receiving a major retrospective
at the Reina Sofia (Madrid, 2002).

Terence Koh *(formerly asianpunkboy)*

1969, Singapore
• Koh's family moved to Canada when
he was twelve, and he studied architec-
ture (University of Waterloo, Canada)
before moving to New York to set up a
gay, punk fashion website which quick-
ly caught the attention of the art
world. He was picked as one of A. A.
Bronson's *Top Ten* for Artforum (2002),
and as Koh, will be represented in the
2004 Whitney Biennial. His recent
installation *The Whole Family* (Peres
Projects, 2003) featured a basement
room completely covered in white pow-
der, and looked at issues of race and
gender. Seemingly disconnected sculp-
tures came into focus as a whole. One
work featured two casts of a Michael
Jackson statue staring at each other.
The casts were made of dark chocolate,
which fade in colour over time.

Thomas Lanigan-Schmidt

1948, New Jersey, USA
• Born in Elizabeth, New Jersey,
Lanigan-Schmidt's family brought him
up in within a religious environment,
which he has transcribed on to his
work. He attended Pratt and studied at
the School of Fine Arts (New York),
where he started to make complex
installations and sculptures often cov-
ered in a multitude of kitsch objects as
faux shrines or religious votives. His *The*

*Infant of Prague as a Personification of
Liberation Theology* (1986–87) features
snapshots, feathers, tape, staples,
bells, cling film, foil, toilet paper, plas-
tic flowers and Christmas garlands. The
work references the famous Czech
sculpture of 1628 as well as contempo-
rary internal conflicts in the Catholic
Church. It is at turns an honest shrine
and an ironic look at his background.
His work has addressed abuse by
priests, domesticity, class, taste and
homosexuality, all with great wit while
pretending to be naïve.

Charles LeDray

1960, Washington, USA
• Born in Seattle, LeDray was, 'taught
to sew at the age of four by his mother,
The artist subsequently trained himself
to fashion other materials into tiny
replicas of real, crafted or industrially
manufactured objects' (Townsend,
2002: p119). LeDray reworks the every-
day into miniature form, distilling the
essence of his finely crafted objects.
Needlework, long seen as woman's
work, punctures the expectations of
what art by same sex lovers can be
about. In remaking clothing associated
with gay men (clone outfits, *Charles*,
1995 or *Village People*, 1993), he finds a
way to get beneath the skin of things,
while depicting them.

Matts Leiderstam, **The Meeting or Bonjour Monsieur Courbet** (Aire de Saint Aunès, east), 1999–2000, 2 c-prints, editions: 6+I AP, 170.4 x 206.I cm, Photo: Per Hüttner and Fredrik Sweger and Jean-Luc Fournier. Courtesy of Andréhn-Schiptjenko, Stockholm

Matts Leiderstam

1956, Gothenburg, Sweden

• Leiderstam has created a series of works where he re-paints classically inspired paintings (his *Returned* series) to examine how they construct nature (via Arcadian landscapes), form social mores and function in his own work. Leiderstam researches his painterly projects so that they function as site-specific installations. For his *Montpellier* work (and most other projects) he used the *Spartacus Guide* (a gay travellers' handbook) to find a motorway lay-by near the city that had cruising sites where men find anonymous sex. The guide also informed him that the Fabre Museum with Gustave Courbet's painting *The Meeting or Bonjour Monsieur Courbet* (depicting the artist walking on a country road meeting two other gents) could be found locally. While the men in the painting happen to be Alfred Bruyas (Courbet's benefactor) and his servant, Leiderstam evokes the possibility that there may be other ways to read this roadside meeting, by restaging the painting at the two A9 (Aire de Saint Aunès) rest stops (east/west). There, where gay sex was definitely available, he painted two similar rural scenes in Courbet's style. He then placed the paintings *in situ*, and photographed them from behind on site at night when cruising takes place (turning the viewer into a voyeur), and from the front during the day at his Stockholm studio (where the viewer sees only a reproduction of an interpretation).

Michael Leonard

1933, Bangalore, India

• Leonard studied at St Martin's School of Art (1954–57) before working as a freelance illustrator. His graphic works softened as he attempted to steer his work towards fine art. His realist homo-erotic works caught the gay *Zeitgeist*, and he entered a long relationship with the Fischer Gallery, London. Works like *Bathers with Yellow Towels* (1980), *Changing* (1981), *Seated Nude* (1983) and *Torso* (1984) recall Ingres, as well as gay male bathhouses the world over. Lincoln Kirstein became a supporter and sat for a confrontational portrait, which shows how attractive he remained, but hints at Kirstein's vanity. Kirstein has said of Leonard' 'He has little interest in the inverse snobbery of reductive deformation … Nor does he flatter … Individual uniqueness is sought, and celebration intended' (Lucie-Smith, 1985: p5).

Micah Lexier

1960, Winnipeg, Canada

• Many of Lexier conceptual works are explained by their titles as in *Self-Portrait as a Lucite cube divided proportionally between a (red) volume representing life lived and a (clear) volume representing life to come, based on statistical life expectancy* (1995) in the form of a 15-centimetre cube. Others feature laser-cut steel phrases as in *Quit Fire: Memoirs of Older Gay Men* (1989), where the words 'I like sex, but I like it with someone who's read a book' are illuminated from behind, or the work *Me* (1993), which glows with the word 'you'. Lexier also subtly entered the political arena with his five sets of *Gentlemen Rings* (1989), which comment on marital possibilities (or the lack of them) for same sex lovers.

Glenn Ligon

1960, New York, USA

• Raised in the Bronx, Ligon's paintings explore the place between text and meaning; quotes from literary sources (James Baldwin) are painted over and over until text becomes image, and it too becomes the other, as in *Stranger in the Village No. 12* (1998). Many of Ligon's works address media stereotypes of black men. *Cocaine (Pimps)* (1993), features the stencilled text of a joke by black American comedian Richard Pryor: 'Niggers be holding their dicks too …

White people go, "Why you guys hold your things?"

Say, "You done took everything else, motherfucker."'

Ligon critiqued Mapplethorpe's representations of black men in *Notes on the Margin of the Black Book* (1991–93). The installation featured images from Mapplethorpe's *Black Book*, framed with additional commentary exploring Mapplethorpe's fascination/obsession with the naked black male body (Golden, 1994: p138). Ligon had a mid-career retrospective at the ICA, Philadelphia (1998), one-man shows at the Brooklyn Museum of Art (1996) and the Hirshhorn (1993), and was included in the Venice (1997) and Whitney Biennales (1993) and the book *Black Male: Representations of Masculinity in Contemporary Art*, (1994) by T. Golden (Whitney Museum).

Ligon as an open gay black man (Arning, 1998: p4) looks at his sexuality fours-quare in *Lest We Forget* (1989), making cast metal plaques marking remembrances of sightings of desirable men, which didn't culminate in a meeting. The plaques were then installed at the locations he originally sighted his objects of desire.

John Lindell

1956, California, USA

• Born in Pasadena, Lindell (a former member of Gran Fury) makes stencil templates for wall logic diagrams.

Micah Lexier, **Me**, 1993, laser-cut stainless steel, fluorescent light, 15.24 x 45.72 x 7.62 cm. Courtesy of Ydessa Hendeles, Toronto

John Lindell, **Relay Race**, 1994, ink on wall, 279.4 x 604.52 cm. Courtesy of the artist

Andrew Logan, **Millennium Pegasus** (Scotts Green Island, Dubley By Pass, UK), 2001, bronze, glass, stainless steel, 4.5 m high. Courtesy of Andrew Logan's Museum of Sculpture, London

Mercury Delayed (Grey Art Gallery, NYU, 1995) featured four abstractly erotic images layered on to the wall. The largest symbols representing the *Platonic/Ideal* were made with HB pencil, the *Spiritual* in silver, the *Logical* in thick black lines, and solid black images formed the *Physical*. Lindell's visual instructions send mouths to penises or testes, followed by intercourse, and are intended to create a visual 'delirum'. The design for the drawing was based on the work of Alan Turing, the Second World War computer genius who committed suicide after being arrested for homosexual acts in private. Lindell has also made a series of free-standing sculptures that are exact replicas of the leather props used by Bruce of LA.

Herbert List

1903–1975, Hamburg, Germany
• List studied art history (Heidelberg University) before working for his family's coffee firm, for which he travelled to Brazil, Costa Rica and the US. Half - Jewish, List spoke English, French, Italian, Greek and German. He moved to Hamburg (1929) and while running the business, became an avant-garde photographer. He met and photographed celebrities of the day (Cocteau, Picasso, Dalí, Magritte, Dietrich) and Stephen Spender wrote

about him and his carefree inter-war years. He moved to Paris (1935/6) to escape the Nazi repression of homosexuals, working for *Vogue* and *Harper's*, and the commercial photos were a change from his surrealist works. List fled to Greece as the Germans swept through France, and his images changed again. Now more classical in feel, they took on a deeply homoerotic quality. Once again, as Germany swamped Greece, List took flight, but settled in Munich where he was drafted and sent to Norway. List worked for Magnum after the war and brought out several photo books, gaining a reputation as an artist as well as a photojournalist. His *Junge Männer* images of idealised, sculptured male bodies have long influenced younger contemporary artists.

Andrew Logan

1945, Witney, UK
• Logan refers to himself as an 'English eccentric', and after studying architecture he has made sculpture and jewellery (most featuring his signature broken mirrors) and created stage designs, and is best known for his *Alternative Miss World* pageants (which started in 1972 as a spoof of the Crufts Dog Show). These outlandish crossgender performance art events have been won by Derek Jarman, a robot

Glenn Ligon, **Lest We Forget**, 1998, cast aluminium and bronze plaques and colour photographs, photographs 23.5 x 35.56 cm. Photograph by Dennis Cowley, © 1998 ArtPace | San Antonio, originally commissioned by ArtPace | San Antonio

Attila Richard Lukacs, **True North**, 1989, oil, gold leaf on canvas, 128.59 x 247.65 cm. Courtesy of the artist

and a marching band. Recently he set up the Andrew Logan Museum of Sculpture (dedicated to his own work) in the village of Berriew in Wales.

Attila Richard Lukacs

1962, Alberta, Canada

• Lukacs was born in Edmonton, Alberta. From Lukacs' first paintings the male nude has figured large in scale and number. Moving to Berlin (1986) he became part of the gay skin-head community, which he painted in all variety of situations. His show at the Künstlerhaus Bethanien (1988) featured *Where the Finest Young Men ...* (1987) and *Authentic Décor* (1988), ironically depicting neo-Nazi skinheads as erotic objects. Lukacs then made a series of paintings based on military academy brochures (1990) depicting all-American youth in various strenuous activities. Their cropped hair and politics were contrasted with those of skinheads and Eastern European communism, as in his *Varieties of Love* exhibition (Diane Farris Gallery, Vancouver, 1992). Lukacs took a vast studio opposite the infamous Lure (gay sex club, New York, 1996) expanding his work into history painting, remaking Tuke's *Noonday Heat* with his type of young man. He has since returned to Canada.

George Platt Lynes

1907–1955, New Jersey, USA

• Lynes was born in East Orange, New Jersey. His 'distinctive black and white photography was born from a desire to create fiction. Initially writing a novel, he subsequently took up a camera to depict narrative. He befriended Gertrude Stein, who introduced him to Pavel Tchelitchev. Their friendship was artistic and non-sexual. 'In 1928 Lynes made his second journey to France' (Crimp, 1993: p138) with Glenway Wescott and Monroe Wheeler, who became his lovers. Cadmus painted this *ménage à trois* in *Conversation Piece* (1940). Lynes photographed his circle of friends including Cadmus, Cocteau, Beaton and René Crevel (his occasional lover, whom he shared with Tchelitchev) (Crimp, 1993: p139).

Lynes showed in the first exhibition to include photography at the Museum of Modern Art (1932), organised by Lincoln Kirstein, a friend from the Berkshire School (1923) (Leddick, 1997: p23). Kirstein was photographed by Lynes and painted by Tchelitchev. A balletomane, Kirstein introduced Balanchine to New York, and Lynes then made a series of dance images. Lynes worked with gallerist Julien Levy and by 1934 was making distinctive commercial fashion photography (Tchelitchev painted the backdrops).

George Platt Lynes, **Monrow Wheeler**, two-picture study (detail), c. 1931, gelatin silver, vintage print, 24.13 x 19.69 cm. Courtesy of John Stevenson Gallery, New York

Martin Maloney, **Love Bug**, 2001, 24 colour screenprint, 43.18 x 73.66 cm, artist proof. © the artist. Courtesy of The New Art Gallery, Walsall

Lynes continued with dance photography and 'many of the principal dancers became Lynes' intimates, and were frequently enlisted in much of his erotic work' (Crimp, 1993: p142).

In 1942 his lover and photographic model/assistant, George Tichenor was killed in the Second World War (Woody, 1981: p10). He photographed Marsden Hartley (1943) who had lost his lover in the First World War, linking their tragedy in one image, the older painter seated in the foreground with a mysterious, out of focus young man hovering in the back. Lynes moved to Los Angeles to work for *Vogue* (1946), but personal disasters led him back to New York and bankruptcy. Wescott began a sexual affair (1951) with Alfred Kinsey (Gathorne-Hardy, 1998: p354) after giving him a sexual history (masturbating on film for Kinsey's research), and put Lynes in touch with the scientist. Kinsey amassed a collection of Lynes' work for his Institute. Kinsey's collection was bolstered by the unimaginable success of *Sexual Behaviour in the Human Male*. Lynes photographed Kinsey, as well as other artists (French, Ernst, Cartier-Bresson) and writers (Isherwood, Forster, Tennessee Williams, Somerset Maugham).

Cadmus, French, Tooker and Bernard Perlin painted many of the models

Lynes photographed (including his lover Charles Howard). The men swapped finds, in and out of bed, recording their youthful beauty. Their views of the same man are often radically different, as would be expected, but what is remarkable is the friendships that formed and lasted once the sexual side of relationships lapsed. During his life, nude male images were all but publicly unseen. Kinsey had to have his prints hand-delivered to prevent Lynes from being arrested for sending corrupting material through the mail. A lifelong smoker, Lynes died of lung cancer.

Martin Maloney

1961, London, UK

• Maloney went to Goldsmiths (1991–93) when the YBA phenomenon was in full swing. Disdaining their hands-off approach, he took to the then unfashionable practice of applying paint to canvas, making comic (though serious) paintings often based on classical references. Maloney wrote for *Artforum* and *Flash Art*, and ran a gallery (Lost in Space) from his home. He also curated *Die Young Stay Pretty* for London's ICA (1998), and was included in Saatchi's *Sensation* (1997). His *Sex Club* paintings (1998), depicting scenes of gay sex in a humorous, everyday fashion, brought him to an even

wider audience. Recent work using cut pieces of paper and vinyl to make the image (instead of paint) were included in Saatchi's *New Labour* (2001).

Robert Mapplethorpe

1946–1989, New York, USA

• Born in Floral Park, Long Island, Mapplethorpe's Roman Catholic family didn't approve of his artistic aspirations. He went to Pratt (where his father Harry had studied engineering), joining the ultra-right Pershing Rifles army ROTC unit (to appease his father who continually threatened to withdraw funding). His ROTC friends and staff grew concerned when he allowed his pet monkey to die of starvation and made a musical instrument from its skull. Experimenting with drugs, he took LSD before his Army medical, securing a discharge (Morrisroe, 1995: p45).

Mapplethorpe met Patti Smith (1967) and they became lovers, sharing androgynous looks and the hippie scene. She convinced him to give up his job to focus on art. Working at a bookstore, she stole from the till for their joint support (Morrisroe, 1995: p53). Mapplethorpe, not wishing to provoke his family's disapproval, introduced Smith as his wife. The family were shocked by the couple's appearance and unconvinced by the marriage. Smith left Mapplethorpe for artist

Howard Michels, and Robert confronted his same sex desires, flying to San Francisco to see if he was 'gay' (Morrisroe, 1995: p58). On return his work became homoerotic, and Mapplethorpe himself became a rent boy after seeing *Midnight Cowboy*. Smith returned to Mapplethorpe, and then moved to the Chelsea Hotel (1970), where he met Sandy Daley, his first photographic mentor. Her room contained books on photography, a flower vase and a Polaroid camera. Daley accompanied Robert (without Smith) to S&M bars. Smith and Mapplethorpe then moved into a loft where he made sculptures from gay porn. When curators viewed the work, its content frightened them off, and homosexual gallerists feared it would compromise their closeted status.

In 1970 Mapplethorpe met model David Croland and they became lovers to Smith's irritation. Using Daley's Polaroid, Mapplethorpe photographed Croland, who introduced him to Halston, the uptown fashion scene and John McKendry (curator of photography at the Metropolitan). McKendry introduced Mapplethorpe to Henry Geldzahler, who in turn introduced him to Hockney and a host of beneficial contacts. When McKendry took Mapplethorpe to London (where he met Jarman), it destroyed his relation-

Robert Mapplethorpe, **Star (Black)**, 1983, frosted mirror (black), wood, unique, unsigned, 119.38 x 124.46 cm. Courtesy of Alison Jacques Gallery. © Robert Mapplethorpe Foundation, used with permission

ship with Crosland. Under McKendry's tutelage Mapplethorpe handled vintage prints (including Eakins' male nudes), and McKendry gave him a Polaroid camera. As the relationship was essentially non-sexual (with one exception in London), McKendry's wife was not concerned, yet as McKendry's infatuation grew, so did his drug abuse. Mapplethorpe cut off contact, but photographed McKendry on his death-bed.

Mapplethorpe said of his lover Sam Wagstaff (1972): 'If Sam hadn't had the money, I might not have been involved with him. He was a package so to speak' (Morrisroe, 1995: p111). Wagstaff, a rich, older (50), debonair curator, took Mapplethorpe under his wing, and taught him about art. Both acknowledged that Wagstaff played surrogate father, by turns generous and miserly (making Mapplethorpe plead for cash). Mapplethorpe's one-man show of Polaroids (Light Gallery) saw society collectors mix with drag queens and leathermen (Celant, 1992: p320). Convinced by Mapplethorpe to buy a Von Gloeden folio, Wagstaff, who had disdained photography, took up collecting with a passion. Participating in a group show through Smith's intervention (with Warhol and Brigid Polk, 1973), Mapplethorpe repaid the favour by giving her $1,000 of the $50,000 Wagstaff had given

him, so she could record two songs. Warhol disliked them, and Mapplethorpe saw that his hero was a potential art world enemy. Wagstaff redoubled his efforts to puff Mapplethorpe to great effect. By 1974, Mapplethorpe was using a plethora of drugs, and engaged in the S&M scene (without Wagstaff) for anonymous sex, as a 'top' (Morrisroe, 1995: p145). Many sex partners found their way on to film when Wagstaff gave Mapplethorpe a Hasselblad. Smith commissioned Mapplethorpe's cover photo for her debut album, *Horses*, propelling them both into public awareness. By the end of 1975 his sexual relationship with Wagstaff was over, although they remained friends.

In San Francisco (1976) Mapplethorpe became immersed in the S&M scene, shooting the cover for *Drummer* magazine (No. 24). He travelled between London and Paris taking society portraits of those with whom he had networked, first McKendry, then Wagstaff. One such man worked for Holly Solomon, and she agreed to show him, saying, 'I wouldn't have touched Robert without Sam. And there were others like me who felt the same way' (Morrisroe, 1995: p172). Solomon presented his society portraits; erotic images were shown at the Kitchen. The double exhibition was a

success and Wagstaff threw a dinner for 200 art world glitterati. His parents saw the Solomon show (on its last day), with ludicrous results; Mapplethorpe's father disparaged Robert's lack of technical know-how, yet, ever the proud dad, suggested to a colleague that he see the show. The man went to the Kitchen by mistake, and informed Harry that his son may have exhibited pictures of Princess Margaret at the Solomon gallery, but the Kitchen was filled with raw gay imagery (Morrisroe, 1995: p186).

In 1978 Mapplethorpe produced his infamous *X Portfolio* of transgressive gay sex. He got men to go beyond their normal boundaries by saying, 'Do it for Satan' (Morrisroe, 1995: p1192). Mapplethorpe belonged to a coprophiliac network. Robert Miller wanted to show Smith's drawings, and she accepted on condition they also show Mapplethorpe. The show was a media success. Wagstaff's photo collection was shown at the Corcoran Gallery (1978), with Mapplethorpe's work on the catalogue's cover, despite Wagstaff's new infatuation with Gerald Incandela (whom he met through Jarman). Mapplethorpe's taste for hyper-masculinity led him to black men, frequenting specialist bars where rich whites hired black hustlers. Many appeared in a series of works, which

when shown, saw Mapplethorpe accused of racism. He met a young black sailor, Milton Moore (1980) and their relationship produced *Man in Polyester Suit*. The reduction of a black man to his penis caused great offence. 'The reception of the photographs, the controversy they provoked, speaks volumes about the fear of black masculinity' (Gloden, 1994: p33). Their abusive relationship led to Moore's mental deterioration, Moore becoming a danger both to himself and to Mapplethorpe.

Mapplethorpe's younger brother Ed became his studio assistant, as Robert came down with the first signs of AIDS (1982). Sandy Nairne organised his first major retrospective (ICA London, 1983). It included S&M images that were stopped by Customs, returned to New York, and smuggled back for the show. A decade later (Hayward Gallery, London, 1992), a similar situation occurred, forcing the gallery to remove three images from the catalogue (Celant, 1992: insert). Jealous and insecure, Robert forced Ed to use their mother's maiden name when both were included in a group show (1984). Ed quit and was replaced by a Spanish photographer, who also replaced Mapplethorpe's then lover, Jack Walls. Wagstaff's lover, Jim Nelson (whom Mapplethorpe had selected in San

Angus McBean, **Boy with Rhubarb**, 1938, photograph, 35.56 x 30.48 cm. Courtesy of the Collection of Leslie-Lohman Gay Art Foundation, New York

John McLachlin, **Joe and Adele**, from the Homework series, 2003, c-print, 17.78 x 27.94 cm. Courtesy of the artist

Francisco and sent to New York), was diagnosed with AIDS (1985). The make-up artist never replaced Mapplethorpe in Wagstaff's affection. Wagstaff felt Nelson was too effeminate to squire in public. Wagstaff gave Mapplethorpe a $500,000 loft on publication of *Certain People*, and Richard Marshall commissioned *50 New York Artists for the Whitney*. Mapplethorpe was hospitalised with pneumonia (1986), and Wagstaff soon died from an AIDS–related illness (1987) (Morrisroe, 1995: p317).

Wagstaff left 75 per cent of his $10,000,000 estate to Mapplethorpe and 25 per cent to Nelson. Wagstaff's family unsuccessfully contested the will. As executor, Mapplethorpe evicted Nelson to sell Wagstaff's penthouse, but made him a settlement (Morrisroe, 1995: p319). As news of his illness grew so did sales of his work. Mapplethorpe continued to have unprotected sex with pickups, and was criticised for his insensitivity. Ed returned from Los Angeles, looking after Robert's studio, as the only family member who knew he was gay. As his illness worsened, his fame grew, and he was celebrated with a retrospective at the Whitney (1988), then a touring retrospective, *The Perfect Moment*, for Philadelphia's ICA (which he was too ill to attend). The Miller Gallery sold $500,000 worth of

prints in one month (unique images went for $10,000) (Morrisroe, 1995: p357). He was hospitalised and died in 1989. As his retrospective tour started, it became the focus of right-wing fury; Washington's Corcoran Gallery caved in to their threats and the culture war was in full swing (see 2.2.1). The fame and notoriety Mapplethorpe sought eventually threatened to consume his reputation.

Keith Mayerson
1966, Ohio, USA
• Mayerson was born in Cincinnati. He was included in the *Stonewall 25: Imaginings of the Gay Past, Celebrating the Gay Present* (White Columns, New York, 1994) and *FAGGOTS* (Rojes Foundations, University of Buenos Aires, 1995), both curated by Bill Arning. He worked with Dennis Cooper creating an artists' book *Horror Hospital Unplugged* (1996). His works, mainly drawings, explore queer fantasy and American norms, and focus on issues of gay identity.

Angus McBean
1904–1990, Newport, Wales, UK
• McBean's first exhibition (of photos and theatrical masks) at a London tea shop brought him to the attention of photographer Hugh Cecil, who hired him as a studio assistant. On opening

his own studio specialising in clean modern portraits, he was soon sought after (even glamorising Quentin Crisp). Yet it is in his work for the Stage Photographic Company that he excelled, developing a style of portraiture that tried to mimic performance. In crazily imaginative portraits, he captured the interior essence of then unknown actors like Gielgud, Olivier and Vivien Leigh. By the 1930s his work was even more surrealist: antlers were attached and heads poked through miniature stage sets (Audrey Hepburn). In *Self Portrait with Third Eye*, an eye emerged superimposed in front of his mouth. After the war his work took a more serious turn, using everyday props that related directly to his clients' lives. In the 1960s he photographed the Beatles for their first and *Greatest Hits* album (at the EMI building) but retired soon after.

McDermott & McGough
David McDermott, 1952, California USA
Peter McGough, 1958, New York, USA
• David McDermott was born in Hollywood, while Peter McGough was raised in New York. McDermott & McGough have lived and worked together (dressing like Edwardian dandies) in an effort to recreate the past in the present. Their quirky paintings and photographs are double

dated, as the pair claim to be able to time travel. Works like *Chart 5* ('1904', 1990) often feature witty sayings painted in the manner of old posters. *Chart 5* features a profile image of a man's head with areas of the brain labelled (Waldo, Lance, Adam) with the inscription below it, 'He loved boys, artists and aristocrats' (Bonuomo, 1996: p61). The painting is signed and dated 1904 by the artists. In their photography, they make prints using traditional nineteenth-century methods to ironically evoke Romanticism, the Pre-Raphaelites and freemasonry in works like *Shocked to Read that Jesus Christ Associated with the Poor and Humble* ('1927', 1989) (Durant, 1998: p68). The evocative blue cyanotype depicts a gentleman seated beside a tree, wearing an elaborate costume (straw hat, cravat, cane), with one foot in a bowl of water and reading a book in dismay. They have also photographed Gilbert & George, their artistic parents, the genitalia of white marble statues and many antique domestic and religious objects.

John McLachlin
1959, Toronto, Canada
• McLachlin initially made works that focused on gay male desire in the form of iron-on transfers for pillow-cases and bed sheets featuring the faces of male porn actors, allowing the viewer to

David Medalla, **Cloud Canyons 2**, 1964, bubble machine ensemble, London (detail), photo 24.13 x 19.05 cm. Photograph by Clay Perry. Courtesy of Guy Brett

Duane Michals, **Man and Serpent**, photographed 1989 (printed 1991), platinum metals and gum, unique print, 22.86 x 34.29 cm. Courtesy of John Stevenson Gallery, New York

sleep with the stars. Recent works have focused on photography, where he alters images in the manner of police shots of crime scenes with faces blanked out to protect the innocent. McLachlin not only highlights self-censorship, but takes the power of the dominant in his own hands, evidencing the fluidity of legality.

David Medalla and Adam Nankervis

David Medalla, 1942,
Manila, Philippines
Adam Nankervis, 1965,
Melbourne, Australia

• Medalla is one of the first generation of Fluxus artists, having worked and performed worldwide, making happenings, installations and time-based sculptures. Medalla (London based) helped to found the seminal Signals Gallery (1964) with Paul Keeler, and acted as the first curator for the Lisson Gallery. Many of his important time-based 1960s and 1970s works have been remade, including the *Bubble Machines* for his exhibition *The Secret History of the Mondrian Fan Club. Mondrian in London* (1995). Medalla and his partner, the Australian artist Adam Nankervis, are the founder and vice president of the Fan Club, currently make performances together, and run The London Biennale. The pair are currently spelling Mondrian's name across the globe (using skywriters) to place one letter in a different city's sky at the rate of one letter per year.

Robert Medley

1905–1994, Devon, UK

• Medley attended the Royal College of Art (1923) and the Slade. In 1925 he met dancer Rupert Doone, the start of a lifelong partnership. Doone had previously been Cocteau's lover, working with him in Paris (1924). Cocteau had introduced Doone to Diaghilev, and when Doone and Medley moved to Paris (where Medley studied at the Académie Moderne), Doone passed on the introduction, allowing Medley to design for the Ballets Russes. Returning to London, Medley became friends with Duncan Grant, was a member of the London Group and was part of the *International Surrealist Exhibition* (London, 1937). Medley and Doone also formed the Group Theatre (1932), which mixed artists (Duncan Grant), writers (Stephen Spender), musicians (Benjamin Britten) and poets (T.S. Eliot). Doone directed and Medley designed the sets for W. H. Auden's collaborations with Christopher Isherwood: *The Dog Beneath the Skin* (1936), *The Ascent of F6* (1937) and *On the Frontier* (1939). When war came, Medley volunteered as a war artist, and then painted camouflage for the Royal Engineers (1940–45). After the war he taught at the Slade (1951) and then at Camberwell (1958), where he was Head of Fine Art until 1965 when he had to retire to look after Doone (who had developed multiple sclerosis and died in 1966). Medley wrote touchingly of their joint life in his memoir *Drawn from Life* (1983), and became a Royal Academician in 1986.

Bjarne Melgaard

1967, Sydney, Australia

• Melgaard's installations mix paintings, sculptures, drawings and posters to create aggressively queer landscapes like *Everything American is Evil* (Kiasma Museum of Contemporary Art, Helsinki, 1998) or *Reinterpretation on Crystal Meth II* (São Paulo Bienal, 1998). His scattered mix of seemingly unconnected fetish objects includes the *Planet of the Apes* and hard-core gay sex magazines. Melgaard' also has a fascination with Ray Johnson and many references to his work can be found in Melgaard's. Melgaard's studio (above a gay bar in Oslo) was burnt out in 2001, destroying a large body of works and archives.

Duane Michals

1932, Pennsylvania, USA

• Born to a working-class family in McKeesport, Michals was brought up by his Czech grandmother, attending art classes at the Carnegie Institute. After going to the University of Denver (1953) he was drafted, serving in Germany. On his return, he studied at Parsons (1956) and started working for *Dance* and *Time* magazines. He visited the Soviet Union (1958), and his photographs of the trip formed his first body of published work (Image Gallery). He produced commercial photography for *Vogue, Esquire* and theatre productions. *Take One and See Mt. Fujiyama* (1976) was published under his pseudonym Stefan Mihal, 'the person who, by rights, he should have become: a factory worker, married with children' (Livingstone, 1984: biography) as opposed to an artist exploring his same sex desires.

His photo series feature his handwritten texts or titles along with sequences of narrative images. Michals uses natural light and black and white film for his artistic work, using colour only for commercial work. Many series feature religion, such as *I Am much Nicer than God* (Michals was raised a Roman Catholic) or his personal experiences an open gay man (Livingstone, 1984: p4 of "A Meeting with Duane Michals"). He has stated, 'I like my photographs to have an atmosphere. Never an overt sexuality' (Livingstone, 1984: biography). *Salute, Walt Whitman* (Michals, 1996) explores a continuity of

Keith Milow, **DATA III**, 1994, iron, resin and fibreglass.
76.2 x 61 x 7.6 cm. Private collection, London

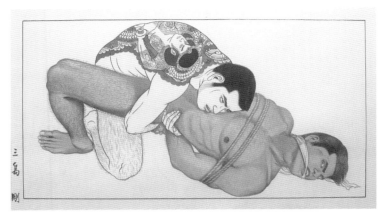

Goh Mishima, **Two Men**, c. 1980, graphite and wash on paper, 25.4 x 43.18 cm. Courtesy of the
Collection of Leslie-Lohman Gay Art Foundation, New York

same sex history between different generations of artists. Solo exhibitions include the Museum of Modern Art (New York, 1970) and the Museum of Modern Art Oxford (1984). Michals was awarded the Infinity Award for Art by the International Center for Photography (1991) and the insignia of the Order of Arts and Letters by the French government (Bujon de l'Estang, March 1, 2000: website) for his outstanding contribution to the visual arts.

Tim Miller

c. 1960, California, USA
• Miller was born in Los Angeles. He became a performance artist, along with Karen Finley, John Fleck and Holly Hughes, became known as the NEA4, when the National Endowment for the Arts withdrew their grants under pressure from right-wing Congressional members. Their work had been deemed pornographic, homosexual and against 'standards of decency'. Their trial went all the way to the US Supreme Court (1998) and although they were given their grants and costs back, the Court found that the NEA could define such standards. Miller is co-founder of two major American performance art centres, Performance Space 122 (New York) and Highways Performance Space (Santa Monica, where he is the current director).

Miller's work is based on his experience as a gay man and his relationships. Starting with *Live Boys* (with John Bernd, 1981) (Miller, 1997: p130), he made a series of works with his lovers. This was followed by *Buddy Systems* (1985) with Doug Sadownick, and *Carnal Garage* (1997) with current partner, Australian Alistair McCartney. Miller and McCartney are currently fighting deportation, for as a same sex lover, McCartney has no equal rights of residence in America, even though the pair have been together for over nine years.

Keith Milow

1945, London, UK
• Milow moved to New York (1980–2002) where his works (which function as hybrid sculptural paintings) consolidated his reputation. Seemingly archaeological works appear to be ancient Graeco-Roman artefacts but are in fact constructs of names. His own name (*Data III*, 1994) and lists of twentieth-century artists (*Roster I*, 1995) are presented as historic finds. The future is reduced to the past; time becomes fluid as he fools the eye into believing that fibreglass is rusted steel. Mortality and remembrance mark times passing and Milow (not as artist, but as any individual) adds his name to those demanding attention.

John Minton

1917–1957, Cambridge, UK
• Minton studied at St John's Wood Art School befriending Michael Ayrton. They were both English neo-Romantics, and Minton moved to Paris (1939) for independent study, making a series of works owing much to the Surrealists. He and Ayrton designed sets for Gielgud's production of *Macbeth* (1940), having returned to London at the onset of the Second World War. War brought the desolate landscapes Minton had been imagining into reality. War also offered him 'sexual liberation owing to the ease with which pick-ups could now be found' (Spalding, 1993: p10). He joined the Pioneer Corps (1941) and was stationed in Wales, but was discharged owing to bad health. He taught at the Camberwell School of Art (1943) and exhibited at the Lefevre Gallery (1944–56).

From 1946 to 1952, Minton and Keith Vaughan shared a flat in London (Yorke, 1990: p129), not far from the Royal College of Art, where Minton was teaching. Minton's unrequited attachments to heterosexual men saw his moods swing and his drinking increase. Minton commissioned his friend, Lucian Freud, to paint him (1952). The portrait conveys much of Minton's anguish, and now hangs at the Royal College. 'Minton would have been the first to

admit the relevance of his sexuality to his art' (Spalding, 1993: p14). Minton was effeminate, and having accepted the dominant's paradigm, sought real men, i.e. heterosexuals. His desire for men who were not available led to internal conflict, forming a vicious Catch 22, as anyone who returned his affections wasn't a real man.

Minton's book illustrations were commercially successful (*French Country Cooking* by Elizabeth David), as were his wallpaper designs. Exhibitions of his paintings were well received until Abstract Expressionism brought into question figuration. Minton's reaction was to condemn the new, and he wound up sidelined. With little or no prospect of imminent personal or professional happiness, Minton took his own life.

Goh Mishima

1924–1988, Tokosuka, Japan
• Born Tsuyoshi Yoshida, he appropriated Yukio Mishima's (writer and militarist) surname, itself a pseudonym, originally belonging to a Japanese poet. While serving in the army Goh had his first same sex encounter, and after the Second World War he became part of the emerging Tokyo gay scene, becoming the lover of an American officer. Goh met Yukio in a gym (1955), and Yukio encouraged his drawings,

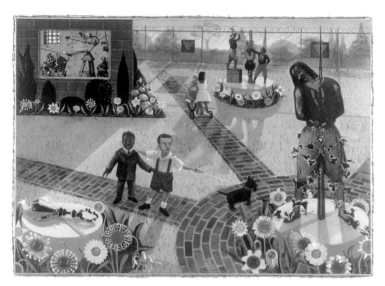

Frank Moore, **Debutantes**, 1992, oil on canvas with attachments, 129.5 x 175.3 cm Courtesy of Sperone Westwater, New York

including those depicting genitals (which was then illegal), and Goh took his name to honour him. Many of Goh's images depict tattooed Japanese mafia men (Yakuza) in sexual situations. Goh's work became increasingly violent after Yukios's suicide (1970) by hara-kiri. Goh founded and edited *Sabu* (1974), a hard-edged male magazine (along the lines of Tom of Finland) that promoted gay sexuality and liberation. Goh made all the cover graphics before dying of cirrhosis.

Donald Moffett

1955, New York, USA

• Moffett was a co-founder of Gran Fury, and started BUREAU (1989), a trans-disciplinary studio to make works that crossed media for social change, which developed from his radical political and social observations. Like many in the ACT UP movement, he used his anger at governmental inaction during the AIDS crisis to make agit-prop works used during their campaigns, which remain sophisticated works of art (*Call the White House*, 1990). Recent works on canvas have featured conceptual explorations of painting, representation and the act of looking, as in *The Incremental Commandments* (2000), based on the Ten Commandments. The work explores how the basis of Judeo–Christian mythology has

become secular law. Each painting, incrementally bigger than the last, painted a deep black, speaks of profound darkness and the muteness of knowledge. He has exhibited in *The Inward Eye: Transcendence in Contemporary Art* (CAM, Houston, 2001), *Power Up* (Armand Hammer Museum, Los Angeles, 2000), *In a Different Light*, (UC Berkeley, 1995), *Don't Leave Me This Way: Art in the Age of AIDS* (National Gallery of Australia, Canberra, 1995), and the Whitney Biennial (1993).

Frank Moore

1953–2002, New York, USA

• A native of New York city, Moore went to Yale (1971) and at a residency at the Cité Internationale des Arts, Paris (1977), became friends with Jim Self, a dancer with Merce Cunningham's company. Primarily a painter, Moore started to collaborate with Self on various projects, culminating in the film *Beehive*. Moore returned to studio based work as his lover, Robert Fulps (a clothing designer), became ill. His paintings long contained imagery of danger and threat, and now took on AIDS as imagery. *Farewell* (1989) was painted as a direct response to his and Fulp's HIV diagnosis. After Fulps died (1991) Moore became active with Visual AIDS, as his

Bryan Mulvihill, **Trolley bus serving tea to Chief Guest HH Dalai Lama, at the World Festival of Sacred Music tea party in Hollywood Bowl**, 10 October 1999. Colour photo by Rick Castro. Courtesy of the artists

Piotr Nathan, **The Thief of Melancholy**, 1997, aluminium and plexiglas, each c. 17 x 25 cm. Installation within Sabine Schmidt Galerie, Köln. Courtesy of Sabine Schmidt Gallerie, Köln

own health started to deteriorate. *Debutantes* (1992) posits the dangerous world a gay child must face. The central children face all manner of torture and degradation surrounded by a 'normal' happy coloured world. The work remains one of Moore's most important images. Moore died of an AIDS-related illness.

Cedric Morris

1889–1982, Swansea, Wales
• Born to a wealthy Welsh family, Morris succeeded his father as 9th Baronet (1947) (Morphet, 1984: p17). He went to the Royal College of Music, and at the outbreak of the First World War, tried to enlist in the Artists' Rifles, but was rejected owing to a childhood illness. 'Either on the Armistice night itself [11 November] or on 13 November Cedric met Lett Haines ... and they immediately fell in love. Cedric moved in with Lett and his wife, Aimée' (Morphet, 1984: p19). They remained lovers throughout their lives. Both had affairs with other men (and bi-sexual Haines [d.1978] with women) but always returned to each other. Morris painted Haines, John Banting, Rupert Doone, founder of the Group Theatre (who produced plays for Auden, Isherwood and Sartre), Barbara Hepworth, and café scenes like those of Burra. Morris and Haines moved to

London (1926) where Morris (seen as a Surrealist) represented the UK in the Venice Biennale (1923, 1932).

Morris and Haines started a studio known as The Pounds (Suffolk, 1929), leaving London and Morris' commercial dealers, to sell work through an extended network of friends. During the 1930s Morris was a major force in contemporary Welsh arts and his paintings addressed social issues, the Depression and its effects on the landscape and people. His portraits depicting sitters in harsh close-ups (Peggy Guggenheim's London gallery, 1938) were a success. Morris and Haines founded the East Anglian School of Painting and Drawing, and, although an artist, Haines put his career second to Morris'. 'Lett was much stronger on theory. Cedric heartily disliked talking about painting, and taught by encouragement and by example' (Morphet, 1984: p56). The school's most famous student was Lucian Freud, whom Morris painted (1940). Their first building burned down (1939), and the school relocated to Benton End (1940). They moved in, initially for the duration of the war, but remained till death. Morris had his first retrospective at the National Museum of Wales (Cardiff, 1968), and the Blond Fine Art gallery had a retrospective in 1981, a year before his death from

complications after a fall in his garden.

Michael Morris

1942, London, UK
• Morris and Vincent Trasov (b.1947) created the Morris/Trasov Archive (1969), functioning until 1977. Originally called the Image Bank, the archive is held at the Morris and Helen Belkin Art Gallery, Vancouver. Jointly and separately they produced work under their own names and pseudonyms and were an important part of the Canadian Fluxus and Mail Art movements. Morris was also part of Ray Johnson's New York Correspondence School (Whitney, 1970) and produced collaborative works like *Marcel Duchamp Fan Club*. Image Bank material was reproduced in the collaborative *FILE* Megazine, along with work by General Idea. Morris, under the pseudonym Marcel Dot, became the first Miss General Idea, Trasov as 'Mr Peanut' ran for mayor, and both men helped found the Western Front (1973). At the time General Idea and Image Bank faced fierce homophobia and criticism for their open homosexuality from the Left (Watson, 1992: p22). After Image Bank's demise both artists continued working solo. They remain friends and even collaborate on occasion.

Mark Morrisroe

1959–1989, Massachusetts, USA
• Born in Boston, Morrisroe's parentage is in question; his mother worked as a prostitute to pay her bills. She too was unsure who his father was. Morrisroe claimed that their neighbour, Albert DeSalvo (the Boston Strangler), was his father (White, 2001: p101). A self-destructive teen, he made a living through prostitution and was shot in his left leg (it remained paralysed) (White, 2001: p105). He made beautiful and technically advanced photographs (sponsored by Polaroid), but scandalised the Museum of Fine Arts School (Boston) by painting swastikas. At the school he met Nan Goldin, the Starn Twins (who 'provided for him as he lay dying' [White, 2001: p107]), and his lover, Jonathan, who changed his name to Jack (Pierson) after their relationship ended. Morrisroe photographed Pierson and their love/hate relationship played out in public. Morrisroe was seen as the *enfant terrible* of the group, its guiding light, but the others would achieve fame first.

Morrisroe met Ramsey McPhillips (1987) and they became lovers (White, 2001: p98). McPhillips helped him throughout his AIDS-related illness, and after Morrisroe's death, McPhillips planned to scatter his ashes on his Oregon farm. Stopped at the airport,

McPhillips was made to empty the contents of the box that held Morrisroe's ashes on to the airline counter. A security guard claimed the ashes (in a clear plastic bag) might be hiding a bomb (White, 2001: p111). After the guard had spilt parts of Morrisroe's remains onto the ground, McPhillips was allowed to take his flight and lay Morrisroe to rest.

Bryan Mulvihill

1950, Vancouver, Canada

• Mulvihill's *World Tea Party* has had a multitude of incarnations. Tea is the most common human beverage (second only to water). As its popularity grew, so did the many diverse rituals surrounding it. Mulvihill's project has been to bring together participants in tea rituals from around the world, documenting the parties as performance art, or 'human meeting rituals'. To that end, he has held his 'collaborative, interactive, trans-cultural tea Salon' (Davison, 2000: p22) events on the web, and served tea to the Dalai Lama and 17,000 people at the Hollywood Bowl. Mulvihill relaunched the Horniman Museum (London) with tea for 5,000 (the Horniman was founded by tea merchant) and was artist in residence for the *Hidden Histories* exhibition hosting the New Art Gallery Walsall *Hidden Tea Parlour* (2004).

Marcel Odenbach, **The Idea of Africa**, video installation, 1998, 2 channels, colour sound, installed within Galerie Stampa, Basel. Courtesy of the artist

Jean-Michel Othoniel, **Le Kiosque des Noctambules (Pavilion for Sleep Walkers)**, Palais Royal station, 2000, aluminum and glass, 5.73 x 5.28 m. © ADAGP, Paris and DACS, London 2004. Courtesy of Newcomb Art Gallery, Tulane University, New Orleans

Piotr Nathan

1956, Gdansk, Poland

• Born in Poland, Nathan lives and works in Berlin. His large installations (like those of Gober, Gonzalez-Torres) examine aspects of gay identity from a highly sophisticated conceptual position. Works are often about the translation of one language into another, whether they are telephone numbers translated into musical notes and then performed, or actual casts of bullet holes in Berlin buildings, in his work as 'The outline of the place that was bombed in the last days of the war follows the contour of a urine mark that emerged on the mattress of a person dying of AIDS'. (1992). The body, when present, stands in for the transitory and fragile nature of life itself.

Marcel Odenbach

1953, Cologne, Germany

• Odenbach is one of the pioneers of video installation, making highly technical works even in the 1970s. His interest in social and sexual politics has developed and deepened in complexity of approach and presentation. Odenbach mixes his own and found footage to create disturbing juxtapositions. For *Keep in View* (1991/2), he filmed his then partner (Mike Sale) playing with his dreadlocks and merged it with broadcast stereotyped media images of Afro-Caribbeans and a menacing soundtrack. His work investigates power (often Germany's Nazi past: *Niemand ist mehr dort wo er hin wollte*/Nobody is there any more, where he wanted to be, 1989–90), its structures and allure (*Vogel friß oder stirb*,/Bird eat or die, 1989). His works have been included in Documenta VIII, Metropolis (Berlin, 1991) and *Video Spaces: Eight Installations* (Museum of Modern Art, NY, 1995) with solo shows at the Reina Sofia (Madrid, 1994) and the New Museum (NY, 1999).

Jean-Michel Othoniel

1964, Saint-Etienne, France

• Othoniel has created a series of sculptures wherein glass takes the form of gigantic necklaces, which frame a setting or a wearer. Works are manufactured under his direction, and usually take the form of large installations (*Kiosque des Noctambules*) or elegant and erotic gallery pieces (*Nipples Rondels*). At the New Orleans Mardi Gras, in a work on a smaller, more intimate scale, he handed out 1,001 red glass bead necklaces in exchange for being allowed to take the new owner's photograph wearing the piece, which were then shown at the local Newcomb Art Gallery (2001), as well as the highly charged *Glory Hole*.

Gregorio Pagliaro

1968, Delaware, USA

• Pagliaro was born in Wilmington and later attended the Royal College of Art where his arresting image *you touched my heart* (1998) was part of his notable degree show. The image is deliberately vague; it can be read as a sexual metaphor, an act or simply as a fiction. The artist resists any form of closure in the description of the work, as any real knowledge of its making (other than the photographic nature of it) would drain its obvious power; the ambiguity is all.

Michael Petry

1960, Texas, USA

• Born in El Paso, Petry moved to London (1981) and works as an artist, curator and Co-Director of the Museum of Installation. His artwork deals with queer sensibilities and mainstream reception of them. Early work as a performance artist transformed into large-scale site-specific video installations (*The History of the World*, Rice Art Gallery, 1999), while recent work has involved blown glass, leather and pearls (*The Milky Way and Other Fairy Tales*, Sundaram Tagore Gallery, New York, 2004). He wrote the libretto (music by Greenaway and Powell) and directed a full-scale (performance art) opera, *An Englishman, an Irishman, and a Frenchman*, on the lives of Auden, Wilde and Cocteau at the German National Gallery (1995). His studio work has addressed beauty, mortality and the legal position of same sexuality in *Barely Legal* (2001). The exhibition featured a cast bronze dildo (*Thor*), which technically broke Texas law on the public display of sex toys without a licence. Other works displayed (*45/46*) broke various European laws.

Paul Pfeiffer

1966, Hawaii, USA

• Pfeiffer was born in Honolulu. His early photo installations addressed his Filipino and gay identity, and in the 1990s he was active in ACT UP. He has subsequently found fame using computer technology to create hypnotic looped videos culled from sport and mass culture, disrupting their everyday quality by removing major elements of the footage. Pfeiffer digitally makes Tom Cruise wiggle endlessly in *The Pure Products Go Crazy* (1998). The work alludes to Cruise as a product (in a reference to a William Carlos William's poem) in his famous *Risky Business* scene when clad only in underwear. In other works sportsmen endlessly howl, as in *Fragment of a Crucifixion (After Francis Bacon)* (1999), or are cut out all together as in his *Untitled* (2003) installation for Artpace, based on the San

Gregorio Pagliaro, **you touched my heart**, 1998, print on aluminium, 24.13 x 33.66 cm. Courtesy of the artist

Michael Petry **Thor**, 2001, bronze, length 45.42/girth 15.24 cm. Courtesy of the artist

Antonio Spurs basketball team. The viewer is left with the courtside guard, flashing cameras and the fans but no players. Pfeiffer won the first prestigious Bucksbaum Award (Whitney Museum, 2000) and has recently had a touring retrospective at the Museum of Contemporary Art, Chicago, and the MIT List Visual Arts Center (2003).

Glyn Philpot

1884–1937, London, UK
• Born to a large devout Baptist family, Philpot developed a deep love and friendship for his older sister, Daisy, who looked after his affairs throughout their joint lives. Philpot converted to Roman Catholicism, his faith expressed in many paintings. *Repose on the Flight to Egypt* (1922), *Angel of the Annunciation* (1925), *Le Jongleur de Notre Dame* (1928) and *St Sebastian* (1932) are suffused with spirituality and peopled with beautiful young men. Early works were classical in style, but as he matured (taking on avant-garde influences), the work became more robust. His interest in male models (many were his lovers) could be seen even in the earliest paintings. He reconciled the sexual with the practical in religion, yet his partners taxed as much as inspired him.

Manuelito, the Circus Boy (1909) was his entrée to Edwardian high society.

Shown at the Modern Society of Portrait Painters, it was selected as a British entry for the Venice Biennale (1910) and brought him fame. Philpot now received commissions from the British aristocracy, he was regarded second only to Sargent. Philpot's style also owed much to his friend Charles Ricketts. Philpot became a successful portrait painter, charming his sitters with tales of the theatre and news of other society individuals he'd painted. Portraits like *The Countess of Dalkeith* (1921) and *Lady Melchett* (1927) were offset by paintings of his family, war poet Siegfried Sassoon (1917) and lovers. These included American heir Robert Allerton, the impoverished German Heinz Muller and Vivian Forbes, a minor water-colourist and his lifelong troublesome companion. Philpot also looked after Henry Thomas, a black model who appears in many of his finest paintings and sculptures.

His work was sexually open for the times. *Marble Worker* (1911) won Philpot the Carnegie International (1913), depicting a handsome, shirtless, young man at work. *Melampus and the Centaur* (1919) depicts a full frontal nude with only part of his genitals covered by a drape. *Après-midi Tunisien* (1922) is an allegory of homosexual seduction. It 'is so languid and the suggestion so subtle as to camou-

flage the painting's full meaning. This ambiguity reflects the duality that had marked Glyn's life since childhood. While outwardly conforming to social norms, he was striving to express his own sexuality in his work as in his life' (Delaney, 1999: p52). Philpot's visits to Berlin and Paris led to a radical change in his work by the 1930s, *The Great Pan* (1933) proving the most erotic and socially disturbing. As a Royal Academician, he was entitled to exhibit works in their Summer Show, but *The Great Pan* was refused on moral grounds. He was forced to remove it, causing a public scandal and gathering the first 'Academy sensation' headlines (Delaney, 1999: p126). The central image of Pan (with glowing red eyes modelled on Roland Bishop, a lover) included a man ejaculating flame. Philpot destroyed the painting. The rejection was a hard blow for a man whose first exhibition (Grosvenor Galleries) 'included two grand-daughters of Queen Victoria' (Delaney, 1999: p49). Philpot was out of favour if not out of artistic step, as his work outgrew public taste.

Muller featured in two of Philpot's important late works, *St. Sebastian* and *Triple Fugue* (1931–32). In each, the main figure 'wears a neckerchief, a detail that must have been a particular feature of Muller's dress' (Delaney,

1999: p121). Philpot's erotic, spiritual and artistic temperaments came together in a new style of painting depicting *eros* and *amos*. Philpot met Forbes (who was prone to histrionics), while both served in the army in the First World War, and they lived together throughout all Philpot's other relationships. When Philpot died (a brain haemorrhage, 1937), Forbes asked a friend for sleeping pills and 'he took them and died in the bedroom where Glyn had passed away' (Delaney, 1999: p153) a few days earlier.

Pierre et Gilles

1976, Paris, France
• Pierre et Gilles was born at a party in 1976. Gilles, a painter, Pierre a photographer 'fell in love and became inseparable' (Marcadé, 1997: p5), making a body of highly stylised photographic works. Like Gilbert & George, their collaboration is as an artist, but unlike them, theirs is not a distanced approach, but based in their erotic and amorous declarations for each other. Eroticism, fantasy and kitsch fight for supremacy in each image jointly produced. As well as images culled from popular culture, many works refer to Von Gloeden, Cocteau and Bruce of LA. They have photographed and made pop videos for Marc Almond, Boy George and Mick Jagger, and created a

Paul Pfeiffer, **Untitled**, 2003, projector, armature and video loop on DVD, 2 minutes. Image © 2003 ArtPace | San Antonio. Originally Commissioned by ArtPace | San Antonio

Jack Pierson, **Untitled (Collage I)**, 2001, digital pigment print, 213.36 x 121.92 cm. Courtesy of Cheim & Read, New York, and Hamiltons, London

body of images featuring artists (Dalí, Christian Boltanski), designers (Jean Paul Gaultier, Thierry Mugler, Yves Saint-Laurent) and actors (Rupert Everett, Tilda Swinton, Catherine Deneuve). While they have not had the critical attention of Gilbert & George, they have been included in *Art in the Age of A.I.D.S* (National Gallery of Canberra, 1994), *Féminin/ Masculin – Le sexe de l'art* (Centre Georges Pompidou, 1995), and their works are held in public and private collections.

Jack Pierson
1960, Massachusetts, USA
• Pierson was born in Plymouth and is perhaps the most famous of the photographers known as the Boston School, which included Nan Goldin, and his lover, Mark Morrisroe. Pierson and Morrisroe famously took photographs of each other while still at the Museum of Fine Arts School and when Jack was known as Jonathan. Much has been made about their drug abuse and sexual licence, but while Morrisroe mainly photographed himself, Pierson's gaze wandered, and his many images of desirable young men are well known. Pierson has also made a series of elegant word sculptures such as *Desire/Despair*, where the words are spelt out from found three-dimensional letters. He has had major solo shows at

the Whitney (1995), the Museum of Contemporary Art (Chicago, 1997) and the Sprengel Museum (Hanover, 1999).

Lari Pittman
1952, California, USA
• Pittman was born in Glendale. From his earliest works He has addressed his homosexuality within the American dominant. *From Venom to Serum* (1982) and *Thanksgiving* (1985) feature highly decorative surfaces encoded with sexual images (anuses, penises). These works lead to candy-coloured ejaculations (*This Wholesomeness, Beloved and Despised, Continues Regardless*, 1990) and outright 'cum' (Fox, 1996: p77) shots (*A Decorated Chronology of Insistence and Resignation No 1*, 1992). Like piped icing sugar, paint almost drips from his claustrophobically dense canvases. The works could be strident, but their almost childlike imagery charms the reluctant viewer. Like Robert Gober, he embraces the idea of the queer artist as a 'decorator'.

Pittman has been with his partner Roy Dowell for over twenty years and is open about their relationship. Stating, 'I am tired of the sexually neutered histories of Robert Rauschenberg, Jasper Johns, Cy Twombly and Ellsworth Kelly' (Fox, 1996: p69). He regards the sexuality of the artist thus: 'There are endless examples of homosexuals making

Lari Pittman, **Untitled #15**, 2003, matte oil, aerosol lacquer and cel-vinyl on gessoed canvas over wood panel, 193.04 x 259.08 cm. Courtesy of Regen Projects, Los Angeles

Joe Plaskett, **Figure on a Settee**, 1979, oil on canvas, 67.31 x 101.6 cm. Courtesy of the artist

art, but there are very few examples of homosexual artists who erase that arbitrary distinction between the private and the public, which is something heterosexual artists can do all the time. They are who they are and so is the work they make' (Fox, 1996: p69).

Pittman lives in Los Angeles and has shown there since 1982, culminating with a retrospective at LACMA (1996). He has had one-man shows in New York (Jay Gorney Modern Art, 1994) Cologne (Jablonka Gallery, 1993), Milan (Studio Guenzani 1995) and has been included in the 42nd Biennial Exhibition of Contemporary American Painting (Corcoran Gallery of Art, 1991), *Helter Skelter: LA Art in the 1990s* (MOCA, Los Angeles 1992) and the Whitney Biennial (1993, 1995).

Joseph Plaskett

1918, British Columbia, Canada
• Plaskett was born in New Westminster. He studied under Clyfford Still and Hans Hoffmann who influenced his early abstract works, but he soon became disillusioned with High Modernism. By the 1950s, living in Paris, he took inspiration from old masters, and the neo-Romantics, painting interiors, portraits and still lifes using lush colour and deep shadow. Plaskett's work is deeply melancholic and beauty stands in for immanent

loss, yet calls for a celebration of the now and present.

Alexis Preller

1911–1975, Pretoria, South Africa
• Preller's family encouraged him to go to London, where he studied with Mark Gertler (Westminster School of Art, 1934). He shuttled between Pretoria, Paris (1937) and the Congo (1939), exhibiting in Pretoria and Johannesburg where he was described as the 'South African Gauguin'. He joined the army but was captured and held as a POW in Italy until 1943. On return to South Africa he produced works dealing with his wartime experiences, including 'nude figures with wounds transformed into butterflies' (Berman, 1970: p241). Over the next ten years he travelled between Zanzibar, Italy and Egypt, taking artistic influences as they came. He exhibited in the 1956 Venice Biennale for South Africa, and progressed from the pictorial (with the use of mythological references) to harder-edged content (homoerotic depictions of male nudity). Often in biblical settings, Adam is seen without fig leaf and in close detail. Preller's work is based in an African sensibility (though Caucasian), and he often worked 'local' imagery into his Western paintings. Yet it is with his later abstractions that he found his genuine painterly voice. In

his later years he became increasingly open about his sexuality, and was asked by the South African government to sit on its committee reporting on the welfare of homosexuals.

Patrick Procktor

1935–2003, Dublin, Ireland
• Procktor moved to Esher when his English father took ill, and was sent to boarding school. He lived in London during the Second World War and 'rather enjoyed the air-raids' (Procktor, 1991: p7). He served in the Royal Navy (1954), worked for the British Council, and went to the Slade (1958), meeting Mario Dubsky, Roger Cook and tutor Keith Vaughan. Procktor befriended Hockney when they showed in *New Contemporaries* (1959) and they travelled together. Procktor met artist Michael Upton and his wife, Ann (1961), and the men began a sexual relationship, culminating in a series of nudes (of Michael) by Procktor (Redfern Gallery, 1963), which was a critical and commercial success. Ann encouraged the men to explore their sexuality (Procktor, 1991: p53), and remained friends when the affair ended. The Uptons remained married and had a son.

Procktor exhibited in the *New Generation* (Whitechapel, 1964) with Hockney, Bridget Riley and Patrick Caulfield. He taught at the Royal

College and become friends with Derek Jarman and Cecil Beaton. In 1968, he met Gervase Griffiths, a young philosophy student from Oxford and aspiring pop star (Procktor, 1991: p115). Procktor devoted the next two years of his life to him. Procktor's New York debut consisted only of images of Gervase (who was said to be more handsome than Mick Jagger). Following a car accident, Griffiths moved to South Africa, and Procktor saw him only once (1977) before his death (1980).

Procktor's neighbour, a young widow, Kirsten Benson, ran Odin's (with Peter Langan), a restaurant where art was given in exchange for food tabs. Procktor and Benson became lovers, having a son, Nicholas. Procktor's work is held in the Tate Gallery, but his later (largely decorative) domestic paintings have not been as esteemed. After Benson's death Procktor said that, 'there is a truth in the idea of a leopard not changing its spots' (Procktor, 1991: p186).

Robert Rauschenberg

1925, Texas, USA
• Born Milton Rauschenberg in Port Arthur. See Chapter 2.1 for information.

Guy Reid

1963, Johannesburg, South Africa
• Reid is a carver, whose work depicts

Alexis Preller, **The Royal Stele**, 1965, oil on canvas, 91.5 x 101 cm.
Courtesy of the Ivan Katzen Collection, London

Guy Reid, **Facing the Bogeyman**, 2000, limewood, concrete, scale one-third life size, installation
dimensions are variable. Photograph by Ian Cole © 2000. Courtesy of the artist

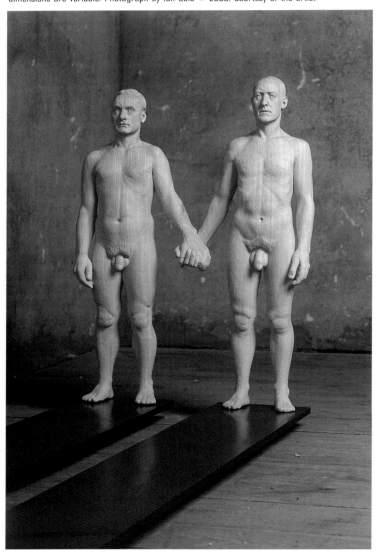

human relationships. *Facing the Bogeyman* (2000) is a self-portrait with his lover (at one-third life size scale), facing a monolith of concrete. The work can be read as a fear of loss associated either with the death of an individual or the end of a partnership, or as an AIDS metaphor. Most of Reid's figures are lifesized, and function as the focal point of an installation.

Hunter Reynolds
1959, Minnesota, USA
• Hunter Reynolds was born in Rochester. His *Patina du Prey's Memorial Dress* (1992), like the *Names* quilt, commemorates those who have died from AIDS-related illnesses. Each of 25,000 names is stamped in gold on a black ball-gown, which can be shown as a sculptural object or is worn by Reynolds as a performance garment. Reynolds speaks of this and other sewn works as being of 'the fabric of memory', and like Le Dray uses traditional craft linked to women's work to question identity and the status of objects.

Eric Rhein
1961, Kentucky, USA
• Rhein was diagnosed HIV positive when he was 22, and like many became seriously ill before combination therapies were developed. It was in a period of recovery at a New

England artists' colony that he hit upon the idea to make leaf portraits of friends he had known who had died from AIDS-related illnesses. He estimates that he has now made over 200 such memorials. Each unique leaf is mounted on paper, and poetically titled defining the person's relationship to Rhein, as in *Benjamin's Friend – Dancing Tom* (1997) or *Singing Joel* (1998) or *Robert M.* (Mapplethorpe, 1998). Some sheets poignantly contain two leaves, as in *David partner of Gordon, Gordon partner of David* (1996). Rhein's sensitive works hark back to Whitman's *Leaves of Grass*, and, like the poems, succinctly recall life.

Larry Rivers
1923–2002, New York, USA
• Born in the Bronx, he studied saxophone at Julliard. Rivers began painting in 1945, and married Augusta Burger. They had a son, Joseph, but separated the following year. Rivers then studied with Hans Hofmann, and in 1950 met Frank O'Hara. Rivers introduced O'Hara to the visual arts, and O'Hara introduced Rivers to poetry. The Museum of Modern Art bought *Washington Crossing the Delaware* from his *Tibor de Nagy* (1953) exhibition. In 1961, he married Clarice Price, having daughters Gwynne and Emma. Throughout this period he was sexually

Eric Rhein, **Robert M. (Mapplethorpe)** detail, 1998, wire and paper, 38.1 x 30.48 cm. Courtesy of the artist

David Robilliard, **International Flavour: Cultural Differences Melt When You Start Slurping,** 1988, acrylic on canvas, 183 x 183 cm. Courtesy of the Estate of Andrew Heard

involved with O'Hara, a curator at the Museum of Modern Art. Rivers saw himself as straight, and in a series of interviews, *Drawings and Digressions* (1979), spoke of many aspects of his work and friendships. Of O'Hara he said, 'He was also gay and he thought he loved me. We slept with each other. I sort of thought, well, I'm straight, but I'm doing this. Well, I don't know how straight I was if I was doing this. And we carried on for a very long time' (Rivers and Brightman, 1979: p79). The effect of their sexual friendship on Rivers' work was considerable, yet Rivers stated, 'Ad Reinhardt ... thought that talking about all these things about life and mixing it up with art was just hokum ... What has my going to bed with Frank O'Hara got to do with the moment that I'm standing in front of my canvas? And actually, he's right in a certain way ... On the other hand, look what Ad Reinhardt ended up doing' (Rivers, 1979: p79).

Rivers exemplified a conflicted homosexual paradigm. He viewed himself as 'straight' (married with children), but his boyfriend as 'gay'. Rivers wanted to believe that sex had no impact on his work, yet knew it was untrue. That his sexual issues became elements in his work is hardly surprising. Rivers states that relationships (sexual or not) are what brought about

specific works. Rivers made a body of work about O'Hara before and after his death (1966). Rivers was also attracted to very young women and in *Snow Cap* (1970) depicts 'a former baby-sitter, who[m] I admit I tried to seduce', but, he said, 'knowing and being desirous of girls when they're teenagers, and then you see them when they're twenty-one, and suddenly, they seem old' (Rivers, 1979: p204).

Having an interest in drawing (like Hockney) Rivers conducted an art-historical battle with his icons (Velásquez, Rembrandt), well-known figures (Napoleon in *Golden Oldies: The Greatest Homosexual*, 1978), and modern advertising (Camel cigarettes). His work has been seen as early Pop Art, and in *The American Century* is referred to as 'figurative work associated with the New York School', works which are 'brushy and irreverent paintings, among them the full frontal portrait of curator and poet Frank O'Hara wearing nothing but a pair of socks' (Phillips, 1999: p46). No mention of their sexual relationship is to be found (see chapter 2.2.1). Rivers' work is held in major public and private collections.

David Robilliard

1952–1988, Channel Islands, UK

• Robilliard was, like Cocteau, a poet first and took that aesthetic into his

painting. He moved to London and shared a studio with Andrew Heard (1976), meeting Gilbert & George, and becoming one of their models. The duo published his first volume of poetry, *Inevitable* (1984), and he contributed on a regular basis at the James Birch Gallery. His second volume of poetry was published to coincide with his one-man show at the Stedelijk Van Abbemuseum (Eindhoven, 1987). Since his death his work has been constantly shown at museums and private galleries.

Paul Ryan

1968, Leicester, UK

• Throughout the 1990s Ryan has kept meticulous visual diaries in standard-sized A7 sketchbooks, which he has neatly filed for ready access. He uses this source material (of quick drawings of people, places and objects) for his finished works. After selecting a diary image (No. 1) that may be no more than 5 centimetres across, he then views it through a strong magnifying glass, to draw each grain of carbon/ watercolour that can be detected (No. 2). One after another, each mark adds up, resembling the original sketch but at a vastly greater scale (finished works can be 3 metres wide). There is almost always no visual difference between the original and final drawings (No. 3).

Børre Sæthre

1967, Norway

• Sæthre creates total environments and installations on the scale of film sets, whose futuristic readings rely on vast budgets (like Hollywood films) to convince the viewer of their reality. They ape lux magazines and consumption on the highest level, yet throughout his body of work, a queer voice undermines the status quo. *Masturbating with the Gods* (1998), *The Bunny Session* (2001) or *Catch Me and Let Me Die Wonderfully* (from his *Quarantine* series, 2003) all feature same sex references within ominous surroundings. Viewers are left to create their own narratives from the many clues provided.

Mike Sale

1966, Birmingham, UK

• Sale's work addresses his status as a black, gay male in the UK and Germany, where he lives, and how racism and homophobia manifest themselves within the art world and greater culture. Works like *TECHNO (Skins nodding)*, which features 33 monitors, each with the face of a different Berlin skinhead nodding to the same blaring rhythm, examine power structures on many levels. These seemingly racist neo-Nazi thugs (who might attack immigrants) are in fact gay

Paul Ryan, **Bill**, 2000, ink on paper, A7 Sketchbook. Courtesy of the artist

Paul Ryan, **Bill**, 2000, rotring ink on Japanese tissue, 76 x 100 cm. Courtesy of the artist

Paul Ryan, **Bill**, 2000 (detail), rotring ink on Japanese tissue, 76 x 100 cm. Courtesy of the artist

Mike Sale, **Mike in a Jasper Conran Suit**, 1994, b/w photograph, 46.2 x 101.6 cm. Courtesy of the artist

ravers, and their individuality, while masked by the effects of their shaved heads, demands more complex readings than might at first be expected. Similarly, in his appropriation of Mapplethorpe's *Man in Polyester Suit* (1980), Sale's elegant work *(Mike in a Jasper Conran Suit* (1994), forces a reappraisal of Mapplethorpe's reduction of black men to a stereotype of massive genitals. Like Glenn Ligon, he takes Mapplethorpe to task for his racial prejudices (seemingly acceptable within the art world).

Dean Sameshima

1971, California, USA

• Born in Torrance, Sameshima is known for his anonymous photographs of the daylight exteriors of seemingly bland Los Angeles shops and strip malls. That they are actually gay sex clubs is not known to the casual observer. They are designed to be passed by, by those not in the know, and bland enough to encourage shy customers. Recent work has focused on very thin and pale young men, the opposite of the darkly tanned, steroid-muscled (gay and straight) Angelino ideal. He stalks dance clubs, covertly shooting such youths as they gyrate, or re-photographs images from magazines to invent and reinterpret stereotypes and notions of masculinity.

John Singer Sargent

1856–1925, Florence, Italy

• Sargent was born in Italy to an American surgeon married to Mary Newbold Singer (daughter of a wealthy Philadelphia businessman), having moved to Europe in 1854. Sargent studied at the École des Beaux-Arts (Paris, 1874) before visiting America for the first time (1876). His portrait of *Madame Pierre Gautreau* (Virginie Avegno Gautreau), known as *Madame X*, caused a scandal in the Paris Salon (1884), and made his name. The writer Henry James (a same sex lover) suggested he move to London (1885). Sargent rented Whistler's former studio and resumed painting, exhibiting at the Royal Academy, of which he became a member (1897). Sargent was a founder member of the New English Art Club (1886), and showed at the Knoedler Gallery (New York, 1909).

In 1892, Sargent started a long-term relationship with nineteen-year-old Nicola d'Inverno. Sargent painted Nicola (and his brother Luigi), who became his valet for twenty-six years. Sargent paid for Nicola to attend the Quintin Hogg Gymnasium to keep his figure trim, an unusual requirement for a valet. They lived together until Sargent's death. Sargent spent years in America painting presidents (Roosevelt), society patrons (Lady

Børre Saethre, **Masturbating with the Gods**, 1998, installation view from within Kunstnernes Hus, Oslo. Courtesy of Galleri Wang, Oslo

Fin Serck-Hanssen, **Untitled**, 1997, iris print, dimension variable. Courtesy of the artist

Randolph Churchill) and murals for the Boston Public Library (1891). One of the most sought after portraitists, Sargent also made erotic nude male studies. 'Many of Sargent's drawings and paintings of the male nude were created for his own personal study and enjoyment, not for public exhibition and sale. He showed a strong preference for portraying the masculine form throughout his career' (Esten, 1999: p11). Sargent made very few works depicting nude women. The nude males were in his possession at death and left to his sisters who 'painstakingly placed these drawings, watercolours, and paintings, that at the time were unsalable, in American museums' (Esten, 1999: p12). That they were unsaleable indicates how charged they were to contemporaneous viewers, and their open homoeroticism still surprises many (see 2.3.1).

Sargent was made an official war artist (1918) and many of his most charming watercolours date from that period. The naked intimacy of comrades and lovers in arms can be seen in Sargent's young men lolling about sunny riverbanks. His drawings of male nudes leave the viewer in no doubt about his love for his own sex. In *Gassed* (1919) we see Sargent's feelings for the soldiers mixed with his revulsion for the war. The Grand Central Art

Galleries (New York, 1924) held a retrospective of his work shortly before his death. His work has been under constant reappraisal since then, with major exhibitions at the Tate (1926, 1998), the Whitney (1986) and the Metropolitan (2000).

Fin Serck-Hanssen

1958, Oslo, Norway
• Serck-Hanssen is a successful commercial photographer working in the music and fashion industries, while making a highly provocative body of fine art work. In the early 1990s he made an arresting series of extremely large facial portraits of AIDS sufferers. Viewers were confronted with their gaze at a time when few treatments were available, and as with *Per Ole, 10.10 1958–5.4. 1997* (1993), the titles are amended if the sitter dies. Almost as if to balance the series' starkness, he started his messy *Gaywatch* pictures depicting gays and lesbians in the clutter of their everyday lives (*Geir and Jørn*, 1996). His *Untitled* series (1997–) features his partner Ole and other young men swimming in dark green fjords. They resemble water nymphs, sea sprites or mermen striving to reach the surface to catch a breath, or frolicking away unaware of any surface danger.

Shannon and Ricketts

Charles (Hazelwood) Shannon
1863–1937, Lincolnshire, UK
Charles de Sousy Ricketts
1866–1931, Geneva, Switzerland
• Shannon studied at the Lambeth School of Art (1881), where he met Charles Ricketts (then sixteen) became life-long partners (Rosenblum et al., 2000: p423). Shannon was considered the more successful at first, exhibiting as part of the New English Art Club. They went to Paris (1887) to study with Puvis de Chavannes, who suggested they return to London and get to work. They decided that Shannon would retire from painting to master his technique and, like a butterfly, emerge into the art world as a master. Ricketts would continue exhibiting, concentrating on print work and *The Dial* magazine they founded and ran from 1889 to 1897. This had the result that Ricketts became well known and Shannon was forever in his artistic shadow.

They rented Whistler's studio (The Vale), and established Vale Press, producing illustrated volumes for friends, including Oscar Wilde (*The Fisherman and His Soul*), who referred to the lovers as Orchid and Marigold. *The Dial* preached the aesthetic ideal, the love of beauty, and was a success. Under the Vale imprint, special editions of Wilde's *The Picture of Dorian Gray* and

The Sphinx (both designed by Ricketts) were brought out. Shannon taught at the Croydon School of Art, and he and Ricketts befriended the young Lambeth alumnus Glyn Philpot, who shared their mania for collecting *objets d'art*. Shannon and Ricketts had a large collection of 'pretty things' (Calloway, 1979: p6), and lavishly entertained. Kenneth Clark said of Shannon, 'One could see that Ricketts turned to him as to a reasonable wife' (Calloway, 1979: p7). The couple lived together for almost fifty years and throughout their lives painted and drew each other. Ricketts, a great raconteur, often held sway over their blue lapis lazuli dinner table laden with lilies.

Ricketts was an accomplished painter and sculptor, his book designs and typography nearly as important as William Morris', and his illustrations are of greater interest than those of his rival, Aubrey Beardsley (who died in 1898). Ricketts was so highly regarded as a critic and collector that he was offered (and turned down) the directorship of the National Gallery. Eventually both men donated their vast collection of art to British institutions (Rouse, 1977: p240). Ricketts was collected by Wilde and supported by W. B. Yeats and George Bernard Shaw. His bronzes were considered among the finest of their period, and at the age of

Charles Shannon, **Mrs. Patrick Campbell**, 1907, oil on canvas,
122.6 x 108.6 cm. Courtesy of Leonie Sturge-Moore
© Tate, London, 2004

Michael Shaowanasai, **Open Gate**, 2002, inkjet on
paper, dimensions vary. Courtesy of the artist

forty he casually took up stage design,
creating many productions from
Salomé to *King Lear*.

Shannon returned to exhibiting at
the turn of the century, and was made
a member of the Royal Academy
(1920). His work may seem saccharine
compared to Ricketts', but was highly
regarded at the time. Their joint taste
for beauty often caused their allegori-
cal work to be heavy-handed. Yet in
portraits (of each other and well-
known sitters) they excelled, each in
his own distinct style. That they influ-
enced each other's work goes without
saying. A contemporary writer, Tis,
said of Shannon, 'if we for the
moment disregard Charles Ricketts,
the companion of his whole artistic life
– his outlook is not only personal but,
in certain respects, even revolutionary'
(Tis, 1918: p1). Tis was discussing
Shannon's attempt to continue a
Renaissance tradition at the time of
Cézanne, Cubism and Duchamp. It is a
strong indication of how the art world
had left them behind. That the
Charleses were commented on as
companions is notable. The euphe-
mism 'companion' contained enough
ambiguity to allow a heterosexual filter
to remain in place, even when dis-
cussing such renowned lovers. While
hanging a picture Shannon fell (1929)
and never recovered. Ricketts took the

calamity hard, dying two years after
the accident of heart failure.

Michael Shaowanasai

1964, Pennsylvania, USA
• Born in Philadelphia, Shaowanasai
lives and works in Bangkok, where he
has made many installations/perform-
ances that address sex tourism, from
forcing gallery-goers to wear a number
and have a Polaroid taken of them-
selves to be added to a menu (men
and women in Thai sex clubs are cho-
sen from such menus and identified by
number) to selling pre-packaged *Thai
Boy Spunk*. He is currently making a
feature film *To be ... or not to be?*, a
cross-dressing James Bond spoof,
where he plays *Iron Pussy*, a Thai lady
boy who always gets her man.
Shaowanasai represented Thailand in
the 2003 Venice Biennale.

Jack Smith

1932–1989, Ohio, USA
• Smith was born in Columbus. He was
relatively unappreciated by the fine art
world in his own lifetime, his work
(overtly gay, camp and kitsch) had a
huge impact on 1960s New York.
Flaming Creatures (1963) documented
an imaginary transvestite orgy (a
Scheherazade party) of friends atop a
Manhattan cinema roof over a period
of seven weeks. The players partied

Dean Sameshima, **Deafdudes Untitled (69)**, 2003, Fuji-Flex print, edition of 3, 24.5 x 31 cm. Courtesy of Peres Projects, Los Angeles

Dean Sameshima, **Deafdudes Untitled (impotent)**, 2003, Fuji-Flex print, edition of 3, 24.5 x 31 cm. Courtesy of Peres Projects, Los Angeles

Dean Sameshima, **Deafdudes Untitled (wel lhung)**, 2003, Fuji-Flex print, edition of 3, 24.5 x 31 cm. Courtesy of Peres Projects, Los Angeles

and mugged to the camera in outrageous costumes, or undressed. Set to music, the film had no linear narrative. When shown, many theatres were raided and the film confiscated (Moon, 1998: p77). Warhol saw the film and it greatly influenced his film work (Smith even appeared in Warhol's *Dracula*). Susan Sontag's *Notes on Camp* was greatly influenced by the film, and she was one of Smith's most ardent defenders. It is difficult to imagine how disruptive the film was to pre-Stonewall audiences. Here were 'flaming queens' (see Hughes) who were proud of it, and revelled in their otherness. Smith was one of the only openly gay men making art using same sex subject matter.

While Smith's 'films are incitements to his audience not only to play fast and loose with gender roles but also to push harder against prevailing constraints on sexuality' (Moon, 1998: p82), he himself was a product of a homophobic upbringing. Unlike Warhol, he was never able to divest himself of some elements of self-oppression, and while he continued making films and performances into the 1970s, his works became shambolic. With the onset of the 1980s, which required a level of professionalism, if not careerism, Smith became ever more marginalised before he died of an AIDS-related illness.

Simeon Solomon

1840–1905, London, UK

• Solomon, the youngest of eight, was born to an artistic Jewish family. His sister, Rebecca, and brother, Abraham, trained at the Royal Academy, and Simeon followed (1856). He befriended Rossetti, who introduced him to poet and same sex lover, Algernon Charles Swinburne. Solomon became an Associate Member of the Royal Academy (1862), and was seen as a serious (if not religious) artist, exhibiting *The Mother of Moses* (1860), *The Betrothal of Isaac and Rebecca* (1863) and *Carrying the Scroll of the Law* (1871). Solomon worked for the Morris Company, creating designs for the home, and showed with the Dudley Gallery (1865).

Solomon illustrated Swinburne's sado-masochistic novel *Lesbia Brandon* and wrote his own homoerotic poetry: *A Mystery of Love in Sleep: An Allegory* (1870) and *A Vision of Love Revealed in Sleep* (1871). Solomon and Swinburne were admonished by Robert Buchanan in *The Fleshly School of Poetry* (1872), as their work was deemed too erotic and Uranian. Solomon was 'arrested with George Roberts and charged with indecent exposure and attempting to commit sodomy' (Simeon Solomon Research Archive, website). Found guilty, Solomon was fortunate to have

his eighteenth-month sentence reduced to police supervision. Within a year Solomon was arrested in Paris (near the Bourse) in a public urinal and sentenced to three months in prison. 'Yet his work and influence did not stop in 1873, the year of his arrest for indecency in a public lavatory, although his public career was effectively over' (Burman, 2001: p23). His life deteriorated rapidly, and he wound up in St. Giles Workhouse, living there intermittently until his death from the effects of alcoholism. Like Wilde, Solomon was a victim of his times, and his reputation has since flourished. Solomon's works are included in the permanent collection of the Tate, and he received a retrospective at the Jewish Museum (London) in 2001.

Robert Taylor

1958, Birmingham, UK

• Taylor worked as an air traffic controller with the Royal Air Force (1975) before studying law and becoming a barrister (1983). He started working with photography, making portraits and nude studies, and has often focused on inter-racial sexuality (*Black on Black on White*, 1993, Baik Gallery, London). Taylor did the photography for *Safer Sexy* (1994), a graphic (and controversial) book on safer sexual practices for gay men, and has had his

book *Portrait Party* (2000) published. Taylor made a Channel 4 (UK) documentary on black divas and their gay fans in 1996.

Pavel Tchelitchev

1898–1957, Kaluga, Russia

• Born to a wealthy family, Tchelitchev was artistic from an early age. 'Against his father's express edict, Pavel had clandestine instruction in both ballet and painting' (Kirstein, 1994: p23) before attending the Moscow Academy. The family fled to Kiev in 1917, where he embraced constructivism. In Berlin he designed avant-garde ballet sets (*Savonarola,Theater in der Königsratstrasse*) and Diaghilev suggested a move to Paris (1923). Tchelitchev went with Allan Tanner, an American pianist and his 'lover and helpmate for the next decade' (Kirstein, 1994: p31). Tchelitchev made paintings of Tanner, Lincoln Kirstein, James Joyce and George Platt Lynes, and met Léger, Tzara, Duchamp and Brancusi.

Through Tanner, Tchelitchev obtained a commission to design packaging for a Chicago beauty products company. He met Cocteau (1924) and became friends with Glenway Wescott and Monroe Wheeler. Because of Tchelitchev's mystic beliefs (in astrology and numerology), his work was seen as an offshoot of Surrealism (to which

Robert Taylor, **Black/Dread**, 1991, colour photograph, 40.64 x 50.8 cm. Courtesy of the artist

George Tooker, **Window XI**, 1999, Egg tempera on gessoed panel, 60.96 x 50.8 cm. Courtesy of the artist and DC Moore Gallery, NYC

he objected). He saw himself as a romantic who drew from nature. *The Basket of Strawberries*, for a group show (Galeries Druet), brought him positive attention. In his review of the show, Waldemar George is said to have invented the term 'neo-Romantic'. Gertrude Stein took him under her wing, bought works and commissioned him to portray her lover, Alice Toklas. She introduced him to important ideas and artists of the day (later severing all contact) and to Edith Sitwell, who fell in love with him. Through Sitwell he had a successful London exhibition, gaining commissions from Beaton, Kenneth Clark and others.

Tchelitchev designed the set and costumes for Diaghilev's *Ode* (1928), based on the work of a Russian scientist's observation of the Northern Lights, developing his mystic ideas in three dimensions. The sets (translucent scrims) and costumes were cinematic, and his innovative use of lights and cine projections propelled Diaghilev to exclaim, 'You are insane and your ideas are terrible!' (Kirstein, 1994: p49). Diaghilev softened his views with the show's success. One of Tchelitchev's innovations was having the dancers clad only in leotards.

Tchelitchev had had an affair with René Crevel, but met the American poet Charles Henry Ford (1932), and

the two became lifelong partners. Tchelitchev, Tanner (as friend only) and Ford travelled to New York (1934), as Tanner (after a twelve-year relationship and loyal as ever) had organised an exhibition for him at the Chicago Arts Club. Tchelitchev showed at the Julien Levy Gallery, and revived a work, *Errante* with Balanchine (1935). For the Metropolitan Opera he designed a production of *Orfeo and Eurydice* with a backdrop of the Milky Way . Ford took over the role as Tchelitchev's main supporter, working tirelessly to ensure his fame and their future. Ford started the seminal *View* magazine to promote European ideas and artists; Duchamp, and Paul Bowles designed notable issues. Ford was a keen photographer but much more eager to be a sitter.

From 1939 to 1942 Tchelitchev made backdrops for Lynes' fashion shoots and worked on a major painting, *Hide and Seek*, purchased by Wheeler for a MOMA retrospective of his work (1942). This painting marked the development of his mature style, a sort of X-ray vision of the body (prompted by sketches of Ford's ear in bright sunlight). Ford appeared in many of Tchelitchev's paintings. The 'Interior Landscapes' continued until his death, and while based on anatomical drawings, were too fantastic to be mere science. These depictions of an

astral form of the body have inspired many bad science fiction versions. In 1950 he moved to Frascati (Italy) continuing to exhibit, as his reputation ebbed away. He had a heart attack (1956), rallying only to die of complications; Ford was in attendance. In the past decade, a reappraisal of his work has seen his star rise.

Wolfgang Tillmans

1968, Remscheid, Germany
• Tillmans moved to Hamburg (1987) where he started photographing the local club scene. In 1988 he became a contributing photographer for the fashion magazine *i-D*. His low-key images of the fashion, music and gay scenes proved immediately popular. 'The erotic charge of the fetish also informs the many photographs that Tillmans has taken of clothing ... This association is only intensified by the fact that the articles of clothing that Tillmans photographs and transforms into fetishes are for some observers especially encoded as queer' (Deitcher, 1998: p9). For gallery installations he mixes pages torn directly from magazines (of his images), with colour inkjet prints and traditional prints. This attempt to blend the worlds of commercial and art photography has proved highly successful and 'In a wider sense, Tillmans might also be seen to be hanging

together seemingly distinct yet in fact overlapping domains of social experience' (Watney, 1995: p8).

Tillmans' images of lovers, friends and celebrities have been widely exhibited. He has participated in many important shows including *Take Me (I'm Yours)* (Serpentine Gallery, London, 1995), *The Winter of Love* (P.S. 1, New York, 1994), *From the Corner of the Eye*, (Stedelijk, Amsterdam, 1998), culminating in his winning the prestigious Turner Prize (Tate Gallery, London 2001).

Tom of Finland (Touko Laaksonen)

1920–1991, Finland
• Laaksonen's parents were teachers in the newly formed country of Finland (1917), sparsely populated by farmers. His draftsmanship was encouraged, and he attended the Helsinki Art School (1939). He became homosexually active when drafted, finding himself in the company of many other men, with blackouts providing cover for sexual activity. He drew native loggers, men in uniform (including German soldiers in jack boots) and sportsmen. After the Second World War, he worked in commercial art, made window displays and travelled to gay meccas. Laaksonen's effeminophobia made him resist entry into the then surfacing gay scene. In 1953 he met Veli, his male lover for the next twenty-eight years.

Laaksonen sent drawings (signed Tom) to *Physique Pictorial* (1956) where Bruce of LA was an in-house photographer (Hooven, 1993: website). Tom of Finland's first cover illustration featured in *Spring* (1957). Demand for his drawings meant that by 1973 he was devoting all his time to art, and held his first exhibition in Hamburg. By the end of the 1970s he had exhibited in Los Angeles, San Francisco and New York (befriending Mapplethorpe).

Veli died of throat cancer (1981), and many of their friends died from AIDS-related illnesses. Laaksonen's commercial gay erotica was so successful that he split his time between LA and Helsinki, until he came down with emphysema (1988), which soon affected his style of drawing, forcing him to use pastels. He established the Tom of Finland Foundation (1986) to oversee his artistic heritage, dying just as his work began to receive critical attention. It is now regularly shown in fine art contexts and is in public and private collections (Ramakers, 1998: p331).

George Tooker

1920, New York, USA

• Born in Brooklyn to a well-to-do family, Tooker went to Harvard to study English, where he became involved with socialist politics (his mother was part Cuban) and saw art as a possible

means for social change. He joined the Marines (1942), but was discharged for health reasons and went to New York to study at the Art Students League (1943). There he became a student, friend and lover of Paul Cadmus, joining the other Magic Realists (French) in using egg tempera as a medium. He injected a social consciousness into the group's output with works like *Subway* (1950) and *Government Bureau* (1956). His paintings often feature people watching or being watched and reflected the McCarthy era. Tooker became part of the PAJAMA set, but moved to Vermont (late 1950s) with his lover, artist William Christopher, of whom he said, 'We both influenced each other, I think. I trusted his judgment; he mine. You know, I never talk about painting, but we talked about painting.' From 1968 they wintered in Spain, as Christopher grew terminally ill, dying in 1973. Tooker then converted to Roman Catholicism and continues to paint religiously inspired works.

Patrick Traer

1959, British Columbia, Canada

• Traer was born in Summerland. He works with a variety of craftspeople to realise his intricate and sensual objects. Early works featured intricate embroidery on shot taffeta or vein-like structures (*cone*, 1993), or on see-through

Tom of Finland, **Dick**, c. 1970, magazine cover, 27.94 x 21.59 cm. Courtesy of Tom of Finland Archive, Los Angeles

Patrick Traer, **rubbed red**, 2002, plywood, cotton, canvas, foam rubber, stainless steel cock-rings, hooks, chain, zippers, horse hair and vinyl imitation ostrich skin upholstery fabric, 121.92 cm tall. Courtesy of the artist

Cy Twombly, **Natural History Part II: Fagus Silvatica**, 1975–6, lithograph, grano-lithograph, two collotype runs (cream-white and light green), printed in nine colours from portfolio of eight prints: Natural History Part II: Some Trees of Italy edition, 76.2 x 54.52 cm. Courtesy of Devin Borden Hiram Butler Gallery, Houston. Collection of Jerry Williams, Houston

voile panels that hung mysteriously in the gallery space (*untitled [veils]*, 1995). Recently Traer has worked with car seat upholsterers to make humorous works like *rubbed red* (2002), *black scrotum* (2002) or *baby blue balls* (2002), which wryly comment on the car (and driver) as phallus.

Henry Scott Tuke

1858–1929, York, UK

• Tuke's Quaker family of doctors, uncharacteristically for the time, supported his artistic ambitions. He won a scholarship to the Slade (1877) and studied under Jean-Paul Laurens in Paris, meeting Sargent and Wilde. The mode for outdoor painting struck a chord with Tuke, a robust young man who had learnt to swim in Cornwall, to which he returned, becoming a crucial member of the Newlyn School. One of his earliest acclaimed works, the highly homoerotic *The Bathers* (1885), features three nude, rosy-cheeked, milky-skinned lads on a boat. Emmanuel Cooper quotes its description in the Leeds City Art Gallery catalogue (1909) as 'a picture of no particular "motive", but evidently done for the pure love of the glowing flesh tints and the sportive merriment of the youthful visitors' (Cooper, 1987: p10). The youths are not merely nude, but actively depicted as desirable, placed

in a highly charged erotic space by the painter. They are naked for the viewer's enjoyment, similar to contemporaneous depictions of women.

Contrasting Tuke's bathers with Eakins' (who are also sportive and aglow), it is apparent both men's gaze is erotic, only the handling of the paint differs. Eakins is after an empirical eroticism, uninfluenced by the emerging French avant-garde. Tuke's bathers (while not academic nor impressionistic), are given a more relaxed handling, and are aware that the gaze upon them is sexual. Tuke is also aware that his gaze is homoerotic. Walter Shilling (one of the bathers), along with Jack Rowling and a few others of importance to Tuke, reappears in many guises in other paintings. Eakins attempts to empty himself and his homoerotic desire from his paintings, and the impossibility of doing so creates tension. Commissioned by Edward Coates to paint *Swimming*, Eakins found on completion that, 'Coates was so taken aback by its flagrant nudity that he bought *The Pathetic Song* instead' (Wilmerding, 1993: p104). Tuke knew his bathers were aware of their erotic power over him; consequently he rarely succeeded in making them abstractly erotic. Cézanne's contemporary bathers are a universe away from Tuke's or Eakins'.

Yet, as with all naked flesh, the erotic charge is too close to the surface for even Cézanne to be fully object.

Tuke moved to Falmouth (1885) where he lived and painted until his death. He took Shilling (who modelled at the Slade) with him (Cooper, 1987: p12), and bought a boat, the *Julie of Nantes*, for a studio and privacy. Tuke painted nautical scenes featuring youths, or classical ones like *Cupid and Sea Nymphs* (1898–99), where the female nymphs are far in the background and Cupid is a naked pale English lad. Tuke was part of the Uranian movement that revelled in the beauty of young men. *August Blue* (1893–4), features pale, ginger-haired youths, apparently fishing. One naked youth holds a net. This pose became a convention for Bruce of LA and Tom of Finland. The viewer is caught by the seen. Desire catches all. Tuke kept meticulous diaries, but desire was unwritten for fear of blackmail. Tuke made only one entry about his relationship with Bert White, using the Greek *Kalos* to describe the model, which has the sexual connotation of beauty at its core. 'A portrait of White, wearing a peaked cap, remained in Tuke's sitting room all his life' (Cooper, 1987: p33).

Tuke exhibited at the Royal Academy, always careful to hide male genitalia, though he made private copies where

they are depicted, as in *Noonday Heat* (1911). This coyness made it possible for his work to be read through a heterosexual filter; the working class was celebrated, happy and unaware of themselves. Without awareness, no social or sexual upheaval was possible. Tuke became an Academician (1914), and the Tate's purchase of *August Blue* 'proved unexpectedly popular' (Rouse, 1977: p241). Lord Ronald Gower commissioned a pair of works from Tuke, of himself and his lover, Frank Hird. Tuke also painted same sex lover T. E. Lawrence (of Arabia).

Tuke was too old to serve in the First World War, but not so his models; most miraculously returned unharmed. After the war he was introduced to Colin Kennedy, an architecture student, who moved in with him, becoming his last significant partner and model. The sunny tone of Tuke's inter-war paintings suited a society searching for a lost generation of young men and for innocence. Tuke died of a heart attack.

Cy Twombly

1928, Virginia, USA

• Born Edwin Parker Twombly Jr in Lexington, he studied at Lee University (Lexington), before attending Boston Museum School and the Art Students League (New York), Where he met and became Rauschenberg's lover (1951).

Keith Vaughan, **Nude Study** (Ramsey McClure), 1951, oil board, 40.7 x 36.8 cm. Private collection, London

Keith Vaughan, **Erotic Fantasy**, c. 1950, drawing mixed media. Courtesy Professor John Ball

Twombly offered an escape route to Rauschenberg from his marriage to artist Susan Weil (Johnston, 1996: p131), and the men enrolled at Black Mountain College (Hopps and Davidson, 1991: p62). Rauschenberg commemorated their affair with a photographic series, *Cy and Roman Steps* (1952), featuring Twombly descending stairs and coming ever closer to the camera, until all that is in view is his pelvis (Hopps and Davidson, 1997: p72/plate39). Jasper Johns provided a similar escape route for Rauschenberg (from Twombly) in 1954. Twombly moved to Italy in 1957, where he continues to live and work.

Robert Hughes, writing about Twombly's MOMA (New York, 1994) exhibition states, 'Twombly … is the Third Man, a shadowy figure, beside that vivid diumvirate of his friends Jasper Johns and Robert Rauschenberg' whose 'American reputation bottomed out in 1964 with a show of nine florid paintings called *Discourse on Commodus*. They were trashed as a fiasco, in print and by word of mouth. Commodus was the degenerate son of Marcus Aurelius'. Adding that 'Twombly will insert "dirty" bits in a painting – a little graffiti-style penis, odd smears of paint with the look of dried sperm – in the hope they will enhance some sense of a Baroque

cityscape' (Hughes, 1994: website). Hughes alludes to Twombly's same sex desires and is censorious of them.

Twombly's work is found in most museum collections, and the Dia Center for the Arts and the Menil Museum (Houston) built a museum just for his work in 1995. Twombly was awarded a Golden Lion for lifetime achievement as a painter at the 49th Venice Biennale (2001), where he exhibited *Lepanto*, a series of twelve paintings based on that battle, in which the Turkish fleet (the Ottoman empire) was destroyed by a task force of Europeans.

Keith Vaughan

1912–1977, Selsey, Sussex, UK
• Vaughan wrote sixty-one volumes of journals, and summed himself up by saying, 'I spent my life looking for myself' (Yorke, 1990: p15). Vaughan was conflicted about his sexuality, but felt he had to be true to it. He wrote, 'Sex has been paramount in my life and my biography must necessarily appear obsessed with the subject because it has been and still is an obsession with me' (Yorke, 1990: p17). He spent his life asking: How did it come about that I am homosexual? Where do my desires generate from? How does it affect my life? Vaughan traced his sexual masochism to his mother's visits to

wounded soldiers. As a child he accompanied her to hospitals and 'tried to recreate for himself their [the soldiers'] discomforts by putting hard and sharp objects in his underpants' (Yorke, 1990: p26). In adulthood he took more extreme sexual pleasures, making a black box, his *soft machine*, which when attached to his genitals would pass an electric current into them. 'His experiments with genital pain continued, with mustard or tabasco smeared under tied-up foreskin, or pins or brush handles inserted into the urethra, sometimes whilst working on a canvas at the easel' (Yorke, 1990: p249).

Vaughan's sexual practices, save for the electrical, have been practised throughout the centuries, but never so well documented. In recent years, tribal body art practice has seen Ron Athey and others take their bodies to extremes, often using techniques similar to Vaughan, as have heterosexual performance artists (Chris Burden, Herman Nisch). Vaughan documented his onanism with a clear eye to publication. His masturbatory project directly influenced his painting, and he even wrote a treatise on masturbation.

Many of the men Vaughan had casual sex with wound up as models. Vaughan and John McGuinness (Yorke, 1990: p132) became lovers (1948), and their relationship is detailed in the

diaries, along with later relationships with Ramsey Dyke McClure (1949) and Johnny Walsh, who remained in his sphere throughout his life. McClure, Vaughan's student at Central School, became his lifelong, troubled companion. Vaughan found the domesticity he originally craved stifling, and McClure was 'to learn that this machine ([the black box] was now his greatest rival for Keith's time and affection' (Yorke, 1990: p137). McClure developed into quite a handful, creating public scenes where he 'lay on the floor rigid with hysteria' (Yorke, 1990: p232), mortifying Vaughan. Vaughan and John Minton shared a London flat (1946) until Vaughan's success as a painter allowed him to take a lease on his own apartment (1952). Vaughan's work was held in considerable esteem. Christopher Isherwood gave a work by Vaughan to E. M. Foster (1952), bringing him a wider audience. His painting developed from illustrative landscapes to complex compositions of men bathing (*Green Bathers*, 1952), fishing or in ambiguous sexual situations (*First Assembly of Figures*, 1952).

Vaughan taught at Iowa State University (1959), and exposure to the open countryside made his landscapes more abstract, as in *Small Limestone Landscape* (1963). Vaughan's *Martyrdom of St Sebastian* (1958) sees

Carl von Platen, **Fredrik Moberg**, 1902, b/w photograph

the saint depicted from the rear. He was made an Associate Royal Academician (1960) and a Commander of the British Empire (1965). At the Slade, he taught Patrick Procktor and Mario Dubsky (an outspoken member of the Gay Liberation movement who introduced Vaughan to gay politics). Hockney was also a friend. Edward Lucie-Smith states that, 'Hockney's career belongs largely to the epoch when homosexuality had at last been decriminalised in England' and that, '[h]is nudes tend to put homosexuality into a domestic context and his works 'reject homosexual guilt'. For Vaughan by contrast 'Fear, guilt and longing are ever-present in his work' (Graham and Boyd, 1991: p5).

The Whitechapel organised a touring retrospective of Vaughan's work (1962) to much acclaim, and Vaughan was a representative for England in the 1963 São Paulo Bienal. Vaughan exhibited throughout the 1960s with Marlborough and with Waddingtons in the 1970s. While his work never took on the developments of Pop or Conceptual Art, it continued to be in demand and to develop in its own terms. In 1975 he developed cancer, and a colostomy left him impotent. He was left with 'no desire – only a desire for desire' (Yorke, 1990: p268). He told friends that, 'if he could not sustain an

erection and ejaculate then he could not paint' (Yorke, 1990: p272). Without the ability to connect directly to his sexual side, he was adrift and felt he could not work, and therefore could not live. In a severe state of depression he took his own life on 4 November 1977, writing his last entry in his diary as the pills took effect.

Wilhelm von Gloeden
1856–1931, Germany
• Like many Victorian aristocrats on the Grand Tour Von Gloeden found that his money and title enabled him to act outside of society's traditional mores in southern climes. He settled in Taormina (Sicily) and began a photographic series of nude young men in classical guise. His attempt to fashion these youths into ancient Greeks and Romans was not dissimilar to *Day in America*, or to Von Platen in Sweden. Over his lifetime, he made more than 3,000 images of local lads who performed not only in front of the camera but in countless orgies that he organised for his Northern European visitors. His wealth protected him and allowed him to be as eccentric as he wanted. After his death the Fascists destroyed the majority of his negatives and prints still in his studio.

Carl von Platen
1863–1929, Stockholm, Sweden
• Born into a well-known Swedish family of minor nobility, Von Platen's position allowed him to make photographs that were extremely homoerotic without fear of censure (even though it was seen as scandalous). Like Wilde, he preferred working-class youths or military men and documented them at rest, often in highly charged sexual scenarios. Many of these men were sexual partners, including Fredrik Moberg, who is depicted lounging on a sofa in Von Platen's salon in a state of casual undress (1902), surrounded by homoerotic paintings and photographs. Unlike Jansson's virile sportsmen (photographed naked in gymnasiums or bath houses), Von Platen's images were shot indoors in a makeshift studio made from hastily hung curtains in his home. Many depict men in drag, styled like Von Gloeden images either in classical drapery, Italian costumes or at rest. The casualness shown in the images belies the different social class of the sitters and the photographer, unusual in such a socially policed period.

Wilhelm von Plüschow
1852–1930, Mecklenburg, Germany
• Wilhelm von Plüschow first travelled to Rome before settling in Naples (1872–90), where he began to photo-

graph local young men in a faux classical style similar to his cousin Von Gloeden's. Both successfully sold images to a variety of rich tourists, and for a long time Von Plüschow was simply thought to be a pseudonym for Von Gloeden. Yet their styles were markedly different, Von Gloeden preferring dark-skinned youths (often covering them with dye, as many Italians were too light-skinned for him), while Von Plüschow preferred the paler city types he found on his return to Rome. He was also less prone to using props than his cousin. Because his imagery was more graphic, Von Plüschow encountered several scandals in Rome, being arrested and imprisoned for eight months for corrupting youth, along with Galdi who worked for both cousins. He returned to Germany in 1910.

Lee Wagstaff
1969, London, UK
• Wagstaff graduated from the Royal College of Art (2000) to great acclaim for his photographic work based on his own tattooed body. Wagstaff designed each of his tattoos based on simple (yet universal) geometric (circles, triangles) and religious shapes (stars, swastikas). His body is his canvas, he is the subject of his own artistic investigations, and the documents produced are works in themselves as well as

Lee Wagstaff, **Viper**, 2001, c-type photograph, edition of 6, 195.58 x 165.1 cm. Courtesy of The Proposition Gallery, New York

reportage of nearly five years of painful ritual. It is a fundamental part of Wagstaff's work that blood is drawn during the tattooing process. In *Shroud*, he used his own blood as ink, for a life-sized impression of his body (shown at the Victoria & Albert Museum, 2001).

Andy Warhol

1928–1987, Pennsylvania, USA
• Born in Pittsburgh to Slovakian parents, he was raised as a strict Ruthenian, attending church throughout his life, learning English at school. He spent long periods inside, reading Hollywood fan magazines, drawing and going to movies. He attended the Carnegie Institute of Technology (1945–49). He moved to New York to work as an illustrator for *Glamour* and *Vogue*, supplementing his income by window dressing. By 1952 he had a one-man show at the Hugo Gallery, *Fifteen Drawings Based on the Writings of Truman Capote*. Warhol's mother moved in with him, staying until her death. Working for the I. Miller shoe company (1955), pandered to his foot and shoe fetish (Rodley, 2002: documentary). He published *A la Recherche du Shoe Perdu* (Crone, 1987: p64), followed by his exhibition *Andy Warhol: The Golden Slipper Show or Shoes Shoe in America* (1956), and founded Andy

Warhol Enterprises, Inc.

In 1960 Warhol made his first paintings based on cartoons (including Dick Tracy [Moon, 1998: p101] and Nancy), and met Billy Name (Linich) who photographed many Factory events. Seeing Lichtenstein's work at Castelli's (1961), Warhol changed track, making the *Campbell's Soup Can* series (Ferus Gallery, Los Angeles, 1962). When Henry Geldzahler (Metropolitan Museum curator) advised him to pick darker topics, Warhol embarked on the *Disaster* series. He experimented with silkscreen, including *Gold Marilyn* (following her suicide), *Mona Lisa*, *Electric Chair* and, after the Kennedy assassination, the *Jackie* series. He bought a 16-mm camera and made experimental films, many set in the first Factory (East 87th) and later in its new incarnation (covered in aluminium foil by Billy Name) on East 47th (Bastian, 2001: p296). Warhol's *Jack Smith Filming 'Normal Love'* was a homage to the then underground art/gay king.

Duchamp was introduced to Warhol at his show of *Elvis* works (Ferus Gallery). Philip Johnson commissioned Warhol's *Thirteen Most Wanted Men* (New York World's Fair, 1964) of famous mobsters Warhol found sexually attractive. Controversy followed and Warhol was forced to censor it, spraying it silver (Hopps, 1988: p106). He

continued the theme with his film *The Thirteen Most Beautiful Boys*. Warhol's *Brillo Boxes* (Stable Gallery) was a huge success, and he was poached by Castelli. When he made *Flowers* he was successfully sued by photographer Patricia Caulfield for use of her image. The Factory became a hang-out for drag queens, artists, rent boys, curators and collectors, including socialite Edie Sedgwick. Paul Morrissey took over Warhol's film production and Warhol made the cover for the Velvet Underground's album. Warhol had his first retrospective at the Philadelphia ICA (1965). *Silver Clouds* (later used in Merce Cunningham's *Rain Forest*) and *Cow Wallpaper*, exhibited at Castelli's (1966), generated a flood of media coverage, and the same year he filmed *The Chelsea Girls*.

In 1968, the Factory moved to Union Square where he met Jed Johnson (Bastian and Dallman, 2001: p298), who became his partner. Warhol was invited to Documenta IV, and had a retrospective at the Moderna Museet (Stockholm). That summer, Valerie Solanas (a Factory habitué, founder of the *Society for Cutting up Men*, and failed screenplay writer), believing (with some basis in fact) that Warhol had stolen her script, walked into Warhol's office and shot him. Warhol survived but his injuries plagued him

throughout his life. He launched *Interview* magazine (1969), featuring himself talking with celebrities, and in 1972, he made a campaign poster featuring Nixon's image and the slogan 'Vote McGovern'. The American IRS immediately started to question his income tax statements, and harassed him until his death. In the same eventful year, Warhol started his *Mao* series and his mother died.

In 1974, Warhol embarked on *Time Capsules* (boxes filled with art, junk and memorabilia, now carefully stored in the Warhol archive), his portrait series (including images of his mother), and produced *Andy Warhol's Dracula* and *Andy Warhol's Frankenstein*. Warhol's collaboration with younger artists continued with Jamie Wyeth (1976), Jean-Michel Basquiat (1983) and Keith Haring in the 1980s. These friendships were seen as opportunistic on Warhol's part, yet produced a body of interesting work. Warhol brought them art world cachet, and they brought street credibility (Warhol was often seen as a dilettante, known as much for hanging out at Studio 54 as for his work). Warhol's *Oxidation* (1978) canvases were covered in copper metallic paint, on which he and his male assistants urinated, so that it developed greenish oxidation marks. Many institutions prudishly continue to refer to the urine as additional

Klaus Wehner, **Hierophilila (Sodom)**, 2004, duratrans on lightbox, 100 x 60 cm. Courtesy of the artist

mixed media. *Oxidation* and the *Shadow* series (1978) of nearly abstract images are now generally regarded as some of his finest work. He also embarked on his homoerotic *Torso* series. *Andy Warhol: Portraits of the 70's* opened at the Whitney (1979), and *Andy Warhol's Exposures* was published, further fixing his name as a brand.

At the start of the 1980s his relationship with Johnson ended, a cable programme was launched (*Andy Warhol's TV*) and he had a meeting with the Bishop of Rome. Having befriended Joseph Beuys, Warhol started an unlikely series of works based on the German conceptualist. They formed an odd couple, Beuys the epitome of high art, Warhol the opposite extreme (his *Dollar Signs* series competed with his magazine for mass public attention). Warhol's *Rorschach* series (1984), based on traditional Rorschach principles of folded ink images, are among his finest output. These paintings were huge in scale and covered in diamond dust. The privileged status of the artist/psychiatrist was undercut by the glittery surface.

In 1986, Warhol's *Self-Portraits* (wearing one of his many wigs) secured his image (as much as his name) as a global. His *Last Supper* images (based on da Vinci's fresco) were hailed as some of the only major religious work in twenti-

eth-century contemporary art. Produced by such a hedonist, they were initially seen as satirical, yet on his death (and the revelation of his private religious works), have been re-evaluated. His *Camouflage* series of huge (295x1,082 cm) empty canvases, save for garish versions of military camouflage, embody different parts of his persona: the public (the empty vessel – known to canvass others for ideas for his art, who stated, 'I was never embarrassed about asking someone, literally, "What should I paint?" – because pop comes from the outside' [Wrenn, 1991: p19)], the private (a gay man, who was out, whose sexuality was often camouflaged by institutional reluctance to engage the homoerotic), and the symbolic (who spoke of signs that hid in the open).

Just as Johns' *Targets* held homosexual signs for those in the know, the *Camouflage* series spoke to an army of lovers. The AIDS epidemic and the Reagan administration's lack of leadership spurred an army of queer young men and women to take direct action, along military lines. Warhol's finger was always on the pulse, and he was aware of this new militancy through Haring, who, like many, died of an AIDS-related illness. *Camouflage* also functions as a final revenge on the Abstract Expressionists. Leonard

Kessler, a contemporary at the Carnegie, quoted Warhol thus: 'Andy said, "I'm starting pop art." I said, "Why?" He said, "Because I hate abstract expressionism"(Wrenn, 1991: p13). Warhol, long taunted by the supporters of real men/artists (Abstract Expressionists), by reproducing abstract marks (in the form of sexual and artistic camouflage) played a trump card. He became the last Abstract Expressionist by 'sampling' those who disdained him. Warhol emptied the picture plane of figurative imagery, and all the viewer has left is the artist's mark which, for Warhol, remains a sign of hidden meanings as opposed to expressionistic marks as heroic gesture. 'Warhol succeeds in turning the theorem of technical reproductibility, as a nonartistic process, into a way of making an artistic statement' (Crone, 1987: p82).

Warhol's importance as a twentieth century artist cannot be overestimated. Like Duchamp, he ushered in a paradigm shift in what art could and would become. Surface, glamour, branding are all part of the current art world, as he predicted. That his art had hidden depths is no longer in doubt. Duchamp (with his *Readymades*) is arguably the first twentieth-century artist; Warhol may come to be seen as its epitome. Warhol was one of the

superstars he chose to document, and there was hardly a media or artistic figure he did not know or interview. Warhol died from complications from minor gall bladder surgery. In the aftermath of infighting for his vast fortune, the Andy Warhol Foundation for the Visual Arts was established. It continues to look after his works, collections and (for the artist who wryly posited that in the future everyone would have fifteen minutes of fame) his name.

Klaus Wehner

1967, Koblenz, Germany
• Wehner's recent digital photomontages use fragments of found bodies taken from the Internet (often of a pornographic nature). He then 'builds' religious objects (reliquaries) from them. The bodies form architectural elements that define and support religious structures, like the herms or Atlantes used in Western sacred architecture. Reliquaries are usually made of precious metals meant to preserve and present body parts for veneration (such as saints' bones). Instead of an aura of permanence and sanctity that the original cult objects generate, Wehner's *Hierophilia* structures feature a grotesque and comic element. Instead of a feeling of the eternal, his bodies look temporary, as if (upheld with great effort) they may collapse at any

Robert Wilson, **Memory/Loss**, Installation: Venice Biennial, Venice, Italy, 1993, mixed media installation. Courtesy of Devin Borden Hiram Butler Gallery, Houston

David Wojnarowicz, **Untitled**, 1992–97, video still, polaroid photograph, 11.43 x 10.16 cm. Private collection, London

moment. Their religious origins also sit uncomfortably with the explicitly sexual source material. At a time when religion seems unable to reconcile itself with human sexuality (gay or straight), Wehner's works highlight these tensions and can be read as a comment on traditional concepts of moral, religious and sexual behaviour.

Minor White

1908–1977, Minnesota, USA

• Born in Minneapolis, White, a photographer, poet, teacher and critic, was given a camera by his grandfather (a keen amateur) when he was ten. At the University of Minnesota he came to understand that his homoerotic feelings would not go away. His same sex desires troubled him throughout his life, and he sought ways to incorporate them into private nude male images (*Tom Murphy*, 1947), while publicly presenting highly charged spiritually influenced city- and landscapes (*Surf Vertical*, 1947). White moved to Portland, Oregon (1937), to start his career with the WPA. He was included in MOMA's (New York) *Image of Freedom* exhibition (1941), and had his first one-man show at the Portland Art Museum (1942), before joining the Army Intelligence Corps (1942) where he was awarded a bronze star. After the war (1945) he studied at Columbia University (New York), becoming part of the photographic scene centred on Alfred Stieglitz. He became Ansel Adams' assistant at the California School of Fine Arts (San Francisco 1946–53) and was a founder and editor of *Aperture* (1952), which became the main American photographic magazine. White taught at Rochester (1956) and later at MIT (1965) while continuing to exhibit, including a touring retrospective (Philadelphia Museum of Art, 1970), but his male nudes were not exhibited until 1989, thirteen years after his death from a heart attack.

Robert Wilson

1941, Texas, USA

• Born in Waco, Wilson studied interior design (Pratt, New York, 1962) and worked for architect Paolo Soleri before turning to performance art for which he is best known. Works include the seminal *Einstein on the Beach* (1976), the *CIVIL warS* (1984) and *Bluebeard's Castle* (1995). He has also made large-scale installation environments (*Memory/Loss*, Venice Biennale, 1993, which won the Golden Lion for Sculpture), and has been awarded the National Design Award for Lifetime Achievement (Smithsonian, 2001) and been elected to the American Academy of Arts and Letters (2000). He has collaborated with Philip Glass, William S. Burroughs, Allen Ginsberg, Laurie Anderson, Susan Sontag and Lou Reed on various projects. Solo exhibitions of his visual works have been held at the Centre Georges Pompidou (Paris, 1991), Clink Street Vaults (London, 1995), the Kunstindustrimuseet (Copenhagen, 2000) and the Galeries Lafayette (2002). Wilson has also designed a series of chair works that exist between sculpture and stage set imagery. Made in a variety of materials from bronze to oak, they appear to function as chairs but cannot be sat on.

David Wojnarowicz

1954–1992, New Jersey, USA

• Wojnarowicz was born to a violent working-class Catholic family, and was sexually and physically abused by his father, becoming a prostitute at the age of nine 'looking for the weight of some man to lie across me to replace the nonexistent hugs and kisses from my mom and dad' (Lippard, 1994: p10). As a child, seeing Tchelitchev's *Hide and Seek*, he decided to be an artist, but dropped out of the Manhattan School of Music and Art. The American underbelly forms the body of his work. Given a stolen camera (1972), he documented his world in images. He stole film but seldom had money to develop it. He made his first major photo essay, *Arthur Rimbaud in New York* (1978), where friends wore a Rimbaud mask, staging the poet's disturbing journey into darkness.

Wojnarowicz met Peter Hujar (1980) who became his friend, lover and mentor. He repaid the debt, nursing Hujar through his AIDS–related illness until his death (1987). Not until 1982 did Wojnarowicz join the art world proper, exhibiting work but seeking to remain an outsider commenting on it. *Fuck You Faggot Fucker* (1984) is one of his best-known paintings of that period. He often used maps to depict officialdom, suggesting that it acted malignly, destroying the lives and freedoms of the people. His work was full of rage at society, yet wonder for the world. After Hujar's death Wojnarowicz used his darkroom for a sustained period, making photo collages that contrasted pornographic, medical and art historical images.

Once known to be HIV positive, Wojnarowicz protested, 'I know I'm not going to die merely because I got fucked in the ass without a condom or because I swallowed a stranger's semen. If I die it is because a handful of people in power, in organised religions and political institutions, believe I am expendable' (Lippard et al., 1994: pp24-25). He directed his anger at the woefully inadequate action of the Reagan presidency and the continued attack on

Martin Wong, **Self Portrait**, 1993, acrylic on canvas, 101.6 cm in diameter. Courtesy of the Estate of Martin Wong and P.P.O.W Gallery, New York

Frank Yamrus, **Untitled (813108) From the Dehon Ice Fields**, 2003, b/w photograph, 71.12 x 71.12 cm. Courtesy of the artist

same sex lovers by Cardinal O'Connor (New York) and the religious right. Wojnarowicz's work was not just a reaction to abuse and illness, it was a clinical look into social oppression and the abyss of death. Wojnarowicz's highly influential show *Tongue of Flames* (Illinois State University Gallery, 1990) forced many to see works they would rather turn from, including his *Sex Series* (1988–89). His autobiographical novel, *Close to the Knives, a Modern Season in Hell*, mixes prose, factual information, and documents seven homophobic politicians and their attitudes.

Wojnarowicz was held in esteem as a radical artist, even among career-obsessed artists of the 1980s. He sued Reverend Donald Wildmon for using his work without permission in American Family Association propaganda tracts. In a trial outcome similar to Whistler's, Wojnarowicz won, but was awarded one US dollar for damage to his reputation. The moral victory in the culture wars was of small comfort. Fran Lebowitz stated that, 'David, instead of turning into a serial killer, turned into an artist' (Lippard, 1994: p74). Wojnarowicz was given a posthumous one-man show at the New Museum of Art (New York, 1999), which confirmed his reputation as a major force in an art world he so often rejected.

Martin Wong

1946–1999, Portland, Oregon, USA
• Born to Chinese parents in Portland, the family later moved to San Francisco. Wong settled in New York at the start of the 1980s. His figurative paintings of ghetto scenes, East Village life and general urban decay were never popular in the decade that celebrated success at any price. Wong's paintings of firemen in love among the ruins (*Big Heat*, 1988), or behind prison bars (*The Annunciation According to Mikey Piñero [Cupcake and Paco]*, 1984) are offset by depictions of Chinatown life (*Harry Chong Laundry*, 1984) and his own family history (*Ms Chinatown*, 1992). Wong's paintings most often include windows, allowing the viewer to gaze in on the subjects, and for them to gaze out into additional pictorial space. Wong's pictorial devices provide a possible escape route from the depicted characters' situation, while simultaneously framing desire.

Cerith Wyn Evans

1958, Llanelli, Wales, UK
• Wyn Evans studied film and video at the Royal College of Art (1984). He then became Derek Jarman's assistant, befriended Leigh Bowery and worked with choreographer Michael Clark. Wyn Evans' installations and sculpture question language and the perception of it

(he taught at the Architectural Association for six years). His *Inverse, Reverse, Perverse* (1996) is a large concave mirror, which, like fun-fair attractions, distorts the viewer; it was included in Saatchi's *Sensation* exhibition. Works dealing with translation of language, *Before the Flowers of Friendship Faded Friendship Faded (after Gertrude Stein)* (2000) have been made from fireworks connected together to spell out the titles in flammable materials (some are ignited, others not). Other works feature Morse code, as in his chandelier pieces that blink on and off, sending light versions of prose into the atmosphere. He represented Wales at the 2003 Venice Biennale, and was represented in Documenta XI (2002).

Frank Yamrus

1967, Pennysylvania, USA
• Yamrus' photo series *The Dehon Ice Fields* was originally conceived as an outdoor, on-site photo essay capturing the remains of the British Columbia Ice Fields (Canada) glaciers, which owing to global warming are rapidly disappearing. In the end this was not possible, so he recreated their likeness in his San Francisco (on Dehon Street) studio, photographing huge blocks of ice as they melted. The largely abstract images capture the melting process as a metaphor for loss. The Kinsey

Institute recently bought Yamrus' previous series of photographs of twenty people at the moment of orgasm (*Rapture*, 2000).

Nahum B. Zenil

1947, Veracruz, Mexico
• Zenil trained as a schoolteacher before studying art, and continues both careers. His first works were abstract, but he soon took up a traditional Mexican format of figurative painting in order to subvert it. His small intricate drawings on paper are similar to *retablos* (a Mexican format of depicting Christian iconography). Instead of saints or Christ, Zenil depicts interaction with his family, students and his lover (Gerardo Vilchis), questioning the machismo and homophobia found in daily Mexican life. Zenil's commitment extends to political action (which is physically dangerous, as Mexican gay rights campaigners have been murdered) and he is a founder of the Semana Cultural Gay Festival. His work is widely exhibited and is in major collections including the Metropolitan Museum of Art (New York) and the Museum of Modern Art (Mexico City).

Cerith Wyn Evans, **Untitled (Gold-plated barrier)**, 1998, plated steel, 2.59 m long 1.22 m high with feet. © The Artist. Courtesy of Jay Jopling/White Cube, London

Advocate, 'No gays in Uganda, says President', News, 5 March 2002, http://www.advocate.com/new_news.asp?id=3303&sd=03/05/02

Advocate, 'Healthwatch', 19 March 2002, http://www.advocate.com/new_news.asp?id=3496&sd=03/19/02

Albertazzi, Liliana, Per Barclay, Bergen, Bergen Kunst Forening, 2002

Artnet.com, 'Christian Bérard', The Grove Art Dictionary http://www.artnet.com/library/00/0080/T008011.asp

Ault, Julie, 'Beyond, Behind, Within' in Jim Hodges, New York, New York CRG Gallery, 1995

Arning, Bill, [Glenn Ligon 98.1], San Antonio, ArtPace, 1998

Avena, Thomas, and Adam Klein, Jerome: After the Pageant, San Francisco, Bastard Books, 1996

Bachardy, Don, Last Drawings of Christopher Isherwood, London, Faber and Faber, 1991

Baert, Renee, Micah Lexier, Lethbridge, Canada, Southern Alberta Art Gallery, 1991

Baker, Paul, and Jo Stanley, Hello Sailor!: The Hidden History of Gay Life at Sea, London, Pearson Education Limited, 2003

Baker, Virgil, American Painting: History and Interpretation, New York, Bonanza Books, 1960

Barthes, Roland, Camera Lucid, London, Flamingo Edition, Fontana Paperbacks, 1990

Barthes, Roland, Taormina: Wilhelm von Gloeden, Santa Fe, Twin Palms/Twelvetrees Press, 1997

Bastian, Heiner, and Antje Dallmann, Andy Warhol Retrospective, London, Tate Publishing, 2001

Bawer, Bruce (ed.), Beyond Queer: Challenging Gay Left Orthodoxy, New York, The Free Press, 1996

Beaton, Cecil, Near East, London, Batsford, 1943

Benderson, Bruce, James Bidgood, Cologne, Taschen, 1999

Benes, Barton Lidice, Curiosa: Celebrity Relics, Historical Fossils, and Other Metamorphic Rubbish, New York, Harry N. Abrams, 2002

Bentley, Kevin, Bruce Bellas: The Naked Heartland, Simons Town, South Africa, Janssen Publishers, 2001

Berman, Esme, Art and Artists of South Africa, Cape Town, A. A. Balkema, 1970

Bernard, André, and Claude Gauteur (eds), Jean Cocteau: The Art of Cinema, London, Marion Boyars, 1992

Blake, Nayland, Lawrence Rinder and Amy Scholder (eds.), In a Different Light: Visual Culture, Sexual Identity, Queer Practice, San Francisco, City Lights Books, 1995

Bleckner, Ross, Page Three, Santa Fe, Twin Palms Publishers, 1998

Blom, Ina, Børre Saethre, Oslo, Galleri Wang, 1999

Boadwee, Keith, Keith Boadwee, Los Angeles, Kim Light Gallery, 1993

Boberg, Oliver, and Stephan Berg, Oliver Boberg, Ostfildern-Ruit, Hatje Cantz, 2003

Boggs, Jean Sutherland, Degas, Metropolitan Museum of Art (New York) and National Gallery of Canada (Ottawa), 1988

Bois, Yves-Alain, Spencertown: Recent Paintings by Ellsworth Kelly, London/New York, Anthony d'Offay Gallery/Matthew Marks Gallery, 1994

Bonuomo, Michele, McDermott & McGough: 1936, Milan, Charta, 1996

Borgen, Trond, Her er mitt legeme, Fin Serck-Hanssen og kroppens krise, Oslo, Spartacus Forlag, 1998

Boswell, John, The Marriage of Likeness: Same-Sex Unions in Pre-Modern Europe, London, Fontana Press, 1996

Brett, Guy, Exploding Galaxies: The Art of David Medalla, London, Kala Press, 1996

Brown, Frederick, An Impersonation of Angels: A Biography of Jean Cocteau, London, Longman, 1968

Browning, Frank, A Queer Geography: Journeys Toward a Sexual Self, New York, Crown Publishers, 1996

Bujon de l'Estang, François, 'France Honors M. Duane Michals', frenchculture.org, New York, 1 March 2000, http://www.french-culture.org/people/honorees/michals.html

Buonarroti, Michelangelo, The Sonnets of Michelangelo, London, Folio Society, 1961

Burleigh, Michael, 'The Church in the Dock' (review of Unholy War: The Vatican's Role in the Rise of Modern Anti-Semitism by David Ketzer), London, The Sunday Times (Culture Section), 20 January 2002

Burman, Rickie (ed.), From Prodigy to Outcast: Simeon Solomon – Pre-Raphaelite Artist, London, The Jewish Museum, 2001

Cage, John, Roylwholyover: a Circus, New York, Los Angeles: Museum of Contemporary Art, 1993

Calloway, Stephen, Charles Ricketts: Subtle and Fantastic Decorator, London, Thames and Hudson, 1979

Campbell, James, Talking at the Gate: A Life of James Baldwin, London, Faber and Faber, 1991

Caples, Garrett, 'Joe Brainard: A Retrospective' (review), Reviewwest.com,

February 2001, http://www.granarybooks.com/reviews/joe_brainard_retrospective/reviewwest.html

Carey, John (ed.), The Faber Book of Science, London, Faber and Faber, 1995

Carr, C., 'On Edge', Village Voice, 19–25 April 2000, http://www.villagevoice.com/issues/0016/carr.php

Carter, Miranda, Anthony Blunt: His Lives, London, Macmillan, 2001

Caveney, Graham, Gentlemen Junkies: The Life and Legacy of William S Burroughs, London, Little, Brown and Company, 1998

Celant, Germano, Mapplethorpe, London, Electa and the Hayward Gallery, 1992

Chappell, William, Well, Dearie!, The Letters of Edward Burra, London, Gordon Fraser Gallery, 1985

Chauncey, George, 'Privacy Could Only be had in Public: Gay Uses of the Streets', in Stud: Architectures of Masculinity, Joel Sanders (ed.), New York, Princeton Architectural Press, 1996

Cinalli, Ricardo, Ricardo Cinalli of Argentina, Washington, DC, Museum of Modern Art of Latin America, Organization of American States, 1982

Cocteau, Jean, The White Paper, New York, Macaulay, 1958

Coen, Vittoria, Per Barclay, Oslo, The National Museum of Contemporary Art, 2000

Collins, Anne, Andrew Logan, Berriew, Wales, Andrew Logan Museum of Sculpture, 2002

Collins, Judith, Howard Hodgkin, London, Dulwich Picture Gallery, 2001

Cooper, Emmanuel, The Life and Work of Henry Scott Tuke, London, Editions Aubrey Walter, 1987

Craig-Martin, Michael, Virginia Button and Richard Cork, Michael Craig-Martin: Inhale/Exhale, Manchester, Manchester City Galleries, 2002

Crichton, Michael, Jasper Johns, London, Thames and Hudson Ltd., 1994

Crimp, Douglas, Melancholia and Moralism: Essays on Aids and Queer Politics, Cambridge, MA, MIT Press, 2002

Crimp, Douglas, and Adam Rolston, Aids Demographics, Seattle, Bay Press, 1990

Crone, Rainer, Andy Warhol: The Early Work 1942–1962, New York, Rizzoli International, 1987

Crowley, Harry, Advocate, 2 September 1997

Crump, James, 'Photography as Agency: George Platt Lynes and the Avant-Garde', in George Platt Lynes: Photographs from

the Kinsey Institute, New York, Bulfinch Press, 1993

Cruz, Amanda, Felix Gonzalez-Torres, Los Angeles, Museum of Contemporary Art, 1994

Dannatt, Adrian, Paradise Lost: Andrew Heard 1953–1993, Rotterdam, Galerie Reisel, 1993

Danziger, James (ed.), Beaton, New York, Henry Holt 1980

Danzker, Jo-Anne Birnie, Robert Wilson: Steel Velvet, Munich, Prestel, 1997

Davison, Liane, Digital Identity: Transforming Communities, Reinventing Ourselves, Surrey, Canada, Surrey Art Gallery, 2000

Deitcher, David, Felix Gonzalez-Torres, Stockholm, Stockholm Konsthall, Magasin 3, (exhibition catalogue)1992

Deitcher, David, Wolfgang Tillmans: Burg, Cologne, Taschen, 1998

Deitcher, David, Dear Friend: American Photographs of Men Together 1840–1918, New York, Harry N. Abrams, 2001

Delaney, J. G. P., Glyn Philpot: His Life and Art, Aldershot, Ashgate Publishing, 1999

DeOliveira, Nicolas, Nicolas Oxley and Michael Petry, Installation Art, London, Thames and Hudson, 1994

DeSalvo, Donna (ed.), Ray Johnson: Correspondences, Columbus, Wexner Center for the Arts, 2000

Dolinsky, Jim (ed.), Bruce of Los Angeles, Berlin, Bruno Gmünder, 1990

Dompierre, Louise, Attila Richard Lukacs/Louise Dompierre, Toronto, The Power Plant, 1989

Duberman, Martin Bauml, Martha Vicinus and George Chauncey Jr (eds.), Hidden from History: Reclaiming the Gay and Lesbian Past, London, Penguin Books, 1991

Dugdale, John, Lengthening Shadows Before Nightfall, Santa Fe, Twin Palms Publishers, 1995

Durant, Mark Alice, McDermott and McGough: A History of Photography, Santa Fe, Arena Editions, 1998

Dyer, Richard, The Culture of Queers, London, Routledge, 2002

Economist, The 'The End of Privacy', 1 May 1999

Ellmann, Richard, Oscar Wilde, New York, Vintage Books, 1988

Esten, John, John Singer Sargent: The Male Nudes, New York, Universe Publishing, 1999

Fairbrother, Trevor J., John Singer Sargent, New York, Harry N. Abrams, 1994

Farson, Daniel, With Gilbert & George in Moscow, London, Bloomsbury, 1991

Fisher, Jennifer, World Tea Party: A

Collaborative Interactive Transcultural Tea Salon/Daniel Dion, Bryan Mulvihill, Marc Patch, Suschnee, Vancouver, Presentation House Gallery, 1996

Flynt, Robert, Compound Fracture, Santa Fe, Twin Palms Publishers, 1996

Forde, Gerard, Paradise Lost, Rotterdam, Galerie Reisel, 1993

Foster, Hal, Robert Gober, Los Angeles, Museum of Contemporary Art, 1997

Fox, Howard N., Lari Pittman, Los Angeles, Los Angeles County Museum of Art, 1996

Francis, Richard, Scott Burton, London, The Tate Gallery, 1985

Fuchs, R. H., David Robilliard: A Roomful of Hungry Looks, Amsterdam, Stedelijk Museum, 1993

Galán, Julio, My Mirrors, New York, Robert Miller Gallery, 2002

Garver, Thomas H., George Tooker, New York, Clarkson N. Potter, 1985

Gathorne-Hardy, Jonathan, Alfred C. Kinsey: Sex the Measure of All Things, London, Chatto & Windus, 1998

Gay Times, London, September 2000

Gay Times, London, October 2001

Gazetteer for Scotland, 'Robert MacBryde' ©1995–2004, http://www.geo.ed.ac.uk/scotgaz/people/famousfirst1171.html

George, Gilbert &, Gilbert & George: The Complete Pictures 1971–1985, Stuttgart, Dr. Cantz'sche Druckerei, 1986

Getty: Explore Art, 'Frederick Holland Day' ©2003 J. Paul Getty Trust, http://www.getty.edu/art/collections/bio/a1804-1.htm

Geldzahler, Henry, 'Hockney: Young and Older', in David Hockney: A Retrospective, Los Angeles County Museum of Art, 1988

Gill, John, Queer Noises: Male and Female Homosexuality in Twentieth-Century Music, London, Cassell, 1995

Gillman, Peter and Leni, The Wildest Dream: Mallory His Life and Conflicting Passions, London, Headline Book Publishing, 2000

Glück, Robert, Frank Moore Between Life and Death, Santa Fe, Twin Palms Publishers, 2002

Goldberry, Robert Colquhoun (1914–62), ©Kilmarnock Academy, 1963, http://members.aol.com/kilmnkacad/colquhoun.html

Golden, Thelma, Black Male: Representations of Masculinity in Contemporary American Art, New York, Whitney Museum of Art, 1994

Gott, Ted (compiler), Don't Leave Me This Way: Art in the Age of Aids, Canberra, National Gallery of Australia, 1994

Gould, Claudia, Charles LeDray: Sculpture 1989–2002, Philadelphia, Institute of Contemporary Art, 2002

Graham, Philip, and Stephan Boyd (eds.), Keith Vaughan 1912–1977: Drawings of the

Young Male, London, Editions Aubrey (GMT), 1991

Grau, Gunter, Hidden Holocaust?, London, Cassell, 1995

Grimes, Nancy, Jared French's Myths, San Francisco, Pomegranate Artbooks, 1993

Gruen, Juhn, Keith Haring: The Authorised Biography, London Thames and Hudson, 1991

Guibert, Hervé, Hervé Guibert Photographien, Munich, Schirmer/Mosel

Gumbel, Andrew, 'Abe Lincoln's home town outraged at his "outing"', Independent on Sunday, 27 June 1999

Gupta, Sunil, Pictures from Here, London, Autograph, 2003

Gustavsson, Martin, The Gospel, Malmö, Malmö Kunstmuseum, 2003

Hall, James Barker, Minor White: Rites and Passages, New York, Aperture Books, 1992

Harris, Lyle Ashton, Lyle Ashton Harris: 20 x 24, Recent Portraits : June 6–July 11, 1999, Aldrich Museum of Contemporary Art, Ridgefield, CT (exhibition catalogue), The Aldrich Museum, 1999

Harrison, Martin, Brian Clarke: Transillumination, New York, Tony Shafrazi Gallery, 2002

Haskell, Barbara, The American Century: Art and Culture 1900–1950, New York, Whitney Museum of American Art and W. W. Norton, 1999

Hay, Harry, Radically Gay: Gay Liberation in the Words of its Founder, Boston, Beacon Press, 1996

Herbert, Lynn M., Nayland Blake: Hare Attitudes, Houston, Contemporary Arts Museum, 1996

Herdrich, Stephanie L., and H. Barbara Weinberg, American Drawings and Watercolors in the Metropolitan Museum of Art: John Singer Sargent, New York, Metropolitan Museum of Art, 2000

Herring, Oliver, Oliver Herring: A Flower for Ethyl Eichelberger, Bedding, Mannheim, Mannheimer Kunstverein, 26.9–24.10.,1993

Hickey, Dave, In the Dancehall of the Dead: Robert Gober, New York, Dia Center for the Arts, 1993

Hirst, Alex, The Last Supper: A Creative Farewell to Rotimi Fani-Kayodé, Wolverhampton, Light House Media Centre, 1992

History Project, Improper Bostonians: Lesbian and Gay History from Puritans to Playland, Boston, Beacon Press, 1998

Hoberman, J., On Jack Smith's Flaming Creatures (And Other Secret-Flix of Cinemaroc), New York, Granary Book/Hips Road, 2001

Hooven, Valentine, III, Tom of Finland: His Life and Times, Tom of Finland Foundation, St. Martin's Press, 1993,

http://www.eroticarts.com/foundation/touko.html

Hopps, Walter, Andy Warhol: Death and Disasters, (film) Houston, The Menil Collection, Houston Fine Art Press, 1988

Hopps, Walter, Robert Rauschenberg: The Early 1950s, Houston, Houston Fine Art Press, 1991

Hopps, Walter, and Susan Davidson, Robert Rauschenberg: A Retrospective, New York, Guggenheim Museum Publications, 1997

Horst, Horst P., Form, Santa Fe, Twin Palms Publishers, 1995

Howes, Keith, 'Outspoken: Keith Howes'' Gay News Interviews 1976–83, London, Gay Times/Cassell, 1995

Hughes, Robert, 'Cy Twombly',1994, http://home.sprynet.com/~mindweb/twombly2.htm

Hughes, Robert, America Visions – The Epic History of Art in America, London, Harvill Press, 1997

Hunter, Jack (ed.), Moonchild: The Films of Kenneth Anger, London, Creation Books, 2002

Jacobson, Bill, Bill Jacobson 1989–1997, Santa Fe, Twin Palms Publishers, 1998

Jivani, Alkarim, It's Not Unusual: A History of Lesbian and Gay Britain in the Twentieth Century, London, Michael O'Mara Books, 1997

Johnston, Jill, Jasper Johns: Privileged Information, New York, Thames and Hudson, 1996

Julius, Anthony, Transgressions: The Offences of Art, London, Thames and Hudson, 2002

Juncosa, Enrique, Bhupen Khakhar, Madrid, Museo Nacional Centro de Arte Reina Sofia, 2002

Kael, Pauline, 'Belle et Bête', World Cinema, http://www.geocities.com/Paris/Metro/9384/films/belle_et_bete/

Kaiser, Charles, The Gay Metropolis, London, Weidenfeld & Nicolson, 1998

Katz, Jonathan, Out, April 1998

Katz, Jonathan Ned, Love Stories: Sex Between Men Before Homosexuality, Chicago, The University of Chicago Press, 2001

Kemp, Arnold J., 'Heavy Petting', Queer Arts Resource, http://www.queer-arts.org/archive/show3/blake/blake.html#top

Kirstein, Lincoln, Paul Cadmus, San Francisco, Pomegranate Artbooks, 1992

Kirstein, Lincoln, Tchelitchev, Santa Fe, Twelvetrees Press, 1994

Klusacek, Allan and Ken Morrison (eds.), Leap in the Dark: Aids, Art and Contemporary Cultures, Montreal, Vehicule Press, 1992

Kozloff, Max and Hripsimé Visser, Peter Hujar: Eine Retrospektiv, Zurich, Scalo (Stedelijk Museum Amsterdam), 1994

Kunstmusuem Düsseldorf, Michael Buthe: MICHEL de la SAINTE BEAUTÉ, Dusseldorf, Umschau Braus Verlag, 1999

Leddick, David, Naked Men: Pioneering Male Nudes, New York, Universe Publishing, 1997

Leiris, Michel, Francis Bacon, Barcelona, Ediciones Polígrafa, 1987

Lewallen, Constance M., Joe Brainard: A Retrospective, New York, Berkley Art Museum, 2001

Lippard, Lucy (et al.), David Wojnarowicz: Brush Fires in the Social Landscape, New York, Aperture, 1994

Livingstone, Marco, Duane Michals: Photographs/ Sequences/ Texts: 1958–1984, (film) Oxford, Museum of Modern Art Oxford, 1984

Lucie-Smith, Edward, 'George Dureau: Classical Variations', New Orleans Art Review, May/June 1983

Lucie-Smith, Edward, George Dureau: New Orleans, London, Gay Mens' Press, 1985

Lucie-Smith, Edward, Michael Leonard: Paintings, London, GMP Publishers, 1985

McDonagh, Michael, 'One of a Kind', Classical Music Review (New Releases), http://www.msu.edu/user/gualtie3/Thomson.html

McDonnell, Patricia, Marsden Hartley: American Modern Art, Minneapolis, Frederick R. Weisman Art Museum, 1997

Maloney, Martin, Martin Maloney: Conversation Pieces, New York, Charta, 1999

Malsch, Friedmann, General Ideas: Fin de Siècle, Stuttgart, Württembergischer Kunstverein, 1992

Marcadé, Bernard, Pierre et Gilles: The Complete Works 1976–1996, Cologne, Taschen, 1997

Marshall, Richard, 'Gilbert & George: New horny pictures', G News, London, 27 July 2001

Marzolf, Helen, Patrick Traer: Matchless, Saskatchewan, Canada, Kenderine Art Gallery, 2003

Maupin, Armistead, 'The First Couple: Don Bachardy and Christopher Isherwood', Village Voice, Volume 30, Number 16, 2 July 1985

Medley, Robert, Drawn from Life, London, Faber and Faber, 1983

Melgaard, Bjarne, The Only Weapon You Have in a Society Like This is a Clear Mind … , Oslo, Galleri Riis, 2000

Metken, Günter, Herbert List Photographies 1930–1960, Munich, Schirmer/Mosel, 1983

Metro (photograph), 12 October 2001

Metrosource, New York, February/March 2003

Meyer, Richard, Outlaw Representation: Censorship and Homosexuality in Twentieth-Century American Art, New

York, Oxford University Press, 2002

Michals, Duane, *Salute, Walt Whitman*, Santa Fe, Twin Palms Publishers, 1996

Miller, James, *Passions of Michel Foucault*, London, Flamingo, 1994

Miller, Tim, *Shirts & Skin*, Los Angeles, Alyson Books, 1997

Mitchell, Mark, and David Leavitt (eds.), *Pages Passed from Hand to Hand – The Hidden Tradition of Homosexual Literature in English from 1748–1914*, London, Chatto & Windus, 1998

Moffat, Alexander, 'Robert MacBryde', 57 Gallery Association, Maybole Community Council, © 1994-2004, http://www.may-bole.org/notables/MacBryde/macbryde.htm

Moon, Michael, *A Small Boy and Others: Imagination and Initiation in American Culture from Henry James to Andy Warhol*, Durham and London, Duke University Press, 1998

Moore, Michael, *Stupid White Men ... and Other Sorry Excuses for the State of the Nation!*, New York, Regan Books, 2001

Morella, Joseph, and George Mazzei, *Genius and Lust: The Creative and Sexual Lives of Cole Porter and Noel Coward*, London, Robson Books, 1996

Morgan, Stuart, and Frances Morris, *Rites of Passage: Art from the End of the Century*, London, Tate Gallery Publications, 1995

Morphet, Richard, *Cedric Morris*, London, Tate Gallery, 1984

Morrisroe, Patricia, *Mapplethorpe: A Biography*, London, Papermac, 1995

Moser, Claes, *Eugène Jansson: The Bath-house Period/ Badhusperioden*, London, Julian Hartnoll, 1983

Nesbitt, Judith (ed.), *Robert Gober*, Tate Gallery Liverpool and London Serpentine Gallery, 1993

Odenbach, Marcel, *Marcel Odenbach: Keep in View*. Stuttgart, Edition Cantz/Stichting de Appel Foundation, 1993

Pearce, Barry, *Donald Friend, 1915–1989: Retrospective*, Sydney, Art Gallery of New South Wales, 1990

Peppiatt, Michael, *Francis Bacon: Anatomy of an Enigma*, New York, Farrar, Straus and Giroux, 1997

Petry, Michael (ed.), *Abstract Eroticism*, London, Academy Editions, 1996

Petry, Michael (ed.), *A Thing of Beauty is ...* , London, Academy Editions, 1997

Petry, Michael, *Blackout*, London, Brixton Art Gallery, 2001

Petry, Michael, *The Trouble with Michael*, London, Artmedia Press, 2001

Pfeiffer, Paul, *Paul Pfeiffer*, Chicago, Museum of Contemporary Art, Chicago, 2003

Phillips, Lisa, *The American Century: Art and Culture 1950–2000*, New York, Whitney Museum of American Art and W. W. Norton, 1999

Pierson, Jack, *All of a Sudden*, New York, Powerhouse Books, 1995

Plaskett, Joseph, *A Speaking Likeness*, Vancouver, Ronsdale Press, 1999

Procktor, Patrick, *Self-Portrait*, London, Weidenfeld & Nicolson, 1991

Raeburn, Michael (ed.), *Salvador Dali: The Early Years*, London, South Bank Centre, 1994

Ramakers, Micha, *Tom of Finland: The Art of Pleasure*, Cologne, Taschen, 1998

Reid, Guy, *Guy Reid Sculpture*, London, St Matthew's Bell Tower, 2001

Reynolds, Hunter, *Patina du Prey's Memorial Dress/Hunter Reynolds*, Cologne, Trinitätskirche, 1994

Ritchie, Andrew Carnduff, *Charles Demuth*, New York, Museum of Modern Art, 1950

Rivers, Larry, and Carol Brightman, *Drawings and Digressions*, New York, Clarkson N. Potter, 1979

Rodley, Chris, *Andy Warhol: the Complete Picture*, (film) London, Channel 4 Television, 2002

Rosenblum, Robert, *Keith Milow: Recent Work*, New York, Nohra Haime Gallery, 1995

Rosenblum, Robert, Maryanne Steven and Ann Dumas, *1900: Art at the Crossroads*, London, Royal Academy of Art, 2000

Ross, Alan (ed.), *Keith Vaughan: Journals 1939–1977*, London, John Murray, 1989

Rothenstein, John, *Edward Burra*, London, Tate Gallery, 1973

Rowse, A. L., *Homosexuals in History: A Study of Ambiance in Society*, Literature and the Arts, New York, Dorset Press, 1983

Ruf, Beatrix, *Taking Place: The Works of Michael Elmgreen and Ingar Dragset*, Ostfildern-Ruit, Hatje Cantz, 2002

Russel, John, *Francis Bacon*, London, Thames and Hudson, 1979

Russell, Jamie, *Queer Burroughs*, New York, Palgrave, 2001

Ryan, Susan Elizabeth (ed.), *Somehow a Past: The Autobiography of Masden*, Hartley, Cambridge, MIT Press, 1997

Sadao, Amy, *Share Your Vision*, New York, Visual AIDS, 2003

Salzburger Kunstverein, *Real Sex, Real Real, Real Aids*, Ritter, Klagenfurt, Verlag 1994

Sanders, Joel (ed.), *Stud: Architectures of Masculinity*, New York, Princeton Architectural Press, 1996

Sandqvist, Gertrud, *Matts Leiderstam Works 1996–2001*, Stockholm, Antenna, 2002

Saslow James, M., *Pictures and Passions: A History of Homosexuality in the Visual Arts*, New York, Penguin Books, 1999

Schwules Museum, *100 Jahre Schwulenbewegung: Goodbye to Berlin?*, Berlin, Akademie der Kunste, 1997

Seymour, Anne, *Dancers on a Plane: Cage, Cunningham, Johns*, New York, Alfred Knopf/Anthony d'Offay Gallery, 1990

Shakespeare, Nicholas, 'The Private Life of Dirk Bogarde', *Radio Times*, London, 8–14 December 2001

Signorile, Michelangelo, *Queer in America – Sex, the Media and the Closets of Power*, London, Abacus, 1994

Simeon Solomon Research Archive, 'Biographical Timeline of Simeon Solomon's Life', http://www.fau.edu/solomon/bio.html

Sinfield, Alan, *The Wilde Century*, New York, Cassell, 1994

Smith, Alison (ed.), *Exposed: The Victorian Nude*, London, Tate Publishing, 2001

Smith, Caroline, 'Lost from View' *Attitude*, February, 2000

Smith, Roberta, 'Sculptor Whose Art Verged on Furniture Is Dead at 50', *New York Times*, 1 January 1990, http://www.columbia.edu/cu/gables/hiv/mem/burton.html

Sösderstrom, Goran (ed.), *Sympatiens hemlighetsfulla makt: Stockholms Homosexuella 1860–1960*, Stockholm, Stockholmia Förlag, 1999

Spalding, Frances, *John Minton*, Newton, Wales, Oriel 31, 1993

Spalding, Frances, *Duncan Grant: A Biography*, London, Chatto & Windus, 1997

Spencer, Colin, *Homosexuality: A History*, London, Fourth Estate, 1995

Stalford, Maria, 'Richmond Burton: Painting in the Light', *The Magazine of Rice University*, Volume 58, Number 4, Spring 2002

Steegmuller, Francis, *Cocteau: A Biography*, London, Macmillan, 1970

Steel, Ronald, 'Big Daddy' (review of *Hostage to Fortune: The Letters of Joseph P Kennedy*), *New York Review of Books*, Volume XLVIII, Number 16, 18 October 2001

Steele, Bruce C., 'The Secret Life of Films', *Out*, February 1996

Storr, Robert, 'FELIX GONZALEZ-TORRES: ETRE UN ESPION', *Art Press*, Creative Time, January 1995, http://www.creativetime.org/torres/storr.html

Taylor, Robert, *Portrait Party*, London, Chronos, 2000

Tilley, Sue, *Leigh Bowery: The Life and Times of an Icon*, London, Hodder & Stoughton, 1997

Tis, *Master of Modern Art: Charles Shannon*, A.R.A., London, Colour Ltd, 1918

Toibin, Colm, *Love in a Dark Time: Gay Lives from Wilde to Almodovar*, London, Picador, 2001

Townsend, Chris, *Rapture*, London, Thames and Hudson, 2002

Turnbaugh, Douglas Blair, *PRIVATE: The Erotic Art of Duncan Grant 1885–1978*, London, Gay Men's Press, 1989

Verga, Max, 'A Meeting with George Dureau', *Houston Public News*, 21 January 1998, http://www.bentvoices.org/culturecrash/verga_georgedureau.htm

Vidal, Gore, *Gore Vidal: Sexually Speaking (Collected Sex Writings)*, San Francisco, Cleis Press, 1999

von Uslar, Moritz, *Marc Brandenburg*, Hamburg, Galerie Crone, 2003

Watney, Simon, *Wolfgang Tillmans*, Cologne, Taschen, 1995

Watson, Scott, *Strange Ways: Here We Come*, Vancouver, University of British Columbia, 1990

Watson, Scott, *Hand of the Spirit: Documents of the Seventies from the Morris/Trasov Archive*, Vancouver, UBC Fine Art Gallery, 1992

Weiermair, Peter, *The Hidden Image: Photographs of the Male Nude in the Nineteenth and Twentieth Centuries*, London, MIT Press, 1988

Weinberg, Jonathan, *Speaking for Vice: Homosexuality in the Art of Charles Demuth, Marsden Hartley and the First American Avant-Garde*, New Haven, Yale University Press, 1993

White, Edmund, *Mapplethorpe Altars*, New York, Random House, 1995

White, Edmund, *Marcel Proust*, New York, Viking/Penguin Group, 1999

White, Edmund (ed.), *Loss within Loss: Artists in the Age of AIDS*, Madison, WI, University of Wisconsin Press, 2001

Whitman, Walt, *Leaves of Grass*, New York, Doubleday Doran, 1940

Wildeblood, Peter, *Against the Law*, London, Weidenfeld & Nicolson, 1955

Wilmerding, John (ed.), *Thomas Eakins (1844–1916) and the Heart of American Life*, London, National Portrait Gallery, 1993

Wilson, Terry and Brion Gysin, *Here to Go: Brion Gysin*, London, Creation Books, 2001

Wollen, Roger, *Derek Jarman: A Portrait*, London, Thames and Hudson, 1996

Woody, Jack, *George Platt Lynes: Photographs 1931–1955*, Pasadena, Twelvetrees Press 1981

Wrenn, Mike, *Andy Warhol: In His Own Words*, London, Omnibus Press, 1991

Yorke, Malcom, *Keith Vaughan: His Life and Work*, London, Constable, 1990

Young, Hugh, 'Samuel Butler – Erewhon Man', *Queer History*, http://www.queerhistory.net.nz/Butler.html

Zenil, Nahum B., *Witness to the Self/Testico Del Ser*, San Francisco, The Mexican Museum, 1996

Figures in bold indicate captions.

David Wojnarowicz, **Fuck You Faggot Fucker**, 1984, b/w photographs, acrylic and collage on masonite, 121.92 x 121.92 cm. Courtesy of the Estate of David Wojnarowicz and P.P.O.W. Gallery, New York

WITHDRAWN